MW00805410

To all the creators of this most honorable art form

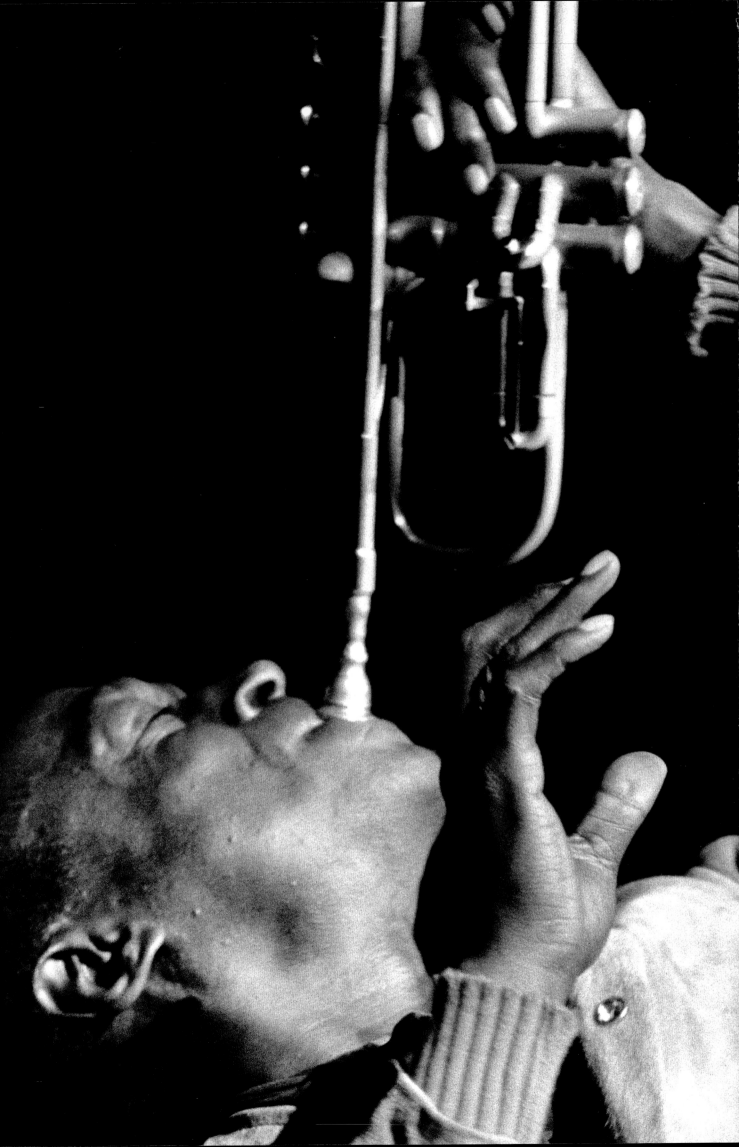

JAZZ
IN AVAILABLE LIGHT

ILLUMINATING THE JAZZ GREATS
from the **1960s**, **'70s**, and **'80s**

STORIES & PHOTOGRAPHS BY
VERYL OAKLAND

FOREWORD BY
QUINCY JONES

Schiffer Publishing Ltd

4880 Lower Valley Road • Atglen, PA 19310

CONTENTS

FOREWORD

Quincy Jones
July 22, 2016

Seventy-nine-time Grammy nominated artist, composer, record producer, artist, film producer, arranger, conductor, instrumentalist, TV producer, record company executive, magazine founder, multimedia entrepreneur, and humanitarian.

If I have learned anything in my life, it is that the only way to get where you want to go is to know where you came from.

As a musician who has worked in nearly every pocket of the entertainment industry for over seven decades, I am fortunate to have lived during a time in which I was able to be a witness to, and play a role in, the growth of the only true indigenous American art form, jazz. America's classical musics are jazz and blues. Unfortunately though, in America, jazz and blues had long been looked down upon as the music of the brothel, but in Europe, they were mature enough to understand it from the beginning for what it was: one of the truest original art forms ever to come from America.

Such knowledge is a gift; it is one we must preserve and pass along to younger generations so that they may know the multitude of others who are pillars upon which we and our music stand. All of American music is derived from a cross pollination of genres—from Jay McShann's band came Charlie Parker, Cab Calloway, and Dizzy Gillespie. Then those guys all went to Earl Hines's bebop big band and met Miles Davis, J.J. Johnson, Sarah Vaughan, Billy Eckstine; and then Billy took all of the beboppers out of that band to go play in his band.

Time and time again, it is evident that we all come from each other, one way or another.

However, many kids these days act as though all the music they listen to was invented only recently! Every time I ask a young person, "In your mind, what was the year of origin of hip hop?" they say something along the lines of, "In 1971, with the Black Panthers or back in the Bronx;" it is sad because it is simply not true. We were rapping back in the day in 1939! Much of the hip hop slang that these kids use derives from jazz. Many assume they know it all, but if they look a little deeper, they would easily find that jazz is the foundation for much of the music they listen to and the culture in which they are a part of. I mean, Lester Young was calling Basie "homeboy," ninety years ago! Just think about it, bebop, doo wop, hip hop, to laptop!

My dream is that all of our young people will have an insatiable hunger to define, explore, and understand our social and cultural pasts so that they may take those giant steps of victory necessary to walk into the future. Unfortunately, since the United States is one of the only countries to not have a minister of culture (or what would be called a "secretary of the arts" here), we are seriously lacking in our musical education. Americans do not know the sources of their own music, from bebop to doo wop to hip hop. Other countries know more about our foundations than we do and are more aware of where we came from than we are. That is an issue. An issue that can only be done away with through the continual music education of our society, and that is exactly what Veryl Oakland serves to do through this unique piece of literature.

This timeless treasure serves as a window into the past to illuminate our future, both musically and culturally; it does not simply highlight photos of a captured moment in time, but it reveals the unheard stories of Veryl's personal experiences with each artist—a truly invaluable work that features some of our most revered music icons, from their strongest to their most vulnerable states as human beings. The pictures and stories to follow pierce the soul in a manner that can only be understood through a personal journey—one in which I urge you to embark on and discover for yourself as you read through the contents of this book.

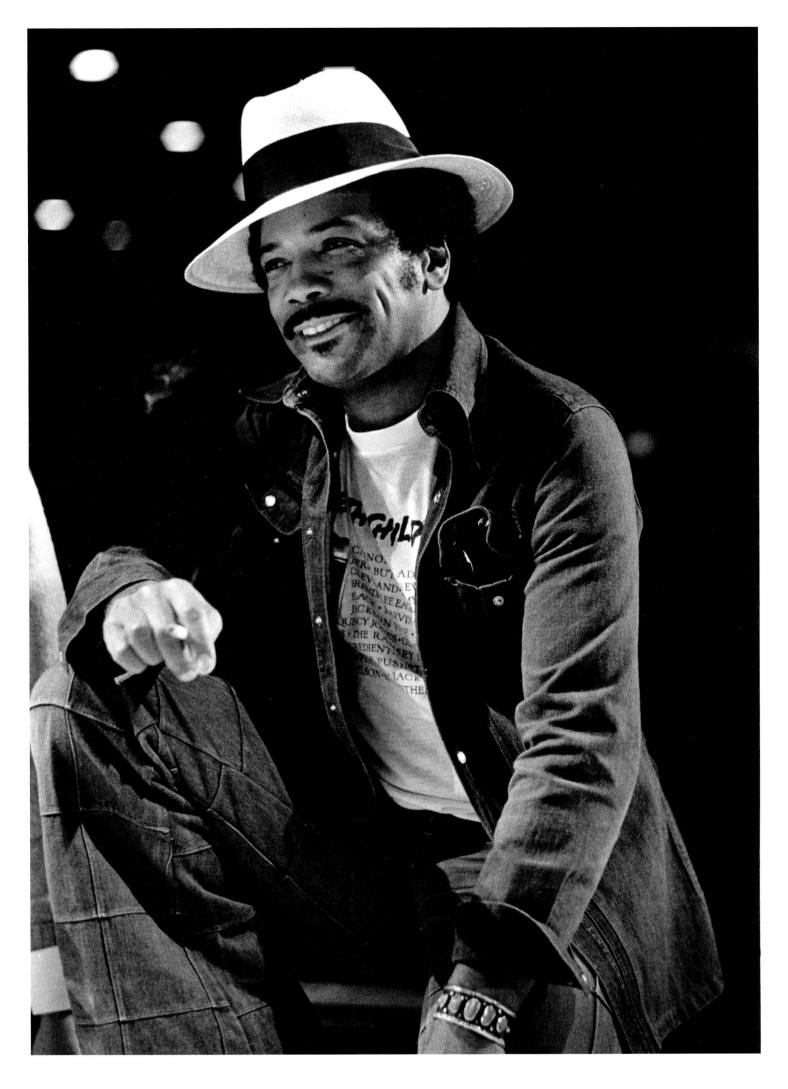

PRE FACE

I found that the instrument I used for "improvising"—for creating some of those special jazz moments— wasn't my cornet. It was the camera.

Growing up in South Dakota during the 1940s, there was virtually nothing resembling live jazz being played anywhere. Yet, even as a kid, music was a big part of our household.

Living with us in our home was my grandfather on my mother's side, C.W. Smith. He played clarinet, and long before I was born, became a member of the legendary John Philip Sousa Marching Band. It was when "The March King" toured throughout the midwestern United States that he used my grandfather as one of his pick-up section players.

On weekends, I can vaguely remember several musician friends of my grandfather from the neighborhood showing up in our living room, setting up their stands and music charts. What everyone played, I don't remember: probably polkas, swing, marches, and any other popular music of the day. If they could find sheet music for all the instruments, that's what they played. All I know is they had a good time.

In grade school, my parents bought me a fancy, completely-engraved King Silvertone cornet. They must have believed I had some potential, because after a few months, they were paying to have me study privately every week, even though money was pretty tight. My classical training continued for more than seven years, about the time I graduated from high school.

At that point, I can honestly say I could pretty much play anything that was written. I was an excellent sight-reader and technically quite proficient.

Before I went away to college— quite by accident—I had my first real jazz revelation. Late one night, after listening on the car radio to St. Louis Cardinals' play-by-play announcers Harry Caray and Joe Garagiola broadcast an extra-inning game on KMOX Radio, I started turning the dial. With the exception of the local stations in Sioux Falls, everything but KMOX in St. Louis was just static.

But all of a sudden, I landed on the clear channel, 50,000-watt station, KSL Radio in Salt Lake City, Utah, and the late night host, Wes Bowen. The evening deejay was a transplant from Wales, and he really knew his stuff. I would later learn that he enjoyed personal friendships with Duke Ellington, George Shearing, and many other jazz artists.

Bowen's opening theme song featured pianist Red Garland's Trio playing the blues. Something right away clicked. Later that night—and at every opportunity from then on—I remember listening to the driving beat of Art Blakey and the Jazz Messengers. Then Horace Silver's Quintet, the Count Basie Orchestra, Ray Bryant, Sonny Rollins, Thelonious Monk . . . I tuned in regularly, and began to memorize all their names and their tunes.

I distinctly recall one night when Bowen played the 1953 recording of bebop pioneers Charlie Parker and

John Birks "Dizzy" Gillespie in Toronto from the album, *Jazz at Massey Hall*, with Bud Powell, Charles Mingus, and Max Roach. The composition was Tadd Dameron's "Hot House," and I was floored when I heard Gillespie. The notes were so fleetingly inventive, yet crisp and coherent, even when Birks was scaling the stratosphere.

From that evening on, I never picked up my horn again.

Playing what was written on the sheet music was one thing. But at that point, I instantly knew I would never be capable of improvising and creating like Gillespie . . . for me, it was personally unattainable.

In her book, *Footprints: The Life and Work of Wayne Shorter*, Michelle Mercer wrote about the great training—and the intense scrutiny— that tenor saxophonist Wayne Shorter received in the late 1950s, when he got a six-week gig with the house band at Minton's Playhouse in Harlem.

"Wayne had to know a broad jazz repertoire for the sessions at Minton's, where anything from Benny Golson's tunes to the blues might be called for. Wayne said, 'You didn't have to totally know the repertoire as much as you had to be able to *hear*,' meaning that if you could improvise, you were way ahead of the competition who could only *see*, i.e. just read the music. If someone could only *read* music, Wayne said you might catch a comment from the audience like, 'Jimmy So-and-so can't improvise, but he can sure see.'"

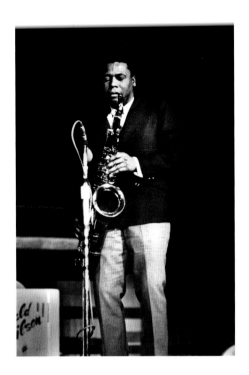

"'Jimmy So-and-so can't improvise, but he can sure see.'"

–Wayne Shorter

Casino in Sparks, Nevada, just three miles east of Reno. My duties included hosting incoming celebrities, setting up radio and television interviews for the stars, covering the acts in the club's main showroom, plus writing performance reviews and press releases about the headliners.

After work, I'd make the nightclub rounds of downtown Reno. There, for just the cost of a cocktail, I was able to witness many of the top nightclub acts that frequently performed in the main lounges of the larger casinos—people like Nat "King" Cole, Tony Bennett, Xavier Cugat and his sassy, "cuchi-cuchi" singer, Charo, and trumpeter Ray Anthony and his Bookends. The frequent-appearing, high-energy Louis Prima Band—and his demure partner, Keely Smith—backed by Sam Butera & The Witnesses was always a huge hit.

I remember the night I sat in during the performance of Billy Eckstine and his Big Band. After finishing one of his numbers, and instead of launching into his popular hit, "Joey Joey Joey," "Mr. B" sang, "Joey Joey Pass-a-la-qua." On cue, the lighting technician shined a spot on jazz guitarist Joe Pass (*nee* Joseph Anthony Passalaqua) sitting in the audience.

One late summer weekend in the early 1960s, a couple of friends and I from college got in the car and drove to California to attend my first Monterey Jazz Festival. Along with the bucolic setting and great music, what stuck in my mind was the image of a few press photographers down in front covering the action onstage. How cool is that, I thought, seeing and photographing all these wonderful musicians up close.

I had never owned—or even used—a camera before, but after graduating from Utah State University and then fulfilling my military obligation, I contacted a former college roommate who was completing his service in Japan. I wanted to see how much I could save by having him buy some camera equipment for me there. My first Nikon F camera and three lenses arrived a few months later. I was twenty-five years old.

As a novice, I spent many months and endured lots of trial and error—both as a shooter and in the darkroom—honing my craft. One of my first real jobs was as the entertainment writer/photographer for The Nugget

Above: Wayne Shorter during a contemplative moment of his solo with the Miles Davis Quintet, at the 1967 University of California-Berkeley Jazz Festival.

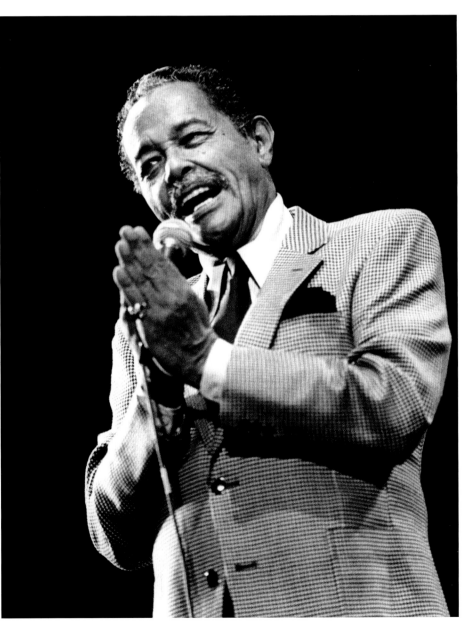

Right: Leader and singer Billy Eckstine in performance.

When Harrah's Club booked the Duke Ellington Orchestra for two weeks, I caught every act.

Back then, particularly if you were still hanging around the darkened lounge during the early morning shows, management seemed to care less what you were doing. Even though there were excellent performers playing exceptional music, the audiences were small, so hardly anyone paid any attention. I was like a regular, walking about with my camera equipment, pretty much doing whatever I wanted. I didn't even have to buy drinks.

Toward the end of his two weeks at Harrah's, I think even Ellington probably thought I was part of the overall scenery. I wasn't bothering anyone, but I was always there, catching all the great soloists— saxophonists Johnny Hodges, Paul Gonsalves, and Harry Carney; trumpeters Cat Anderson and Cootie Williams; clarinetists Russell Procope and Jimmy Hamilton; drummer Sam Woodyard; and the Maestro himself.

I even wound up getting access to their backstage dressing rooms.

A delightful interplay with (from left) Johnny Hodges, Harry Carney, and Russell Procope.

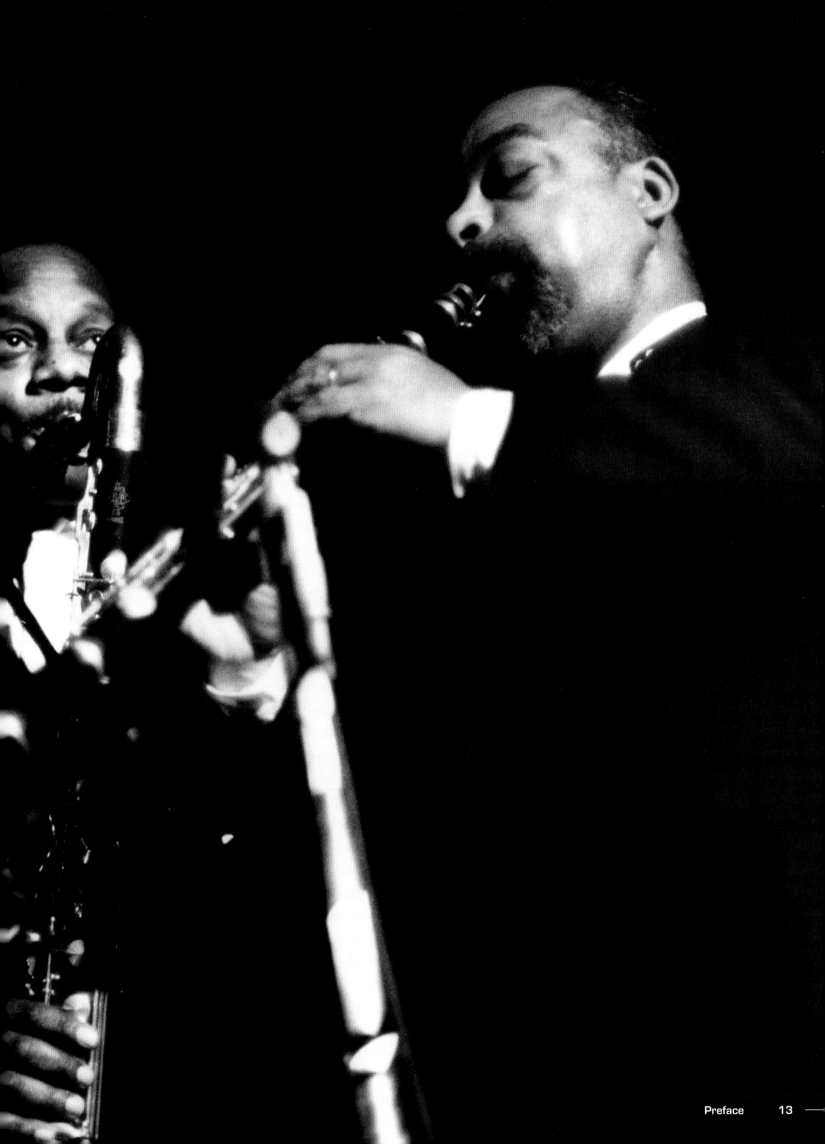

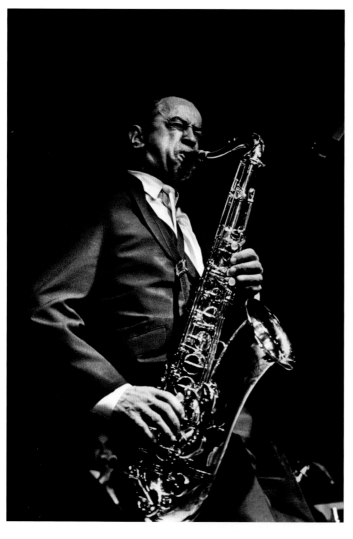

I think even Ellington probably thought I was part of the overall scenery.

In the introductory pages of his book, *The World of Duke Ellington*, critic/historian Stanley Dance described in some detail Duke's attention to certain aspects of his personal health, beginning—early on in his career—when he gave up alcohol. He took brisk walks; mistrusted air conditioning; followed a rigorous, monotonous diet consisting mostly of grapefruit juice, steak, and salad; took a variety of vitamins and protein tablets; and "... [put] his feet high on the wall above the headboard, while presumably reversing the blood flow."

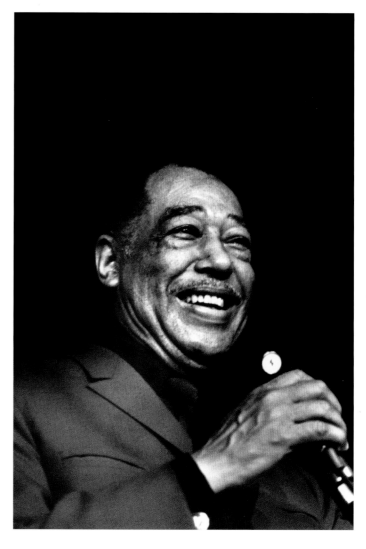

From top left: Paul Gonsalves soloing on tenor sax, with trombonist Lawrence Brown in the far background; and the ubiquitous Duke Ellington in the midst of conducting and acknowledging the crowd.

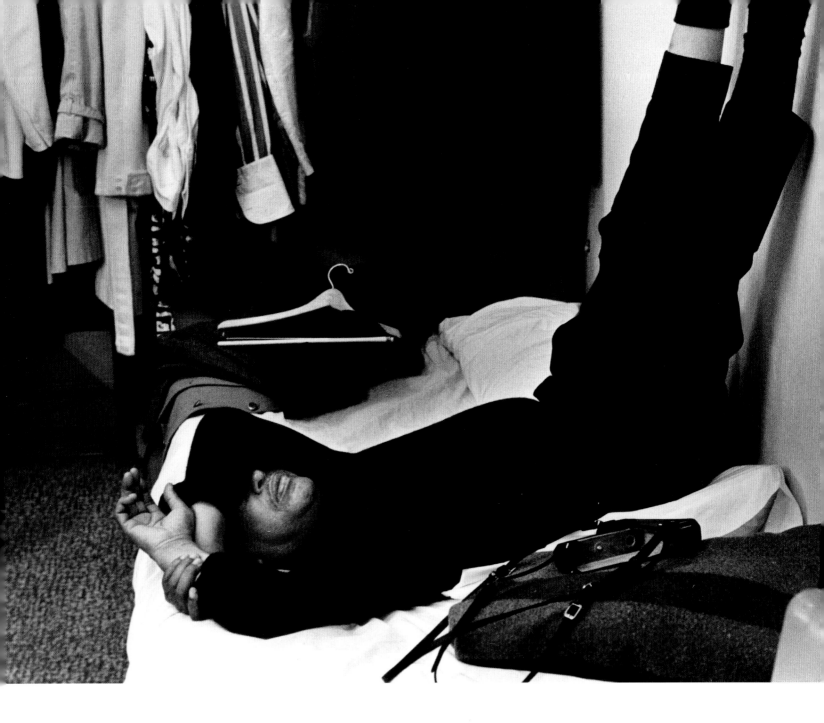

While employed at the Nugget, the most exciting two-week engagement for me was when the exquisitely beautiful, fabulous vocal stylist Lena Horne performed in front of a full orchestra, but with special backing by a quartet featuring pianist Paul Smith and the Hungarian guitarist Gabor Szabo. For me, Lena Horne was the classiest, quintessential female singer/entertainer of them all . . . stunningly sensual but elegant. An enchantress in the most sophisticated of ways.

Almost a decade later—in the midst of her "rebirth" era as a singer when she was pushing sixty—Lena teamed up with Tony Bennett for a worldwide tour, capping it off with a two-and-a-half-week New York stint at Minskoff Theatre on Broadway. In his book, *Lena: A Personal and Professional Biography of Lena Horne*, James Haskins talked about Lena's preferences when it came to putting on her shows. "Despite the presence of a thirty-two piece orchestra, she relied in many of the numbers on the kind of backup that she had become accustomed to over the years: piano, drums, and guitar played by Gabor Szabo."

After one of their rehearsals, I happened to strike up a conversation with Szabo. Later, during their engagement, we connected again to talk about jazz. On their final night, he mentioned wanting to go to San Francisco the next day. I told him I was going into the City to catch some jazz acts and offered to give him a lift.

On our way the next morning, we just shot the breeze, and talked about his upcoming gigs, future plans, and scheduled recording dates. That day would mark the beginning of my personal involvement with jazz artists. When I dropped him off at a friend's apartment, Gabor asked me for $5, which caught me a little off guard. A little later, I thought to myself . . . good thing it was my car and I was doing the driving.

I met up with Szabo again in 1967—this time in his Monterey Jazz Festival debut—as leader of his own

In characteristic fashion, Duke Ellington catches a few winks in his dressing room at Harrah's Club in Reno, Nevada.

quartet. After that, we would occasionally cross paths at various other venues.

Over time, as I built a growing photo repertoire of jazz artists and became a small part of their world, it was clear that I had substituted photography for playing an instrument. There was nothing conscious on my part, but I found that the instrument I used for "improvising"—for creating some of those special jazz moments—wasn't my cornet. It was the camera.

Early on with my photography, I decided that I would only use whatever existing light was present— no matter the circumstances—to produce my jazz images; thus, the title of my book, *Jazz In Available Light*. As a freelancer, I believed it was rude and disrespectful—both to the musicians and the audiences—to flash an annoying strobe light into any setting, particularly during performances or intimate gatherings. Beyond that, especially when shooting with black-and-white film, I found the results to be more even and earthy, consistently natural, and to my mind, legitimate.

I also liked spontaneity, just working on the fly. After all, I was in the company of modern music's best practitioners who relied on their inherent abilities to create brilliant, memorable sounds at any given

That day would mark the beginning of my personal involvement with jazz artists.

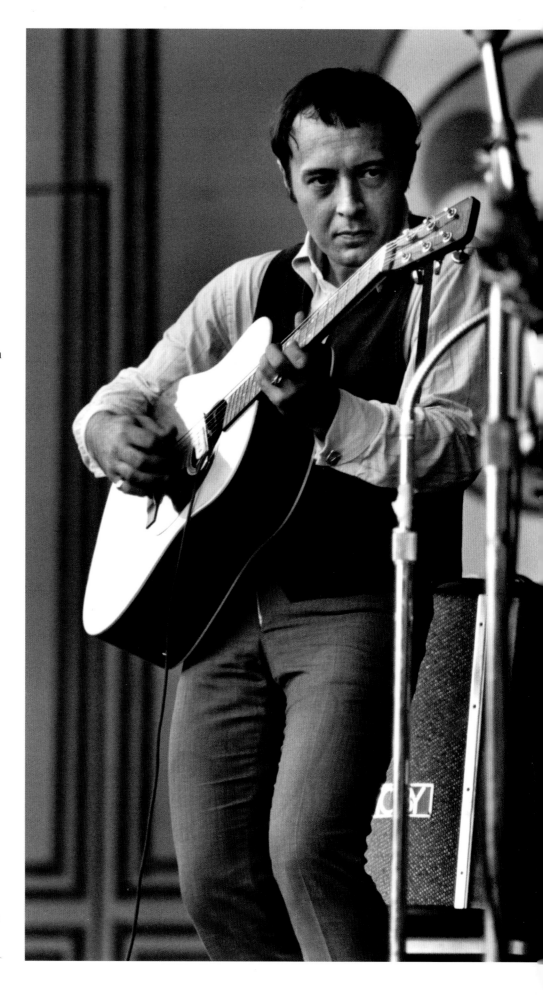

Gabor Szabo, whose Hungarian roots and vast musical influences helped set him apart from many other guitarists, drew a wide assortment of followers with his eclectic palette that ranged from classical-oriented sounds to hard jazz/rock. When he wasn't leading his own groups, he would rejoin Lena Horne, even recording with her in 1973.

So, this is the thrust of my book, an attempt to personalize— through both the lens and the pen—some of the world's greatest creators of modern music. To pay my respects to them. And to honor them.

moment. I surely didn't want to be the antithesis of that, taking up their valuable time laboriously arranging special equipment and foreign lighting just to take forced poses. Working within each situation and the existing surroundings frequently required random, on-the-spot decisions. Whether catching them in live performances or interacting with them in the privacy of their homes, I always chose to make the most of what I was given. If at all possible, I was "shooting" to get the best results in one take—just like a jazz musician.

As a semi-regular in their midst, I began to develop closer relationships, and by doing so, uncovered out-of-the-ordinary, more illustrative occurrences and events that were happening in their lives: matters of relevance not readily known by the average fan, but certainly worth publicizing. Before long, I was developing interesting, often captivating backstories to go along with my photographs. I was also finding new markets, primarily across Europe and in Japan, whose editors— and their readers—welcomed more in-depth pictorial reports about these complex, fascinating artists.

So, this is the thrust of my book, an attempt to personalize—through both the lens and the pen—some of the world's greatest creators of modern music. To pay my respects to them. And to honor them.

You might ask, Why me? Why now? And why am I only *Illuminating the Jazz Greats from the 1960s, 1970s, and 1980s*? First, with no understanding of photography and no formal training, I was late getting started. And while I certainly assumed that I would continue covering the vibrant jazz scene well past my fiftieth birthday, I was totally unprepared— and caught off guard—when our home in Sacramento flooded in 1990. I had stored all of my negatives and photographs in our downstairs, so the better part of three decades of work was severely damaged.

After that happened, I stopped shooting. I withdrew, and for the longest time, purposely avoided the boxes of damaged negatives. I couldn't even bring myself to open them.

But progressively, as the years turned into decades, I began to analyze my situation anew. In 2010, I decided to tackle head-on everything I owned—damages and all—of my jazz photography collection. I still had an extensive stockpile of negatives that had survived the flood, and now, all of my images deserved a serious re-examination. I knew I had plenty of valuable material: critical work that needed to be made available to the public. And I knew these vitally important artists deserved to be recognized in a manner that hadn't been seen before.

As I painstakingly began analyzing every negative strip, I realized that what had long ago been placed far out of sight was not a total loss. Many of the negatives, surprisingly, were unscathed, or relatively untouched. Others, it turned out, were not severely affected, and thus, were still correctable. It was at that point I realized I had to make up for lost time and get down to work.

Only portions, or excerpts, of the individualized photo-stories shown within these covers have previously appeared in select—but limited— media around the world. Readers of this book will be the first to see the pieces as a full collection. And while astute jazz followers will recognize a good number of my photographs used within these pages—having seen them in other jazz books and publications over the past 50+ years—scores of them have never before been published.

I consider myself supremely fortunate to have had the opportunity to be in the midst of, interact with, and get to know, so many of our jazz giants, virtually all of whom have left a treasure trove of critically important works of lasting value through their recordings. The voluminous contributions of these great artists, their like-minded musical brothers and sisters, and the masters who came before them, are truly incalculable.

Most of the personalities I have featured in these pages are no longer with us. My apologies in advance to the hundreds of other preeminent and worthy notables who had to be omitted because of publishing limitations—if only this book could be a tome.

I sincerely hope you will enjoy what you see and will appreciate my special tribute to these men and women of jazz whose legacies are absolute.

Veryl Oakland
Sacramento, CA

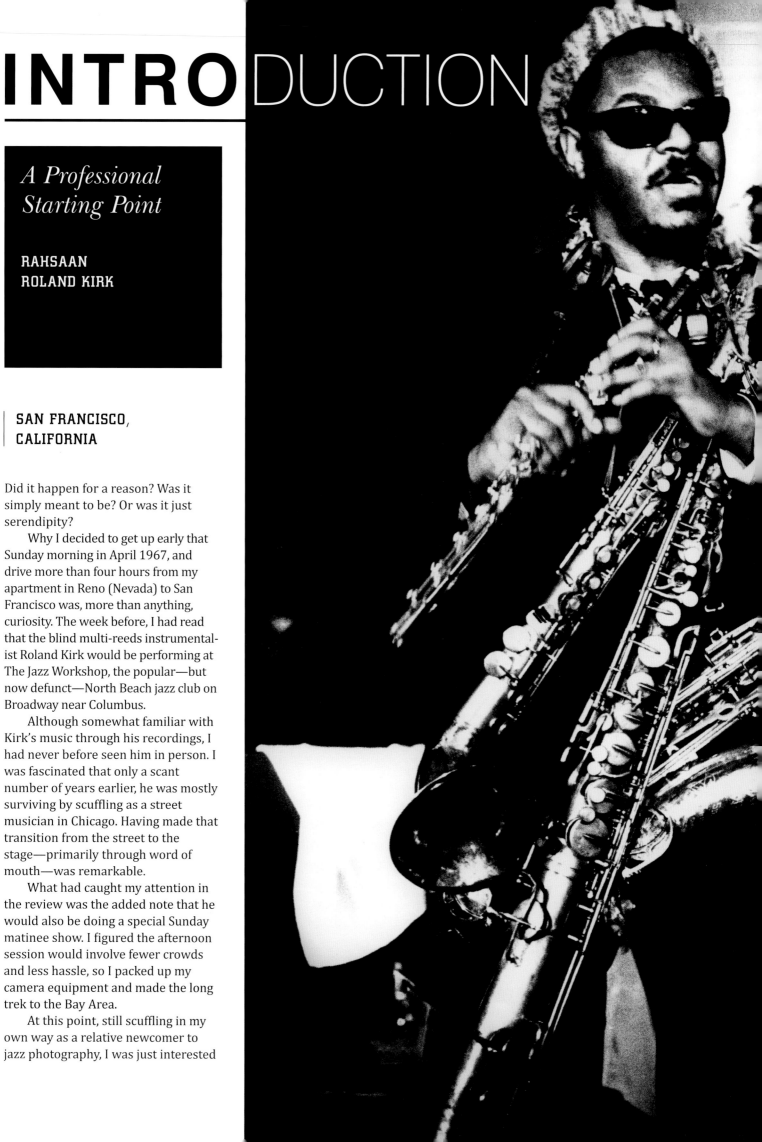

INTRODUCTION

SAN FRANCISCO, CALIFORNIA

Did it happen for a reason? Was it simply meant to be? Or was it just serendipity?

Why I decided to get up early that Sunday morning in April 1967, and drive more than four hours from my apartment in Reno (Nevada) to San Francisco was, more than anything, curiosity. The week before, I had read that the blind multi-reeds instrumentalist Roland Kirk would be performing at The Jazz Workshop, the popular—but now defunct—North Beach jazz club on Broadway near Columbus.

Although somewhat familiar with Kirk's music through his recordings, I had never before seen him in person. I was fascinated that only a scant number of years earlier, he was mostly surviving by scuffling as a street musician in Chicago. Having made that transition from the street to the stage—primarily through word of mouth—was remarkable.

What had caught my attention in the review was the added note that he would also be doing a special Sunday matinee show. I figured the afternoon session would involve fewer crowds and less hassle, so I packed up my camera equipment and made the long trek to the Bay Area.

At this point, still scuffling in my own way as a relative newcomer to jazz photography, I was just interested

His inspired performance was so vibrant and magnetic that I didn't dare move from where I was for two complete sets. I was absolutely blown away.

in getting as much experience as possible—seeing, hearing, and photographing as many of the top performers as I could. Little did I know that this afternoon would serve as the launching point for a career working amongst the world's greatest musicians. Thank goodness I made that drive.

When the doors opened at 12:30 p.m., I was one of the first to go inside, making my way down to a front row seat adjacent to the stage. As Roland and his quartet made it onstage to start their first set, the club was nearly vacant. But that didn't matter, as Kirk put on a dazzling show, employing all of the wide and strange arsenal of horns— tenor saxophone, flute, clarinet, manzello, stritch—plus homemade apparatus and other equipment, such as siren whistle and wooden nose flute, attached to his body.

At various points, when he wanted to keep building on an extended solo for up to minutes at a time without any breaks whatsoever, he executed the art of circular breathing, continuing to play as his neck and cheeks expanded and contracted over and over. Few instrumentalists even have the capability of accomplishing this feat, let alone doing it for so long or so seamlessly.

On another occasion, Kirk performed a flute solo that was nothing short of amazing: after playing the theme and the first of his choruses straight, Roland turned up the heat by simultaneously adding humming and vocalizing to his solo. For the finale, he launched into a series of blistering, double-tongue passages just before ending in a flourish and blowing his siren whistle.

His inspired performance was so vibrant and magnetic that I didn't dare move from where I was for two complete sets. I was absolutely blown away.

It was nearly five o'clock when it all ended. I had shot five rolls of black-and-white film under near-impossible lighting conditions. Honestly, I wasn't even sure if most of my shots had turned out. The Workshop was like being in a cave with meager light— basically, just one less-than-optimum

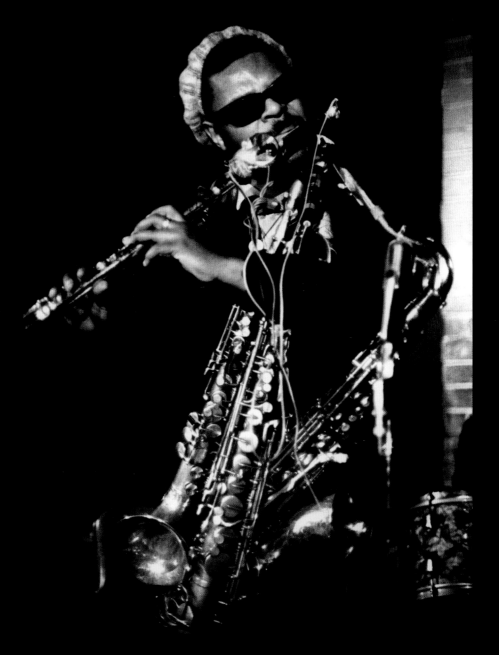

Roland Kirk performs a flute solo, mixes in an accompanying chorus on nose flute, and then reacts after completing a sizzling display of blowing using all of his reed instruments.

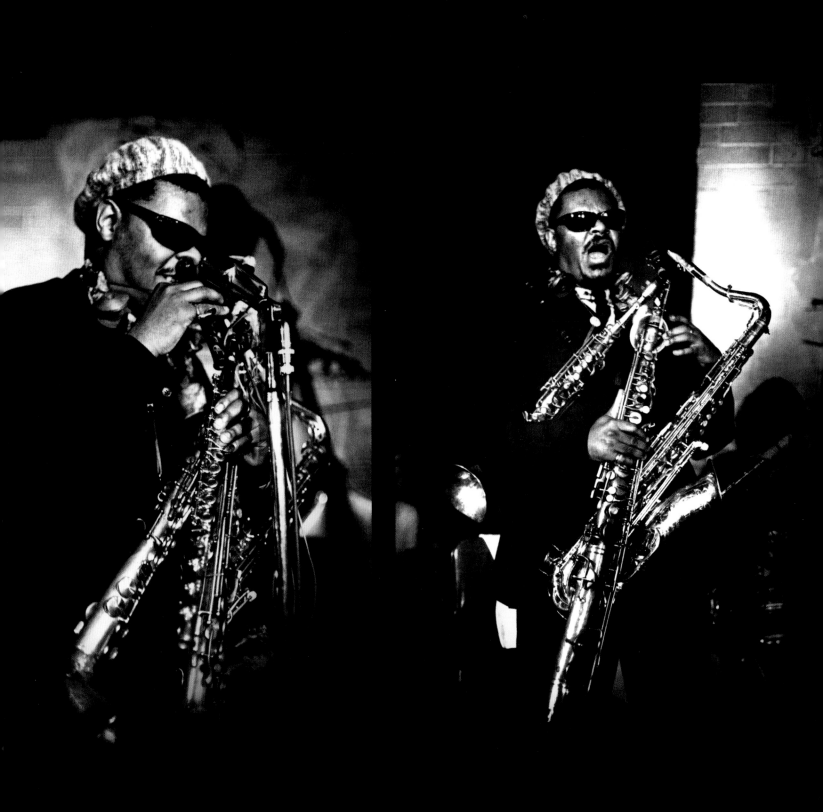

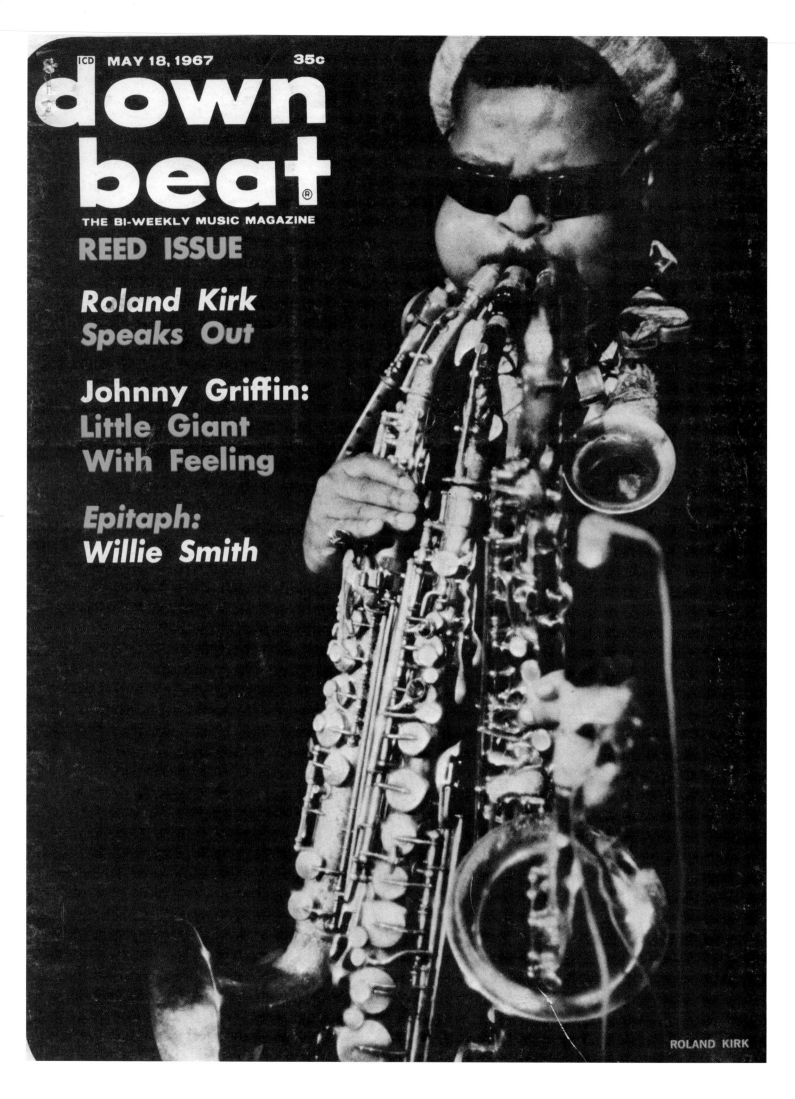

ROLAND KIRK

main spot plus a weak filler. That, and the soft glow from the club doors at the very back of the room, which remained open all afternoon in hopes of attracting more patrons.

Later, in the darkroom, I discovered that despite having to use very slow shutter speeds, a wide open lens (f1.4), and dealing with the overall exuberance of Roland's presentation, there were dozens of very good images.

On a whim, I air-mailed a note, along with copies of my contact sheets, to the editors of *Down Beat* magazine. Within days—surprisingly—I had received a reply, asking for several enlargements. One of those images graced the May 18, 1967, cover of *Down Beat*, becoming my first photograph ever sold.

I was fortunate to catch the man on several other occasions and never once was disappointed. He remained both a solid player and dynamic performer—and, as an individual, one of the most exciting jazz acts imaginable—even after suffering a massive stroke near Thanksgiving of 1975, that permanently paralyzed the entire right side of his body.

Following the crippling setback that made his right arm useless, Kirk underwent months of therapy. During this period, he also had the keys of his horns refitted in order to still be able to play two instruments simultaneously—only this time, just left-handed.

Returning to the scene six months later in his first engagement following the stroke, Rahsaan performed before an excited, much-anticipated crowd at the May 1976 Berkeley (CA) Jazz Festival.

In December of the following year, while headlining at Indiana University, Bloomington, Kirk suffered a final stroke. He was forty-two.

RAHSAAN ROLAND KIRK

tenor saxophone, flute, clarinet, manzello, stritch, composer
Born: August 7, 1935
Died: December 5, 1977

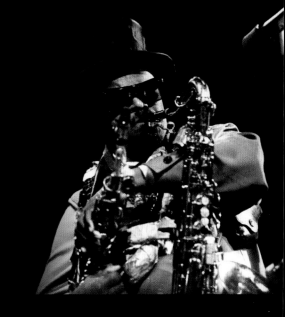

Opposite: Some three years later, after hearing the name "Rahsaan" in his dreams, Roland Kirk officially became known as Rahsaan Roland Kirk.

Above: In this photo, after finishing a chorus playing two horns simultaneously, Kirk reaches across his body with his left hand to push the manzello out of his way in order to free up his tenor saxophone for a one-horn solo. Despite all odds, Rahsaan Roland Kirk had miraculously bounced back. Not only had he figured out how to compensate for his debilitative condition, but was once again well on his way to creating new music and winning new fans.

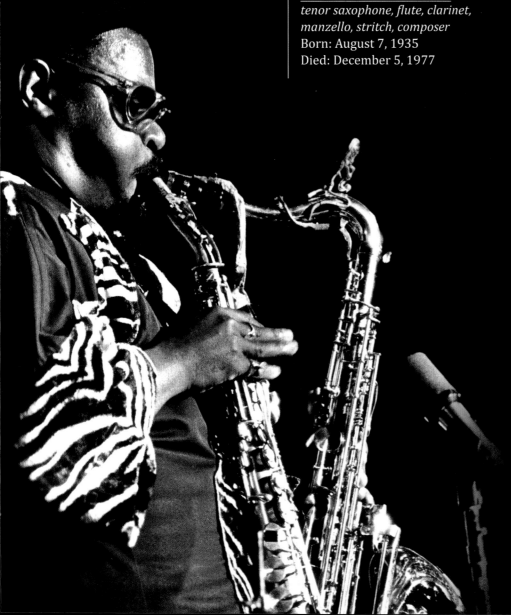

A DAY IN THE LIFE

JIMMY GARRISON	DENNY ZEITLIN
SHORTY ROGERS	CHARLES LLOYD & MICHEL PETRUCCIANI
MONK MONTGOMERY	JACKIE MCLEAN
STAN GETZ	YUSEF LATEEF
SUN RA	JAMES MOODY
ART PEPPER	DICK GIBSON
FRANK MORGAN	JOE HENDERSON
JOSEF ZAWINUL	PHIL WOODS
PAT MARTINO	EMILY REMLER
DEXTER GORDON	RED GARLAND
JOE WILLIAMS	WEATHER REPORT
CHET BAKER	JOHNNY GRIFFIN
PAUL BLEY	WYNTON MARSALIS
ART FARMER	
MAL WALDRON	
BLUE MITCHELL	
CARLA BLEY	
CECIL TAYLOR	
EDDIE HENDERSON	

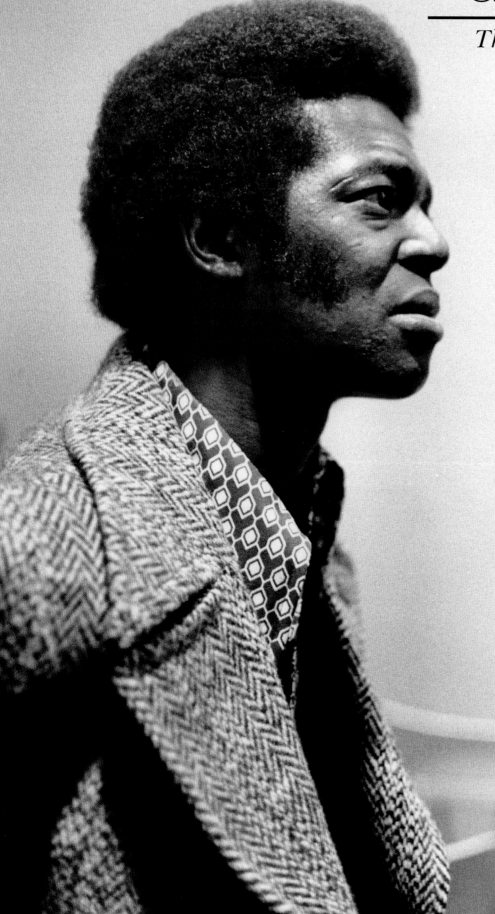

JIMMY
GARRISON
The Missing Ingredient

| BERKELEY,
| CALIFORNIA

I had already missed what, to me, was the "jazz opportunity of a lifetime." It was something that stewed in me over and over again and continues to this very day.

My only chance of ever photographing tenor saxophonist John Coltrane was expected to be the week of April 24–30, 1967, when he was scheduled to perform at The Jazz Workshop in San Francisco. It was not even two years earlier that I had acquired my first camera, but I was learning fast and making big strides. At the time, I was convinced this was going to be my good fortune and was anxiously awaiting the tenor titan's visit to the west coast.

I was completely unaware that he was dying. Sadly, his last public performance was just the afternoon before, on April 23, at the Olatunji Center of African Culture in Manhattan. Coltrane did only the early show and never performed again. All of his remaining bookings were canceled. He passed away on July 17.

Since then, that huge letdown has become a continuing, nagging pain— one of those "if only" scenarios that keep bugging me: "If only I had known in advance of his condition, I would have made whatever arrangements necessary to fly to New York and photograph him."

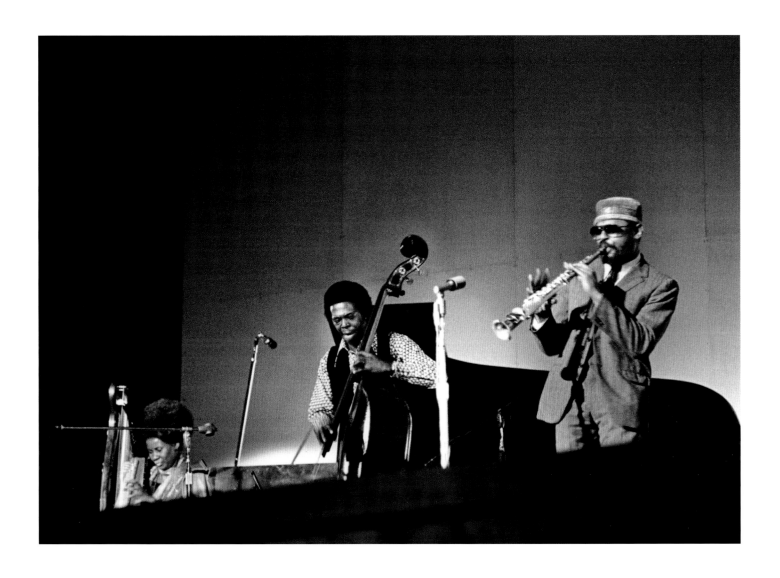

His solos captivated both the audience and his fellow bandmates who were in rapt attention.

A few years later, I made sure that I wouldn't miss the opportunity of at least seeing his formidable bassist, the only remaining member of Coltrane's greatest quartet that I had never previously photographed. It was at the Fifth Annual Berkeley Jazz Festival in 1971, that I got to witness Jimmy Garrison, now performing in a quintet led by the saxophonist's widow, pianist/harpist Alice Coltrane.

The several years that Garrison had spent with Coltrane, pianist McCoy Tyner, and drummer Elvin Jones, producing such everlasting triumphs as *A Love Supreme* and *My Favorite Things*, cemented that group's legacy, which persists today and forever into the future. This quartet ranks as one of the most classic music groups ever formed.

Jimmy Garrison, as it turned out, was the missing ingredient for Coltrane's great quartet. The leader had experimented with a number of different bassists before Garrison arrived, bringing his powerfully deep tone and distinctive harmonic sounds to the group. He was the exact fit.

When I caught him at the Berkeley engagement, it was confirmation of just how rock solid he was, the foundation for that night's rhythm section. Whether playing arco (bowing) or pizzicato, his solos captivated both the audience and his fellow bandmates who were in rapt attention.

Jimmy Garrison (center) performs with Alice Coltrane on harp and soprano saxophonist Archie Shepp.

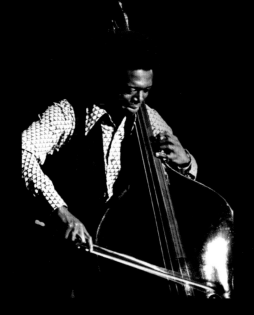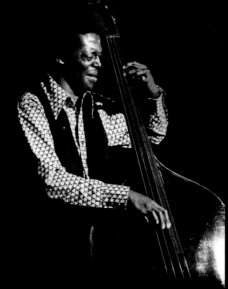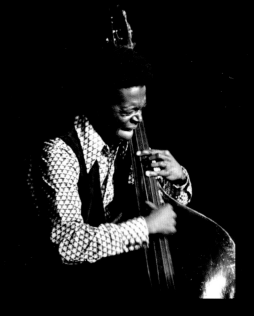

On one stimulating number, while strumming his bass strings, Garrison's deeply resonating sound was so riveting that I sensed the audience was actually searching the wings for some famous, unannounced guitarist who had just entered the stage.

Afterwards, talking with him backstage, I congratulated him on his performance and told him how much of an impact he and the Coltrane quartet had made on me over my years of listening and relistening to their critical works. And how I marveled at the powerfully interactive bond he shared with his rhythm mate at the time, Elvin Jones.

It was the only time I got to see and hear the bassist, who was felled by lung cancer. Sadly, the final bar, chronologically, for both Jimmy Garrison and John Coltrane was nearly the same. Although born some eight years apart, the two were barely into their forties when each passed away.

JAMES EMORY (Jimmy) GARRISON
bass, composer
Born: March 3, 1934
Died: April 7, 1976

Garrison performing solos arco style (bowing) and by striking the strings (pizzicato).

Top right: Garrison lit up the crowd with his strumming of the bass strings.

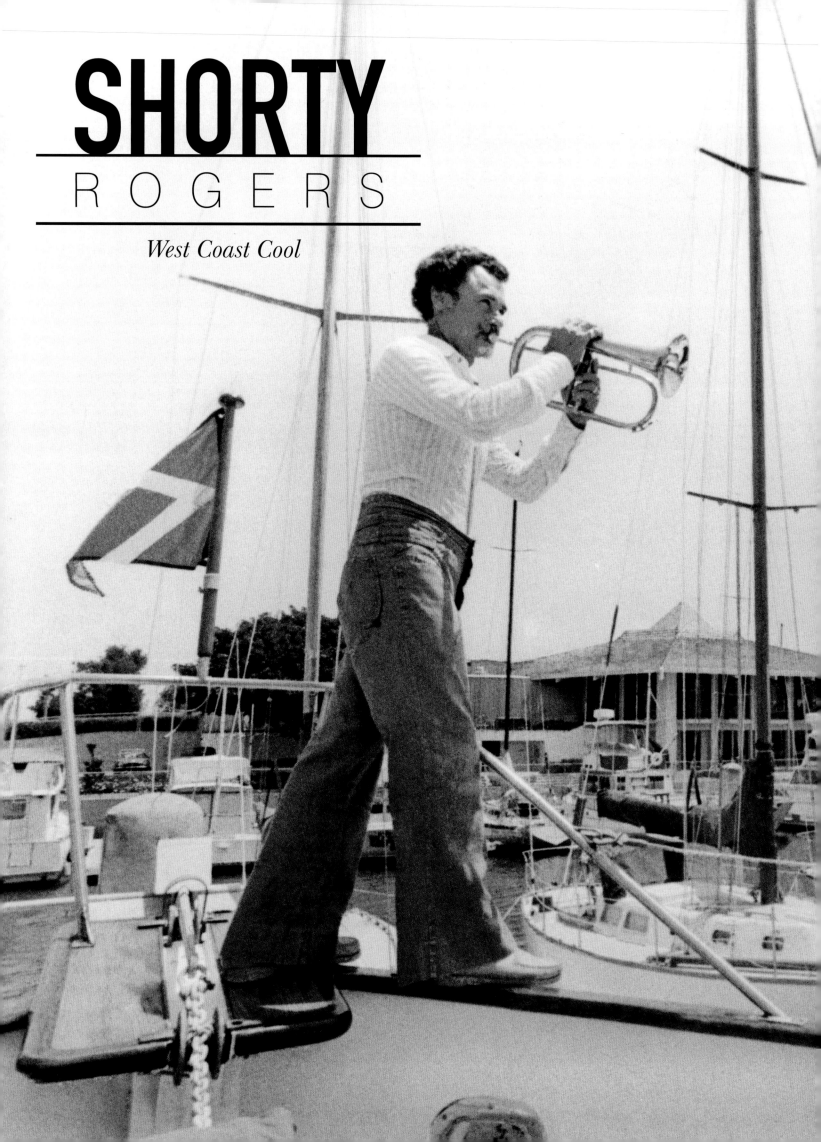

SHORTY
ROGERS

West Coast Cool

MARINA DEL REY, CALIFORNIA

I welcomed the photo assignment from London that materialized in 1978, even though it seemed to me a little late in coming.

The editors of *Jazz Journal International (JJI)* called to say they were doing a story on Shorty Rogers and the west coast jazz scene, and asked me to come up with something that personified his laid-back, cool California image.

I thought back to one of my early big band purchases by "Shorty Rogers and His Giants" from the mid-1950s. *The Big Shorty Rogers Express* showcased the trumpeter/flügelhornist leading an all-star, brass-heavy lineup featuring five

trumpets, three trombones, a French horn, and tuba. The album cover revealed the diminutive leader perched on the front of a Santa Fe locomotive.

When I reached Rogers at his home and told him what the magazine wanted, he said, "Come on down to Marina del Rey. We'll take pictures on my yacht." We set the date and time. He told me to just walk out on the marina and ". . . look for the Jolly Rogers."

The afternoon of our visit, I found Shorty aboard the Jolly Rogers, which all but dwarfed most of the other surrounding rigs in the harbor. He was nattily-attired in an expensive, white, long-sleeved, linen shirt and khaki

slacks. To my mind, the scene seemed most-fitting . . . Shorty Rogers and (One More of) His Giants.

We talked about that most fruitful recording period of the 1950s and early 1960s, when he wrote so many fresh charts and great arrangements for the top-notch LA studio musicians he used for all of his different bands. He also filled me in on his ongoing commercial TV/film activities and noted that he was thinking of playing once again in some small combo club dates.

As we were finishing up the photo session in and around his expansive schooner, I asked Shorty what was significant about the name he chose.

"'Jolly Rogers' was the first of many compositions I did when I was still with Stan Kenton's Band [in the early 1950s]," he said. "It was just a straight-ahead swinging piece, and it [the royalties] helped pay for the boat."

Note: Historically, Shorty Rogers is recognized as one of the prime movers who helped shape the various styles of jazz music. "West Coast" jazz, which sprung from the recognized cool period of the 1950s, is synonymous with Shorty Rogers and drummer Shelly Manne. For all of his contributions to modern music, Rogers did not receive a lot of media attention from the so-called jazz intelligentsia. Perhaps making up for that long-overdue recognition, *JJI* magazine wound up publishing a cover feature celebrating the career of Shorty Rogers. Just a few years later, *Jazz* magazine in Paris followed up with its own cover feature of him from that same day's photo shoot.

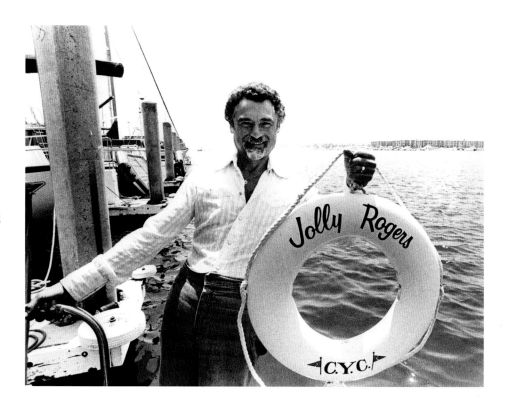

MILTON M. "SHORTY" ROGERS
(Rajonsky)
composer, arranger, trumpet,
flügelhorn, leader
Born: April 14, 1924
Died: November 7, 1994

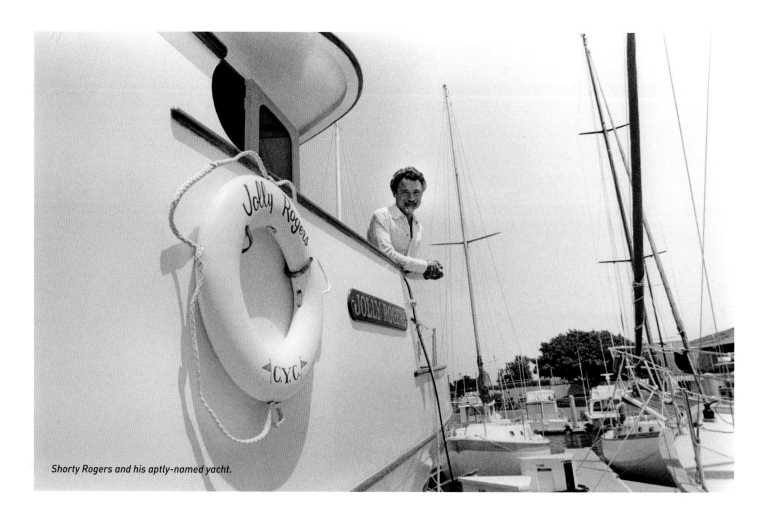

Shorty Rogers and his aptly-named yacht.

Rogers shown in his living quarters and at the helm of his yacht.

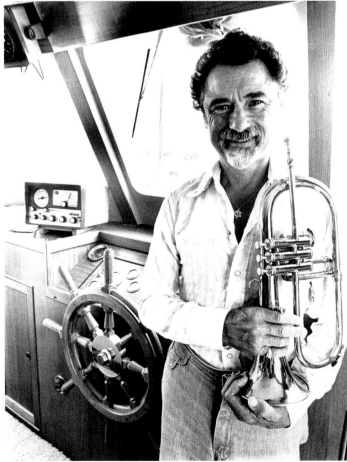

MONK
MONTGOMERY

Keeping Jazz Alive in the Desert

LAS VEGAS,
NEVADA

Among the many blessings that jazz offers is the vast number of incredibly talented musicians who have come from the same families. For starters, there are the Jones brothers—pianist Hank, trumpeter Thad, and drummer Elvin; the Heath brothers—saxophonist Jimmy, bassist Percy, and drummer "Tootie"; the Marsalis family—father and pianist Ellis Jr., trumpeter Wynton, saxophonist Branford, trombonist Delfeayo, and drummer Jason; and the Montgomery brothers—guitarist Wes, vibraphonist/pianist Buddy, and electric bassist Monk.

Of the Montgomery brothers, it was Wes who, deservedly, commanded most of the jazz world's attention. Using his thumb instead of a plectrum, the guitarist enhanced his already identifiable warm sound by implementing an impeccable octave technique (simultaneously voicing the melody line in two registers), even on the most difficult, extended solos. No one since Charlie Christian has been more imitated or has had a greater impact on guitarists than Wes Montgomery.

But it was Monk, the eldest of the Montgomery brothers, who I consider to be one of modern music's most underappreciated and unheralded champions: in fact, I'd say that a more passionate, tireless, behind-the-scenes promoter of jazz and its outstanding artists would be hard to find.

Monk Montgomery could well be the most unlikely figure in jazz to have had a major impact on this music's rich history. He didn't even begin playing bass until age thirty, yet within a few months had honed sufficient chops to make it in Lionel Hampton's Orchestra, with whom he toured from 1951–53. While with Hampton, Monk introduced

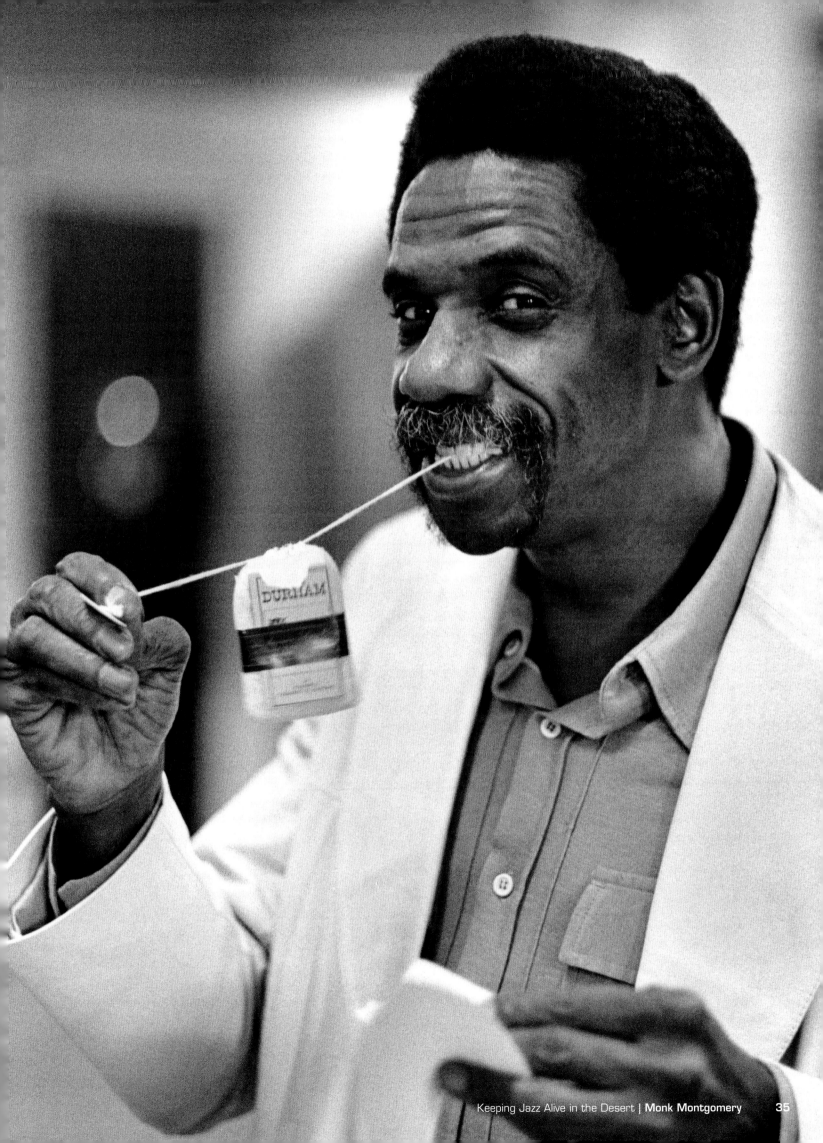

to the public his pioneering skills by becoming the first to play an electric bass guitar, the Fender Precision.

Writing in *The Encyclopedia of Jazz in the Seventies*, producer/arranger Quincy Jones, who played trumpet in the Hampton band at the same time, said, "... 1953 locked up the incubation period for the granddaddies of electronics. Specifically, there was Charlie Christian, who established the electric guitar in 1939; and in 1953 ... Monk Montgomery was playing fender bass—the first musician ever to use one. Those two instruments turned the whole thing around Basically, the thrust of evolution was motivated by the electric guitar and fender bass."

I got an up-close glimpse of Monk Montgomery's passion for jazz promotion when I met with him for the first time in November of 1975, at the Shrine Auditorium in Los Angeles. As founder of the Las Vegas Jazz Society (LVJS), he had booked a tour bus, filled it with his fellow jazz fans from the desert, and made the long haul to catch the "1st Annual World Jazz Association Concert," featuring the Quincy Jones Orchestra, plus an all-star lineup of jazz giants.

Following the afternoon soundcheck, I sat down with Monk and listened as he raved about all the things the LVJS was doing to promote jazz in

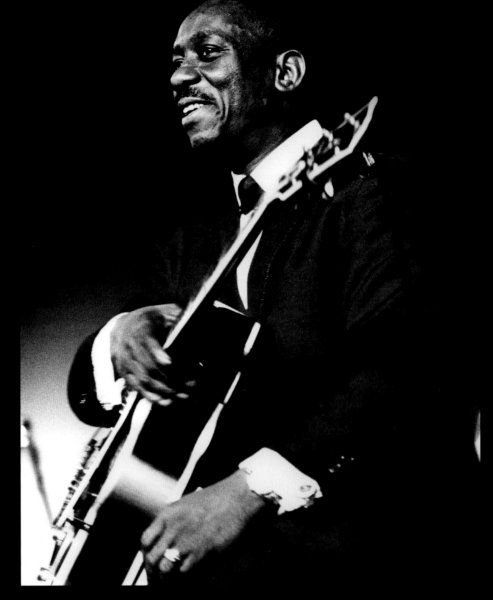

the nation's entertainment capital. The more he shared, the more animated he became. By the time we finished talking, I was convinced that his personal story needed to be covered.

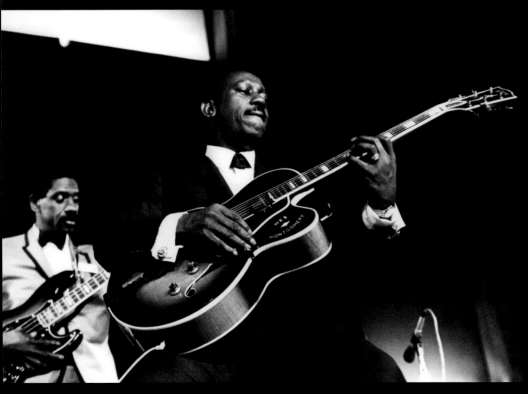

Above: Guitarist Wes, the most famous of the Montgomery brothers.

Left: Monk Montgomery playing Fender electric bass in a 1968 performance at the University of California, Berkeley, with brother Wes on guitar.

Monk Montgomery was playing fender bass—the first musician ever to use one.

Over the next several months, I reached out to various editors who I thought might be interested in publishing a photo report about Monk Montgomery and his devotion to making jazz music commercially compatible with Las Vegas. Finally, I got a note from the editors at *Swing Journal* magazine in Japan. They agreed that their readers would be interested in knowing the story about the Montgomery brother who was making jazz a significant part of the Las Vegas musical landscape. I was asked to photograph as many of the legitimate jazz artists who were still active and calling this city their home.

After sharing all this information, Monk told me he would find out when the majority of the Las Vegas jazz musicians would all be in town at the same time so as to maximize my coverage. A few weeks later, he called back and we agreed on a weekend in August of 1977.

When I reconnected with Monk, this time at his home, he had already put together a list of all the musicians who would be awaiting my call. Before leaving, we did a brief photo session, and because I was curious, I asked him to share how his hard-earned quest to put jazz on the Las Vegas map all came to pass.

Monk told me that after several years of touring and recording with

brothers Wes and Buddy as the "Master-sounds," he moved here in 1970, to take a job with vibraphonist Red Norvo and his trio. For the next year and a half, he played steadily at the Tropicana Hotel on the Strip. Monk was happy to be in Las Vegas, believing his jazz future in this desert resort would be good.

But then the job abruptly ended. The cold reality came when Monk started looking for other jazz gigs. He went around to the clubs and lounges, talking with entertainment directors—yet there was nothing in the way of regular work to be found. For the next two years, he single-handedly met with the Las Vegas entertainment hierarchy to pitch the need for quality jazz. Without any compensation, he

offered to book compatible players, arrange available dates, and literally do all the legwork to bring in top jazz talent. Still there were no takers.

It made no sense to Montgomery. As he questioned, "You can see top name jazz artists in Japan, throughout Europe, across the United States—many of whom live in LA, just 280 miles away—but they don't appear here? What's with that?"

Unwilling to accept defeat, Montgomery decided that some kind of non-profit jazz organization had to be formed. He invited two close friends representing the business and education communities who were well-connected with the local political scene in for a serious meeting. A week

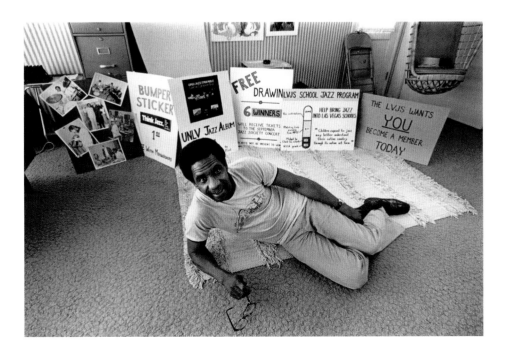

Monk Montgomery shown amidst Las Vegas Jazz Society promotional materials in his living room.

Monk also featured live, in-studio interviews with visiting jazz musicians, as well as open mic discussions with top artists to share what was happening with them while they were on tour.

later, thirty-five other business professionals who had an appreciation for jazz came on board.

In April of 1975, Monk Montgomery founded the Las Vegas Jazz Society, a 501(c)3 non-profit organization dedicated to bringing jazz to the attention of the Strip hotels, club owners, the education establishment, and music fans throughout the region. They started a membership drive, began printing stationery, made posters, and did all the other jobs necessary to get the society off the ground.

Right away they began booking concerts. Working with the University of Nevada, Las Vegas (UNLV), Montgomery brought his first jazz act to town—trumpeter Freddie Hubbard and his quintet, featuring tenor saxophonist Junior Cook, pianist George Cables, bassist Henry Franklin, and drummer Carl Burnett. Vocalist Joe Williams opened the show. The student union ballroom sold out.

Later that year, he brought the Dizzy Gillespie Quartet, then Milt Jackson, and the LA Four. Before long, such acts as the Louie Bellson Big Band, the Ron Carter Trio with Sarah Vaughan, Count Basie's Orchestra, Max Roach, Phineas Newborn, Jr., and Herbie Hancock's Quintet all came through on tour. Monk was also instrumental in bringing many jazz bookings to the Strip hotels: Maynard Ferguson and his band headlined at the Stardust; Stan Getz and Bob Brookmeyer performed at the Sahara; even such diverse acts as Blood, Sweat & Tears, Chick Corea, Herbie Mann, Jean-Luc Ponty, and the Thad Jones/Mel Lewis Orchestra all made it to the big stages.

Always in search of new promotional opportunities, Montgomery took over as host of a Sunday evening jazz show on KLAV Radio called the "Reality of Jazz" to plug the many worthwhile activities of the Las Vegas Jazz Society. Presenting the best in jazz music, Monk also featured live, in-studio interviews with visiting jazz musicians, as well as open mic discussions with top artists to share what was happening with them while they were on tour. The ultimate compliment was paid one evening when—unannounced—Count Basie, Oscar Peterson, Tommy Flanagan, Joe Pass, and Louie Bellson all crammed into the studio with Monk for an animated discussion.

After our weekend together, we continued to stay in touch. The indefatigable promoter always had important jazz projects on the front burner, even helping to head up major events as far away as Lesotho, South Africa. Another person in his shoes taking on such a noble cause would likely have focused more on his own self-aggrandizement. Not Monk Montgomery. Putting jazz front and center was always the goal, the greater good. To me, he will always be remembered as one of the jazz world's great ambassadors.

WILLIAM HOWARD (Monk)
MONTGOMERY
bass, composer
Born: October 10, 1921
Died: May 20, 1982

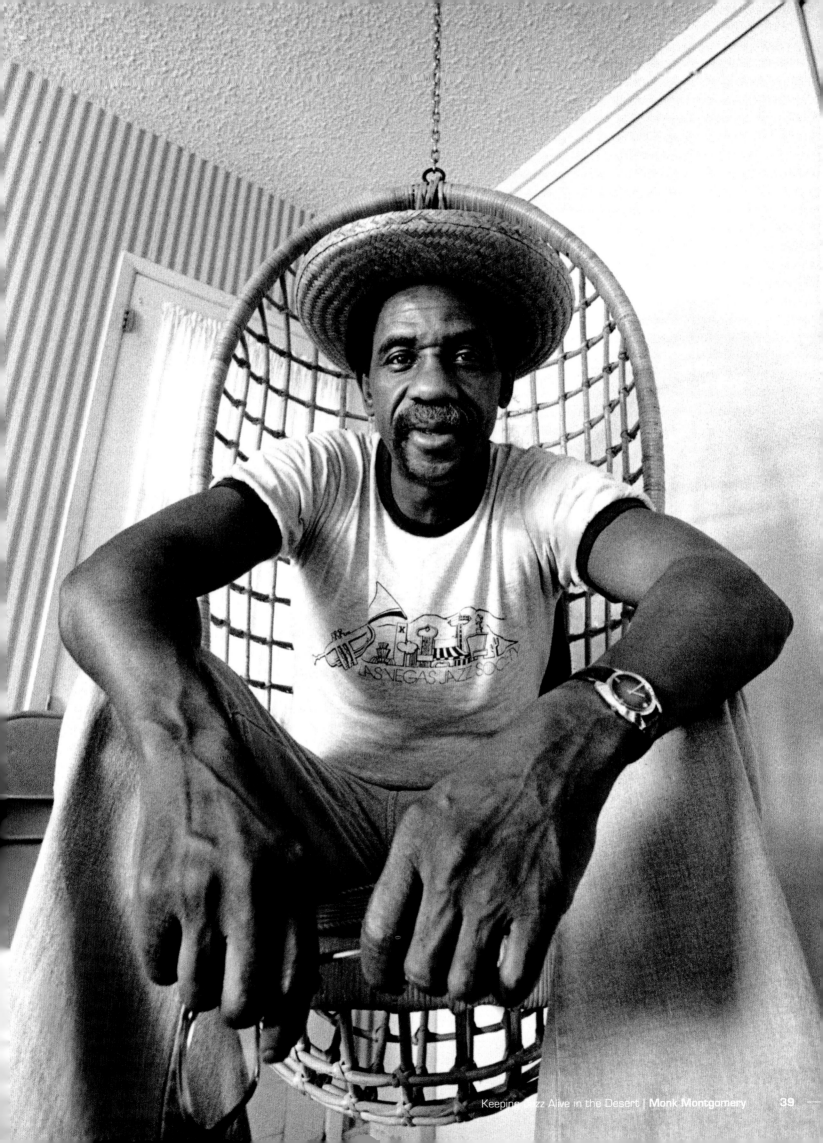

The Other Las Vegas Notables

During the remainder of my stay, I tracked down and photographed all nine of the working musicians on the list Monk had provided. Every one of them praised Monk Montgomery for his passion and perseverance in making "Jazz" and "Vegas" compatible. Two of the most prominent and internationally-known artists included vocalist Joe Williams and tenor saxophonist James Moody, whose photo-stories appear separately (*see pages 82–87 and 164–169, respectively*).

My first contact was with elder jazz statesman **Garvin Bushell**, perhaps the most musically-diverse of all the artists I met that entire weekend.

The multi-reeds specialist, who was then just a few weeks shy of his seventy-fifth birthday, had first broken in with Mamie Smith's Jazz Hounds in the 1920s. From there, he joined Fats Waller, followed by performances in the orchestras of Fletcher Henderson and Cab Calloway. Clearly proficient in any setting and a master of virtually all the woodwind instruments, he later went on to record with such contrasting stylists as John Coltrane, Eric Dolphy, and the Gil Evans Orchestra.

Bushell told me that he had settled in Las Vegas about the same time as Monk Montgomery, and reiterated just how smart the man was as a businessman. Among the many gigs he enjoyed with Monk's support included playing in the orchestra with Sammy Davis, Jr. at Caesar's Palace, backing a variety of stars such as vocalist Carmen McRae at locally produced jazz concerts, and subbing for other musicians in the big hotels whenever needed.

When he wasn't performing, Garvin maintained the same kind of success he enjoyed when he worked as a woodwinds teacher in New York. Here, he was giving lessons to fifty students a week. In what little spare time remained, Bushell kept busy making repairs on his many reed instruments in the home workshop.

Joking about one of his earlier involvements here in the desert, Garvin shared with me what happened when Monk tried to land him a job in the relief band at the Dunes Hotel. "A friend of mine told me, 'Garvin, they're not going to hire you. First place, you're black. Second, you're old. Third, you don't have hair.'"

Note: The ever-involved Bushell would go on to write a most highly acclaimed autobiography, *Jazz from the Beginning*, that included his rich experiences performing with many of the world's greatest musicians.

Right: Garvin Bushell surrounded by just a sampling of his many instruments

Opposite: In his music workshop, Bushell makes some minor repairs to one of his instruments.

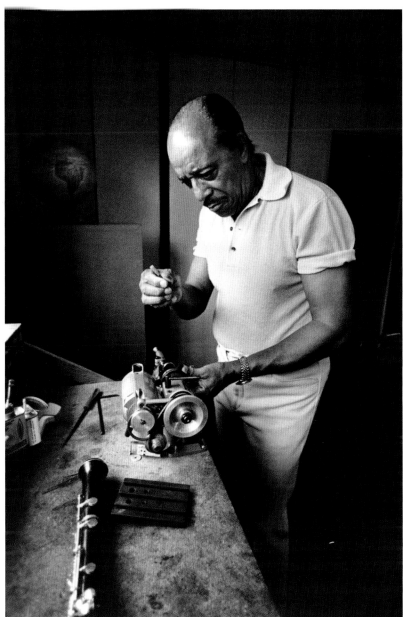

Clearly proficient in any setting and a master of virtually all the woodwind instruments.

I connected with the remaining musicians in the comfort of their homes, or backstage at various Strip hotels while their respective orchestras were on break. Because of their special talents, each of the artists had successfully carved out particular niches and was enjoying steady work in the desert entertainment capital. They included:

Si Zentner

The bandleader/trombonist, who won an amazing thirteen consecutive *Down Beat* "Best Big Band" polls in the 1950s and 1960s, pretty much defied all odds by continuing to head up quality orchestras long after the big band era had faded. He held the distinction of being named musical director for the Tropicana Hotel's *Les Folies Bergere*, which would become one of the longest-running floorshows in Las Vegas.

Tommy Turk

Trombonist Tommy Turk is remembered for his performances and recordings with bebop pioneer Charlie Parker, and his nearly two years with Norman Granz's popular *Jazz At The Philharmonic* tours, playing with such greats as Coleman Hawkins and Lester Young.

Billy Root

Multi-reeds player Billy Root, relaxing backstage at The Frontier Hotel between shows, early on recorded with the Stan Kenton Orchestra, and later with trumpeters Roy Eldridge and Lee Morgan. In one of his early claims to fame—as the house tenor saxophonist at Philadelphia's Blue Note club in the 1950s—Root played with the top soloists of every major act that passed through.

Left: Si Zentner poses with one of his specially made, three-belled trombones.

Middle: Tommy Turk poses in the back patio area of his home in Las Vegas.

Right: Billy Root, surrounded by instruments, poses in his dressing room at the Frontier Hotel in Las Vegas.

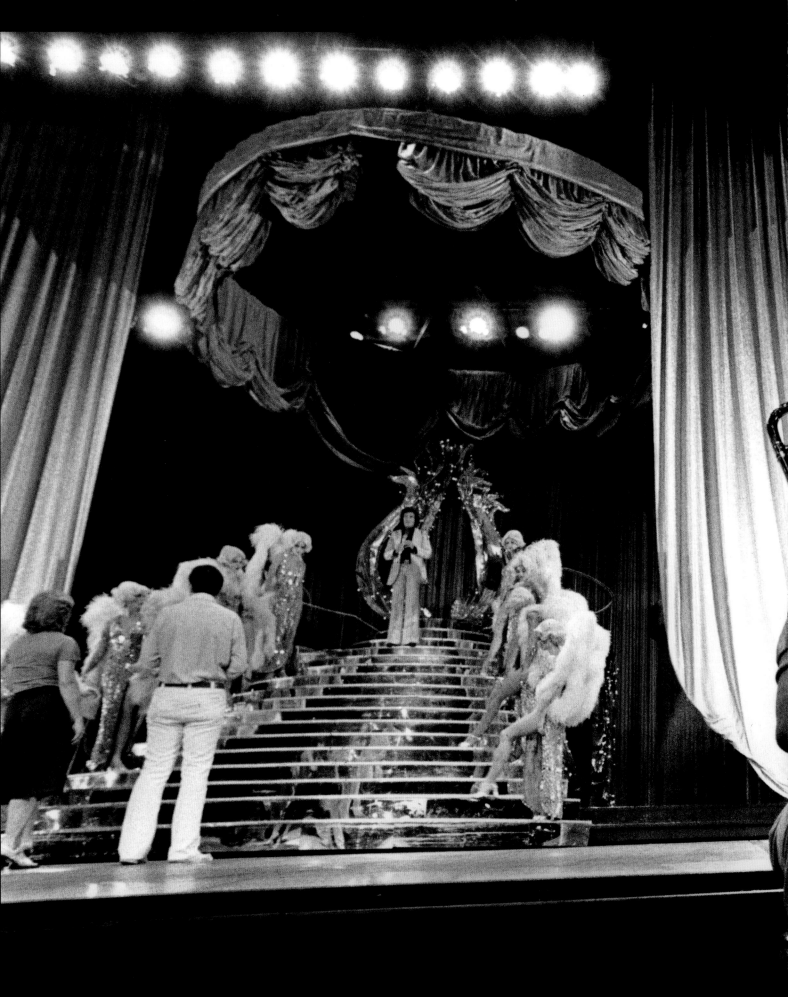

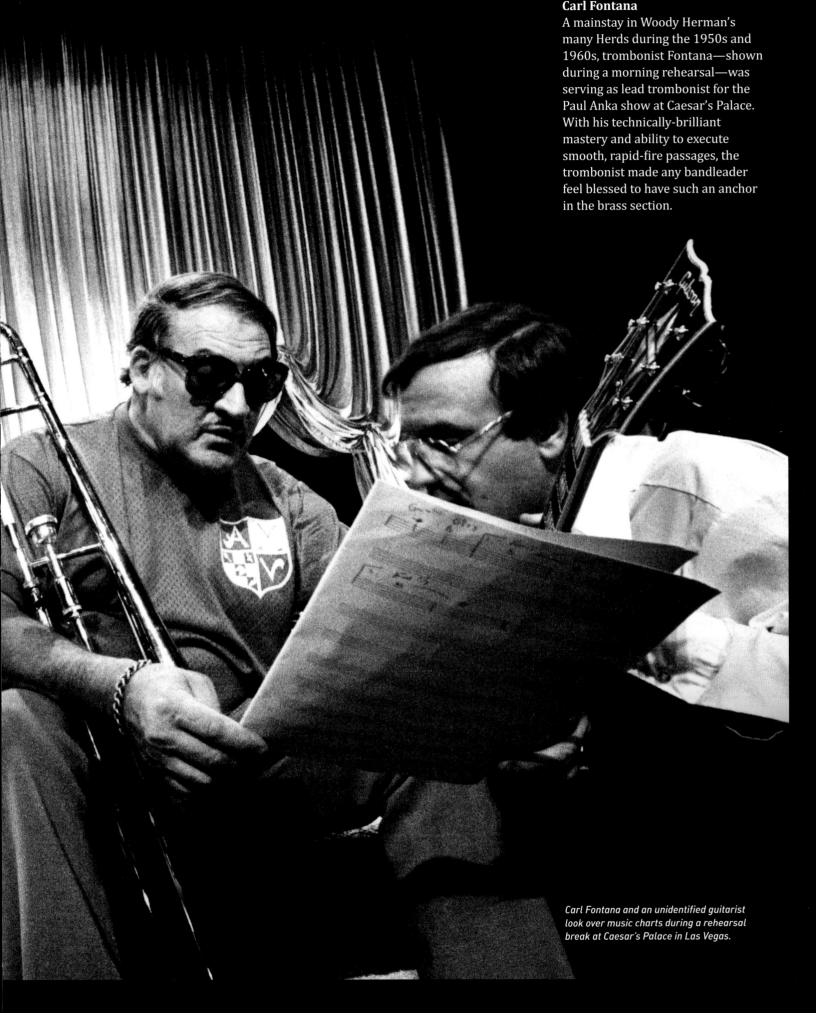

Carl Fontana
A mainstay in Woody Herman's many Herds during the 1950s and 1960s, trombonist Fontana—shown during a morning rehearsal—was serving as lead trombonist for the Paul Anka show at Caesar's Palace. With his technically-brilliant mastery and ability to execute smooth, rapid-fire passages, the trombonist made any bandleader feel blessed to have such an anchor in the brass section.

Carl Fontana and an unidentified guitarist look over music charts during a rehearsal break at Caesar's Palace in Las Vegas.

Carson Smith

Among jazz followers, bassist Carson Smith was best known for his work with Gerry Mulligan, the baritone saxophonist who introduced the jazz world to his influential pianoless quartets. When I told Carson where my Las Vegas photo report would be published, he lit up, sharing the story of his 1964 tour of Japan with saxophonist Georgie Auld. "The Japanese are true jazz fanatics," he said. "They know everybody. When I got off the plane, there were dozens of people all waiting in line to see us at the airport. As I walked by, they bowed and said, 'Carson Smith, the bassist.' It was an incredible experience."

Elek Bacsik

Early in his career as both a violinist and guitarist, the Hungarian-born gypsy and cousin of Django Reinhardt worked throughout Europe with pianist Bud Powell and drummer Kenny Clarke.

My introduction to Bacsik came when I heard his distinctive guitar sounds on the 1962 Dizzy Gillespie album *Dizzy on the French Riviera*. Soon after arriving in Las Vegas, Bacsik made such a strong impression on the popular headliner, Wayne Newton, that the singer chose Elek as his full-time concertmaster and leader of the string section.

Left: Carson Smith poses with his acoustic bass near the front entrance to his home in Las Vegas.

Right: Elek Bacsik poses with a violin in the backyard of his home in Las Vegas.

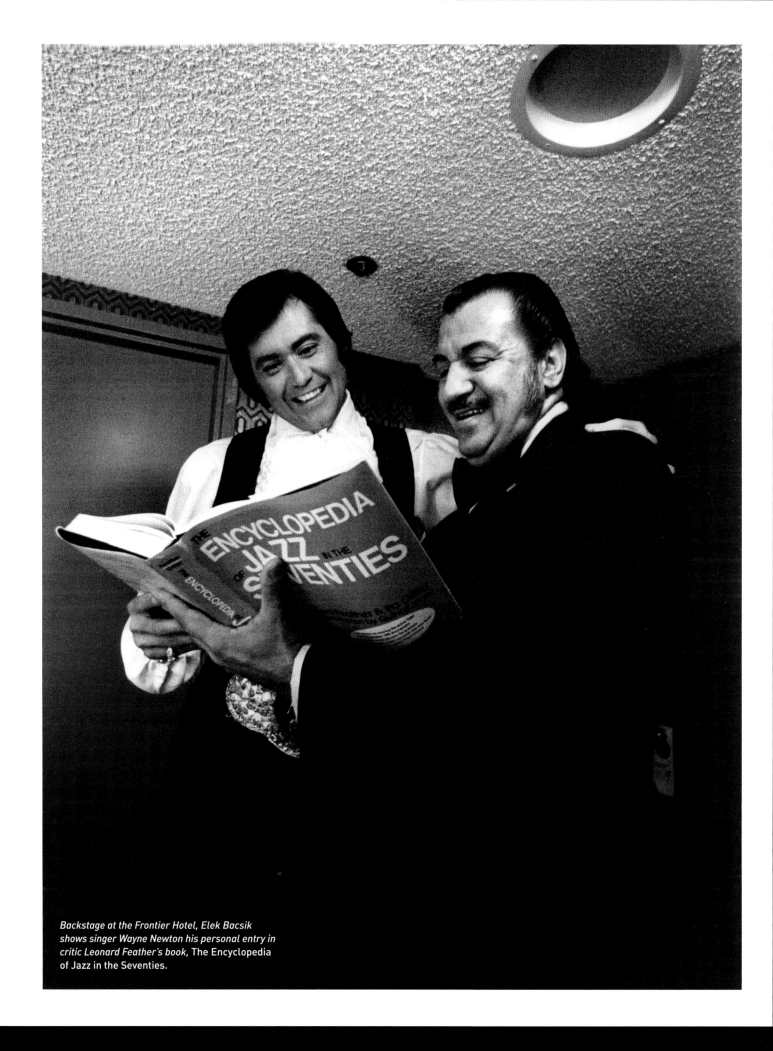

Backstage at the Frontier Hotel, Elek Bacsik shows singer Wayne Newton his personal entry in critic Leonard Feather's book, The Encyclopedia of Jazz in the Seventies.

STAN
GETZ

The Stars Align;
"Stars" Intertwine

The last time we had visited was a couple of summers earlier. Stan Getz had been relaxing on the beach in front of his hotel, Le Grand Pavois in Antibes, France, after an invigorating swim in the Mediterranean Sea's Bay of Cannes. As a sun worshiper and outstanding swimmer, he relished performing at such waterfront jewels as the Juan-Les-Pins Jazz Festival where he was one of the top headliners.

On this occasion, in February of 1978, the tenor saxophonist was back in San Francisco preparing for a new engagement at the popular jazz club Keystone Korner. I had made arrangements several weeks earlier to do a photo session with him once he arrived in the City, but I could never have envisioned just how fitting the day would turn out to be. Recalling how that afternoon's events unfolded,

it was almost as if the stars were in perfect alignment.

When I picked him up at his hotel, Stan was in great spirits, primarily because he was reconnecting with one of his all-time favorite musical

After finishing a vigorous swim in the Mediterranean Sea, Stan Getz relaxes on the beach in front of his hotel in Antibes, France.

collaborators, Bob Brookmeyer. The valve trombonist, having last worked with Getz some fourteen years earlier, had just rejoined him for the start of a new tour beginning on the west coast.

When we got into the car, I asked him if he wanted to do anything in particular. He said he just felt like taking in different parts of the city. We did some sightseeing, driving through North Beach, out along the Marina, and then I headed over to Golden Gate Park. After parking, we went for a leisurely walk of the grounds, even stopping along the way to pick and eat wild blackberries. Next we visited the de Young Museum, where we spent quite a bit of time viewing the many artworks, and finally ended up browsing through the grounds of the Japanese Tea Garden, where we stopped to take some photographs.

Throughout the day, Getz periodically expressed his delight in being reunited with Brookmeyer after so many years. It was obvious the two of them shared a strong musical bond.

Upon returning to his hotel, Stan asked me to bring my gear and come into the lobby with him while he changed clothes. Before going upstairs, he picked up a house phone and called Brookmeyer in his room. "C'mon down," he told Bob, "we need to take

some pictures together." When Brookmeyer arrived, the three of us walked a couple of blocks to the financial district for some photos of the utterly compatible pair.

During my years of covering Stan Getz, I always found him cordial but occasionally preoccupied, perhaps dealing with something personal. If I sensed he was distracted or concerned about more pressing matters, I gave

him some space. In part, what made this day so special was how open-armed and "free" he seemed.

Thinking back on that memorable afternoon, I often reflect on the absolute good fortune of being so close with the man I consider to be the most distinctive melodious creator of music on the tenor saxophone. Not only was the day particularly meaningful for me, but also fortuitous in that I got to share

I often reflect on the absolute good fortune of being so close with the man I consider to be the most distinctive melodious creator of music on the tenor saxophone.

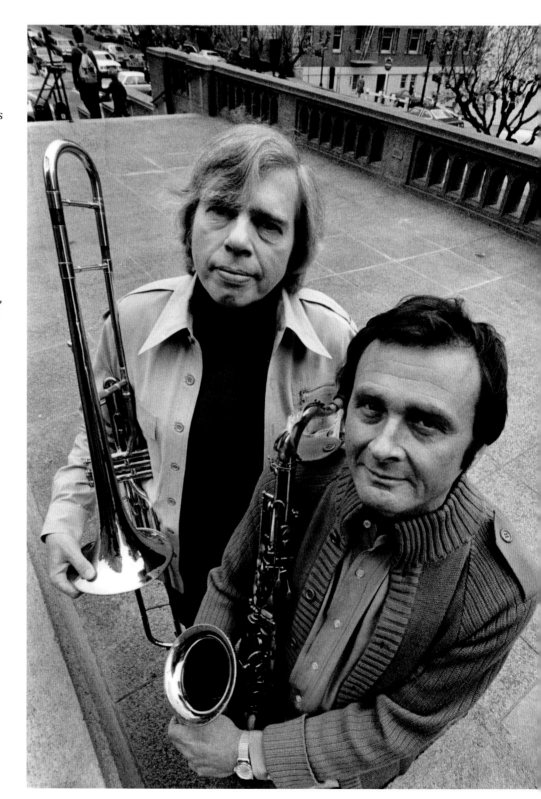

Musical soul mates Bob Brookmeyer and Stan Getz.

some fleetingly happy times with two clearly simpatico artists whose musical minds were so closely attuned.

In Donald L. Maggin's book, *Stan Getz: A Life in Jazz*, the saxophonist talked about the close ties he enjoyed with Brookmeyer: "We seem to be on the same wave-length musically and personally. We complement each other naturally . . . [and] have the same yearning for fresh, uncluttered, melodic improvisation."

STAN GETZ (Stanley Gayetsky)
tenor saxophone
Born: February 2, 1927
Died: June 6, 1991

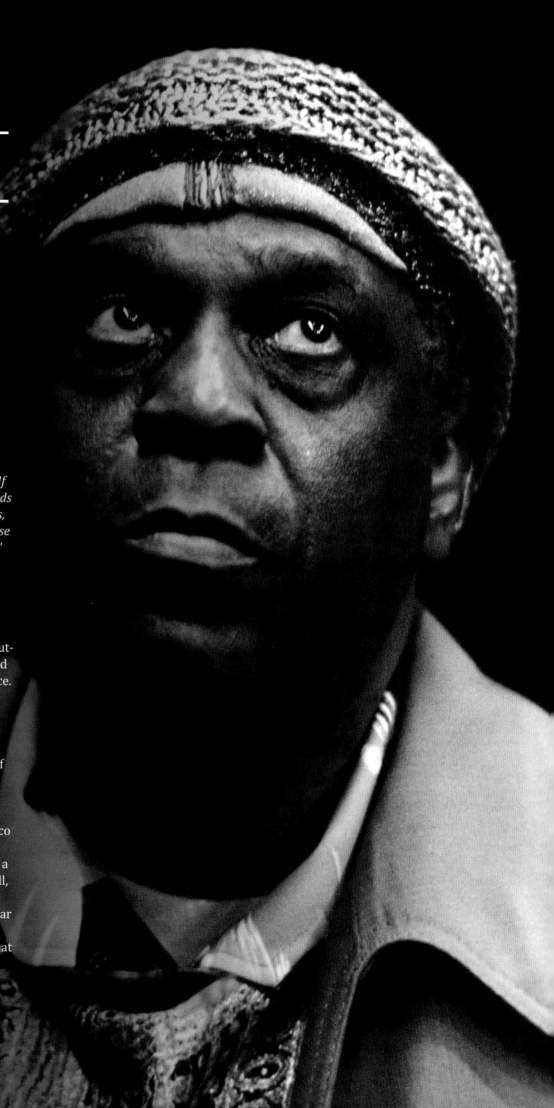

SUN
R A

In His Own "Space"

PHILADELPHIA,
PENNSYLVANIA

"I play the music of the universe. If humans should one day hear the sounds of cosmic beings from different worlds, their music will sound familiar, because they will have heard Sun Ra on Earth."

– from *Jazz: A Photo History*,
by Joachim-Ernst Berendt

It didn't matter that many writers dismissed Sun Ra as a gimmick or a put-on. He personified and even celebrated his "otherworldly" image and existence. He delighted in promoting his unique brand. Wherever in the world he performed, the crowds would follow. And in the end, he survived as one of jazz's most prolific recording artists of the twentieth century.

My first couple of sessions witnessing Sun Ra and his Solar Arkestra occurred in the San Francisco Bay Area in the mid-1970s. During a conversation after he had completed a soundcheck at a Berkeley concert hall, I told him I was expecting an assignment to cover him in his familiar surroundings back east. We shared contact information and I told him that I'd be in touch.

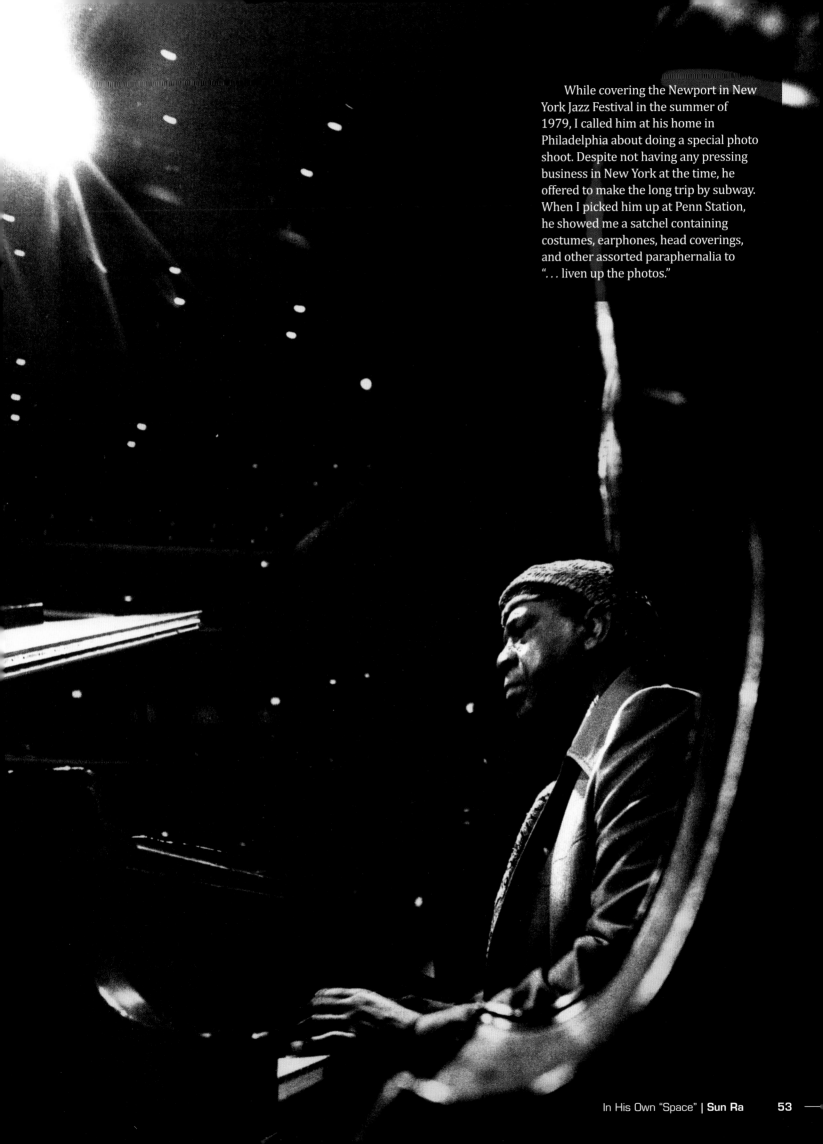

While covering the Newport in New York Jazz Festival in the summer of 1979, I called him at his home in Philadelphia about doing a special photo shoot. Despite not having any pressing business in New York at the time, he offered to make the long trip by subway. When I picked him up at Penn Station, he showed me a satchel containing costumes, earphones, head coverings, and other assorted paraphernalia to "... liven up the photos."

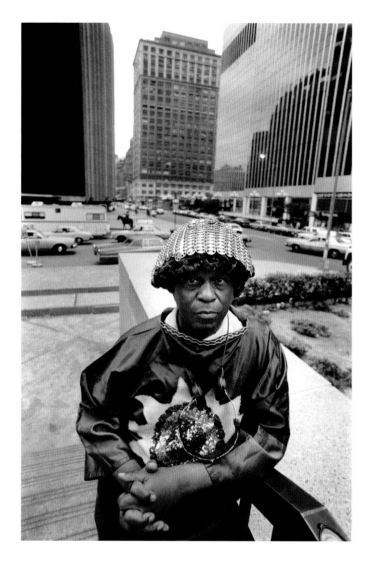

After the session, we had dinner together at a Thai restaurant that he liked. Before he left to check into a hotel for the night, we agreed it would be good to meet once more on his own home turf for a more personal and extended photo session. I told him I'd be back the following July.

The next year prior to the Newport Festival, I tracked him down by telephone while he was in Boston preparing to present what he described as an "... Outer space Visual Communicator light show," at the Massachusetts College of Art and Design (the OVC was developed by scientist Bill Sebastian). He told me when he would be due back home. We set the time then for our photo shoot in Philly.

The day of our meeting, I took the hour-and-a-half subway ride from Penn Station to 30th Street Station in

Sun Ra in downtown Manhattan wearing some of the paraphernalia he brought with him for the photo shoot.

I tracked him down by telephone while he was in Boston preparing to present what he described as an "... Outer space Visual Communicator light show."

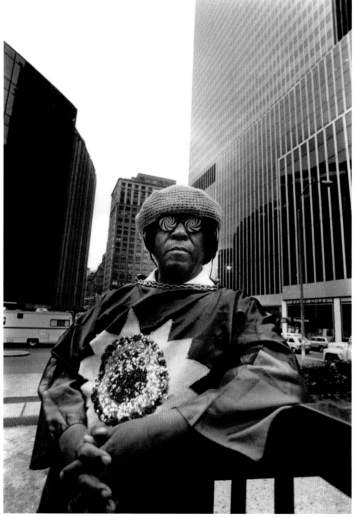

Philadelphia. As pre-arranged, Danny Ray Thompson, baritone saxophonist and road manager, picked me up, and we drove to Sun Ra's 5626 Morton Street home in the nearby suburb of Germantown.

After we arrived, I was ushered into a long room on the main floor. It was packed wall-to-wall with recording equipment, speakers, amplifiers, paintings, murals, tapestries, pieces of sculpture, a drum set, two makeshift couches piled high with overstuffed pillows, even a portable television set.

While I was photographing the main room's interior, Sun Ra appeared. He explained that this was his group's "rehearsal room." He promptly opened a movable divider closest to the street, went around, and sat down on a bench accompanying his large Crumar brand organ.

On this occasion, he made five changes of flashy outerwear and headgear. We took photographs in the main room and around the house, in some outdoor settings, and with several members of his Arkestra.

After completing the photos, we returned to his rehearsal room and talked for more than an hour. He discussed many topics, offering opinions on a variety of subjects, fellow musicians, and prior experiences that ran the gamut of believability. Sun Ra alluded to his

Right: I actually wasn't even aware that Sun Ra had made some minor garment changes along the way for each of the different poses we did in and around his home.

Below: "Space Jazz musician Sun Ra occasionally played the Crumar DS-2," is how the Italian organ manufacturer referred to the keyboardist in its advertising and promotional materials.

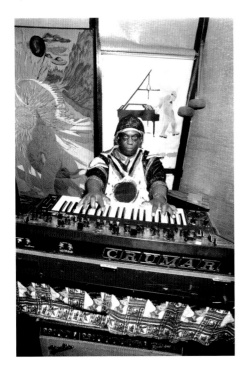

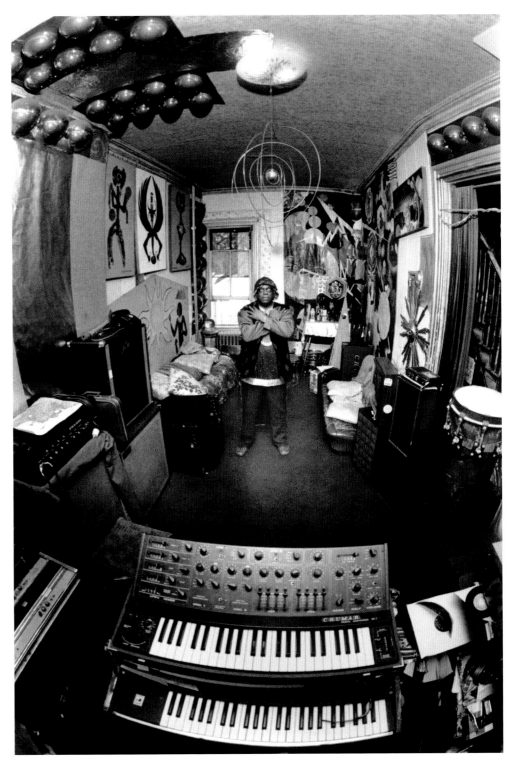

"advanced" state and how people were unable to accept him because of it.

He referred specifically to a manuscript he had written, *The Immeasurable Equation,* which he offered to Doubleday, the book publisher. Doubleday kept it for three months, said they could not decipher it, and finally gave it back to him, explaining, "It might as well have been written in a foreign language." Despite this, Sun Ra noted that Impulse Records had re-released one of his albums—the 1973 disc, *Astro Black*—which included seven of his verses from that manuscript in the sleeve. He said that what he had written about was the "cosmos" and the "ultimate in truths," explaining that his words do not relate to human standards.

Sun Ra told me that by cosmos standards, he was three years old, but noted that he had existed ". . . for several lifetimes and one 'so-called lifetime,'" the latter referring to his current presence on Earth.

As if to authenticate what he was saying, he gave me seven pages containing thirty-seven examples of typeset verse printed on both sides of faded blue paper, representing a portion of his manuscript. The pieces ranged from a short, few lines to others extending a half-page in length, each bearing its own title. Before finishing up talking about his manuscript, he picked up a simple protractor and, without saying anything, drew a half-inch circle with a dot in the middle at the bottom of one of his verses titled "On."

Right: Sun Ra poses in front of his row house in the Philadelphia suburb of Germantown with some of his Arkestra members who were on hand for the day, including: (from left) Lex Humphries, drums; Mark "The Black Hole" Anthony, guitar; James "Jac" Jacson, percussion, flute, bassoon; John Gilmore, tenor saxophone, clarinet; Kenny Williams, baritone and tenor saxophone; Yahya Abdul-Majid, tenor saxophone and percussion; Craig Haynes, drums; Marshall Allen, alto saxophone and flute; and Eric "Samarai Celestial" Walker, drums.

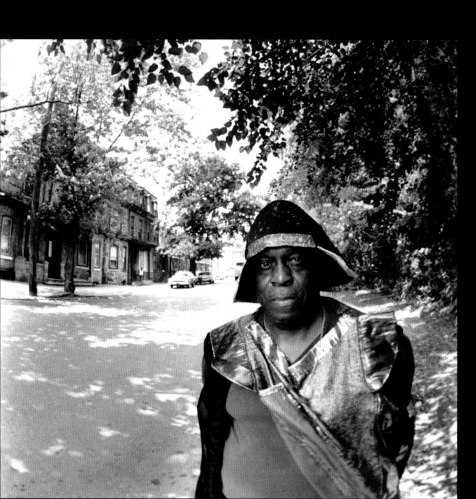

He said that what he had written about was the "cosmos" and the "ultimate in truths."

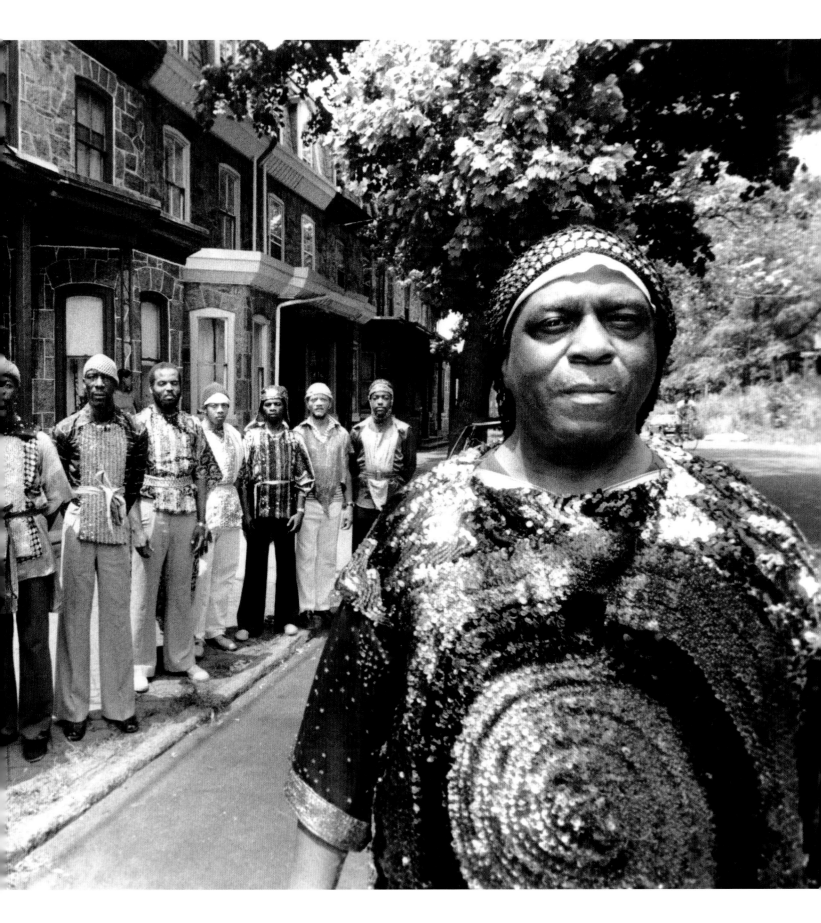

Note: Later, after going through his writings, I noticed he had made the identical circle two other times, but each with embellishments. One, accompanying a hand-drawn seated figure in a robe wearing headgear and scarf, was positioned between two verses titled "Intergalactic Master," and "Here Am I." Attached to the other circle, at the bottom of the verse "Victory Dual," was a squiggly symbol to the left and a "tail" to the right. I read it as, "ra," but it's certainly open to interpretation.

Far more understandable were Sun Ra's remarks about other musicians and how they were influential in shaping the future of jazz. The biggest influence on him and the development of his music was composer/arranger/bandleader Fletcher Henderson, with whom he worked as pianist and arranger in 1946–47. It was Henderson who prompted Sun Ra to organize his first *Arkestra* in Chicago1954 (so-named because the first and last two letters backward and forward spelled his name). As if implying that some strange bond existed between he and Fletcher Henderson, Sun Ra told me that Fletcher's band members "... always thought I played weird," but quickly countered with, "Fletcher played piano; I played piano. That's why he hired me."

He recalled how Henderson asked him to bring some of his own arrangements for the band to play. "I remember bringing in 'I Should Care,'" he said with a smirk, "but the band couldn't play it, even after two hours. I've had teenage students, though," he continued, "who could play the charts because I'm able to bring out musicians' abilities after working with them."

Several times Sun Ra appeared to enjoy poking fun at Henderson's band members, but had only the highest praise for Fletcher himself. Regarding the popular bandleader's skills as an arranger, he said to me, "Fletcher's 'King Porter Stomp' was the best jazz feeling ever written. Everything he wrote was meticulously correct." Sun Ra's ongoing dedication to Henderson was obvious. During our time together, he explained that when he and the band weren't traveling, the Arkestra members rehearsed in his home almost every day, "... [and] when we're not rehearsing, I play them Fletcher Henderson records."

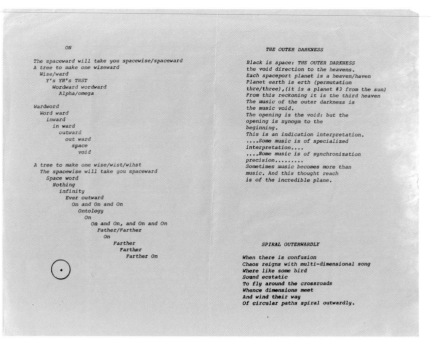

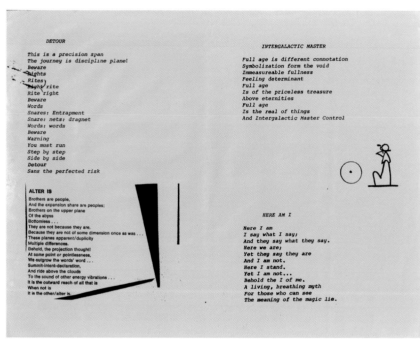

Sun Ra spoke at length about his personal qualities as a teacher, healer, and seer. He noted that a lot of musicians received the wrong upbringing and weren't educated properly. Regarding the very diverse styles of pianists Oscar Peterson and Paul Bley, he said, "Oscar plays like a machine, never making a mistake. Paul Bley will take chances and make a mistake, but it comes off right."

Besides receiving the proper kind of musical education, Sun Ra stressed that artists need to ". . . do what's right for themselves. The most important thing for black people," he said, "is to produce what they feel, not what they think."

SUN RA (Herman Poole "Sonny" Blount) (Le Sony'r Ra)
piano, composer, synthesizer; electric keyboards, leader, educator
Arrival Day: May 22, 1914
Departure Day: May 30, 1993

Note: In his book, *Space Is the Place: The Lives and Times of Sun Ra*, author John F. Szwed shared what Sun Ra thought about his so-called existence on Earth. He wrote, ". . . life and death did not interest him, he was talking about 'being,' a third state, which forms a triangle with life and death. Being gave life and death permission to exist. The birthday should be the arrival day, and what you call death should be the departure day."

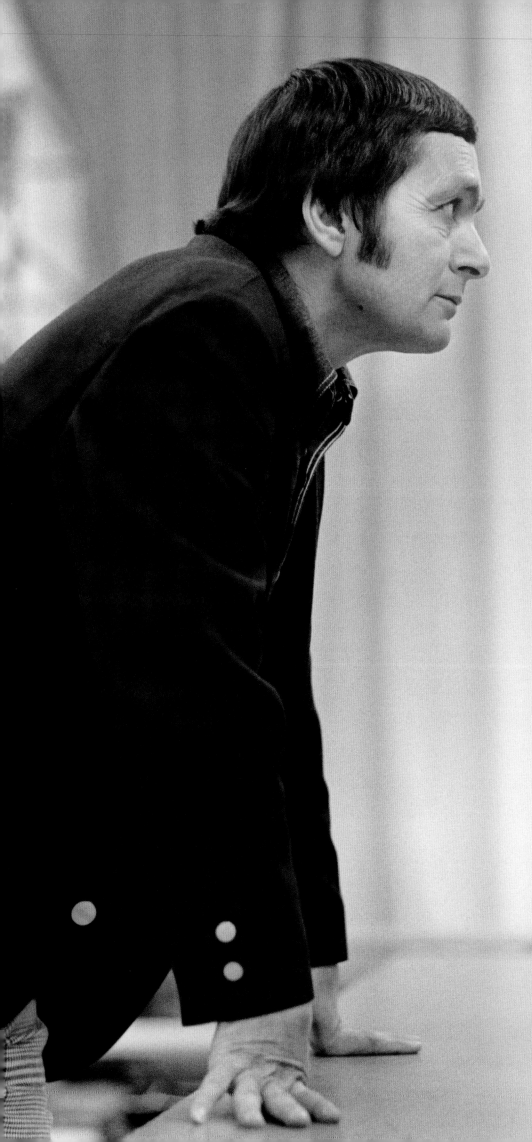

ART
PEPPER

*Careers Saved by
Significant Partners
(Take 1)*

| SAN FRANCISCO,
CALIFORNIA

For the longest time, Art Pepper's career had been going nowhere—throughout much of the 1950s and 1960s, he had been imprisoned because of heroin addiction.

My introduction to Pepper's raw talent came with the release of his 1957 Contemporary Records album, *Art Pepper Meets the Rhythm Section.* From the time I acquired that disc I too became hooked, marveling at how the hard-edged alto saxophonist was able to mesh so passionately with Miles Davis's impeccable timekeepers from that period—pianist Red Garland, bassist Paul Chambers, and drummer Philly Joe Jones.

I longed to see and hear the man in person, yet never thought I would get the opportunity. But then in 1974, after he married his third wife, Laurie, I began seeing the reports that Art Pepper's life was beginning to change . . . that he was about to make a genuine resurgence on the scene.

It was March of 1975, when I learned he would be serving as clinician and guest artist at the University of Nevada's annual jazz festival in Reno hosted by the school's jazz studies department.

Art Pepper had begun a revival. Not only was he now a popular and in-demand clinician for universities across the country, but within a few months Contemporary would release his "comeback" recording, *Living Legend*, featuring pianist Hampton Hawes, bassist Charlie Haden, and drummer Shelly Manne.

The morning of the event, I headed east over The Sierras. There, I spent most of the day in his midst at the soundcheck, and later, while he conducted classes for the enthralled students. That evening, in a solo performance with the University jazz band, Art Pepper brought the house down. Watching the man at work, I would never have guessed that he had been in such torment early in his career.

From that time forward, with Laurie's nurturing and constant attention, Art simply bloomed. For the next six years, Pepper fronted or co-led several dozen acclaimed recordings, as well as proved to be a solid draw on the international festival circuit. For a time, he was the hottest property in Japan, literally revered by his many jazz fans.

In October of 1981, I caught him one final time as featured soloist with the Mel Lewis Jazz Orchestra at the San Francisco International Jazz Festival. Backstage in his dressing room with his wife Laurie, Art was in good spirits.

Outwardly, he didn't appear to be placing much importance on his apparent "rebirth" as a musician. The fact that he was back performing at such a high level was simply as it should be. In my eyes, he was living completely in the moment, content knowing he was right alongside the person he considered his savior.

At one point before the show he found himself without a neck strap for his alto, and the backstage hands ran around trying to find something that would work as a substitute. Eventually, someone produced a handful of twisted plastic wire, and Laurie fashioned some sort of hook to it so Art would be able to keep his horn in place.

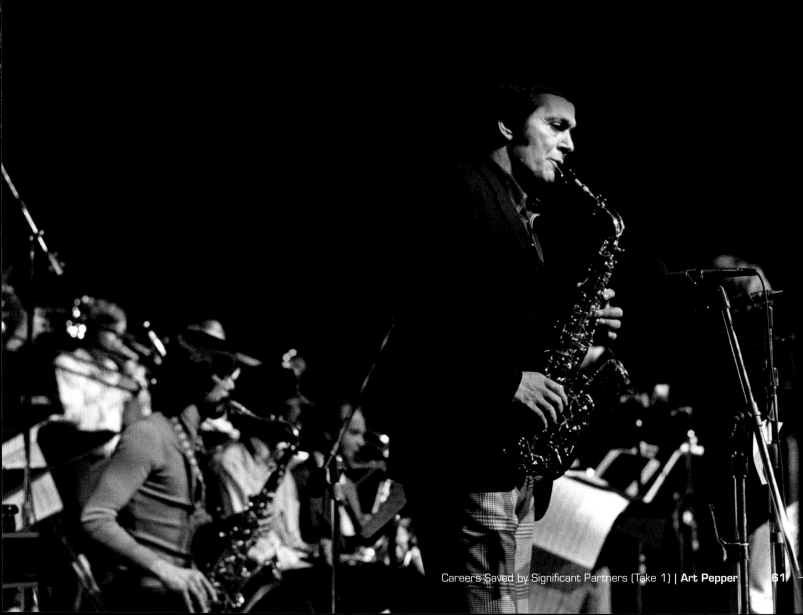

While he was waiting to be called onstage, I took several candids of Pepper as he was warming up. Then, after placing his horn back in the case, Art leaned over and said to me, "Hey, you've gotta catch this. I'm going to pretend to be giving my last concert while having a heart attack."

Dutifully, I snapped away.

After getting back up from the floor, Art and Laurie shared a big laugh over his joke. Ever in the moment, Art Pepper could make light of where he was and who he'd become.

Sadly, in June the following year, Art passed away at age fifty-six from complications following a stroke.

Critic Larry Kart, who witnessed the alto saxophonist in performance just days before his passing, wrote this of Art Pepper in his book, *Jazz In Search of Itself*: "On any given night until the very end—his last Chicago performance, which took place only two weeks before his stroke was typical—Pepper challenged himself to the utmost. In his life, Art Pepper seemed to be skating at the edge of an abyss. And yet his music managed to encompass that sense of danger, seeking and finding a wholeness that was, so it seems, denied to its maker."

ARTHUR EDWARD (Art) PEPPER, JR.
alto saxophone, composer; also tenor and soprano saxes, clarinet, flute
Born: September 1, 1925
Died: June 15, 1982

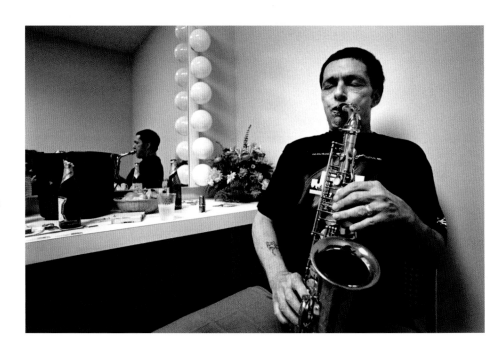

Ever in the moment, Art Pepper could make light of where he was and who he'd become.

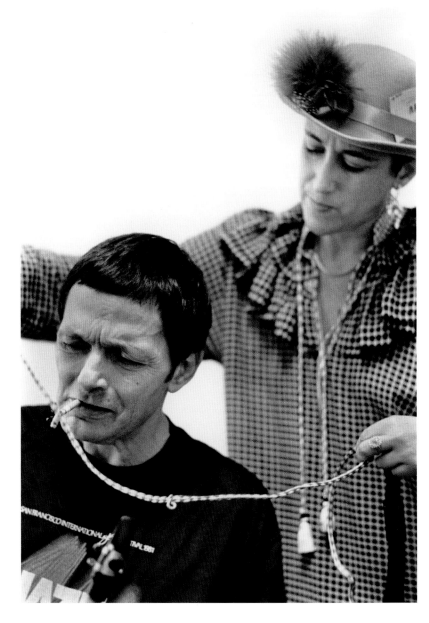

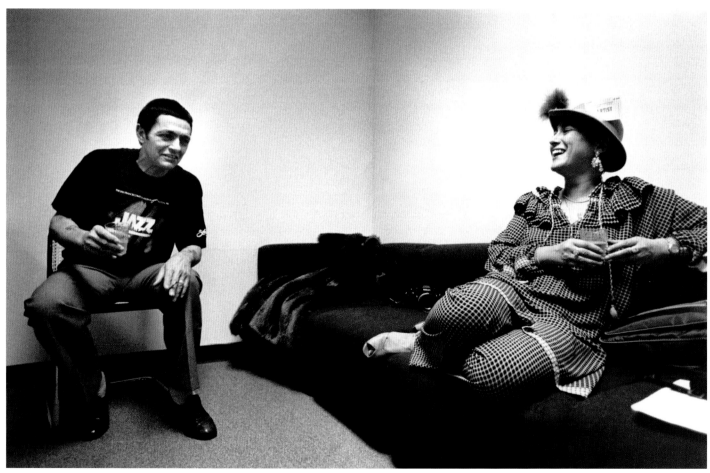

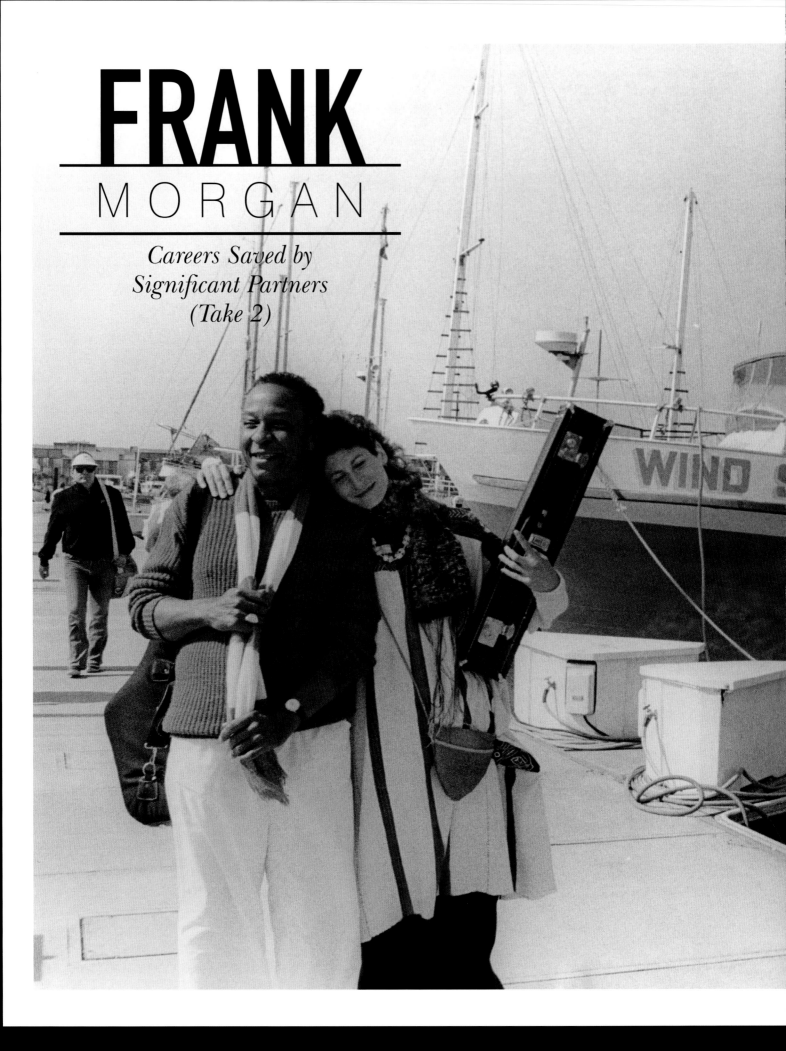

FRANK
M O R G A N

Careers Saved by
Significant Partners
(Take 2)

After thirty wasted years, mostly spent within prison walls, the alto saxophonist had at last tasted true freedom.

OAKLAND, CALIFORNIA

The setting could easily have been seen as totally scripted, but this was no act.

Watching and photographing the pair as they strolled along the Berkeley Marina—two blissful soulmates, so much in love—there was no avoiding what was obvious. Locked in a warm embrace, the couple practically floated as one as they made their way along the boardwalk. I couldn't help but notice all the passers-by, their heads turning to witness the magnetism radiating between these two.

Here it was in May of 1987. For those who knew his story, it was perfectly understandable why Frank Morgan would now be projecting such a warm, inviting glow wherever he went. That's because after thirty wasted years, mostly spent within prison walls, the alto saxophonist had at last tasted true freedom. He had found his guardian angel, artist Rosalinda Kolb, and because of her, was now back on the scene and finally receiving long-overdue critical acclaim as a major voice in jazz.

Lovers Frank Morgan and Rosalinda Kolb bask in each other's company.

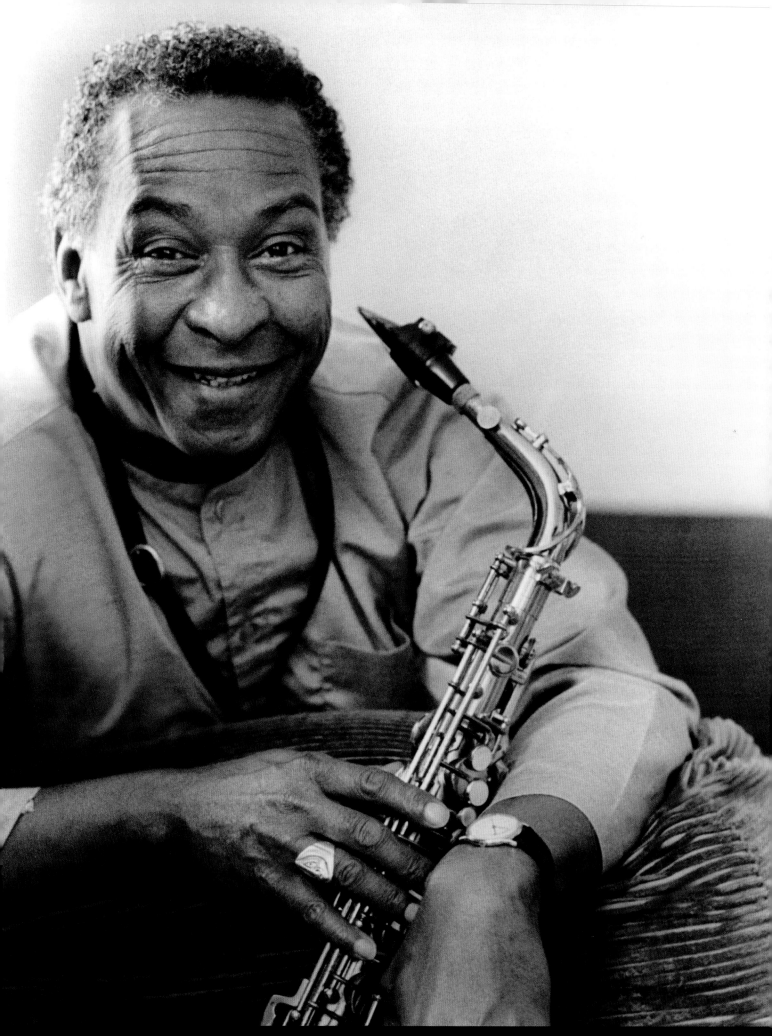

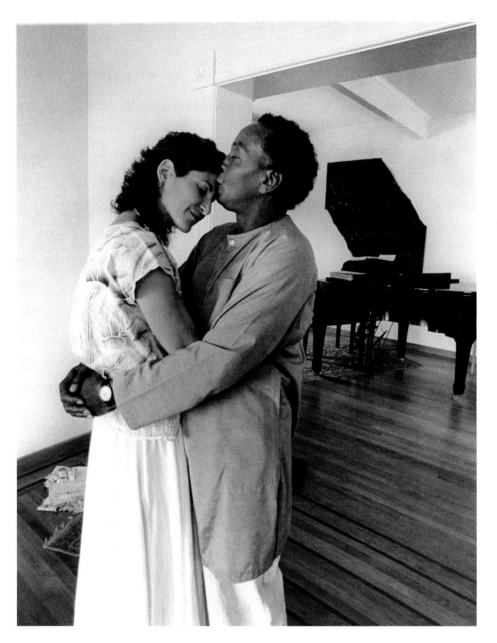

Frank and Rosalinda warmly embrace in the living room of their home. "Rosalinda," he told me, "is directly responsible for saving my life."

Coming back after missing out on three decades of what should have been the most productive period of his playing career was not easy.

In her book, *Leave 'Em Hungry: A Love Story and Cautionary Tale*, Rosalinda talked about those trying times, the difficulties of working with someone of Frank's nature, where addiction absolutely ruled his life. For nine years from the time of their first meeting until Morgan's final release in 1985, it was a near constant struggle getting Frank to break his cycle of dependence and face the responsibilities of surviving in the real world.

I spent most of that late spring day with the two Southern California transplants in and around their Victorian-style home in Oakland. It was a happy time. They had just returned from Frank's New York debut—a week-long gig at the Village Vanguard—which had produced a cascade of rave reviews.

Remarkably, in less than two years—following the distribution of his long-awaited, return-to-the-scene record, *Easy Living*, with pianist Cedar Walton—Frank had already completed a total of five albums. A sixth, featuring pianist McCoy Tyner, had just wrapped up and was now in production. Morgan's bookings were coming in from far and wide.

Back here in the Bay Area, Morgan was keeping a busy bookings schedule, as well as welcoming a regular stream of out-of-towners—visiting musicians who just wanted to hang out and jam. Frank referred to their spacious digs as ". . . our west coast version of the New York loft scene." Since their move, some of those who had come by to play included trumpeter Kenny Wheeler; pianist George Cables; drummers Billy

Like so many other musicians during the 1940s, who became totally absorbed by the new and scintillating sounds of bebop and its leading practitioners—including trumpeter Dizzy Gillespie and alto saxophonist Charlie "Yardbird" Parker—it was only natural to want to emulate everything about these jazz giants.

For Morgan, the intense love affair of "all things Bird" actually began when he was just seven years old. His guitarist father had taken him to see the Jay McShann Orchestra featuring Parker; afterwards, he even got to meet and talk with the alto legend in his dressing room. By age twelve, Frank had mastered many of Bird's solos, and in his early twenties had already recorded, including his debut album as a leader. But by then, he had also embraced Parker's heroin habit and destructive lifestyle. What followed would be a ruinously long span of incarceration.

Coming back after missing out on three decades of what should have been the most productive period of his playing career was not easy. Not for Morgan, nor for Kolb, his virtual companion for the last thirty years of his life.

Higgins and Eliot Zigmund; and saxophonists Steve Coleman, Pharoah Sanders, plus the father-son duo Von and Chico Freeman.

The change of scenery and solid home base also gave Rosalinda, who holds a Master of Fine Art degree from Chicago's School Of The Art Institute, an opportunity to spend more time developing what she calls her "personal vision," original artworks which she compartmentalizes by different-named series.

As I looked back on that day, I kept thinking about the arduous journey of Frank and Rosalinda, what they achieved by working together, and how the rewarding outcome could only have been realized through personal sacrifice and the power of perseverance.

FRANK MORGAN

alto, soprano saxophones, composer
Born: December 23, 1933
Died: December 14, 2007

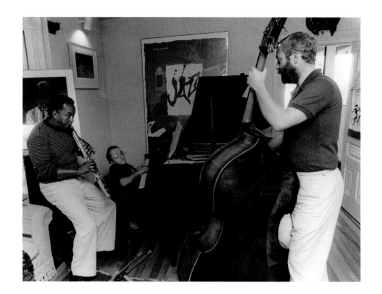

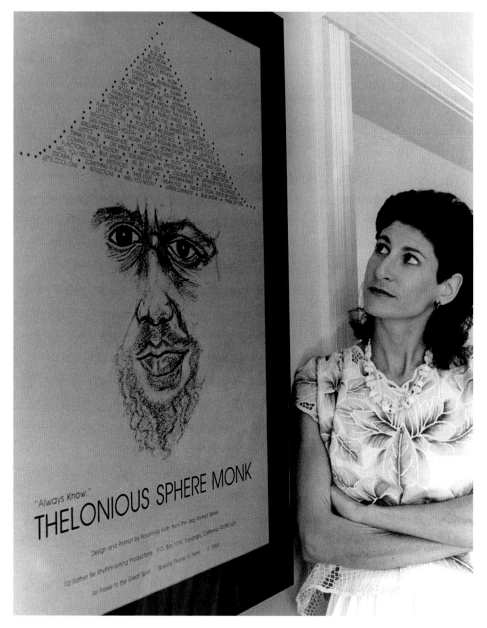

Top: Morgan, along with pianist Michel Petrucciani and bassist Dave Holland, rehearses at Frank's home in advance of a week-long engagement at a jazz club in the South Bay city of San Jose.

Bottom: Artist Rosalinda Kolb poses next to one of her "Jazz Portrait Series" posters of Thelonious Monk, whose hat spells out the names of many of the pianist's famed compositions.

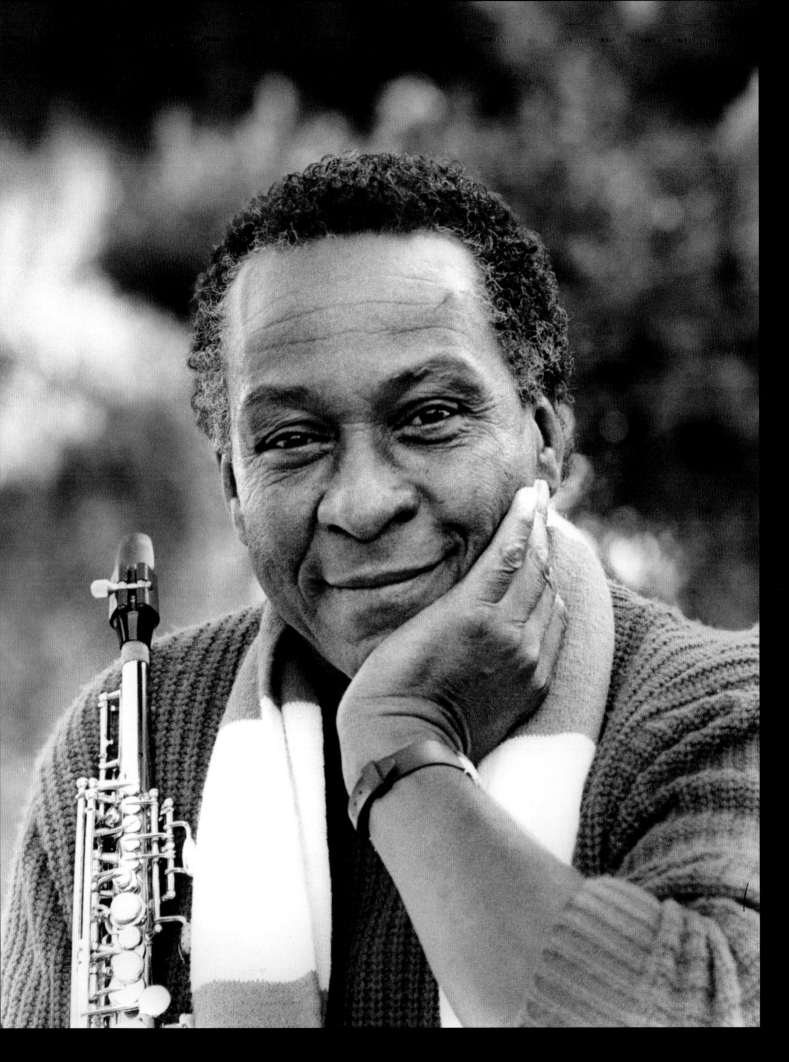

JOSEF
ZAWINUL

The Fitness Regimen

**PASADENA,
CALIFORNIA**

The best photo assignments are those where editors give you free rein to do what you think best.

That was the case in November of 1979. *Swing Journal* magazine in Japan was going to feature keyboardist Joe Zawinul in support of the much-anticipated release of the quartet's album, *Weather Report 8:30*. All they asked me to do was "... get up-close-and-personal coverage of him in comfortable surroundings."

I reached him at home and explained the details of my open-ended photo assignment. I told him we could do whatever he wanted. We agreed to meet at his residence in Pasadena.

Zawinul's spacious, Spanish-style home, with its fresh stucco exterior and red tile roof, was situated some distance away in the hills overlooking the Rose Bowl. From his entrance, looking in the opposite direction of the football stadium, loomed Mt. Wilson Observatory (5,715 feet elevation), the astronomical research facility located in the San Gabriel Mountains.

As soon as I greeted Joe at the front door, it was apparent he had already decided how he wanted to be viewed by the magazine's readers. Fashionably outfitted in full track suit attire, cap, and all-terrain running shoes, he exclaimed, "C'mon, let's head up to the observatory. I'm working out today."

After arriving near the summit, I found an area to set up. Joe told me to "... shoot whatever you want." For the next half hour or more he wound his way through the rough and tricky vertical trails, never once stopping to catch his breath or taking time out to rest. I did my best to keep him within sight, moving from one point of the mountain to another, anticipating where I thought would be the best spots to capture the fitness buff as he whizzed by.

After completing his challenging workout, we did some informal poses amidst the dramatic backdrop and then headed back down to his home.

I have to admit I was pretty well drained by this time, even though I was

several years younger than Joe and recognized that he was the one who had actually burned all the calories. But instead of relaxing or taking time out to enjoy a big lunch, Zawinul changed into some work clothes and spent the next hour sawing dead branches from trees on his property, carrying several armloads of firewood to his home, and even planting a young sapling.

During the many times I encountered Weather Report, it was entirely understandable why Joe Zawinul did not carry even a tinge of body fat. As Weather Report's co-leader, he was always the "non-stop" director, involved in every aspect of the band's activities—from staging, to set-up, to group interaction, and improvisation; even such details as interviews and photo sessions.

Joe's mind continually raced, along with his body. He was a clear trailblazer on so many fronts.

JOSEF ERICH (Joe) ZAWINUL
piano, keyboards, synthesizer, composer
Born: July 7, 1932
Died: September 11, 2007

Like a mountain goat, Joe Zawinul traverses up a long, steep grade in the San Gabriel Mountains above his home in Pasadena as part of his intense workout before continuing the run along a rock wall leading to Mt. Wilson Observatory.

As Weather Report's co-leader, he was always the "non-stop" director, involved in every aspect of the band's activities.

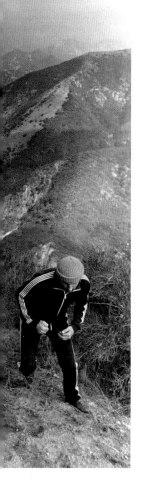

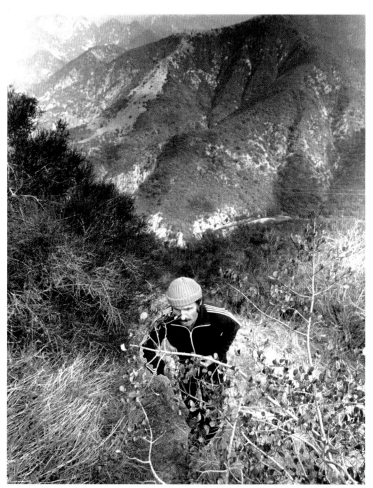

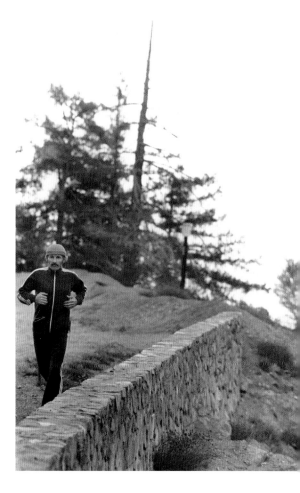

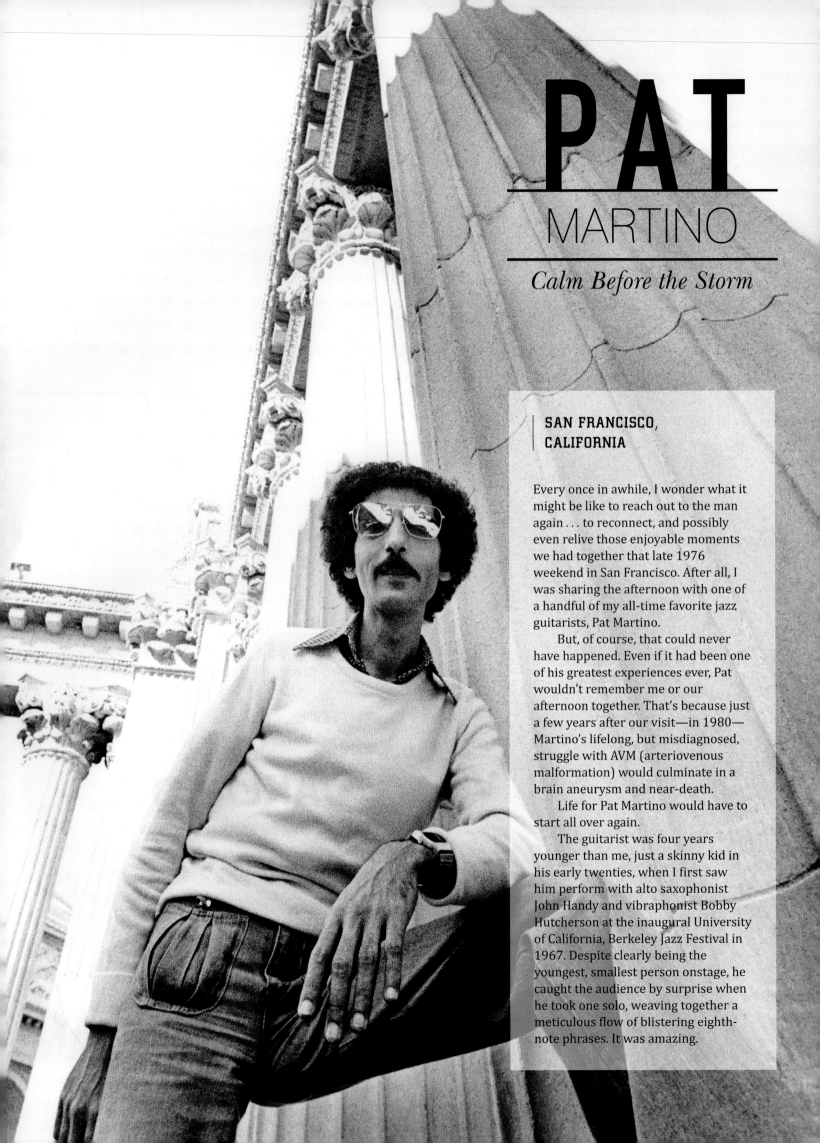

PAT
MARTINO
Calm Before the Storm

| SAN FRANCISCO,
| CALIFORNIA

Every once in awhile, I wonder what it might be like to reach out to the man again . . . to reconnect, and possibly even relive those enjoyable moments we had together that late 1976 weekend in San Francisco. After all, I was sharing the afternoon with one of a handful of my all-time favorite jazz guitarists, Pat Martino.

But, of course, that could never have happened. Even if it had been one of his greatest experiences ever, Pat wouldn't remember me or our afternoon together. That's because just a few years after our visit—in 1980—Martino's lifelong, but misdiagnosed, struggle with AVM (arteriovenous malformation) would culminate in a brain aneurysm and near-death.

Life for Pat Martino would have to start all over again.

The guitarist was four years younger than me, just a skinny kid in his early twenties, when I first saw him perform with alto saxophonist John Handy and vibraphonist Bobby Hutcherson at the inaugural University of California, Berkeley Jazz Festival in 1967. Despite clearly being the youngest, smallest person onstage, he caught the audience by surprise when he took one solo, weaving together a meticulous flow of blistering eighth-note phrases. It was amazing.

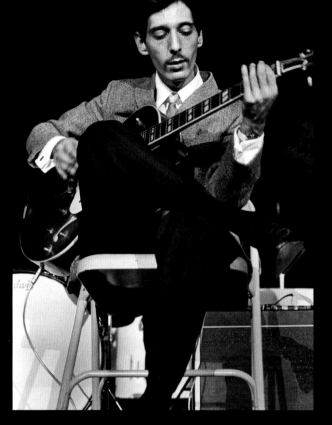

He caught the audience by surprise when he took one solo, weaving together a meticulous flow of blistering eighth-note phrases. It was amazing.

Below: Saxophonist/leader John Handy, along with Pat Martino and vibraphonist Bobby Hutcherson, were backed by drummer Doug Sides and bassist Albert Stinson at the 1967 Berkeley Jazz Festival.

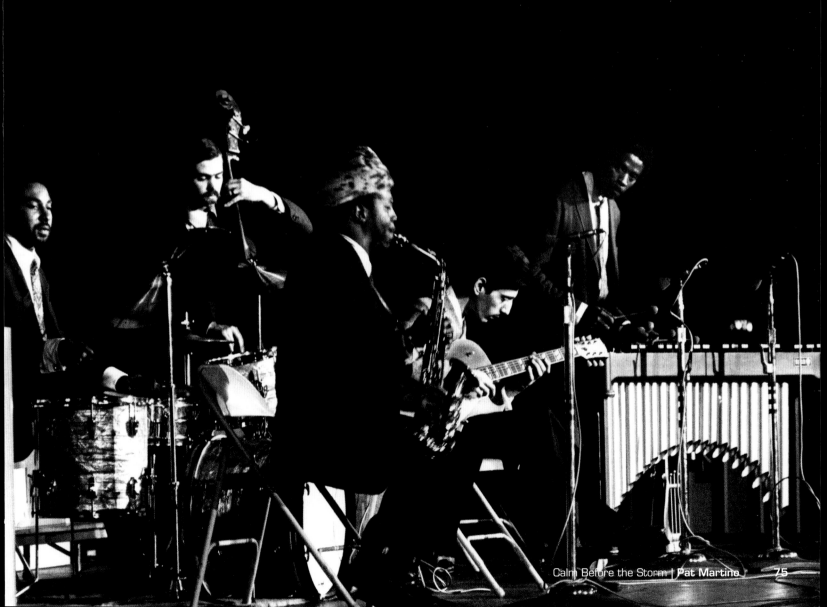

Handy recalled those times, saying, "He was a tiny guy, but he played big music. He could play his little ass off, man."

Every time I witnessed Martino's future performances, he did things that were totally surprising, even revelatory. He never disappointed.

When we met for our photo session that afternoon at the Palace of Fine Arts, Pat was joined by his newest pianist, Berklee College of Music alum Delmar Brown. The two were in the midst of an international tour promoting their Warner Brothers release, *Joyous Lake,* which would become one of the finer jazz/fusion recordings from that period. The guitarist was jovial and upbeat our whole time together. It was obvious that Pat Martino was enjoying the fruits of his ever-expanding career.

Right: Martino, practically as thin as his guitar case.

Below: Martino with his keyboardist Delmar Brown.

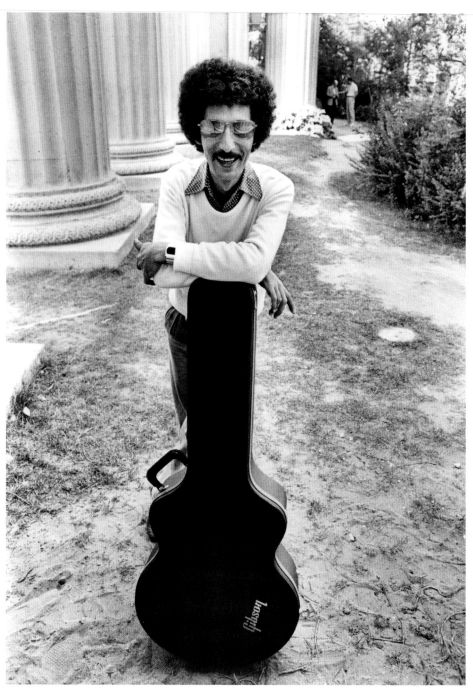

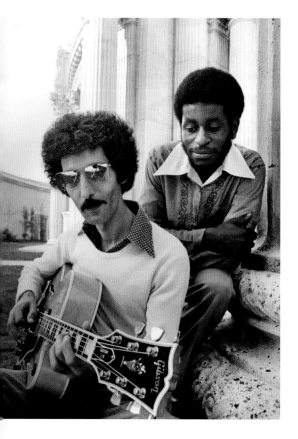

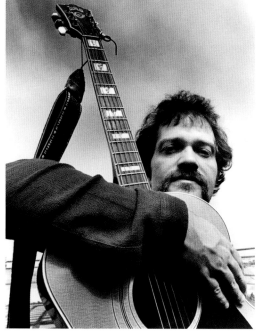

Among Martino's many peers was guitarist John Abercrombie, who offered the following testimony in Pat's autobiography about the first time he saw him performing with organist Jack McDuff: "That night, Pat came on the bandstand . . . playing a black Les Paul Custom guitar. We knew the guitar was like carrying a Buick on the stage—it was so heavy. And Pat was such a frail little guy. So when we saw this young, very thin little guy walking up to the bandstand with this heavy guitar . . . our reaction was, 'Oh, man this can't be the guitar player! Who is this?' So we were all chuckling. And then, he started to play and we ceased chuckling. Because he just floored everybody in the club. I never heard anything like that . . . it was the constant stream of eighth notes and his amazing time, his feeling that was so perfect."

Every time I witnessed Martino's future performances, he did things that were totally surprising, even revelatory. He never disappointed.

It was only many years later, following his miraculous surgery, that I learned the details of Martino's life-altering course through his revealing autobiography, *Here and Now! The Autobiography of Pat Martino.* In it, Pat chronicled how he overcame the devastating effects of memory loss, depression, anxiety, and overwhelming negativity throughout an arduous recovery period. I discovered how it took years for him to re-learn his art and re-emerge as one of today's most vibrant and inspiring performers.

It occurs to me that all of us in the jazz community have been truly blessed, given a second chance to see and hear two highly productive—and beyond talented—walking miracles: Pat Martino and Quincy Jones, who also survived a brain aneurysm and surgery in 1974. Both escaped near-death and just kept on contributing, kept on creating some of the greatest music for us all to enjoy.

PAT MARTINO (Pat Azzara)
guitar, composer
Born: August 25, 1944

DEXTER
GORDON

Reclaiming What Was Long Overdue

Gordon was blessed with an endless stream of musical ideas that helped propel him through the demanding bebop tempos.

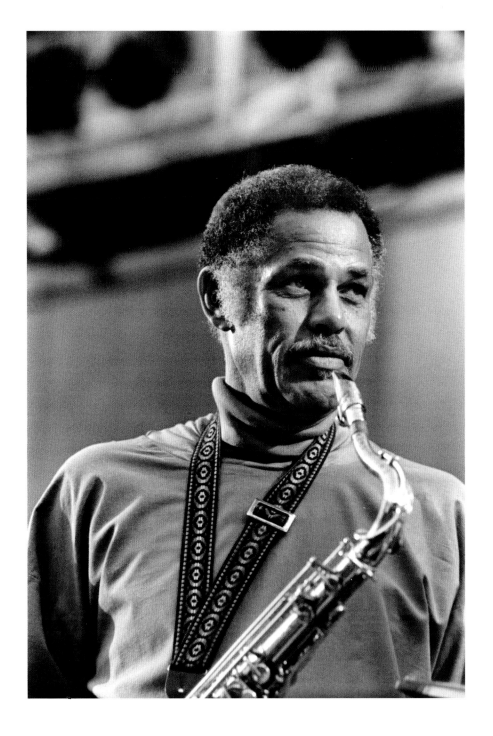

BERKELEY,
CALIFORNIA

He was many things in the jazz hierarchy: the first important bebop tenor saxophonist (the equivalent of Charlie Parker on alto saxophone and Dizzy Gillespie on trumpet); the most celebrated of its many expatriate musicians; and the only individual to receive an Academy Award nomination for Best Actor in a Leading Role.

For all of his eminence and notoriety, one would expect Dexter Gordon to be a mover and shaker, an outgoing firebrand, and always on the go. Instead, he was relaxed, laid-back, and generally unflappable.

Gordon was blessed with an endless stream of musical ideas that helped propel him through the demanding bebop tempos, and yet became easily recognized for his big sound and signature behind-the-beat playing style.

In the early 1960s, after becoming disenchanted with jazz's free movement and lack of playing opportunities, Dexter moved to Europe. Beginning in 1962, he spent the better part of fourteen years across the pond, first living in Paris and finally settling in Copenhagen.

Returning to a hero's welcome in 1976, Gordon basked in an extended period of adulation from fans beginning at the Village Vanguard in New York, and later through successful tours around the country. It was at the Berkeley Jazz Festival in May 1977—which drew esteemed admirers from many corners—that I saw the leader fronting a solid band featuring trumpeter Woody Shaw, pianist Ronnie Mathews, bassist Stafford James, and drummer Louis Hayes.

When I met with Dexter for a photo shoot in his Berkeley hotel room, he was just kicking back and enjoying the good vibes along with his sideman, Woody Shaw. Their

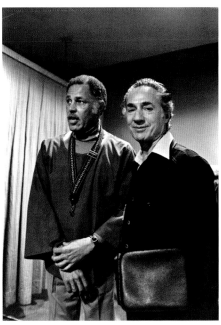

Bottom right: Among the many luminaries catching up with Dexter Gordon during his long-awaited west coast swing was Los Angeles-based critic Leonard Feather.

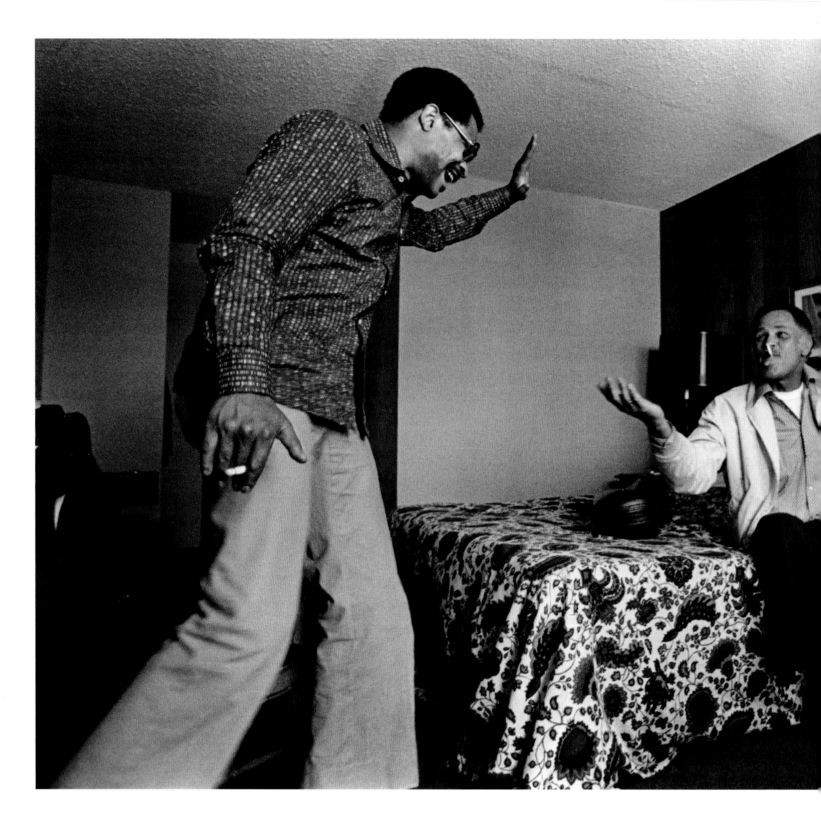

Joining Dexter Gordon in his hotel room after their performance, Woody Shaw high-fives the tenor saxophonist.

exuberant but refined blowing session turned out to be the highlight of that weekend's festival.

During our time together, the friendly and affable tenor saxophonist seemed bemused by all the outpouring of attention he was receiving after having returned stateside. It was like, "Where were all these adoring fans and huge crowds when I needed them back in the sixties?"

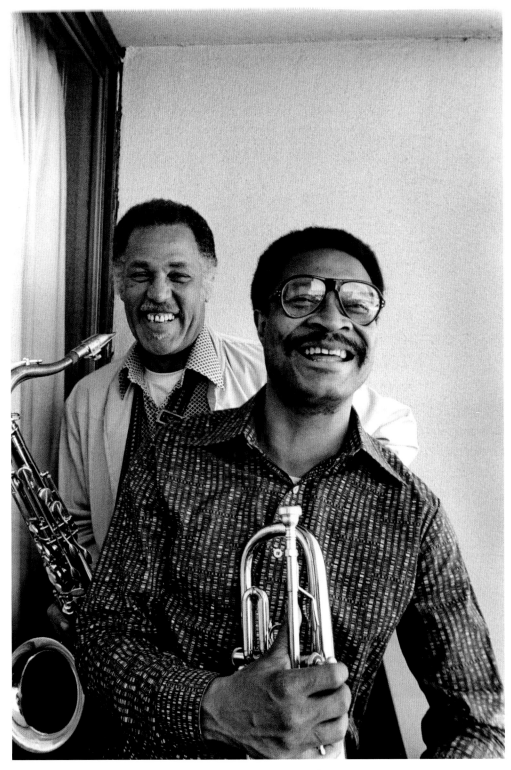

It wasn't as if Dexter Gordon had been overlooked during those many years abroad. After all, wherever the icon appeared, he was amply celebrated. But as he told me, "It's good to be back and feel the love."

After his long-overdue return to America in 1976, Gordon remained, playing to appreciative crowds wherever he went. Ten years later, the tenorman appeared as the fictional Dale Turner, an American jazz musician living in Paris, in the Bertrand Tavernier film, 'Round Midnight. The following year, he received the Oscar nomination.

The nominee did not win the Academy Award for Best Actor. But we all know that Dexter Gordon was undisputably the only contender that year—or perhaps any year—who didn't need to learn how to act his part.

DEXTER KEITH GORDON
tenor and soprano saxophones, composer
Born: February 27, 1923
Died: April 25, 1990

JOE
WILLIAMS

Some Rare Down Time

"... his perfect enunciation of the words gave the blues a new dimension. All the accents were in the right places and on the right words."

–Duke Ellington

LAS VEGAS, NEVADA

It was a late morning in August 1977, when I finally caught up with the popular, globetrotting, jazz and blues singer at his home in Las Vegas. Joe Williams had just returned the day before from his most recent junket, a multi-city tour of Japan where he had been sharing the stage with the popular vocalist Nancy Wilson.

When I arrived at his door, I was greeted by both Joe and his British-born wife, Jillean. After we introduced ourselves, Joe was quick to say, "I hope you don't mind, but this is going to be a relaxed session."

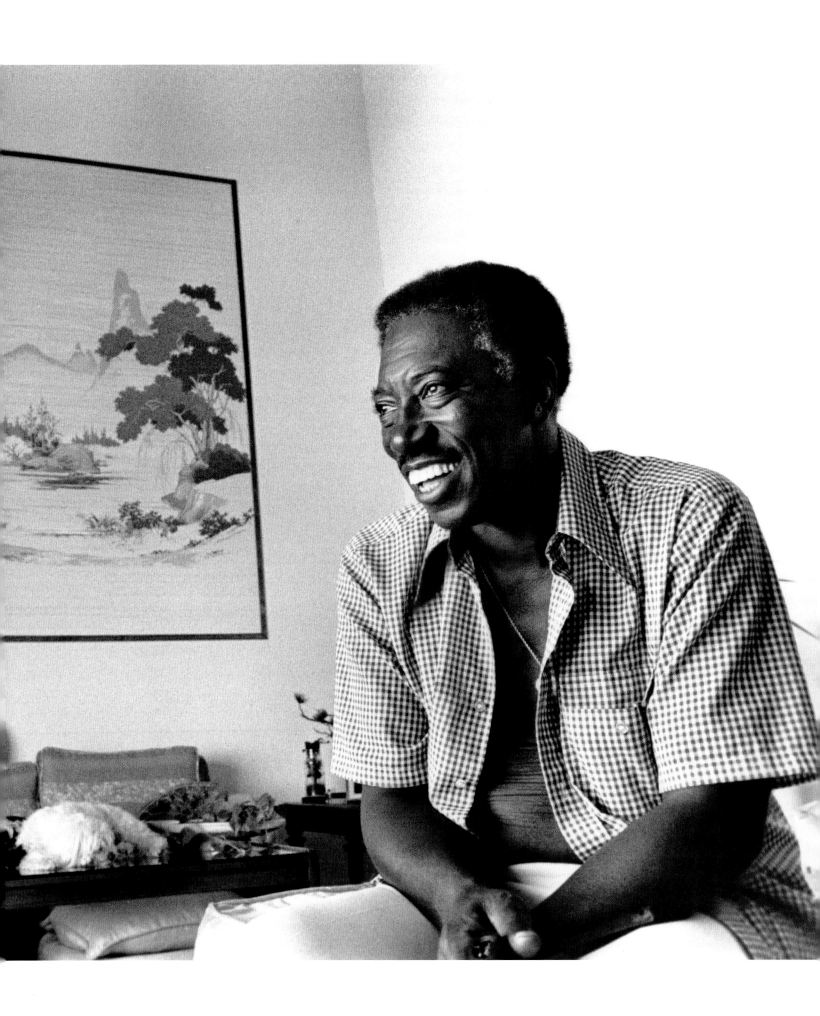

Joe poured coffee and we talked about his ever-busy but always enjoyable life on the road. He reminisced about some of his most memorable engagements over the years, particularly those involving the high-profile big bands.

Having broken in during his early days with the likes of Coleman Hawkins' and Lionel Hampton's Bands, he lit up

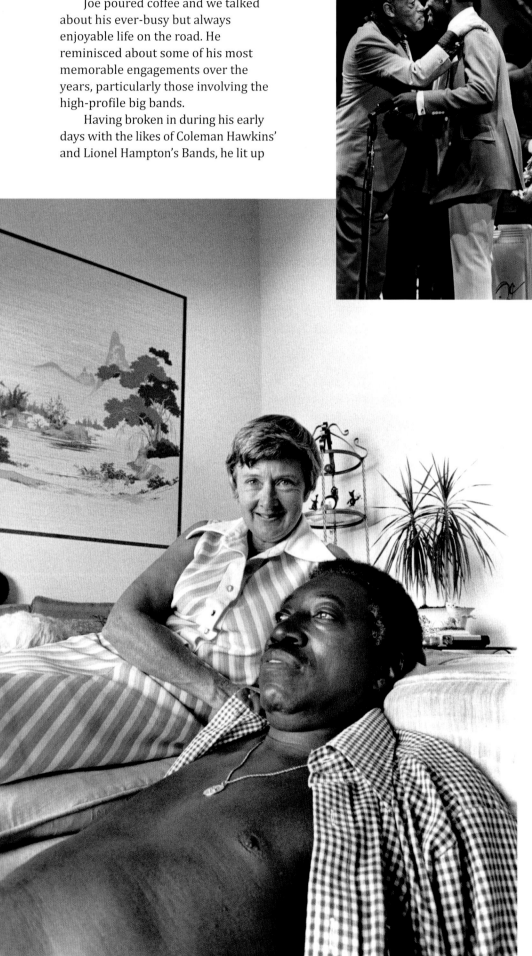

Above: Sharing the stage with the Duke Ellington Orchestra for the rousing Friday night finale to the 1970 Monterey Jazz Festival, Joe Williams receives an embrace from the Maestro as special guest/leader Woody Herman, along with happy orchestra members Paul Gonsalves, Joe Benjamin, and Harold Ashby look on.

Left: Joe with his wife Jillean, the most relaxed I'd ever seen him.

when he shared what it was like to perform with such giants of the day as Duke Ellington, Buddy Rich, Louie Bellson, the Thad Jones/Mel Lewis Band, and especially, Count Basie, with whom he worked for seven years.

It was always a most reciprocal arrangement. While he was quick to praise the great bandleaders who hired him, they too basked equally from the adoration of the crowds. The leaders understood perfectly that Joe Williams's resonant baritone and engaging stage demeanor would always be a big hit, adding much to the ensemble's overall presentation as well as the box office receipts.

Joe explained that Las Vegas was a good place to call home. It allowed him the opportunity to get in some rounds of golf ". . . so I can maintain my respectable eight handicap." On this trip, he would also get the latest news from bassist Monk Montgomery and the Las Vegas Jazz Society, as well as sit in with singer/songwriter Jon Hendricks, who was performing at the area's only jazz club, The Tender Trap.

At one point, while alternately sipping coffee and watching a baseball game on TV, Joe got up from the sofa and stretched out on the carpet. It was like a signal. His and Jillean's

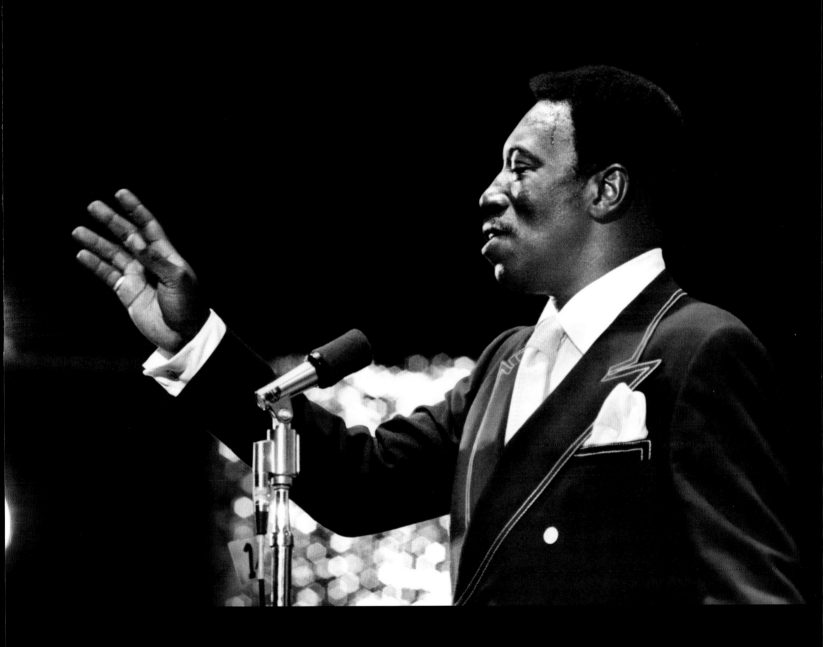

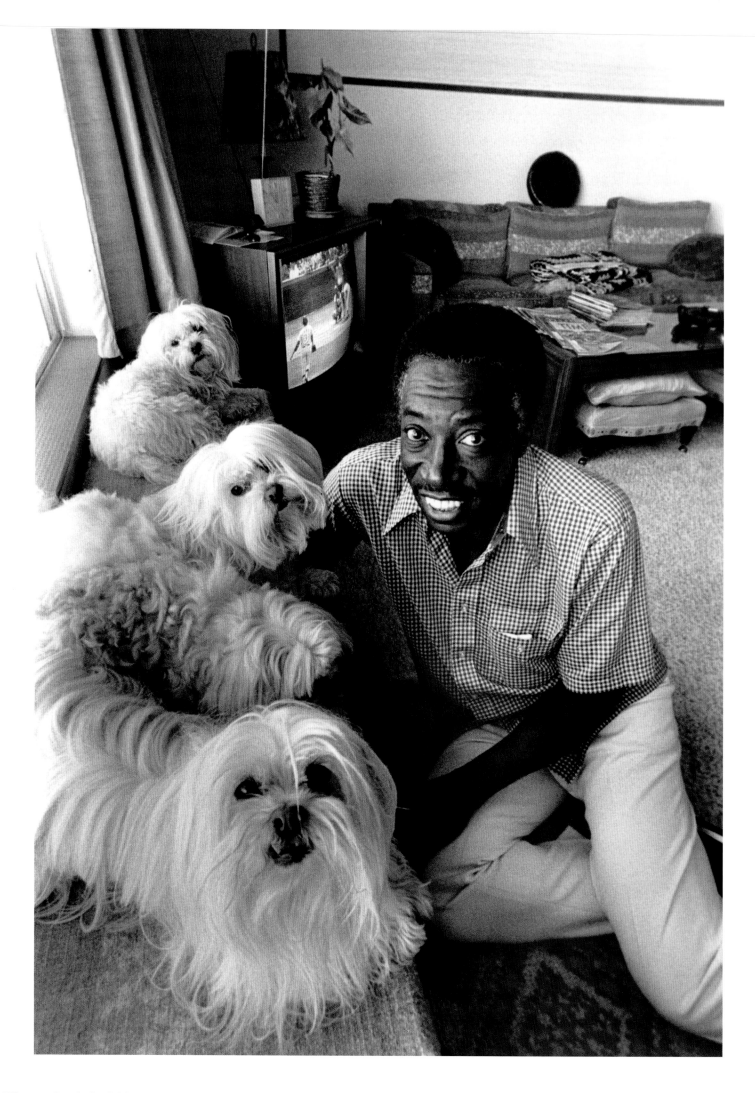

Pekingese/poodle-mix dogs Tosh, Pookie, and Roo immediately jumped down from a ledge and took turns licking his feet.

Because I knew the strong bond that existed between Joe Williams and Count Basie, near the end of our visit I brought up the bandleader's name, noting that he would be returning to the Monterey Jazz Festival stage in just a few weeks (Basie was a no-show the previous year because of a heart attack).

"My bags are already packed," Joe exclaimed. "'Base' is in great shape and I can't wait to see him."

As I was about to head out the door, I noticed an opened, hard-bound book lying on the piano bench. It was Duke Ellington's *Music Is My Mistress*. I asked Joe for a final candid of him with the book. Some time later, I read the Maestro's glowing review of the great jazz and blues artist:

". . . [Joe Williams] sang real soul blues on which his perfect enunciation of the words gave the blues a new dimension. All the accents were in the right places and on the right words."

Joe Williams truly enjoyed the best of both worlds. Even when the popularity of the big bands diminished, he stayed very much in demand, often working with his own groups or alongside such diverse headliners as Clark Terry, Cannonball Adderley, Dave Pell, and George Shearing. Steady bookings brought him to major jazz festivals, plus the name clubs and hotels across Europe, Japan, and the US. He kept busy an average of forty weeks a year.

JOE WILLIAMS (Joseph Goreed)
singer
Born: December 12, 1918
Died: March 29, 1999

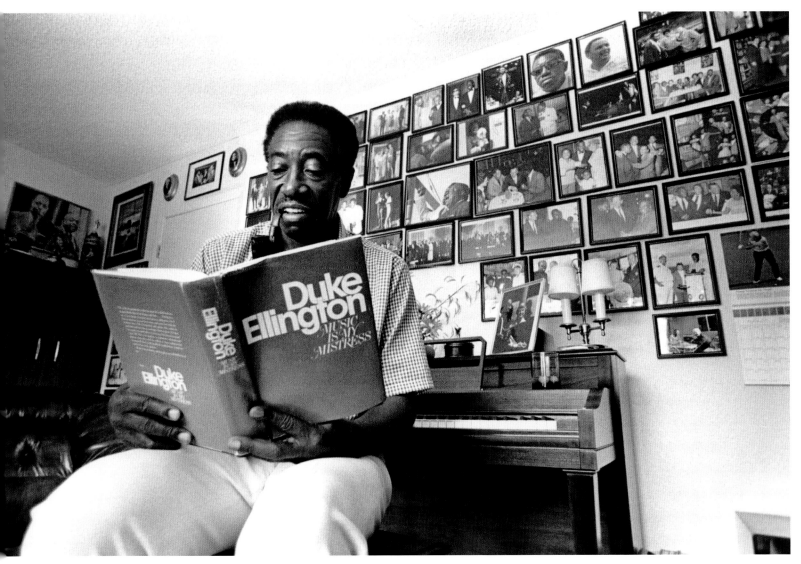

CHET
BAKER
Defying the Odds

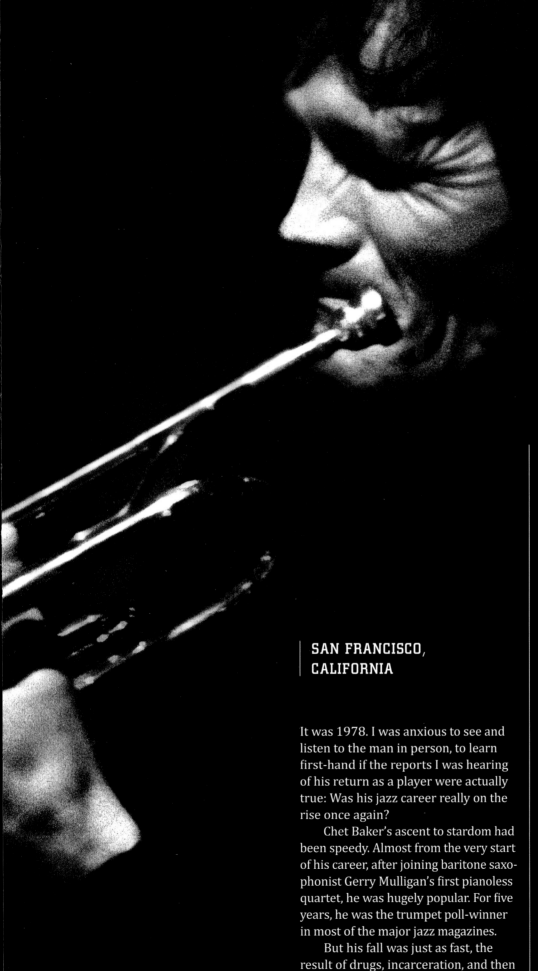

SAN FRANCISCO, CALIFORNIA

It was 1978. I was anxious to see and listen to the man in person, to learn first-hand if the reports I was hearing of his return as a player were actually true: Was his jazz career really on the rise once again?

Chet Baker's ascent to stardom had been speedy. Almost from the very start of his career, after joining baritone saxophonist Gerry Mulligan's first pianoless quartet, he was hugely popular. For five years, he was the trumpet poll-winner in most of the major jazz magazines.

But his fall was just as fast, the result of drugs, incarceration, and then the San Francisco beating. It had been ten years earlier, in this same city, that Chet Baker's already flagging career

was pronounced "finished" after sustaining a severe beating and losing most of his teeth at the hands of local drug addicts. It was almost like starting over again. The trumpeter had been fitted with a set of false teeth and was struggling through a painfully-long recovery period.

When I first heard about his upcoming date at Keystone Korner, I managed to track him down on the road and explained that I wanted to do a photo session once he was in the City. He told me where he would be staying and we set the day for our get-together.

The night before our shoot, I touched base with him at the club and then stayed to catch his opening set. Had I not known about his recent problems, I would never have guessed that Chet Baker was anything other than one of jazz's most lyrical trumpeters, totally in command of his singular talents. From what I could tell, he was clearly at the top of his game.

Late the next morning, I picked him up at his hotel and we headed over to the popular Ghirardelli Square near the Bay to take the photos. I mentioned how impressed I was hearing him in performance playing both trumpet and flügelhorn. I told him that to my ear, he sounded even purer than on any of his previous best recordings. He said he was still bothered by mouth pains and

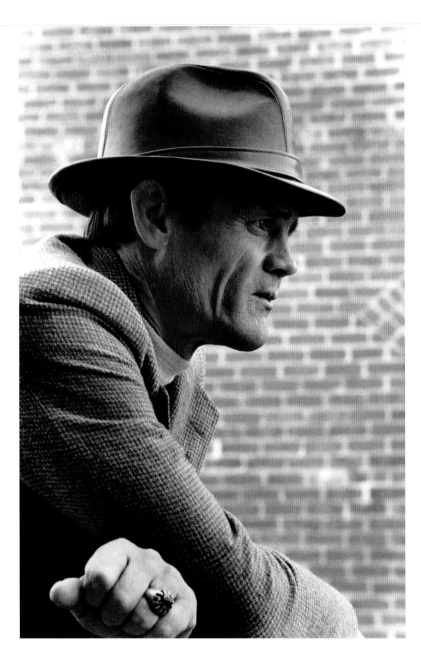

nagging embouchure problems, but agreed with my assessment.

It was perfect, our day together in the sun. Chet appeared confident in his stylish sport coat, turtleneck sweater, and leather hat, looking refreshed and invigorated. At the end of our shoot, I asked him if he thought he would be returning anytime soon. "Europe is better for me," he said simply.

I never got to see him again, but for the next decade, he would enjoy his most prolific era as a recording artist. One of my very close collaborator friends, the German critic and producer Joachim Berendt, who knew first-hand the trumpeter's many career ups and downs, remarked in the 1980 edition of his internationally-known jazz calendar, "Slowly he came back onto the scene [and] . . . something astonishing happened; Chet Baker played better than he ever had during the time of his great successes—more masculine, more mature, more sovereign."

CHESNEY (Chet) BAKER
trumpet, flügelhorn, singer
Born: December 23, 1929
Died: May 13, 1988

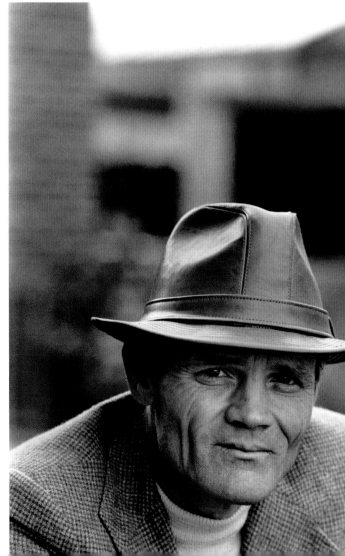

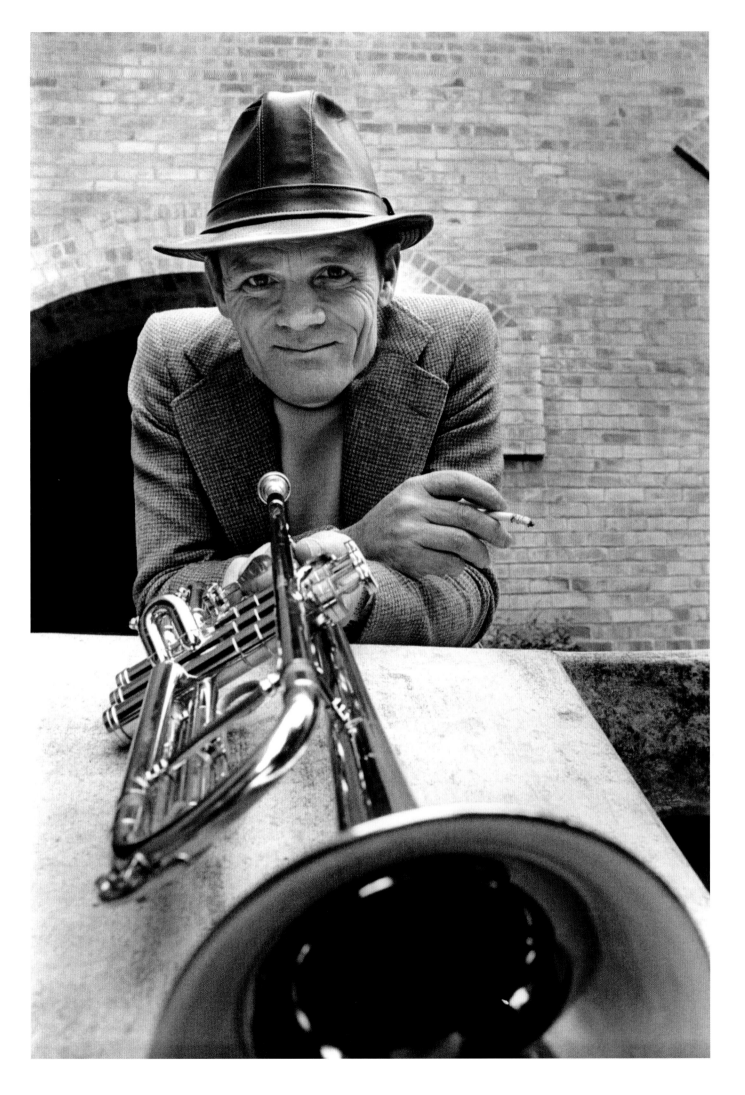

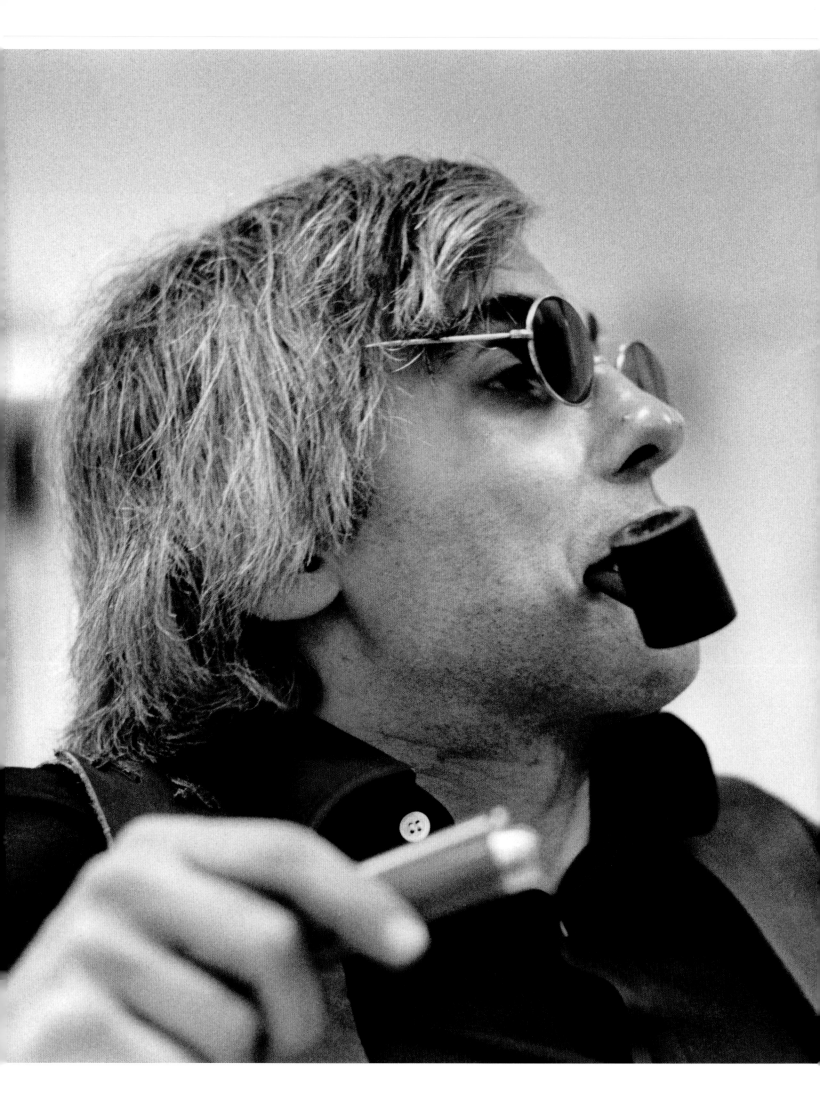

In my estimation, he was one of the most comfortable of all people in his own skin. Who else, while barely a teenager, could have hired and managed all the business affairs and payroll of his own band (which included players twice his age), and just a few years later—serving as his accompanist—had the moxie to book the unpredictable genius Charlie Parker for a concert in Montreal, even shepherding him to and from New York to ensure his safe passage?

Paul Bley, one of jazz's finest free thinkers and players—as well as the astute, yet ultimate nonconforming businessman—personified the image of the self-promoter, but without all the fanfare and grandstanding.

What originally struck me about the pianist/composer was his quiet assuredness. With an assortment of his trademark pipes, typically never out of reach, the professorial-appearing Bley impressed me with his unassuming, in-charge demeanor that naturally extended throughout his musicianship, personal dealings, and life in general.

For me, the joy of being in Paul Bley's midst was always one of anticipation. Whatever the pianist chose to

PAUL
BLEY

Expect the Unexpected

The way he communicated his thoughts was just a natural extension of how he composed and presented his unique offerings to the public.

explore on any given evening might depend on the surroundings, his mood, perhaps the electricity in the room. As a devoted fan, I never knew what was on that night's musical agenda, which was a good thing. I only knew that it would be fresh, inspiring, and fanciful: completely different from anything I'd heard the last time I'd seen him.

I also savored each opportunity to be in his company, whether at soundchecks or in the privacy of his dressing rooms. The way he communicated his thoughts was just a natural extension of how he composed and presented his unique offerings to the public. Paul Bley may have been direct and off the cuff in his comments, but after taking it all in, I kind of sat back and marveled at just how cogent, convincing, and well-reasoned they always were.

As a photographer, I looked for certain mannerisms and idiosyncrasies that strictly identified this adventuresome innovator. On occasion, Bley would create drama by reaching inside the piano, sometimes muffling the strings with one hand while striking the keys with the other. To help facilitate such moves, to the consternation of certain snobbish writers who considered it an attention-grabbing ploy, he might stack telephone directories on top of the piano bench for an easier reach.

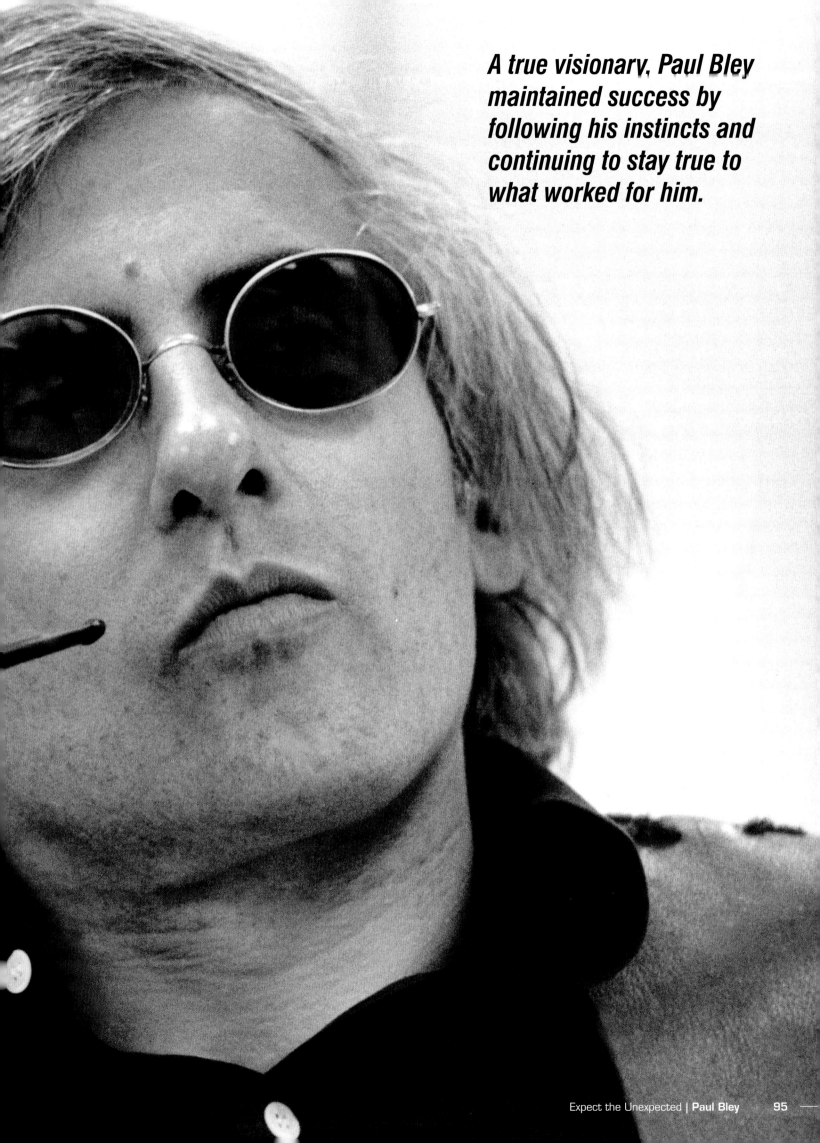

A true visionary, Paul Bley maintained success by following his instincts and continuing to stay true to what worked for him.

A true visionary, Paul Bley maintained success by following his instincts and continuing to stay true to what worked for him. For more than fifty years, he served as a direct influence on the most disparate of musicians, as well as the vibrant, ever-changing jazz scene.

As he traversed the globe performing in some of the world's most elegant halls, a new and ever-growing appreciative public arrived at the same reality that those in the know have recognized for a very long time—the sheer greatness that was Paul Bley.

PAUL BLEY

piano, synthesizer, composer
Born: November 10, 1932
Died: January 3, 2016

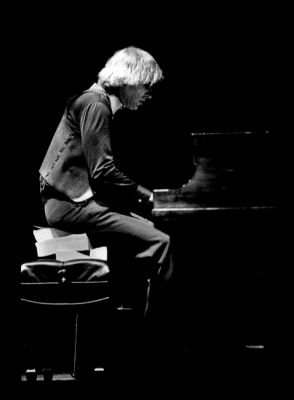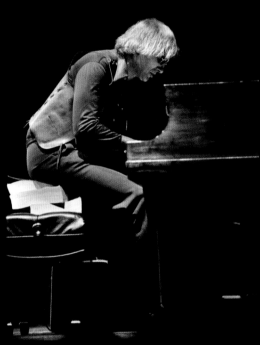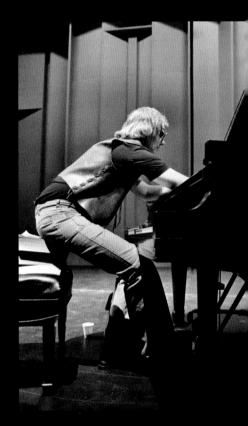

Quality Exports

In the jazz world, there's plenty of documentation detailing the number of Americans who left home to pursue their craft on distant shores. Much has been written, and at least two significant motion pictures were made depicting the lives of expatriate jazz artists: *Paris Blues*, a 1961 release featuring Louis Armstrong and the music of Duke Ellington; and *'Round Midnight*, a 1987 production set in 1959 Paris that closely mirrored the tragic life of pianist Bud Powell, played by tenor saxophonist Dexter Gordon.

Besides Powell and Gordon, other superb jazz musicians—including Kenny Clarke, Ben Webster, Art Taylor, Kenny Drew, Don Byas, Ernie Wilkins, Sahib Shihab, Johnny Griffin, Horace Parlan, Benny Bailey, Richard Boone, Jimmy Woode, Tony Scott, Archie Shepp, and Steve Lacy—all chose Europe as their homes. Some of the reasons given: Europeans were more appreciative, steady work was more readily available, and unlike in the United States, the people were pretty much color-blind.

Commenting in the Foreword pages of Leonard Feather's *The Encyclopedia of Jazz in the Sixties*, pianist John Lewis wrote, "We should learn to think internationally. A watchful eye should be kept on the European scene, where the opportunities for development seem to be better. There are radio station house bands in all European countries, which give the musicians not only financial security, but also the opportunity to play different kinds of music."

I had long admired, and was particularly interested in, two of these jazz expatriates who had chosen Europe for their primary residences beginning in the late-1960s— trumpeter and flügelhornist Art Farmer, and pianist Mal Waldron. Having closely followed their works and careers, I was always looking for opportunities to catch them while on tour.

For quite some time, I had thought about doing special photo reports of the two artists in their home countries of Austria and Germany. When I learned that both Art and Mal would be performing in San Francisco at separate times in 1978, I decided to plant the seed.

During their Bay Area engagements, I made arrangements to do private photo shoots with each of the artists. Afterwards, I told them I might be able to land a magazine assignment featuring them in the comfort of their European homes, and asked if they would be interested in such coverage. Both agreed on the plan and said we should stay in contact.

We kept in touch off-and-on during the months that followed. When I earned a photo assignment to cover the 1983 North Sea Jazz Festival at The Hague in the Netherlands, I reconnected with both Art and Mal to see if they would be home during that part of the summer. Both artists checked and found openings in their schedules. After the festival, I made arrangements to drive to Vienna and later, to Munich, to photograph them on their home turfs.

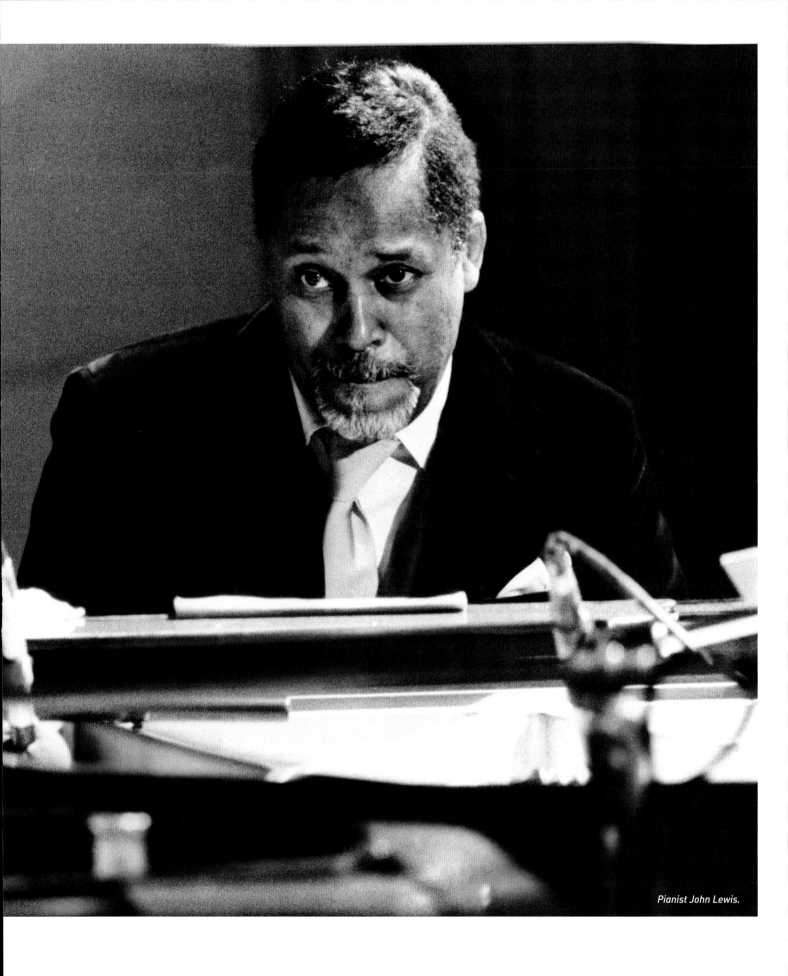

Pianist John Lewis.

ART
FARMER

*Quality Exports
(Take 1)*

**VIENNA,
AUSTRIA**

I had been taken with Art Farmer from the time I first heard him in 1959, with baritone saxophonist Gerry Mulligan's quartet, and then as co-leader of The Jazztet alongside tenor saxophonist Benny Golson.

He wasn't flashy or flamboyant. But to me—as a former cornet player myself—Farmer always stood out in any musical group because of his pure, melodiously-constructed solos all projected with a seemingly buttery tone. His performances consistently attained the kind of quality that I could only dream about.

Bassist Sam Jones once remarked, "Art Farmer is one of the most lyrical trumpet players in the world. I mean he really knows how to play a melody with feeling."

It was only after spending some time with Art at his home in Vienna that I began to understand the far-reaching impact he had made following a series of tours across Europe on the heels of his early recording successes. What I learned was that his stature here in 1983 was complete: not only did he enjoy a strong bond among fans and concert-goers, but along the way had won the respect and admiration from every type of musician imaginable.

Soon after his initial European tours, Farmer discovered there was a much wider audience for his particular sound. In 1968, he was invited to

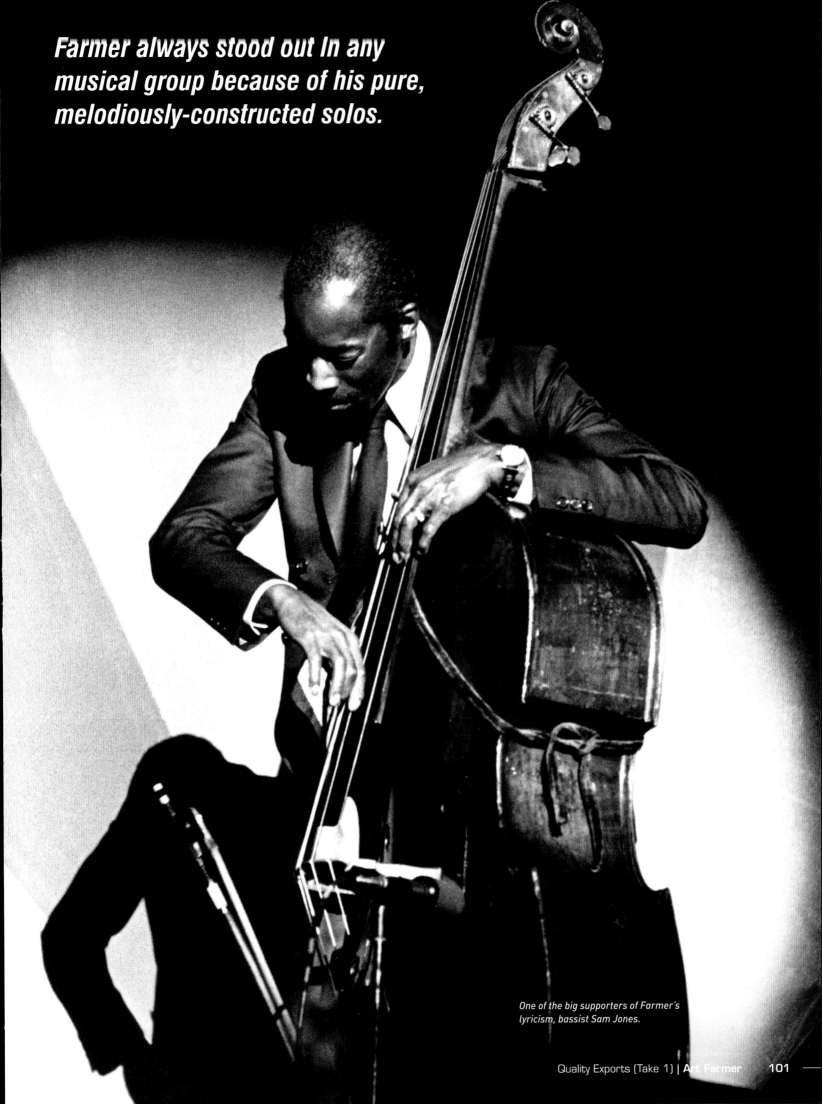

Farmer always stood out in any musical group because of his pure, melodiously-constructed solos.

One of the big supporters of Farmer's lyricism, bassist Sam Jones.

join the Austrian Radio Orchestra, based in Vienna. For the job, he was assured ten days of work each month, nine months out of the year. Later, he would even be featured as guest soloist with various orchestras, including the Austrian-Hungarian Haydn Philharmonic Orchestra.

On the strength of that contract, Art was convinced that his unique brand would provide plenty of work on the continent. He decided that Vienna would become his home base.

Once established, Farmer found out pretty quickly that, as he told me, "Word travels." Soon he had assembled a group of quality jazz musicians and began filling in his open calendar dates. Three or four times a year the Art Farmer Quintet would tour France, Germany, Italy, Switzerland, Liechtenstein, as well as the rest of Austria. When it was time to leave for recording dates and tours of the US and Japan, his sidemen returned to their other musical activities. For example, Art's fine pianist at the time, Fritz Pauer, served as director of the Swiss Jazz School in Bern, Switzerland.

I met Art, his wife Mechtilde—who worked as a local banker—and their

eleven-year-old son Georg in their home at 40 Durwaringstrasse, a delightful place on a long cul-de-sac near the Vienna Woods.

It became quickly understandable why the Farmers decided to call Vienna "home." Mechtilde's mother, two brothers, sister, two nieces, and three nephews all resided there. Art, who enjoyed a certain degree of notoriety and recognition among the citizenry, also found the grandeur and

Old World charm of the Austrian capital to his liking.

During our visit, Art showed me around his home, a retreat perfectly suited for someone of his creative talents. He had two favorite rooms— one for serious business, the other for relaxation and unwinding.

Whenever he had a break in his schedule and returned home, Art kept his chops in shape by following a set regimen of "heavy-duty workouts,"

Once established, Farmer found out pretty quickly that, as he told me, "Word travels."

Right: The "AF Brand" was in high regard throughout Europe.

Opposite: Art Farmer joins his wife Mechtilde and son Georg for a pose together in the backyard of their Vienna home.

practicing for long hours in his specially designed basement room. Farmer's soundproof music den was actually a room constructed within the confines of another original space. Specially-fitted acoustic windows permitted natural lighting, and all the walls and ceiling were finished in thick foam padding. A separate telephone ringing attachment was installed to alert him when there was an important incoming call.

When it was time to just settle back and take it easy, Art would inevitably retreat to his European sauna room constructed by the well-known German manufacturer, Klafs.

Above: The personalized door leading to Art Farmer's basement practice room included artist badges and other memorabilia he had accumulated from different venues.

Opposite: A wide angle view reveals Art practicing in his secluded soundproof den.

When I asked about booking local club gigs during his trips home, Art had a quick answer. "It's the same problem wherever you live," he told me. "If you make yourself available too frequently for concerts and club dates in your own home town—no matter how popular and established you are—pretty soon the audiences wear away to nothing. The people figure, 'Why should I pay to see him? I can catch that act anytime.'"

While we were still at his home, I photographed Art tending to his mini-garden in the backyard, playing roughly with his Hungarian sheep dog, Aszu, and instructing son Georg on the piano. Afterwards, we all went out for an ice cream treat and a walk through Vienna's City Park.

Before wrapping up, Art grabbed hold of me and we headed off to a busier area of the grounds.

I had no idea where he was taking me as we walked through an area filled with visitors and vacationers. All of a sudden he stopped, unpacked his horn, strolled up a hill, and climbed onto the base of a statue to pose next to the famous composer, Johann Strauss II.

Every once in awhile, thinking back on that day, I have this crazy scenario in which Johann Strauss is transported forward to the present, joining forces with Art Farmer. Can you imagine how terrific those waltzes would sound?

ARTHUR STEWART (Art) FARMER
flügelhorn, trumpet, composer
Born: August 21, 1928
Died: October 4, 1999

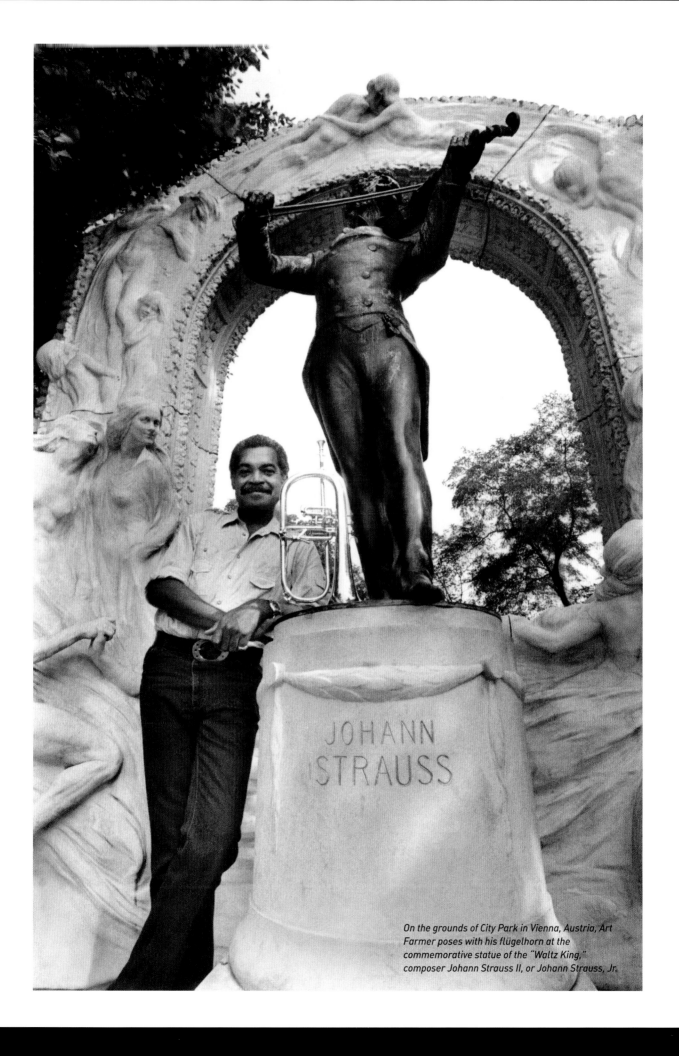

On the grounds of City Park in Vienna, Austria, Art Farmer poses with his flügelhorn at the commemorative statue of the "Waltz King," composer Johann Strauss II, or Johann Strauss, Jr.

MAL
WALDRON

Quality Exports
(Take 2)

Easily one of the most intriguing artists I ever met was Mal Waldron. During our first get-togethers in San Francisco and later, New York, the soft-spoken pianist always appeared so calm and at ease.

It was only after visiting with Mal in his Munich third-floor apartment at Nietzschestrasse 26 that I realized his life was not at all as it appeared. Here was the true jazz world Renaissance Man: tireless, ever on the go, and always in search of fulfilling his next intellectual conquest, of which there were many.

Mal Waldron personified the image of the inveterate international jazz figure, one constantly on the move across the globe doing festivals, club dates, and recording sessions. On the day of our meeting, he had just returned "home" from a date in London, but in less than twenty-four hours, would again be out the door and en route by train to Paris to perform at a new club, Le Paname.

Looking back on that summer day, I consider myself lucky to have interacted with him.

Mal Waldron, in a playful mood, strikes a pose before heading out to another engagement as part of his busy schedule.

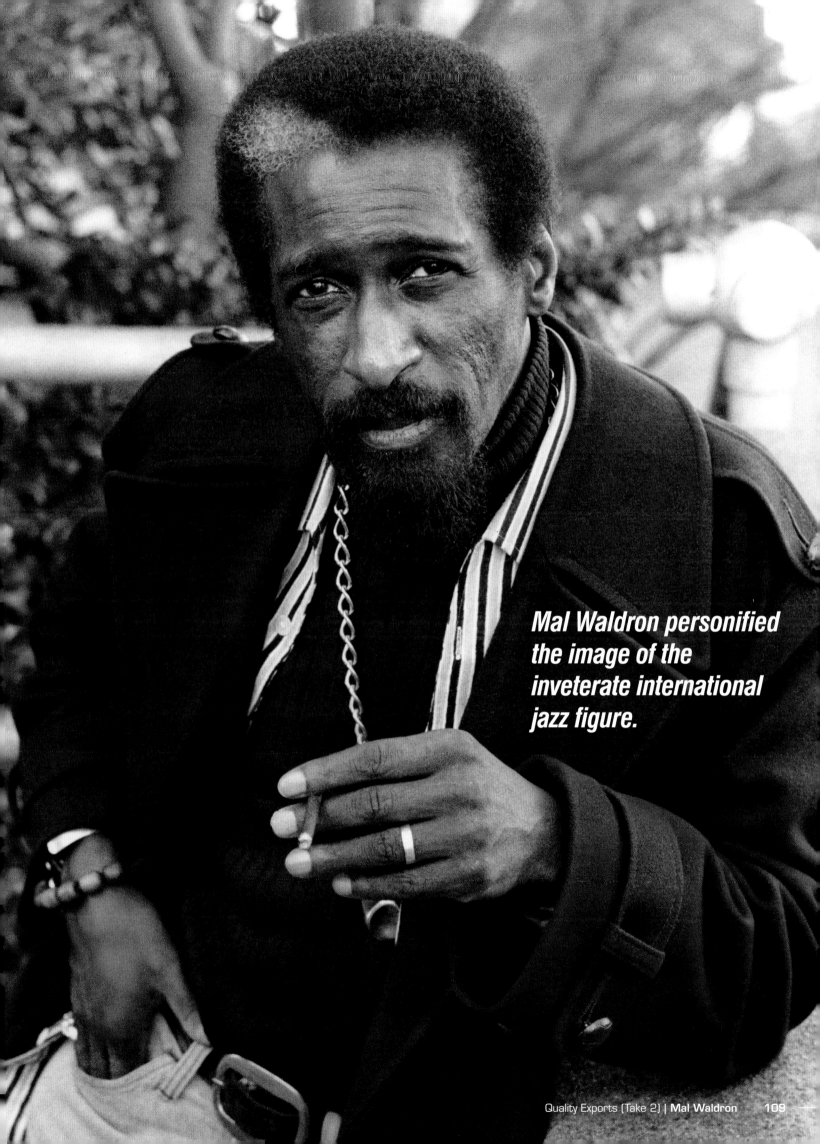

Mal Waldron personified the image of the inveterate international jazz figure.

If the music was new, exciting, and challenging, he was all in.

A voracious reader who was conversant in five languages, Waldron made his initial trek to Europe in 1965, first residing in Paris, next Italy, then a brief stay in Holland, followed by several cities in Germany before settling in Munich. By the time co-founders Matthias Winckelmann and Horst Weber launched Enja Records in 1971—selecting Mal Waldron for their first pressing—the expatriate pianist had already laid claim as that city's modern music idol.

As a player and composer, his goal line was purposely never in plain sight. Classically trained, Waldron listened early to Bud Powell and Thelonious Monk, but throughout his career thrived as an innovator in virtually every musical style. If the music was new, exciting, and challenging, he was all in.

Waldron was committed to sharing his very special artistry with any and all who were interested in the experience. The ultimate testimony to this drive and devotion was made crystal clear when Mal described to me one of his most personally satisfying tours of Japan during which he played eighty-six concerts in ninety days, even reaching out to perform before audiences in small towns and fishing villages. It was no wonder his enduring base of Japanese fans held Mal Waldron in such high esteem.

Not surprisingly, Mal's extended musical outreach to his many fans was always repaid in the form of personal, from-the-heart gifts and rewards. Displayed around his living room, for example—amidst stacks of books, record albums, and other media—was a variety of art pieces, wood carvings, photographs, and other mementos from dedicated followers of his music.

Some of his other personal gifts were substantial. In 1967, Waldron was presented with a brass sculpture from the Dutch artist, Jan Schoonhoven, while performing at a jazz club in Delft, The Netherlands. The piece was awarded to Mal for being "Best Jazz Artist of the Year" in Holland. Similarly, in November of 1970, he was presented with a marble statue on behalf of the people of Sondrio, Italy.

Besides his insatiable reading, composing, touring, and performing, Mal was also recognized as a chess master. The day of our visit, he had two separate games going with himself: a standard board set situated on his balcony and another electronic version in the living room.

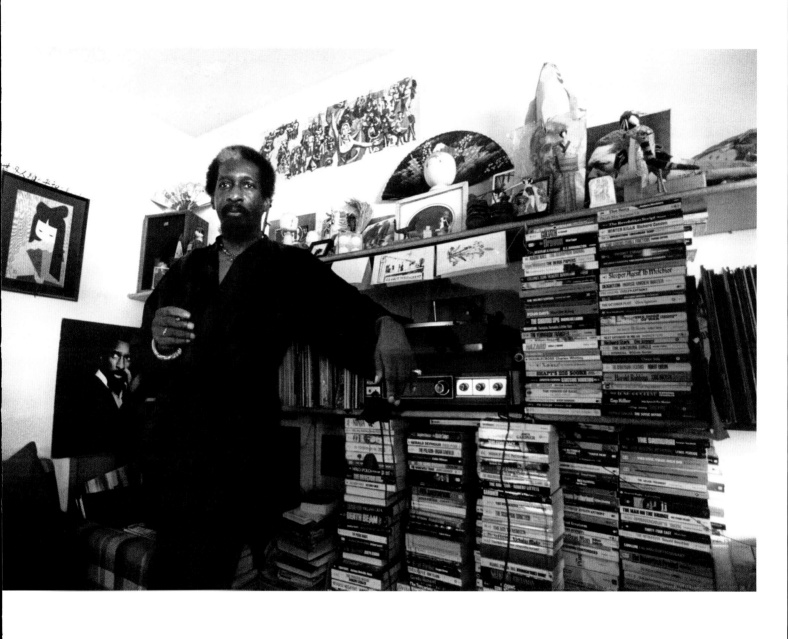

Regarding southern Germany's competition at that time, Mal told me, "Only one person (who he described as the Baron of Münchhof), can beat me regularly, and playing chess is all the man does."

Toward the end of our visit, which at the time seemed to be coming to a close almost before we had even gotten started, I was checking out and photographing an assortment of the pianist's memorabilia mounted on his living room walls. I stopped to study a baby picture of Mal Waldron in the buff.

When he saw me checking it out, he said, "Go ahead, you should shoot it. You never know, someone might want to publish that one day."

MALCOMB EARL (Mal) WALDRON
piano, composer
Born: August 16, 1925
Died: December 2, 2002

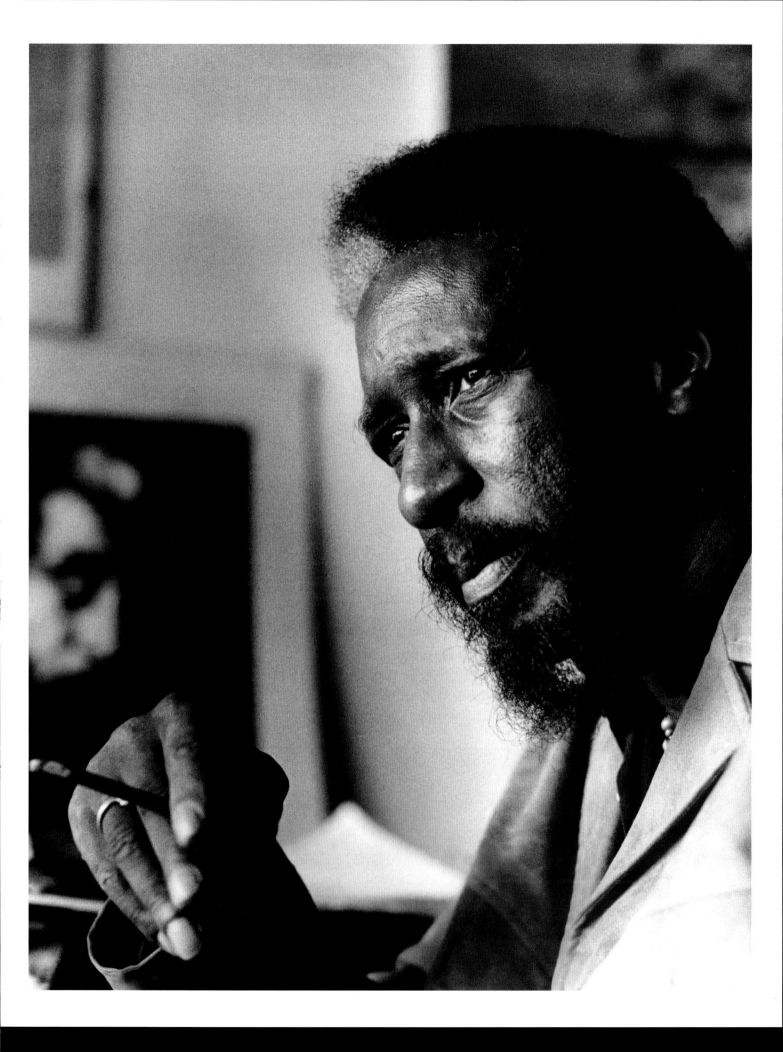

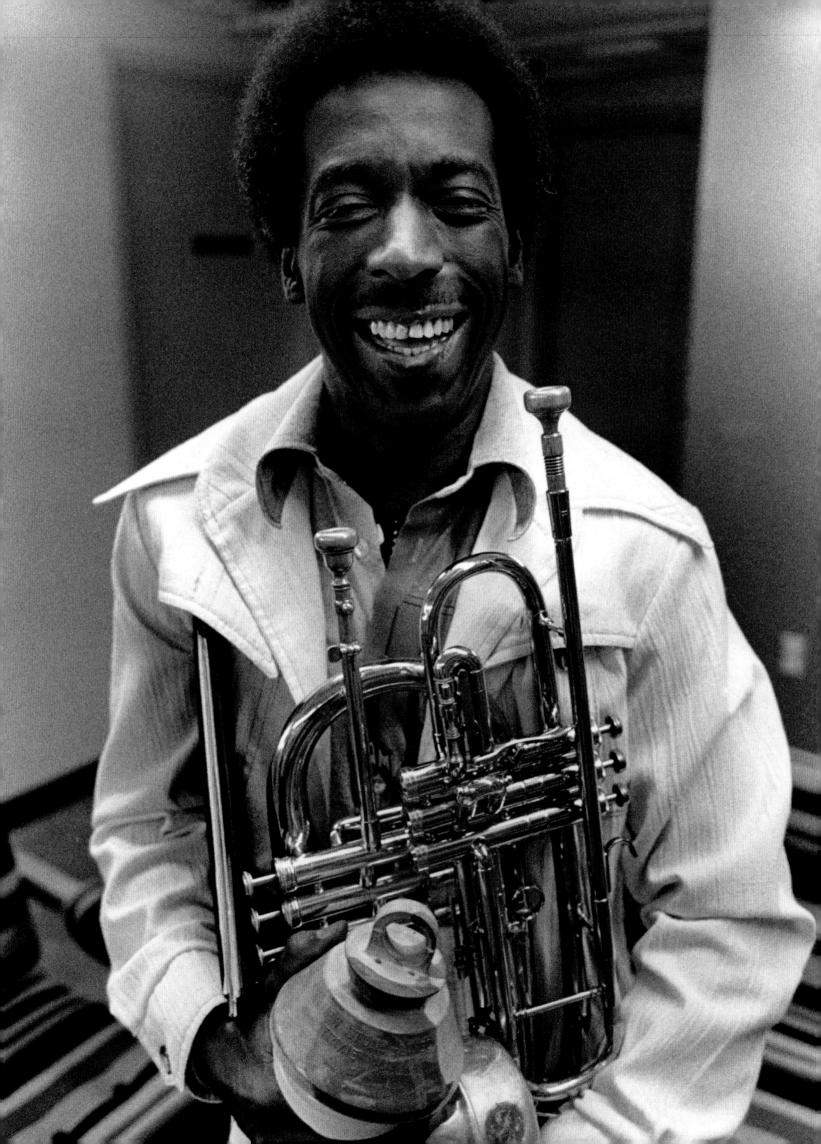

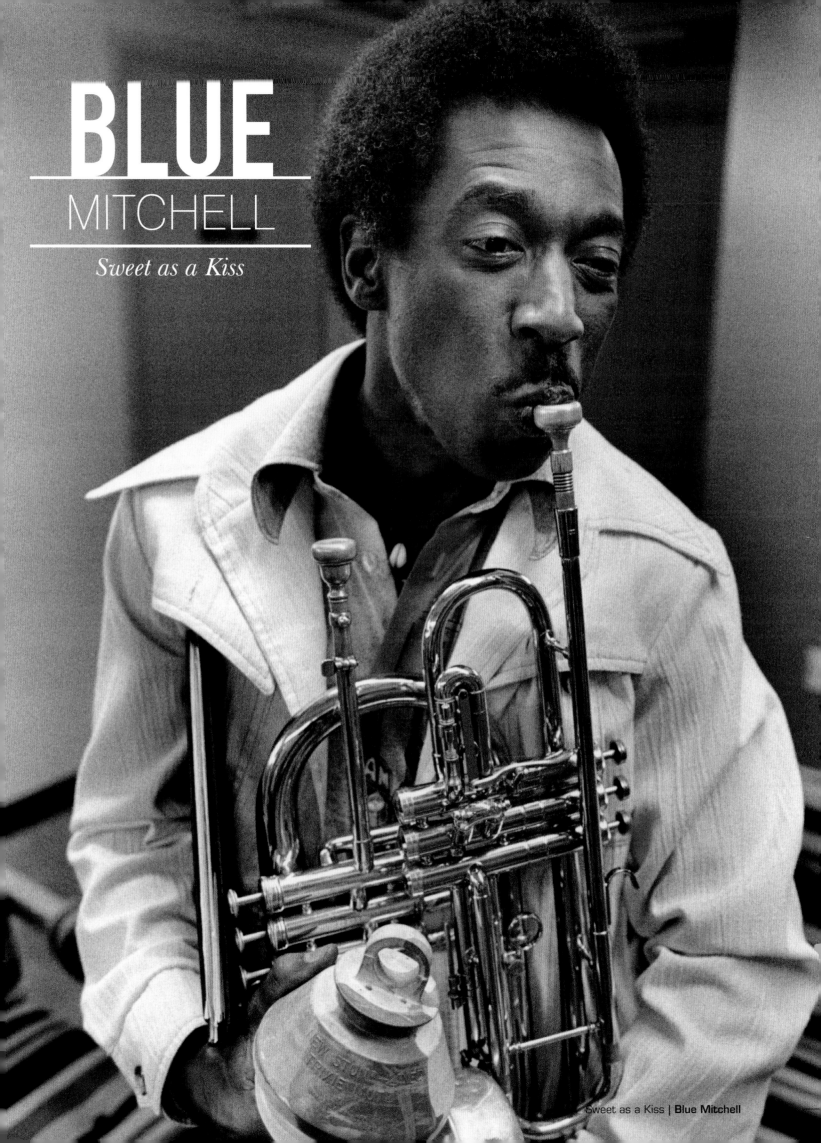

BLUE
MITCHELL
Sweet as a Kiss

The first time I saw him in person was in 1967. The pianist was backstage at the inaugural University of California-Berkeley Jazz Festival, waiting to be called onstage, where he would join the rest of his high-energy quintet. There, standing alone with a cup of coffee, the mild-appearing, practically shy man was neatly and conservatively dressed in a matching black suit and tie.

Was this really who I thought it was—the extrovert, hard-charging leader of those tight-knit, pulse-pounding musicians that I'd been grooving to for the past decade? The leader of the same guys whose earthy, funky sounds inspired everyone wherever they went?

Horace Silver turned and smiled.

During the previous decade, especially after hearing his most popular unit performing on the albums *Blowin' The Blues Away* and *Doin' The Thing*, from the late 1950s and early 1960s, featuring trumpeter Blue Mitchell and tenor saxophonist Junior Cook, I had become a huge fan. The prolific Silver, with his seemingly endless book of the most catchy and compelling tunes, along with his own essentially simple, straight-ahead percussive piano play, had the exact recipe that ensured genuine excitement from every audience.

In his book *Let's Get to the Nitty Gritty,* Silver wrote about that wildly-successful six-year period. "The Blue Mitchell, Junior Cook, Gene Taylor, Louis Hayes/Roy Brooks band was one of the best bands I ever had. We made a lot of great recordings together and made a lot of people happy through our music."

My introduction to their infectious hard bop sounds occurred long before I ever owned a camera. And being a former brass player myself, I was captivated every time I heard Blue Mitchell in performance. I loved his distinctively rich, mellifluous tone that stood out, whether he was soloing on a fast-paced, uptempo number or simply playing some moody blues. But by the time I began shooting professionally, he had already left the

quintet and begun recording as a leader of his own groups.

During that same period, I would keep track of Blue Mitchell, but for a variety of reasons, was never able to catch up with him in person. First, I noticed that he had linked up for a period with the soul-inspired Ray Charles Orchestra. After that, he had joined the blues/fusion band of John Mayall, and from there had become part of the jazz/rock craze with pianist Chick Corea.

In the early summer of 1976, while covering the Juan-les-Pins Festival on the French Riviera, I caught up with Horace Silver once again on a stroll of downtown Antibes. We shared some small talk, spoke a little about our previous interactions over the years, and discussed what plans he had on tap for the rest of his European tour. I remember saying that I had "grown up" with his great quintet nearly two decades earlier when he had one of my favorite players, Blue Mitchell, in the band.

Above: Silver catching a break in Antibes, France.

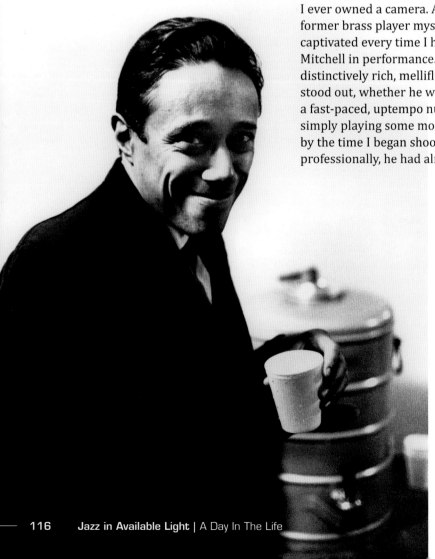

Left: A most-reserved Horace Silver—the exact opposite of what I expected.

August of that same year became the summer of my contentment, because I finally made contact with Blue Mitchell at the Concord Summer Festival. He was set to co-lead a quintet that night with Harold Land, a most solid and dependable hard bop tenor saxophonist who was a key cog in the legendary Clifford Brown–Max Roach Quintet of the 1950s.

It was a most fitting and eventful time, a time for reminiscing. I told him how I grew up with bands like those of his former boss—Horace Silver's Quintet—and how much I focused on

Left: As leader, Horace Silver visually personified the pulsating drive that was synonymous with his hard-charging quintets.

Below: During an exchange with tenor saxophonist Harold Land, a fleet-fingered Blue Mitchell solos on a furiously-paced cooker.

his superlative playing during his years with the pianist.

That night, the two bop-inspired leaders, backed by an all-star rhythm section from Los Angeles, put on a show that rekindled some of the same kind of memories that had stuck in my head from listening to Blue's playing fifteen years earlier. His solos—just as before—were crisp, clean, and captivating.

The band was polished and smooth; everyone was on his game. Then came the highlight of the evening for me, that personal confirmation. It was during a tender ballad, with the pace slowed down and the lights turned down low.

Along came Blue Mitchell's solo, so clear and pure . . . just as sweet as a kiss.

RICHARD ALLEN (Blue) MITCHELL
trumpet, flügelhorn, composer
Born: March 13, 1930
Died: May 21, 1979

CARLA BLEY

The Mechanical Music Arcade

When interacting with particularly gifted people, I discovered early on that it was always best to just remain loose—be prepared for the unpredictable.

It was early in 1979 that I learned Carla Bley would be making her first visit home to the Bay Area in fifteen years. After tracking down the brilliant composer and explaining what I wanted to do, she set the time, date, and location for our meeting. Before hanging up, all she said was, "Meet me at the Cliff House . . . at the Musée Mecanique arcade."

I had no idea why we would meet at a music arcade. But it turned out that this little playground jewel of Carla's was the genesis of her most recent album, completed just the previous November, entitled *Musique Mecanique, The Carla Bley Band*. A later review of *Musique Mecanique* read, "The three-part title piece of the album evokes, in glorious musical portraiture, the marvelous inner workings of mechanical music boxes."

Arriving that day at the Cliff House, I found my way down the steps and around the back, which faced the ocean. At this odd spot was the arcade, a series of glass-enclosed window boxes containing all sorts of mechanical musical contraptions and scores of metallic, moving figures. People would deposit their quarters and the musical machines came to life.

The random displays, featuring one box after another, included the likes of "The Unbelievable Mechanical Farm," complete with sounds of moving windmills, tractors, and farm animals; the "Laughing Sal" mannequin; "The Corn Cob Gulch Festival and Volunteer Fire Department;" the "Dueling Buffaloes;" and the "Marionettes, Puppet, and Monkey Band."

Again, I wondered what we were doing here as I watched kids running around playing with the enigmatic machines; and then Carla Bley appeared along with her then-husband and trumpeter Michael Mantler.

Just like the kids, she sprung to life; it was obvious that this place held

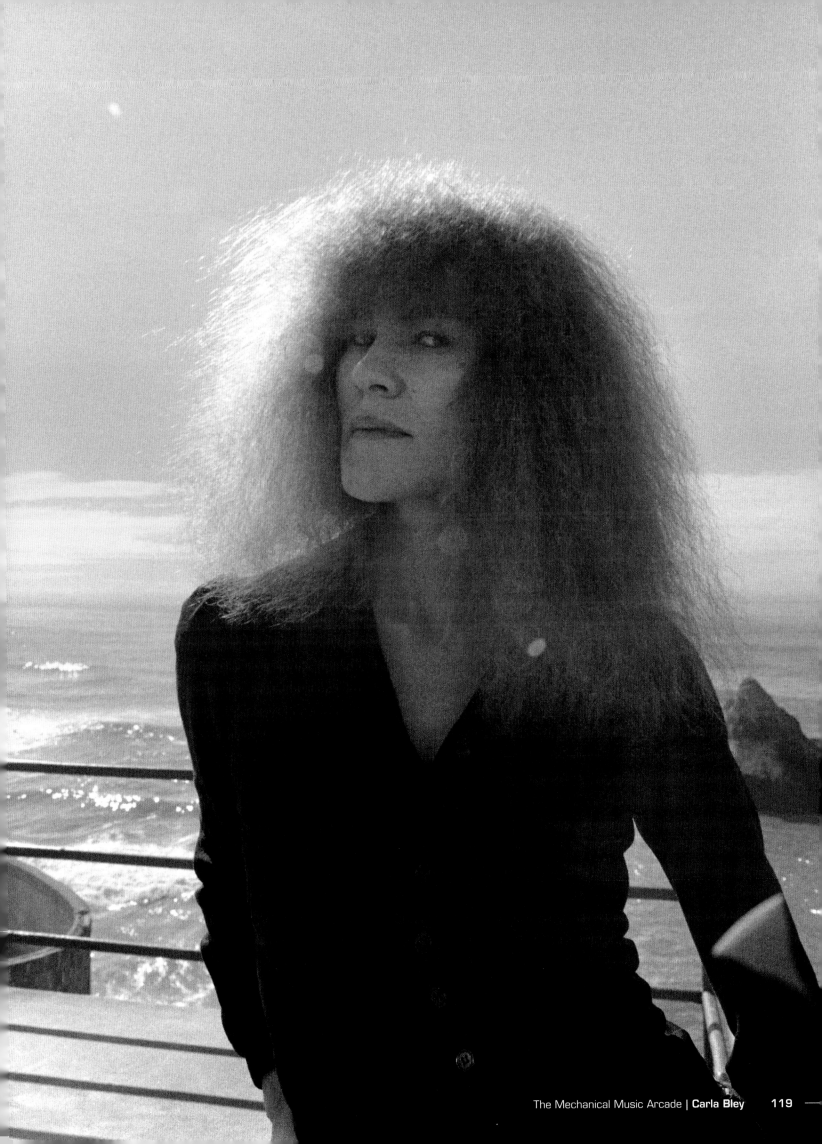

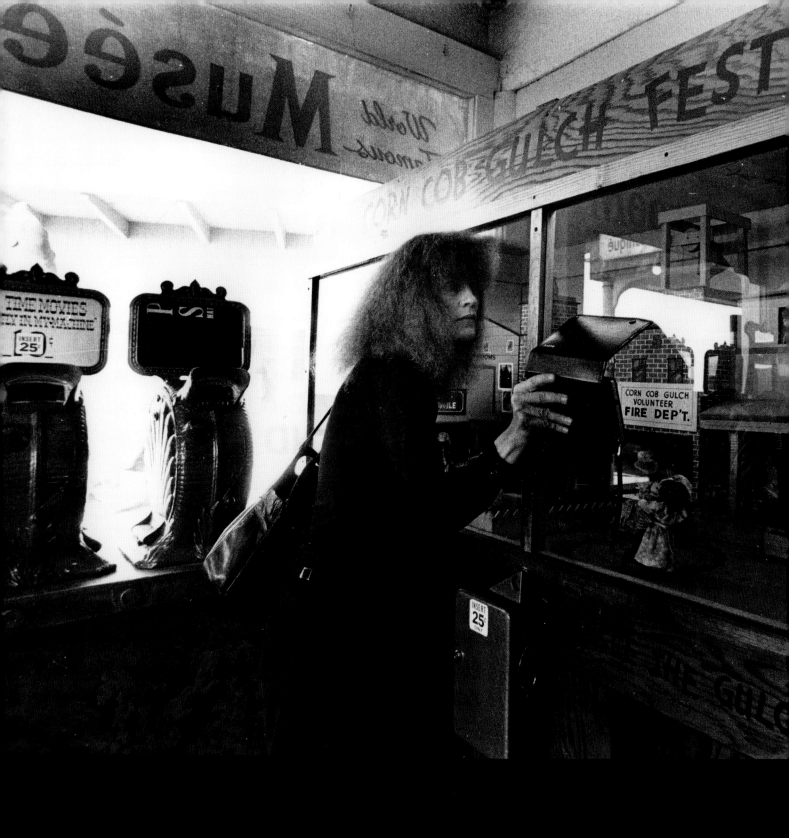

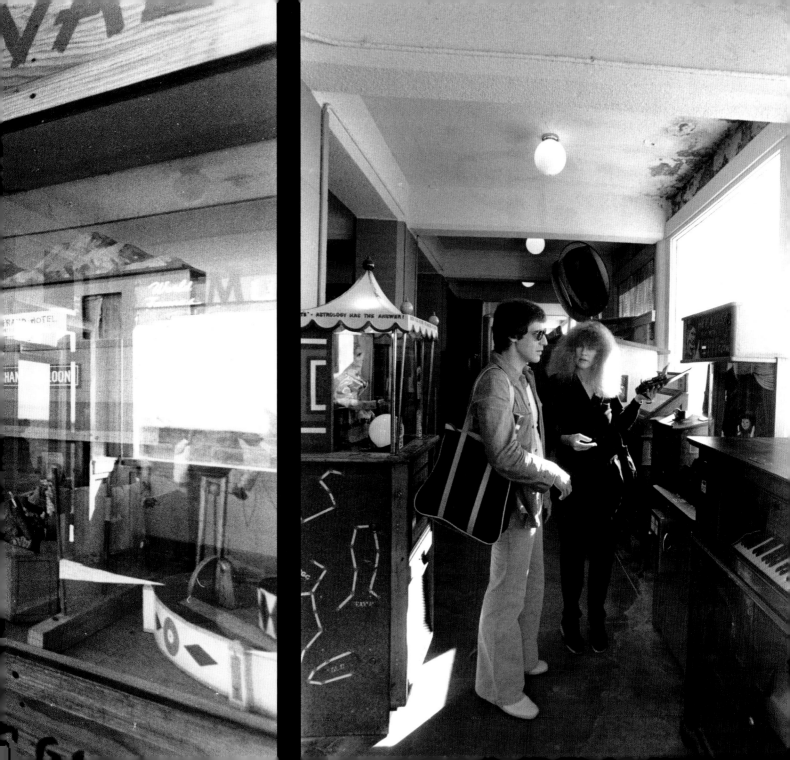

"Those sounds have remained in my head to this day. Wrong notes and getting stuck were two of my favorite things."

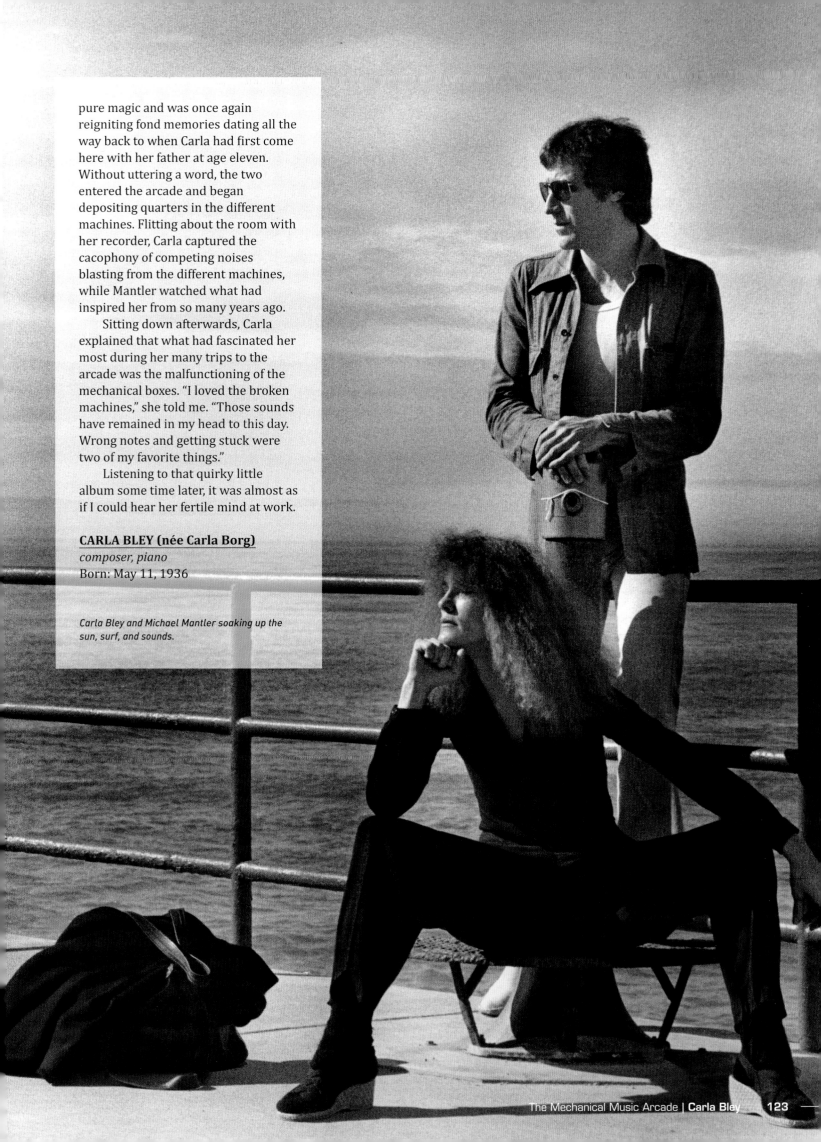

pure magic and was once again reigniting fond memories dating all the way back to when Carla had first come here with her father at age eleven. Without uttering a word, the two entered the arcade and began depositing quarters in the different machines. Flitting about the room with her recorder, Carla captured the cacophony of competing noises blasting from the different machines, while Mantler watched what had inspired her from so many years ago.

Sitting down afterwards, Carla explained that what had fascinated her most during her many trips to the arcade was the malfunctioning of the mechanical boxes. "I loved the broken machines," she told me. "Those sounds have remained in my head to this day. Wrong notes and getting stuck were two of my favorite things."

Listening to that quirky little album some time later, it was almost as if I could hear her fertile mind at work.

CARLA BLEY (née Carla Borg)
composer, piano
Born: May 11, 1936

Carla Bley and Michael Mantler soaking up the sun, surf, and sounds.

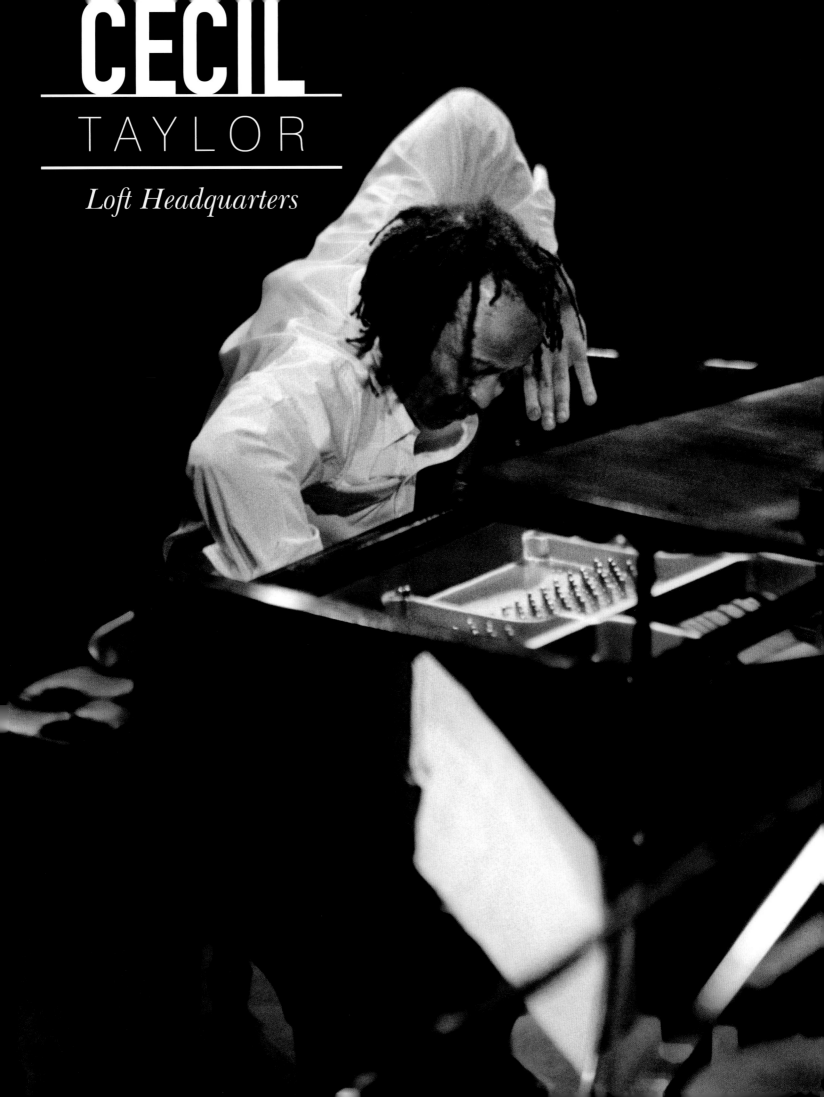

CECIL
TAYLOR
Loft Headquarters

Writers and critics generally have a hard time interviewing Cecil Taylor. Answers to their questions aren't always forthcoming, and those which are given often fluster or confound them. For many, conducting an interview with Taylor can be as overwhelming as reviewing one of his marathon performances, occasionally—depending on the venue—running up to two hours or more.

A true jazz visionary with deep roots going back to the masters, his well-documented debts to other pianists span a wide-ranging progression of modern music styles dating back to the early twentieth century. Included among those who have influenced Taylor are Duke Ellington, Mary Lou Williams, Thelonious Monk, Bud Powell, Horace Silver, even Dave Brubeck. But Cecil's own playing essentially defies categorization. He is recognized as *the* outstanding pianist of free jazz, or, as critic Leonard Feather wrote in 1976, "The avant of today's avant-garde."

The late 1970s were arguably the most innovative, barrier-breaking, and fruitful times of Taylor's career. There was the experimental 1976 recording *Nachricht Vom Lande (Message From The Country),* at the Moosham Castle in Salzburg with Austria's eccentric concert pianist Friedrich Gulda, followed the next year by Cecil's

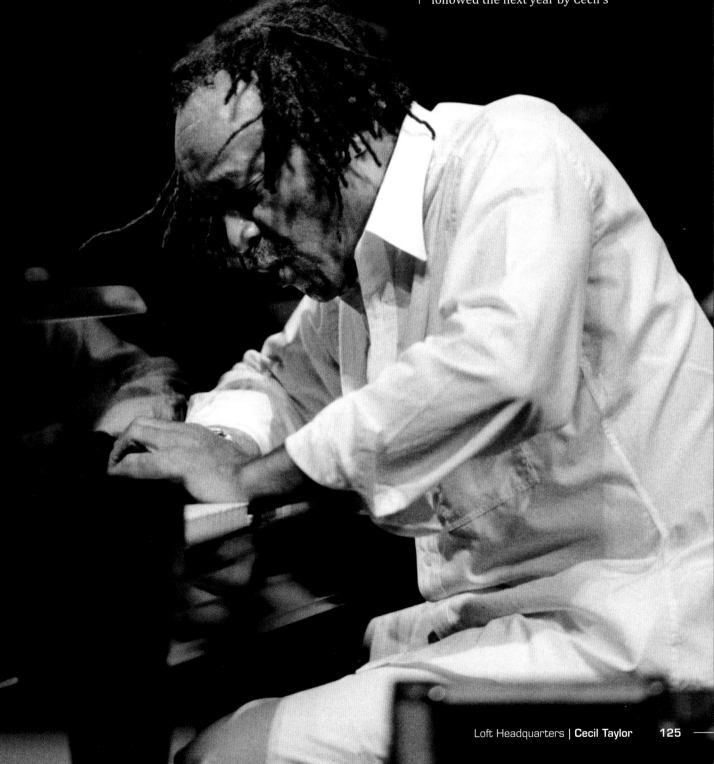

unlikely match-up with pianist Mary Lou Williams at Carnegie Hall, and then his 1979 collaboration with drummer Max Roach. That same year, Cecil startled the jazz community when he appeared on the same stage in three US cities with the premier ballet star Mikhail Baryshnikov and ballerina Heather Watts. (See *Looking for a Little Respect*, pages 284–289)

It was the summer of 1979 when we met formally for the second time, on this occasion in his top fourth-floor loft at 96 Chambers Street. Since 1975, this had served as his primary residence and base of operations.

I had remembered very clearly the details of my initial face-to-face encounter with Taylor some years earlier—and the personal letter he sent me following our get-together several months later. At that time, I had accompanied a writer to meet with him at his hotel in San Francisco. The first thing that hit me upon entering his room was the oppressive heat. Cecil, who must have cranked up the thermostat past ninety degrees, nevertheless was attired in wool slacks, a smart, warm jacket, scarf, and cap. Regardless of why he did so, the place was really uncomfortable, and the interview did not go particularly well. After the writer left—and despite the temperature—I suggested that we do some photographs and he agreed.

It was several weeks later that I sent him a couple of complimentary photographs from that session, one of which he decided he wanted used for his album *Cecil Taylor: Live In the Black Forest,* recorded by MPS Records in Villingen, Germany.

Before engaging in our extended photo shoot in his New York loft, Cecil wanted to share with me a particularly satisfying event that had occurred earlier in the year at the Creative Music Studio in Woodstock; at the time, this facility was considered the foremost study center for contemporary creative music. He had been commissioned by directors Karl Berger and his wife Ingrid Sertso to conduct a seminar and compose a series of pieces for some forty student musicians at the studio.

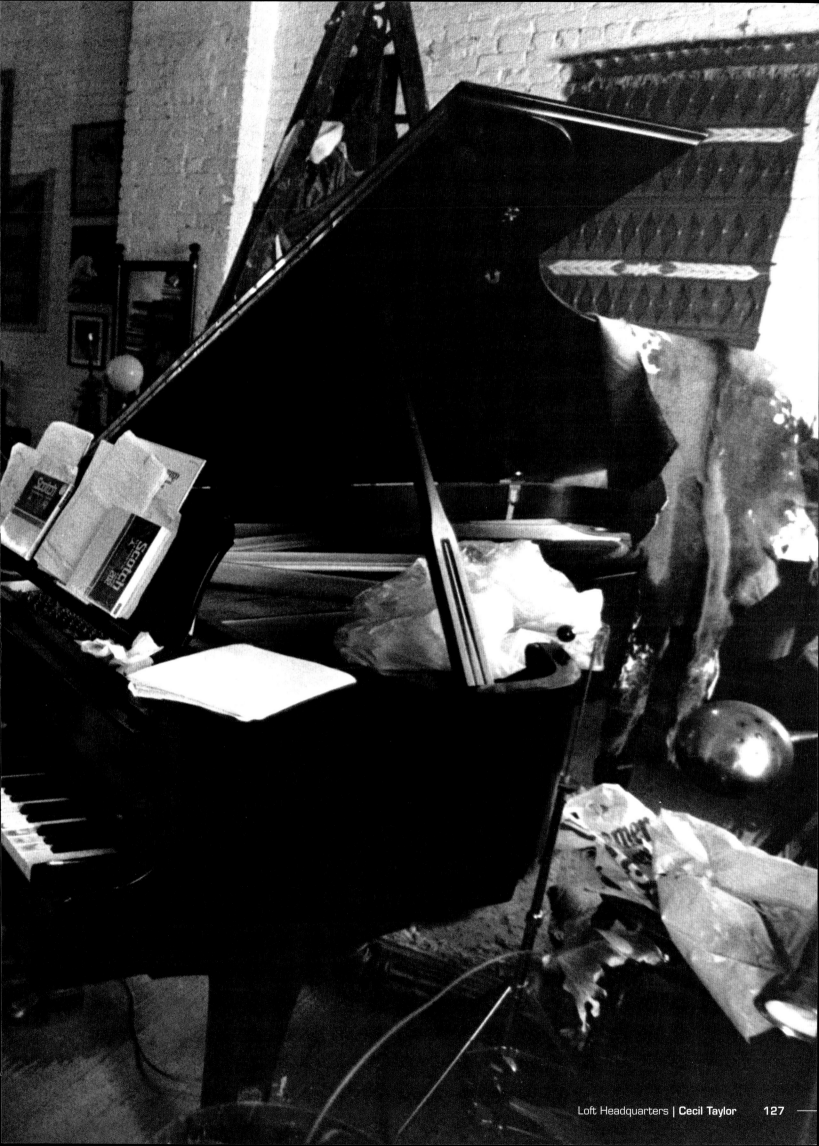

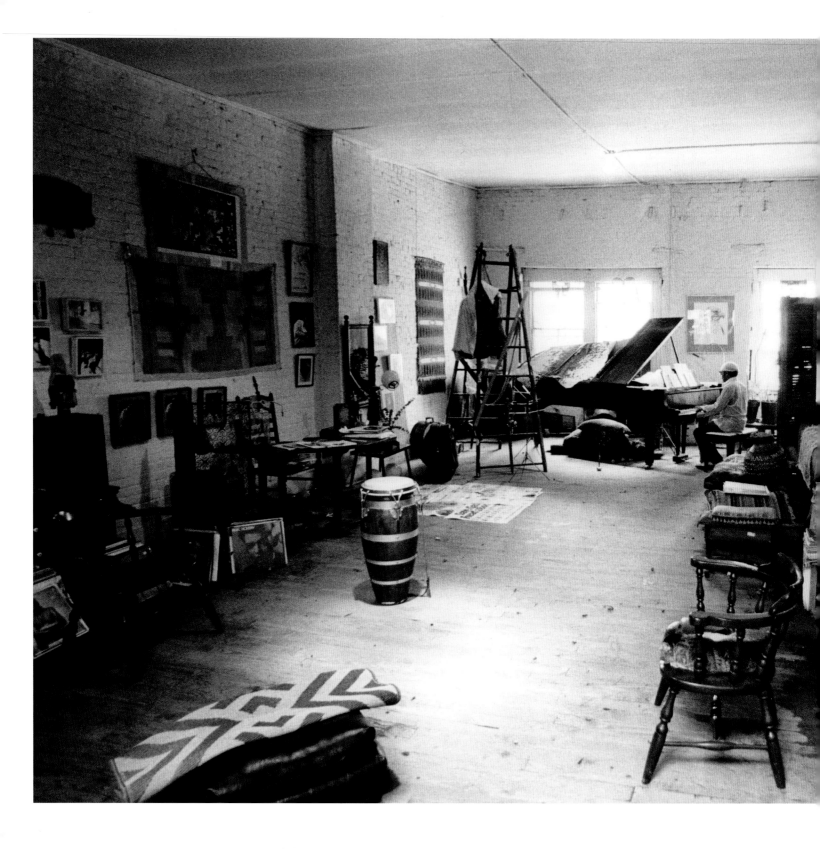

The program featured the Cecil Taylor Unit (with alto saxophonist Jimmy Lyons, violinist Ramsey Ameen, percussionist Jerome Cooper, bassist Alan Silva, and drummer Sunny Murray), plus members of the Creative Music Studio. Consistent with Taylor's passion for music, poetry, and dance, the ensemble of instrumentalists completed five of his orchestral pieces, interspersed with segments of interpretive dance performed by the acclaimed danseuse, Diane McIntyre,

plus recitation of Cecil's poetry by noted poet Thulani Davis.

As with most of Taylor's efforts during this time, the center for embarking on such a unique production was his fourth-floor loft. For Cecil, creating the ideas, composing the scores, and rehearsing with The Unit (or any other group of musicians) just naturally took place in his business and personal living headquarters.

The long, one-room loft spread out more than 2,000 square feet. At the

street-side end of his quarters sat Cecil's imposing Yamaha concert grand piano. Getting it there, as he explained, was no small achievement. "[Two adjacent] . . . windows had to be taken out before movers could hoist the piano by crane to the top floor and place it safely inside. That portion of the move alone cost $600."

Along both walls heading into the interior of the loft was a veritable hodgepodge of paintings, macrame, and fabric art pieces, along with

As with most of Taylor's efforts during this time, the center for embarking on such a unique production was his fourth-floor loft.

programs, posters, and photographs of himself, ballet stars, and other artists or personalities from previous concerts and events.

Rows of long-playing records and a stereo system were situated along one wall, facing a mattress supported on four 2″x8″ slabs of wood which served as his bed.

Cecil Taylor is shown seated on his makeshift bed, with a stereo system and record collection in the background.

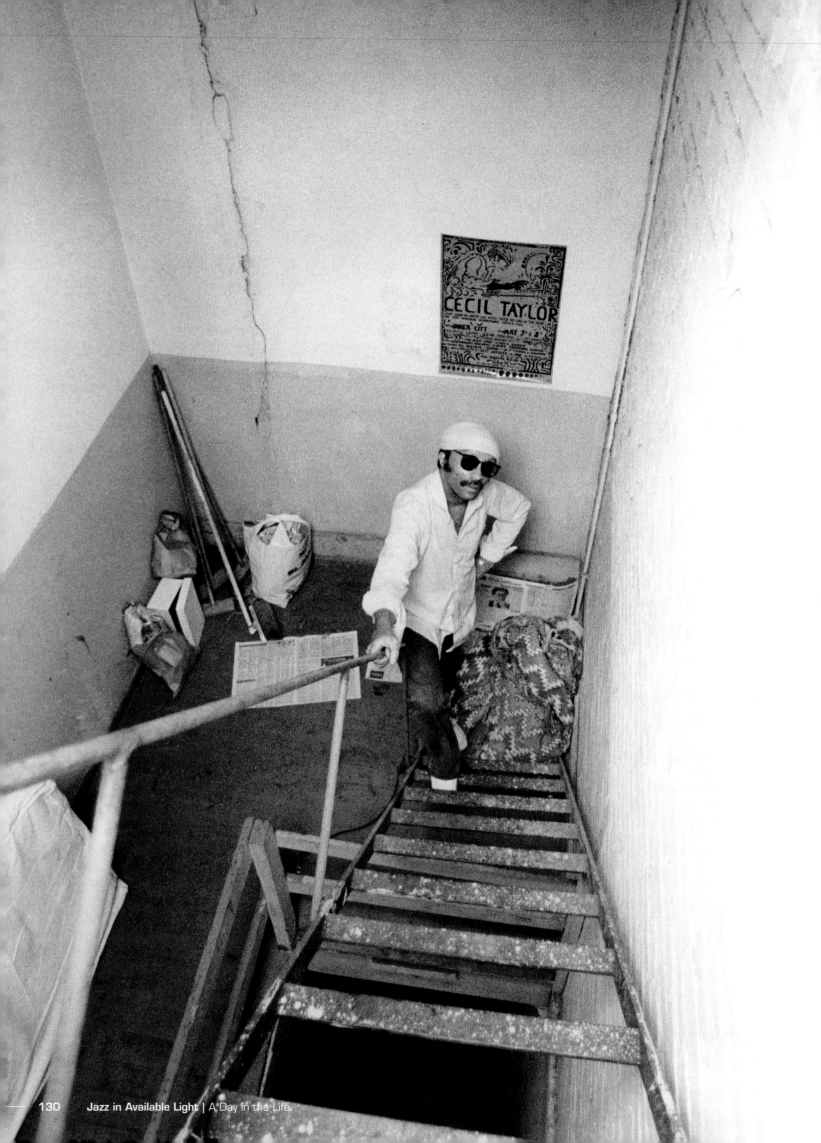

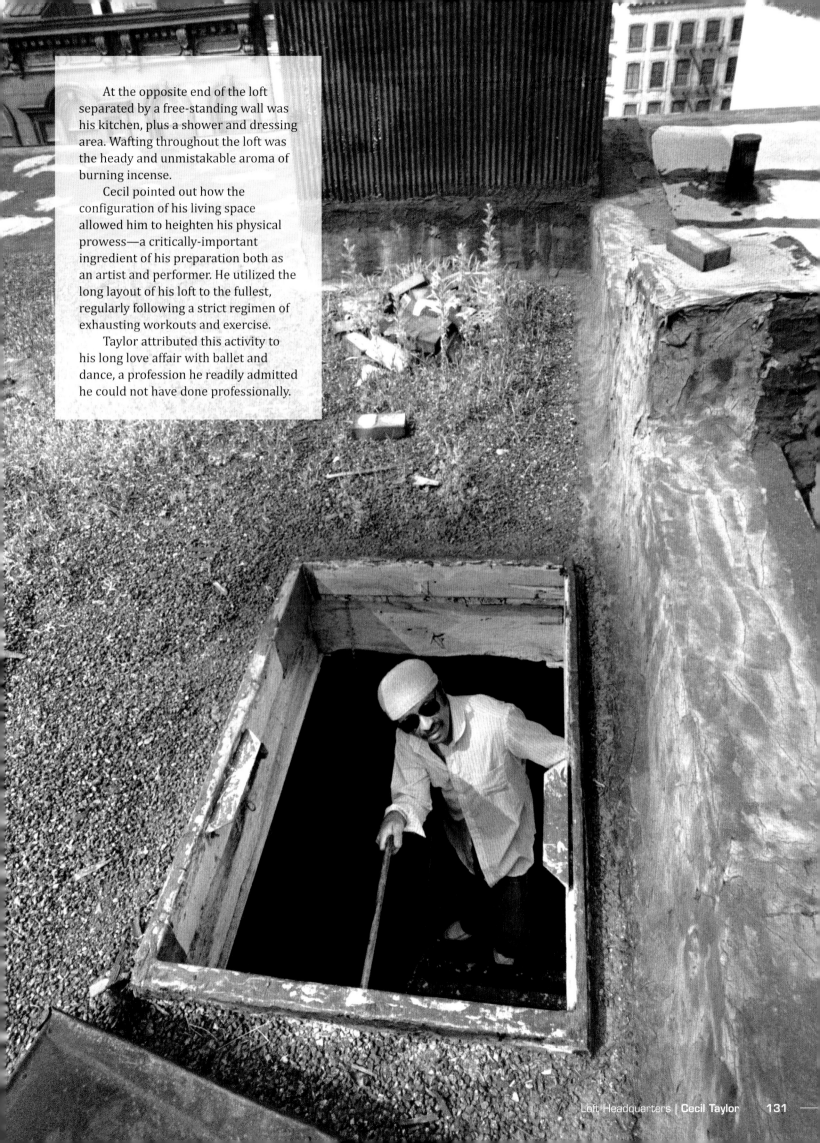

At the opposite end of the loft separated by a free-standing wall was his kitchen, plus a shower and dressing area. Wafting throughout the loft was the heady and unmistakable aroma of burning incense.

Cecil pointed out how the configuration of his living space allowed him to heighten his physical prowess—a critically-important ingredient of his preparation both as an artist and performer. He utilized the long layout of his loft to the fullest, regularly following a strict regimen of exhausting workouts and exercise.

Taylor attributed this activity to his long love affair with ballet and dance, a profession he readily admitted he could not have done professionally.

"The avant of today's avant-garde."

–Leonard Feather

Nevertheless, his routines were not unlike those of some of the best dancers on the circuit. "The idea is to use as much of the musculature as possible," he told me, "and try to keep at least in the same condition [as a ballet star] as much as possible."

Several months earlier, Cecil's exercise routine proved too intense, costing him a trip to the hospital. A diagnosis of pinched nerves resulted in his being placed in traction for ten days.

For the rest of our time together that day, it was obvious that Cecil was none the worse for wear. Lithe as a cat, he was constantly on the move throughout the quarters as we took photos, even bounding up his metal stairs and through the trapdoor leading to the roof of his loft.

Afterwards, Cecil retrieved a couple of glasses from the kitchen and we shared an expensive, exquisitely smooth, mature Cognac with very complex notes. It was the perfect finale, a fitting and most delectable coda.

CECIL PERCIVAL TAYLOR
piano, composer, educator
Born: March 25, 1929

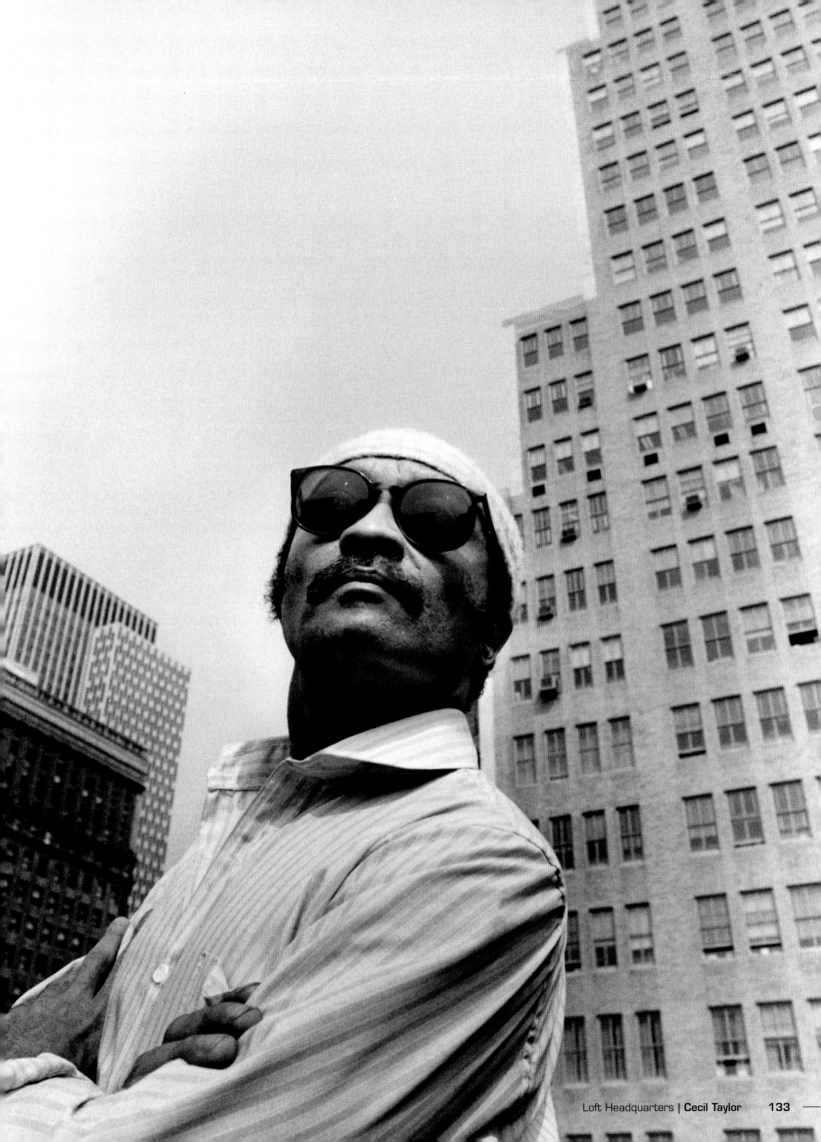

EDDIE
HENDERSON

Is There a Doctor in the (Jazz) House?
(Take 1)

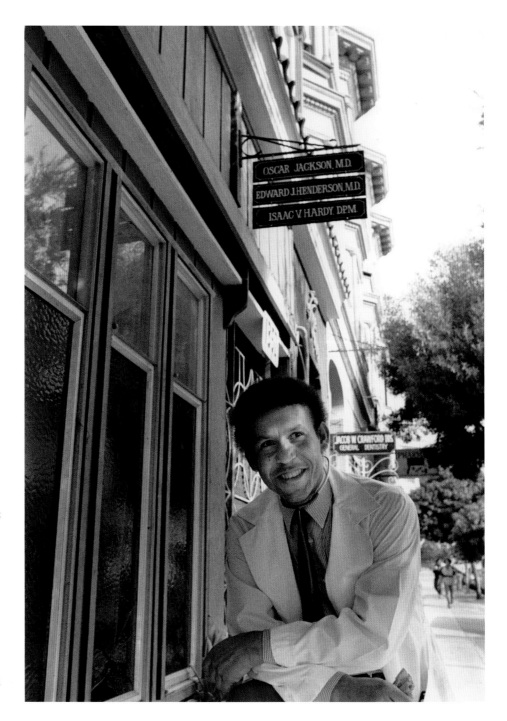

Your mother in the videotape is a dancer at the original Cotton Club performing "Ain't Misbehavin'" with stride piano legend Fats Waller. Growing up, your first informal music lesson at age nine is provided by none other than trumpeter Louis Armstrong. Your stepfather, a medical doctor, is the physician of choice for the touring jazz musicians playing the west coast nightclub and concert circuit—names like Duke Ellington, Sarah Vaughan, Count Basie, Joe Williams, Dizzy Gillespie, Julian "Cannonball" Adderley, John Coltrane, and Miles Davis.

So, if this is the life you inherit, what do you become? The decision seems only natural—you become Eddie Henderson, jazz trumpeter, and Eddie Henderson, doctor of medicine.

Although classically trained at the San Francisco Conservatory of Music while a teenager, Henderson was most heavily influenced by Miles Davis. It was during his 1958 engagement at the Blackhawk jazz club, while a guest at the home of Eddie's parents, that Miles took the teenager along with him to his gig. Eddie's introduction to live jazz with Miles—plus saxophonists Coltrane and Adderley on the front line, and the solid rhythm section of pianist Wynton Kelly, bassist Paul Chambers, and drummer Jimmy Cobb—had a profound impact that stayed with him for life.

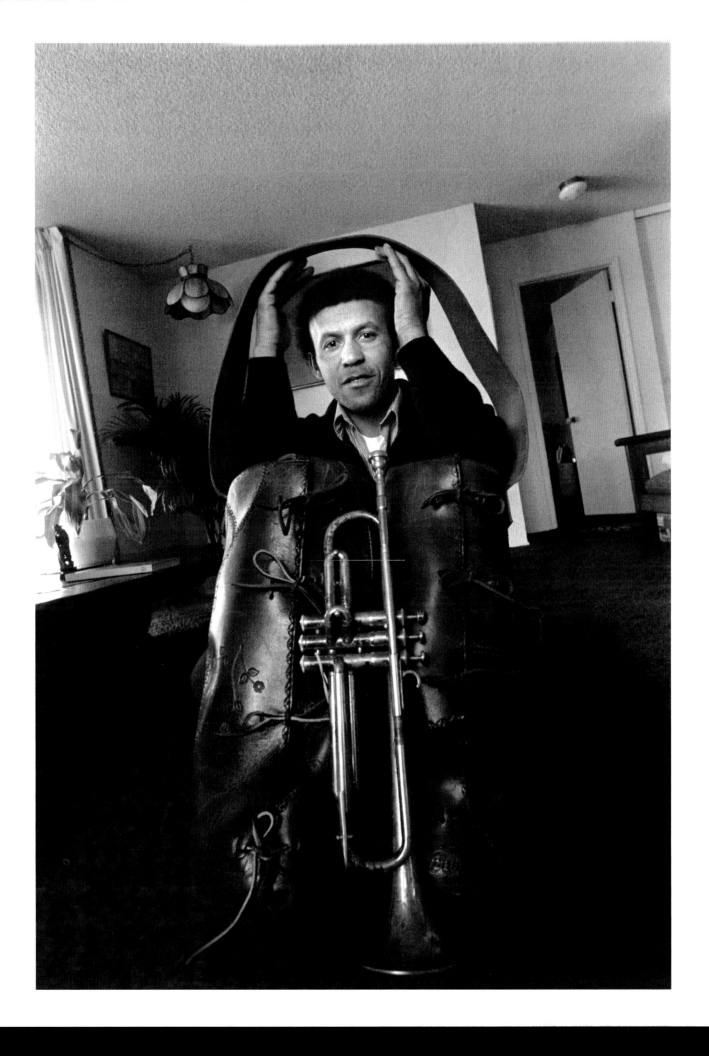

Upon graduating from the University of California, Berkeley, Henderson went on to complete his medical degree from Howard University in Washington, DC, before returning to the San Francisco Bay Area.

In 1970, Herbie Hancock called on Eddie to join his newly-formed Mwandishi Sextet, along with trombonist Julian Priester, tenor saxophonist Bennie Maupin, bassist Buster Williams, and drummer Billy Hart. Henderson made his first recordings with that group, staying with the pianist for three years.

Bob Gluck, jazz historian and associate professor of music at the University of Albany, SUNY (State University of New York), described that period in his book, *You'll Know When You Get There: Herbie Hancock and the Mwandishi Band*. Each of the sextet members adopted Swahili names that personified who they were as individuals, and as Priester explained, helped develop a ". . . unifying effect," making them feel like family. Herbie, or *Mwandishi,* meant the "Composer;" Eddie was *Mganga*, for "Doctor of Good Health."

Gluck also wrote about that period of Henderson's life. He revealed that the trumpeter was determined to succeed in his dual career partly to spite his stepfather, whom he described as ". . . competitive, bitter, and negative," and not believing that Eddie would ever become a doctor.

Eddie stated that he would attend class ". . . every day from 8:00 to 5:00 in medical school, come home, study every day from 5:15 to 9:30, go out and play [music] until 2:00 in the morning. Come back and study until I'd go to sleep about 4 or 5 in the

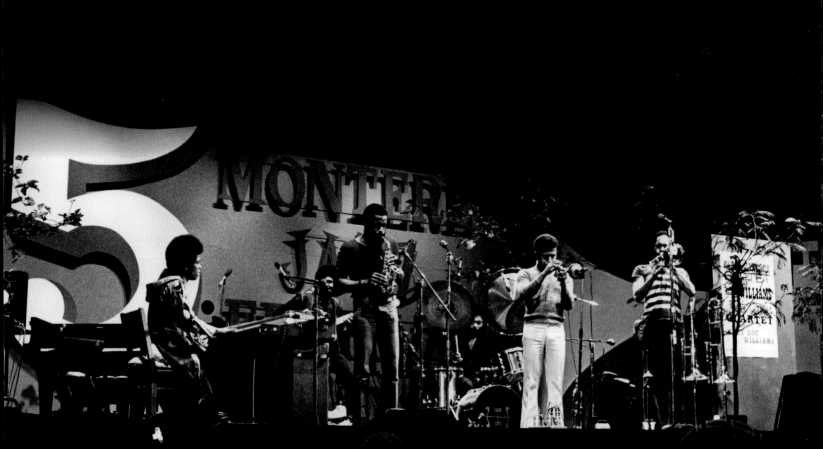

The trumpeter was determined to succeed in his dual career.

At the San Francisco clinic the two shared, Eddie Henderson joins with Dr. Oscar Jackson to check a patient's X-ray.

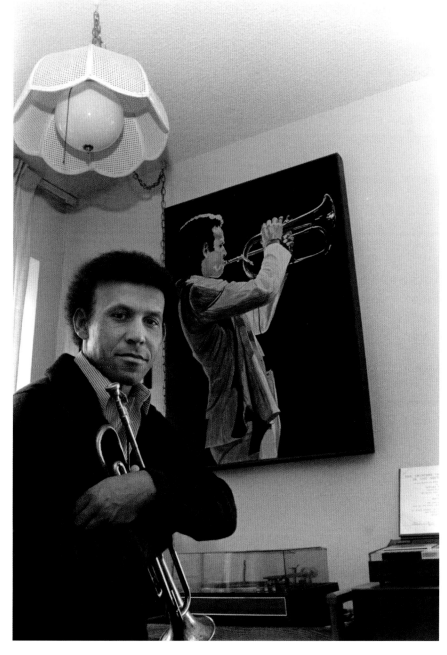

morning, and then wake up at 7:30 and go back to school. Every day. I never missed a class."

After we met for a photo shoot at his home in January of 1983, Dr. Henderson took me a block away to the Haight Street Medical Clinic where he practiced medicine with two other colleagues.

For Eddie, the business association was a real blessing, thanks to Oscar Jackson, M.D. and head of the clinic. Because Dr. Jackson knew how much music meant to Henderson—and being a jazz aficionado himself—the two forged an agreement that afforded the trumpeter the luxury of taking off whenever he was able to schedule a jazz tour or book an important gig.

EDWARD (Eddie) JACKSON HENDERSON

trumpet, flügelhorn, composer
Born: October 26, 1940

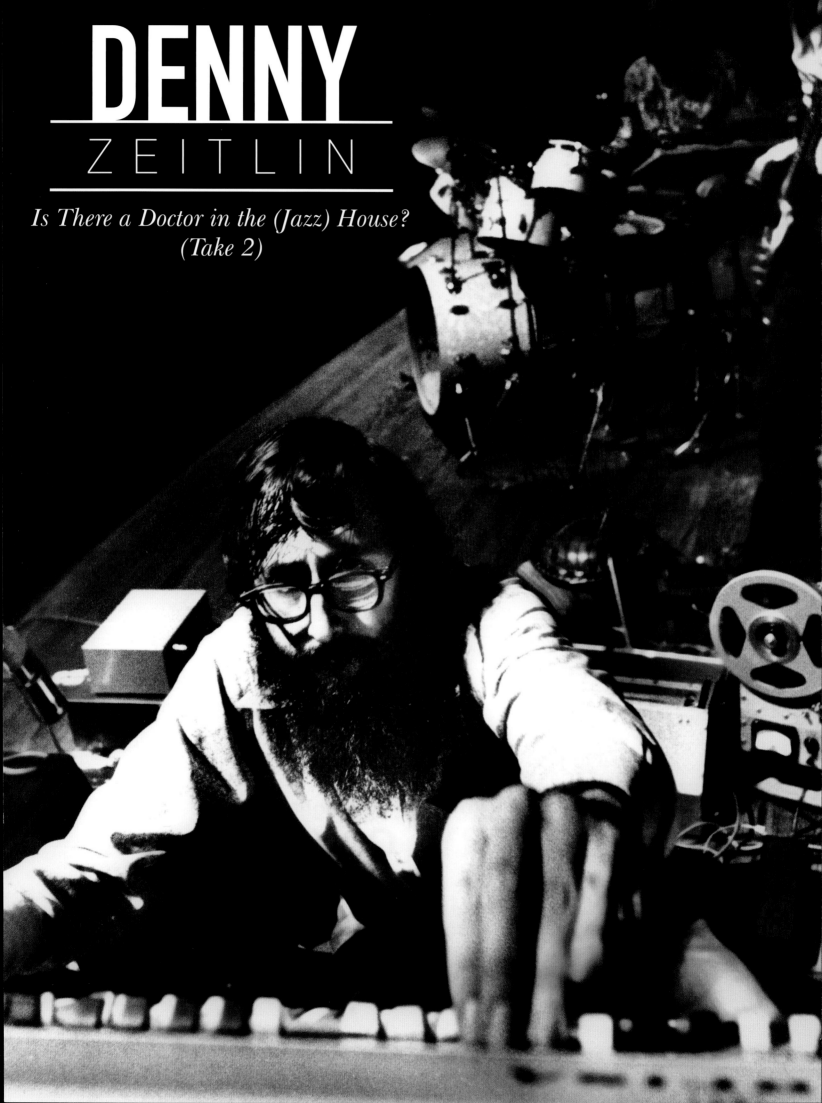

DENNY
ZEITLIN

Is There a Doctor in the (Jazz) House?
(Take 2)

KENTFIELD, CALIFORNIA

At a very young age, some already know for sure what they want to do in life. Convinced they are embarking on a future that was pre-ordained, they choose a profession meant just for them. If they are very lucky, they become especially good at it, thoroughly enjoy everything about it, and realize immense satisfaction from it.

Remarkably, Denny Zeitlin is one of those people, twice over.

"As far back as I can remember," Zeitlin explained to writer/critic Nat Hentoff with the release of his first album as a leader, *Cathexis*, in 1964, "my two main interests have been medicine and music. Deleting either would leave me feeling so incomplete that there has never been a question of not doing both." Coincidentally, the same year of his Columbia release, the pianist became *Dr.* Denny Zeitlin with the completion of his degree from Johns Hopkins Medical School.

How this all came about has been very well chronicled. From the age of two, Denny remembers climbing on the laps of either his father, a radiologist who played music by ear, or his mother, a speech pathologist who also taught piano. Very soon thereafter, the toddler with limitless curiosity and

superior intelligence was creating and playing his own music at the keyboard.

The editors of *Swing Journal* magazine thought their Japanese readers would be interested in knowing more about the life of this complex, multi-talented personality, so they gave me the assignment. It was in October of 1982, when I met with Denny and his wife Josephine in their Marin County home, about a half-hour drive north from San Francisco.

By this time, Zeitlin was already well-established and much in demand in his dual chosen fields. On the music side, he had recorded eight critically-acclaimed albums as a leader, as well as composed the stunning soundtrack

for the *Invasion of the Body Snatchers* musical score in 1978.

In the field of medicine, he was an award-winning clinical professor of psychiatry at the University of California, San Francisco's Langley Porter Psychiatric Institute, plus maintained two very successful practicing businesses in both his home office and in San Francisco.

During my visit, I discovered just how active and on-the-go Denny and Josephine were, and how these two

Prior to meeting with one of his clients, Dr. Zeitlin reads from a psychiatric journal in his San Francisco offices.

professionals shared so many complementary interests. As serious wine connoisseurs, both actively participate in the art of wine tasting and appreciation. Denny, a respected oenology critic and authority, even reviews particular wines for well-known food and wine publications.

Josephine, a self-taught horticulturist and licensed California contractor, has her own successful career as a landscape designer, and regularly contributes stories and photos for industry magazines.

During the early afternoon, Denny and I spent some time together with the photo shoot in and around the Zeitlin home.

Unbeknownst to me, while Denny and I were involved with the photo session, Josephine had retreated to the kitchen. It turned out that the couple were ardent "foodies," and as such, Denny explained that their culinary sensitivities were not limited only to dining out. In fact, before finishing our photo engagement that day, I learned—much to my surprise and delight—why he raved about Josephine. She was a true gourmet cook.

In an early version of his home's climate- and humidity-controlled wine cellar, Denny Zeitlin checks the sediment in an aged bottle of wine.

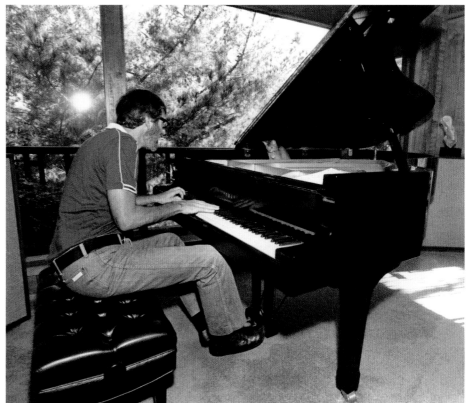

Shibumi, a most inquisitive, six-month-old Abyssinian kitten, gets its toes tingled by the piano strings as Denny practices.

"My two main interests have been medicine and music. Deleting either would leave me feeling so incomplete that there has never been a question of not doing both."

Without any recipes, she prepared an early three-course gourmet dinner of distinction. Here was our dinner, which I catalogued:

A ZEITLIN FEAST TO REMEMBER

Course 1
*Fettuccini noodles with
Mascarpone (Italian cheese),
pine nuts, and fresh basil*

Course 2
*Skewered scallops, prawns,
and thresher shark soaked in
a marinade of olive oil, wine,
and herbs, then topped with
sauce of tomato butter, sweet
cream, and shallots*

Course 3
*Rum-soaked cake filled with
vanilla custard, berry jam,
and fresh strawberries, topped
with Kahlua liqueur, almonds,
chocolate shavings, and
whipping cream*

Wine
*1975 Scharzhofberger Spätlese
(Germany)*

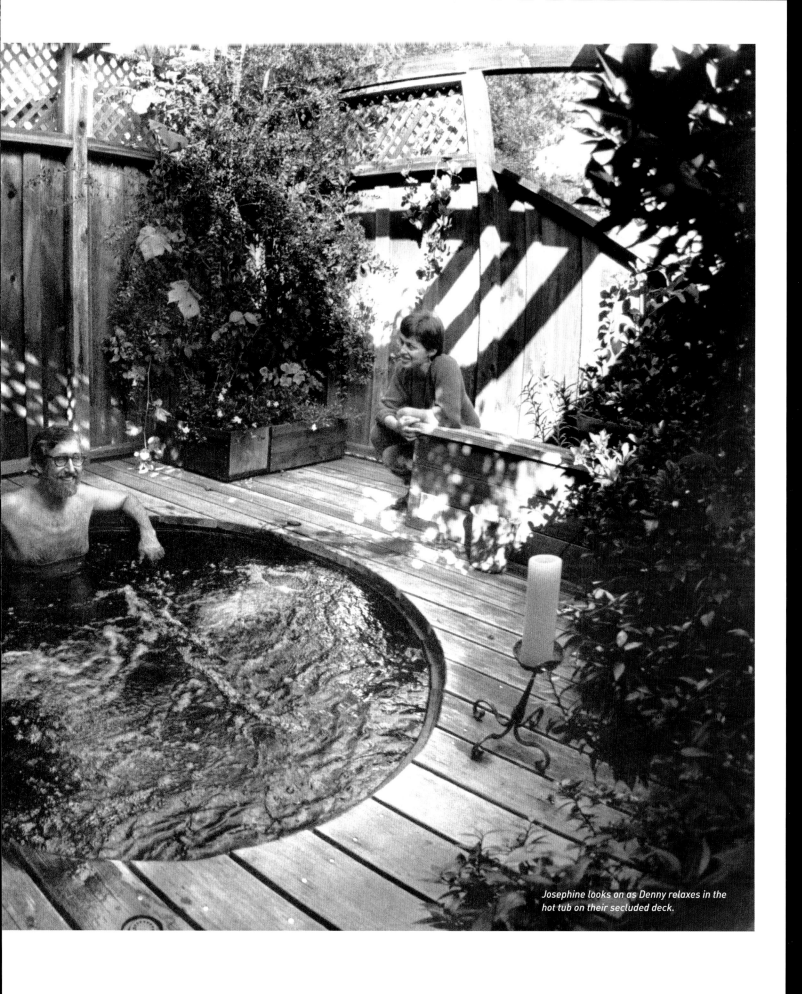

Josephine looks on as Denny relaxes in the hot tub on their secluded deck.

Is There a Doctor in the (Jazz) House? (Take 2) | **Denny Zeitlin** **143**

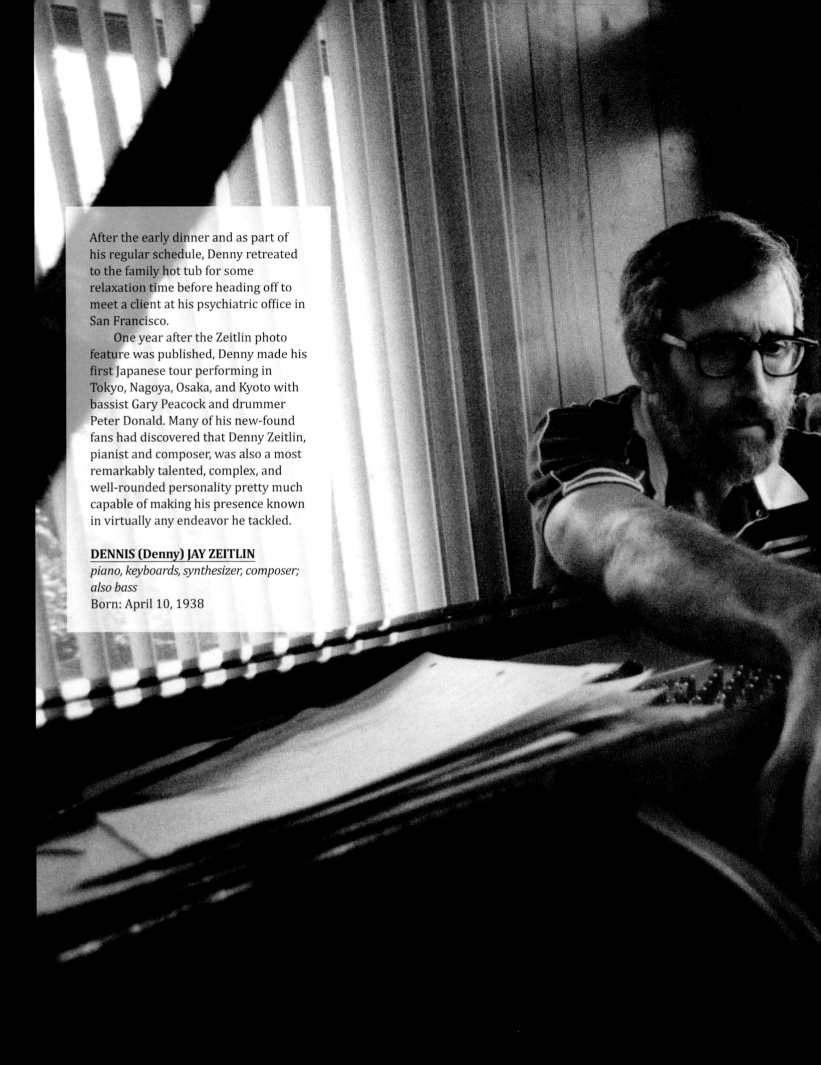

After the early dinner and as part of his regular schedule, Denny retreated to the family hot tub for some relaxation time before heading off to meet a client at his psychiatric office in San Francisco.

One year after the Zeitlin photo feature was published, Denny made his first Japanese tour performing in Tokyo, Nagoya, Osaka, and Kyoto with bassist Gary Peacock and drummer Peter Donald. Many of his new-found fans had discovered that Denny Zeitlin, pianist and composer, was also a most remarkably talented, complex, and well-rounded personality pretty much capable of making his presence known in virtually any endeavor he tackled.

DENNIS (Denny) JAY ZEITLIN
piano, keyboards, synthesizer, composer;
also bass
Born: April 10, 1938

CHARLES
L L O Y D

& MICHEL
PETRUCCIANI

The Forest Farm Retreat

**BIG SUR,
CALIFORNIA**

"The first time I heard him, it was over the telephone. I was away. He was in the background. I was very touched by what I heard. I drove 200 miles in two hours. I got back, took out my instrument. We played, and I knew that it was time again."

Living in relative obscurity since the early 1970s, on this wild and secluded Big Sur property high in the hills overlooking the Pacific Ocean—the place he called "Forest Farm"—tenor saxophonist and flutist Charles Lloyd said simply it was "providence" that brought the eighteen-year-old French pianist phenom Michel Petrucciani to his doorstep in 1981. Whether he knew it or not at the time, Lloyd's self-imposed decade in exile from the commercial music scene would soon come to an end.

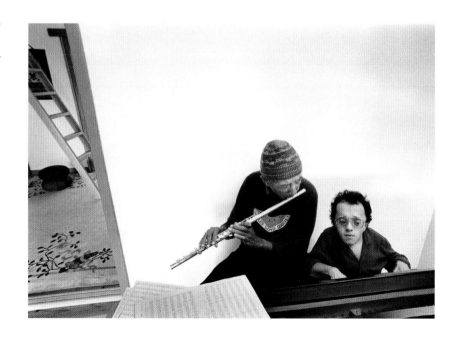

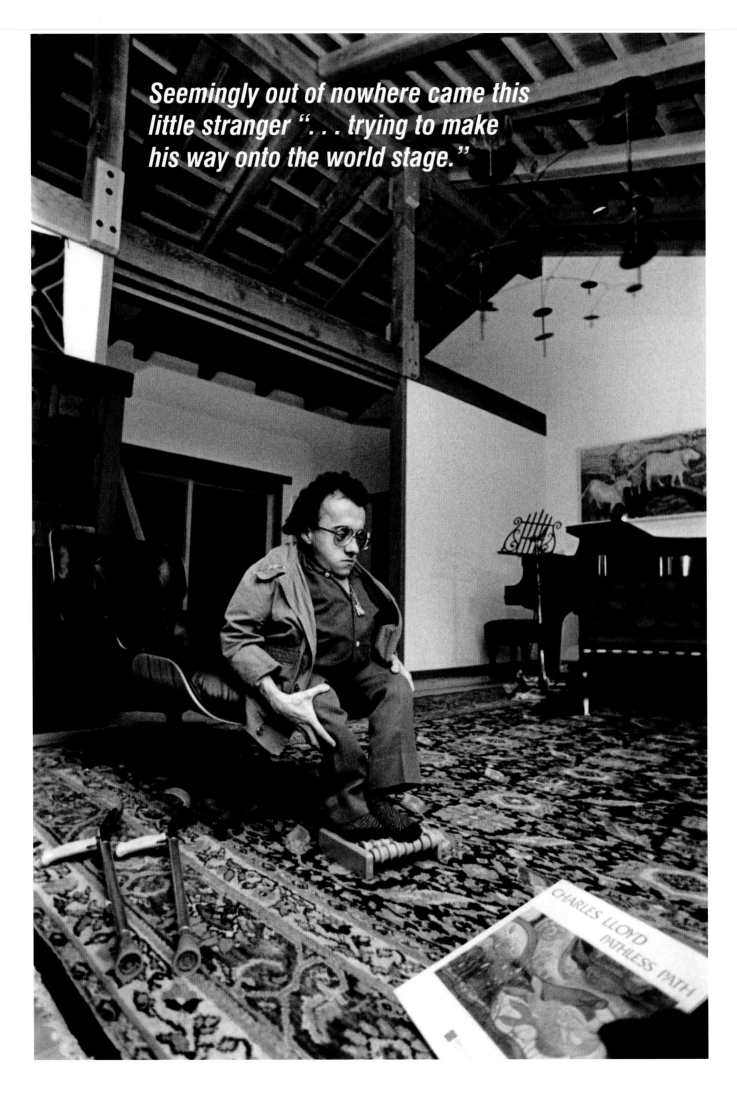

Seemingly out of nowhere came this little stranger ". . . trying to make his way onto the world stage."

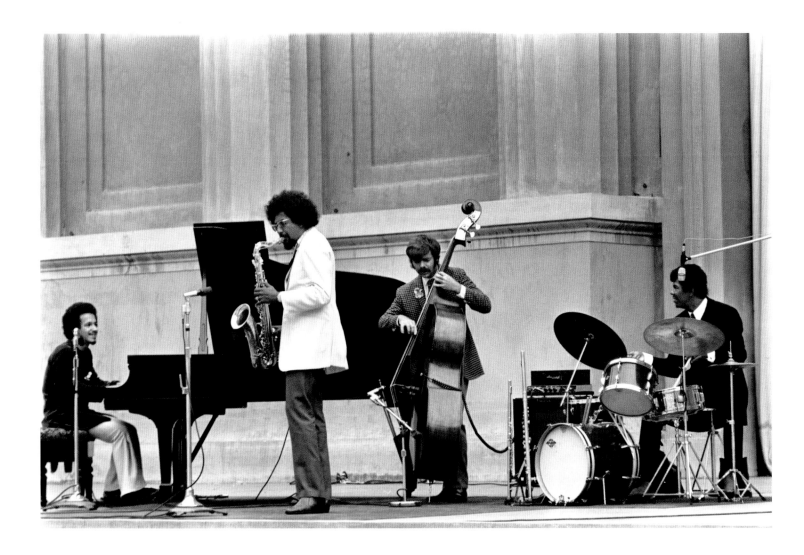

Seemingly out of nowhere came this little stranger ". . . trying to make his way onto the world stage," Charles recalled. "He had a great talent, but had been born with such a rare bone disease." (Petrucciani stood three feet tall and suffered from osteogenesis imperfecta, or "glass bones" disease.)

I had followed Charles Lloyd's dazzling career from the time he had first chosen Keith Jarrett for his quartet in 1966. That young pianist, today one of the most recognized and successful of all jazz artists, had also asked Charles if he could join under his direction. Their albums, *Dream Weaver*, then *Forest Flower: Live at Monterey*, broke through previously-defined musical categories to capture heretofore unreachable audi-

ences and catapult the group to international prominence. Lloyd's composition, "Forest Flower," made history by being the title track of one of the first jazz albums to sell a million copies.

The success that followed him was unsustainable. Month after month of relentless touring, controls on his time, and ongoing demands from his growing, insatiable fans around the globe took its toll. Charles was exhausted, and retreated ". . . to pursue an inner journey. It's something I had to experience in silence," he said.

When I learned that the now-rejuvenated Lloyd and his newest piano discovery would be enjoying a brief break at his home in January of 1983, following the current quartet's

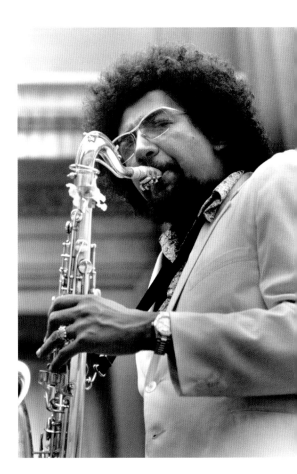

Opposite: Taking time out to relax in Lloyd's Big Sur home, Michel Petrucciani alleviates some discomfort in his lower extremities by rubbing his legs and employing a wooden foot roller massager.

Above: The Charles Lloyd Quartet with pianist Keith Jarrett, bassist Ron McClure, and drummer Jack DeJohnette performed at the University of California's Greek Theatre in Berkeley in 1967.

acclaimed European tour, I literally jumped at the opportunity. I wanted to be the conduit for sharing and re-enacting this memorable turning point in both of their lives.

It was a day of total relaxation and contentment for Charles and Michel. It was obvious the two were perfectly-matched musical soul mates who not only understood, but brought out the best of each other. As an invited visitor that day, I sensed a loving bond between the two artists. On the one hand, Charles appeared protective of Michel, almost as a father would be with his child. But musically, the two were on equal footing.

Charles Lloyd was totally at peace that day, reflective and introspective. Once again, he knew that his latest young recruit was gaining his own footing, making huge strides, and would soon be ready to strike out on his own.

"Over the years," he said, "all these incredible musicians continue to come to me and want to serve with me. So that's like being chosen. That's a great blessing."

CHARLES LLOYD
*tenor saxophone, flutes, composer;
also synthesizer*
Born: March 15, 1938

MICHEL PETRUCCIANI
piano, composer
Born: December 28, 1962
Died: January 6, 1999

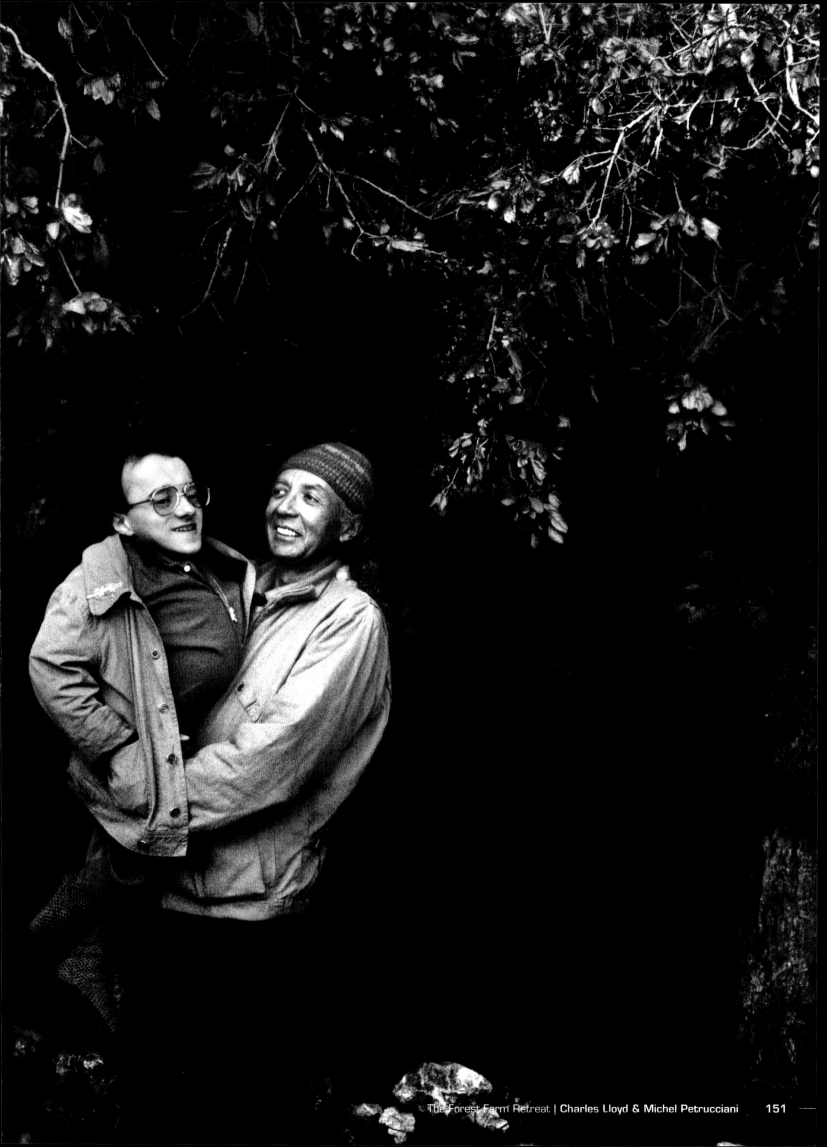

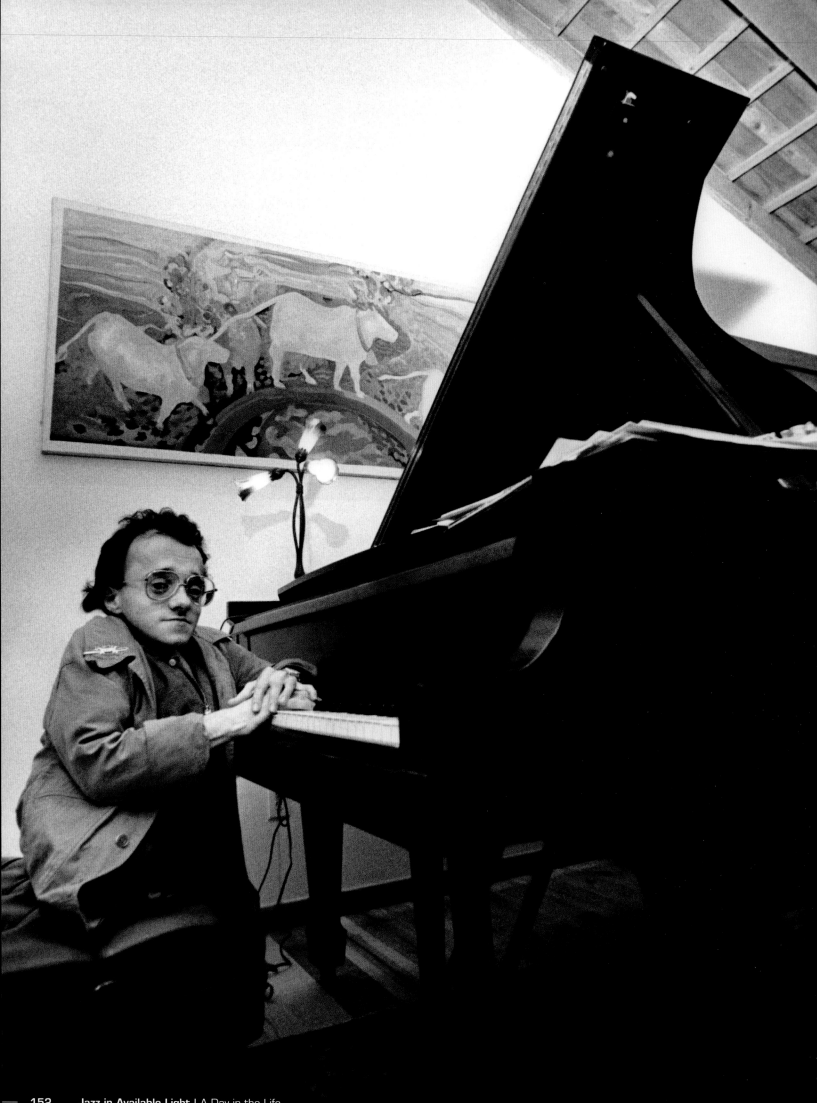

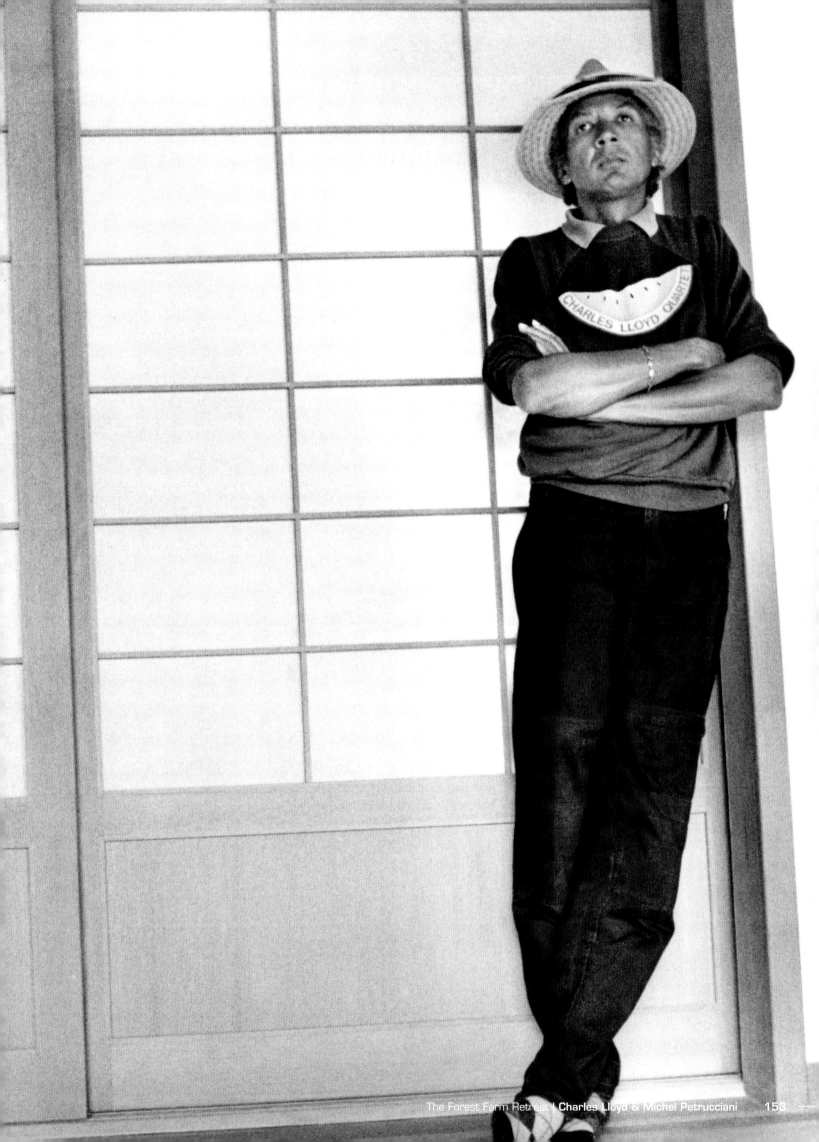

He knew that his latest young recruit was gaining his own footing, making huge strides, and would soon be ready to strike out on his own.

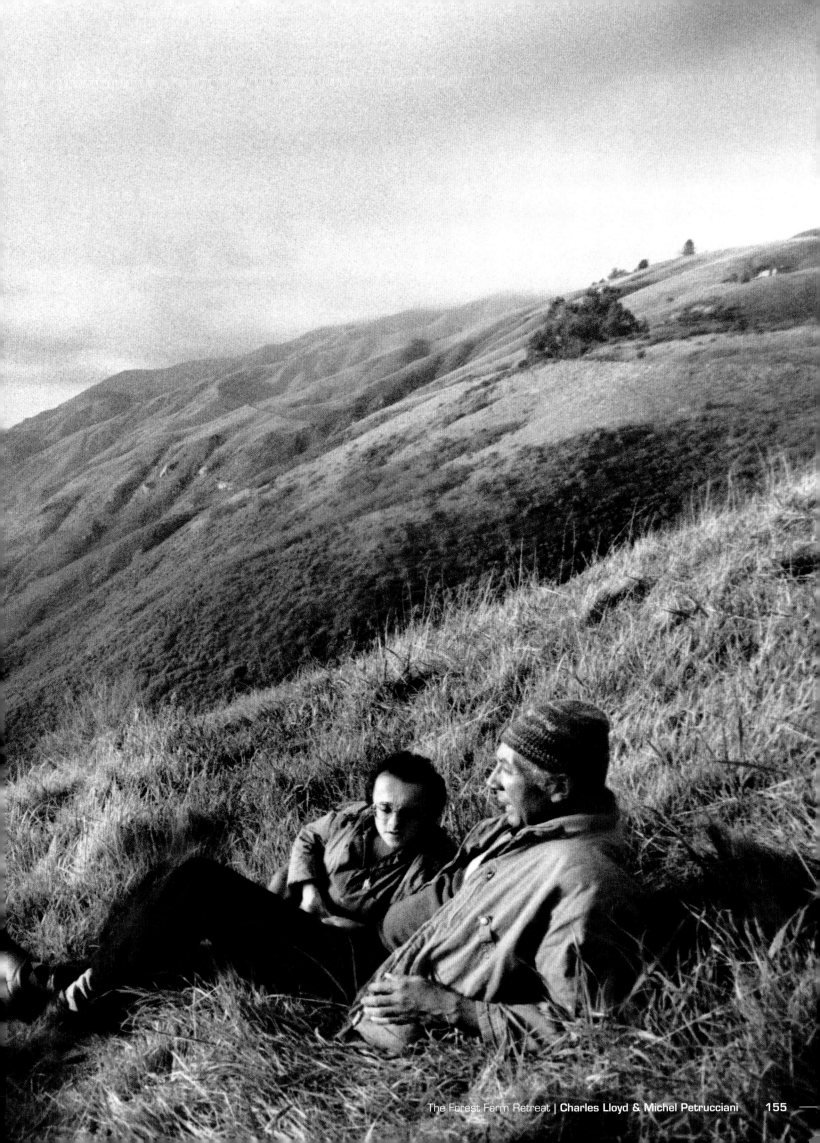

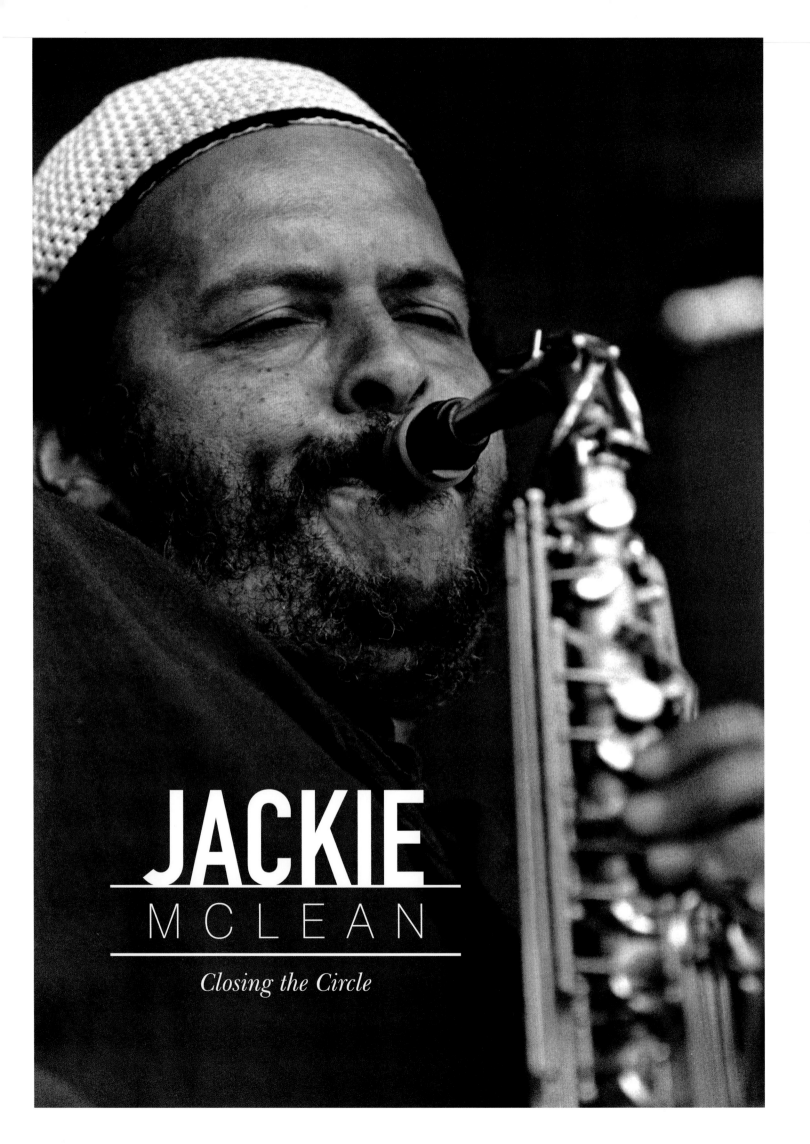

JACKIE
MCLEAN

Closing the Circle

TELLURIDE,
COLORADO

made the trip, so many camped out instead, rain or shine. The music was certainly worth it, even though—when the heavens opened—some of the fans looked pretty miserable.

Here it was, the summer of 1980, almost three decades removed from the young man's historic breakthrough recording date featuring the all stars Miles Davis, Sonny Rollins, and Art Blakey. It was momentous for me to finally witness and photograph McLean in such fine form, now heading a quintet featuring trumpeter Woody Shaw and trombonist Steve Turre. But as solid as that group played together, capturing their performance did not prove to be my highlight of the weekend.

Who would have guessed that I would finally cross paths with Jackie McLean at . . . [a] ski village . . . in the Colorado Rockies?

On this day, in this most remote, out-of-the-way retreat, I got to share the excitement first-hand. That's what made it all so fulfilling.

For a multitude of reasons, I never had an earlier opportunity to catch one of the premier bop-inspired pioneers of the alto saxophone in the flesh. Who would have guessed that I would finally cross paths with Jackie McLean at an outdoor jazz festival in the "one-way-in, one-way-out" ski village of Telluride (population 2,500), nestled at the base of the 13,000-foot San Juan Mountain range in the Colorado Rockies?

As jazz festivals go, I thought Telluride represented a kind of oddity. It was well off the beaten track, but the festival promoters nevertheless consistently booked a notable cross section of top-name players. There weren't sufficient accommodations to accept the thousands who inevitably

Had he been spotted on campus, Miles Davis might have been mistaken for a most hip, contemporary college administrator.

As the festivities were winding down, I learned that Jackie needed a ride to the airport. Getting to Denver and then back home to New York meant driving more than an hour to Montrose, where he could make his puddle-jumper connection to the Mile-High City. Just how great would it be, I thought, if I could spend some time up close with the man. I immediately offered to give him a lift.

Once on our way, I couldn't help but notice McLean was in a great mood. He was upbeat, almost excitable. Right away, he began talking about having been named "Founder of the Department of African-American Music" for the Hartt School of Music in Hartford, Connecticut. The start of this new decade was pivotal for him because it signified a sort of official validation point for all of the years he had invested at the school as a jazz educator.

Long a champion of giving back when it came to preaching the jazz "gospel," McLean had begun his association with Hartt as a teacher in 1968. During our ride, he filled me in on how meaningful his many experiences had been with both students and faculty over his years with the school. I understood the man had clearly paid his dues. He was now ready to take on greater responsibilities and to further expand his influence.

A thoroughly animated Jackie McLean made our trip just fly by.

Through research of Jackie McLean's life some time later, what stuck in my mind were all the hard knocks he had endured along the way. While just twenty years old when he gained the notoriety of performing with Miles and other such luminaries, that period in his life was hardly the "days of wine and roses." His early leader was actually one of Jackie's harshest critics. In his book, *Miles: The Autobiography*, the trumpeter told how he frequently upbraided Jackie for his laziness and not wanting to learn certain standards like "Yesterdays."

Miles explained that all of his heavy criticism of McLean only made him that much better, an eventual master who could play anything. He wrote, "After awhile, when they asked him where he studied music, he'd tell them, 'I studied at the University of Miles Davis.'"

Despite all of his early trials as a player—or maybe because of them—Jackie McLean only continued studying

and improving. It did not go unnoticed. From fledging player, to understudy and woodshedder, to master performer and teacher, Jackie McLean had closed the circle.

Note: In 2000, the Hartt School of Music's Department of African-American Studies was renamed the "Jackie McLean Institute of Jazz." Recognized over the years as one of the nation's top institutions, the program has featured master

classes by a myriad of jazz greats, including pianists Hank Jones, Randy Weston, Barry Harris, and Cedar Walton; saxophonists Jimmy Heath, Yusef Lateef, and Cecil Payne; trombonists Curtis Fuller and Slide Hampton; and trumpeters Eddie Henderson and Wynton Marsalis.

JOHN LENWOOD (Jackie) MCLEAN
alto saxophone, flute, composer, educator
Born: May 17, 1931
Died: March 31, 2006

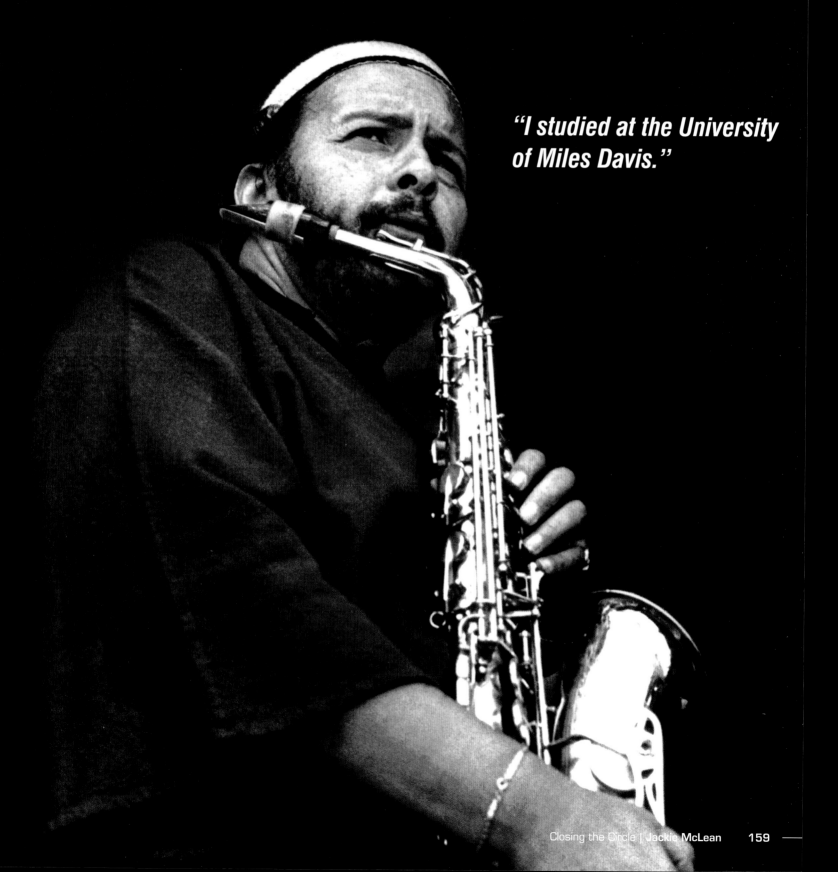

"I studied at the University of Miles Davis."

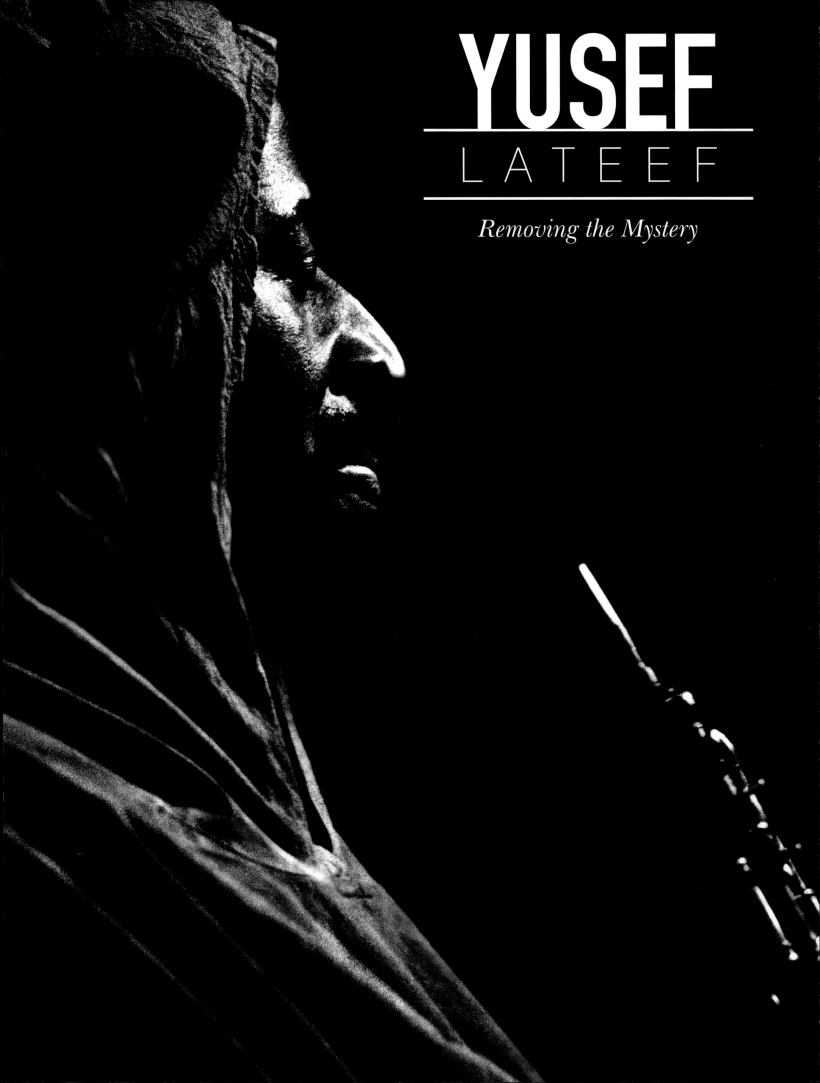

YUSEF
LATEEF

Removing the Mystery

Lateef's drawn-out, distinctive vibrato notes quietly reverberated throughout the room, casting a haunting, trance-like spell. I was mesmerized.

SAN FRANCISCO, CALIFORNIA

"Entranced" perhaps best describes my impressions of the man and his music the first time I saw him onstage leading a small quartet in the early 1970s.

There in the darkened club, shrouded in a lightweight, hooded cape, sat Yusef Lateef, surrounded by an assortment of obscure reed and exotic flute-like instruments: I knew this was not going to be any typical jazz engagement. The atmosphere at times during his set was almost hypnotic. On one number while playing oboe, Lateef's drawn-out, distinctive vibrato notes quietly reverberated throughout the room, casting a haunting, trance-like spell. I was mesmerized.

After that performance, I knew I needed to work with the man one-on-one the next time our paths crossed. I just had to. It was October of 1977, while headlining at Keystone Korner in San Francisco that I caught up with Lateef in person.

Talking with him backstage after his set, I suggested we do an afternoon photo session. He agreed to do the shoot later in the week, offering to meet me in the home where he was staying on Bay Street near Fisherman's Wharf.

In some ways, working with Yusef Lateef that day was unexpectedly surprising, but overall, perfect. Unlike

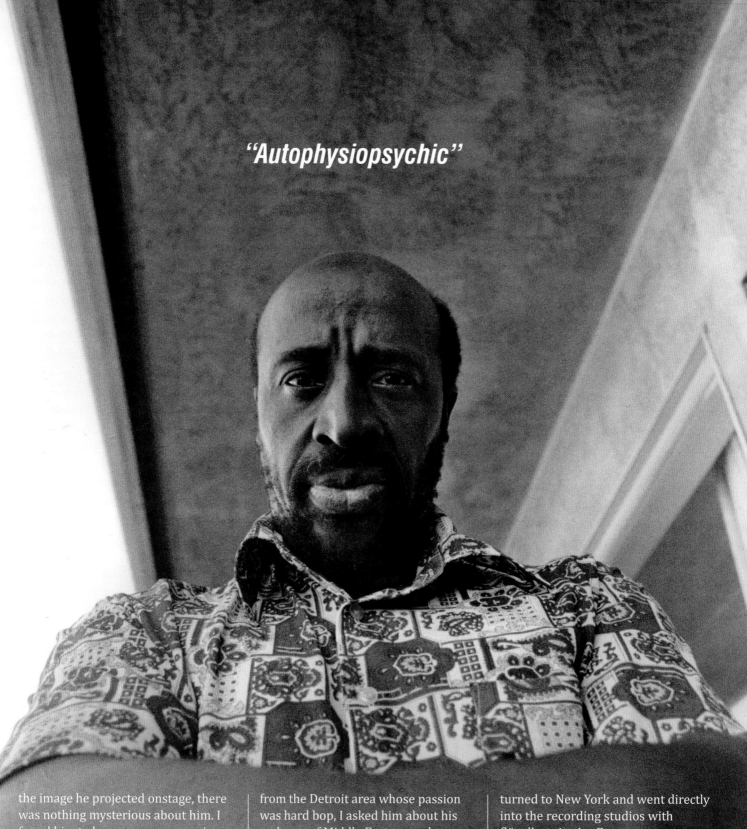

"Autophysiopsychic"

the image he projected onstage, there was nothing mysterious about him. I found him to be very open, engaging, and down-to-earth. During our time together, he exhibited an air of naturalness unlike that of any other artist I'd met. It brought to mind the title of one of his albums, *The Gentle Giant*. We spent an hour or so talking about his current work and taking photographs in and around the home.

Because he had grown up and worked with so many of jazz's greats

from the Detroit area whose passion was hard bop, I asked him about his embrace of Middle Eastern and Oriental musics, and what it was that he felt made him unique from all the others. He mentioned one word, "Autophysiopsychic," that at the time I had never heard of, and wasn't even able to spell correctly, to best describe his work. He told me, "You'll find out what I'm talking about later."

I discovered that after completing his Keystone Korner gig, Yusef re-

turned to New York and went directly into the recording studios with flügelhornist Art Farmer to co-produce, along with Creed Taylor, the CTI album entitled *Autophysiopsychic*. Lateef's surprising creations on that disc—representing more of a laid-back funk and soul sound—were a far cry from any of his previous explorations that I had heard.

Lateef has explained that the word comes from one's spiritual, physical, and emotional self. Looking

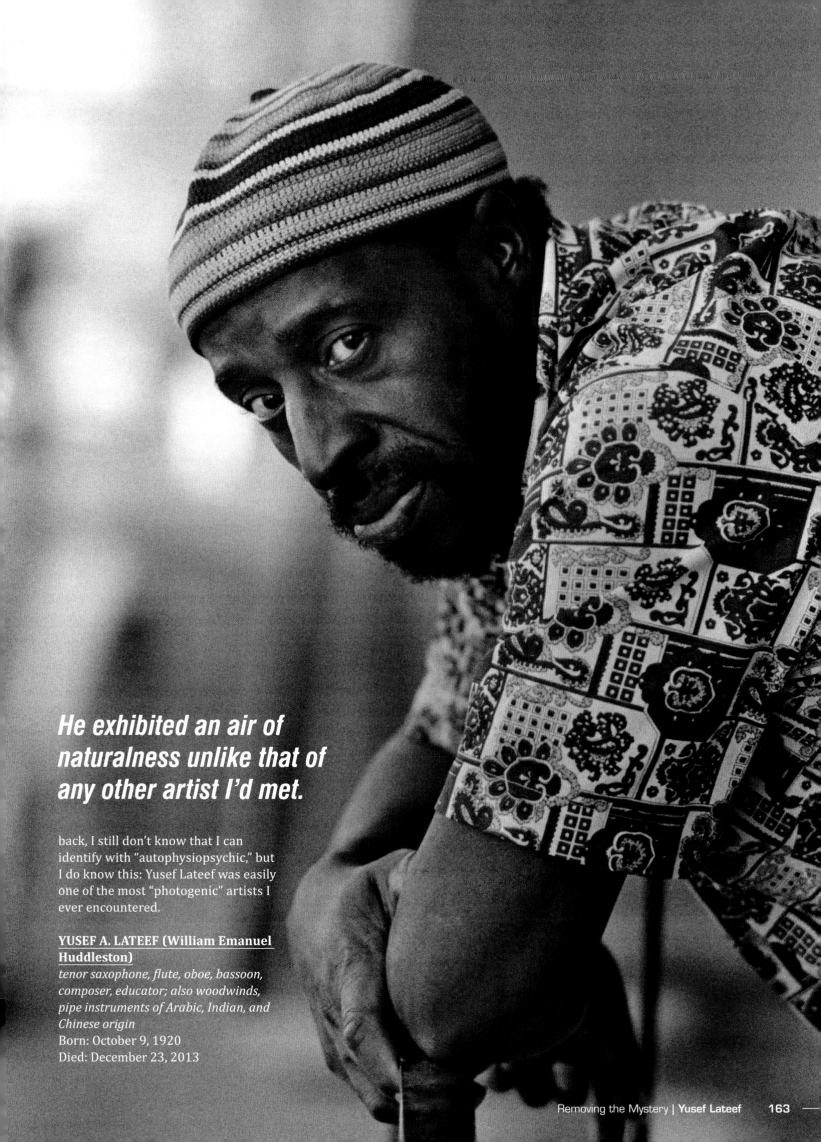

He exhibited an air of naturalness unlike that of any other artist I'd met.

back, I still don't know that I can identify with "autophysiopsychic," but I do know this: Yusef Lateef was easily one of the most "photogenic" artists I ever encountered.

YUSEF A. LATEEF (William Emanuel Huddleston)
tenor saxophone, flute, oboe, bassoon, composer, educator; also woodwinds, pipe instruments of Arabic, Indian, and Chinese origin
Born: October 9, 1920
Died: December 23, 2013

JAMES
MOODY

Hiatus from the Jazz Scene

A powerful soloist whose fountain of ideas and unique brand of humor made him an instant and lasting hit with audiences.

LAS VEGAS,
NEVADA

He was one of the jazz world's elite hard bop tenor saxophonists, a powerful soloist whose fountain of ideas and unique brand of humor made him an instant and lasting hit with audiences. I wondered why I hadn't seen him for so long. The last occasion had been ten years earlier: he was totally in his element then, enjoying the best of times performing with the man who had the most influence on him and his career, trumpeter Dizzy Gillespie.

In the summer of 1977, James Moody's life was clearly different. Here in the entertainment capital of Las Vegas, he was still very much in demand, but jazz at this time was, sadly, on the back burner. Instead of relying on his unique improvisational skills and creative juices night in and night out, Moody's primary role was now centered on sight reading and playing exactly what was scored on the charts. And, as he told me, "... doing lots of doubling."

For Moody, serving as the leading reeds man and resident member for one of the top music production

James Moody performs with Dizzy Gillespie at the 1967 Monterey Jazz Festival.

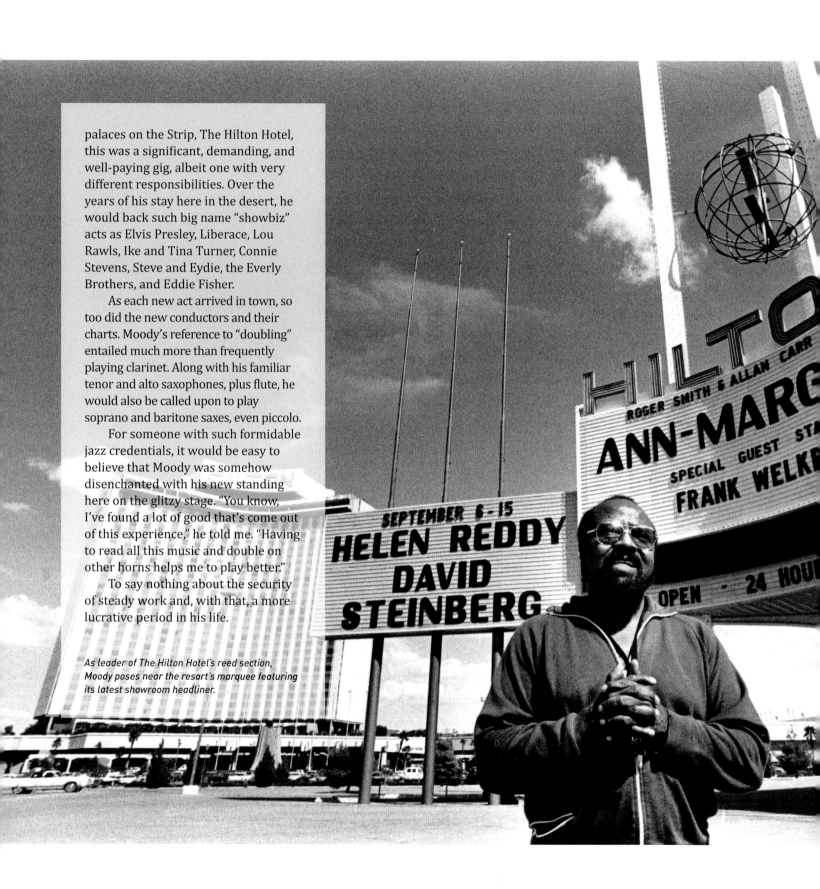

palaces on the Strip, The Hilton Hotel, this was a significant, demanding, and well-paying gig, albeit one with very different responsibilities. Over the years of his stay here in the desert, he would back such big name "showbiz" acts as Elvis Presley, Liberace, Lou Rawls, Ike and Tina Turner, Connie Stevens, Steve and Eydie, the Everly Brothers, and Eddie Fisher.

As each new act arrived in town, so too did the new conductors and their charts. Moody's reference to "doubling" entailed much more than frequently playing clarinet. Along with his familiar tenor and alto saxophones, plus flute, he would also be called upon to play soprano and baritone saxes, even piccolo.

For someone with such formidable jazz credentials, it would be easy to believe that Moody was somehow disenchanted with his new standing here on the glitzy stage. "You know, I've found a lot of good that's come out of this experience," he told me. "Having to read all this music and double on other horns helps me to play better."

To say nothing about the security of steady work and, with that, a more lucrative period in his life.

As leader of The Hilton Hotel's reed section, Moody poses near the resort's marquee featuring its latest showroom headliner.

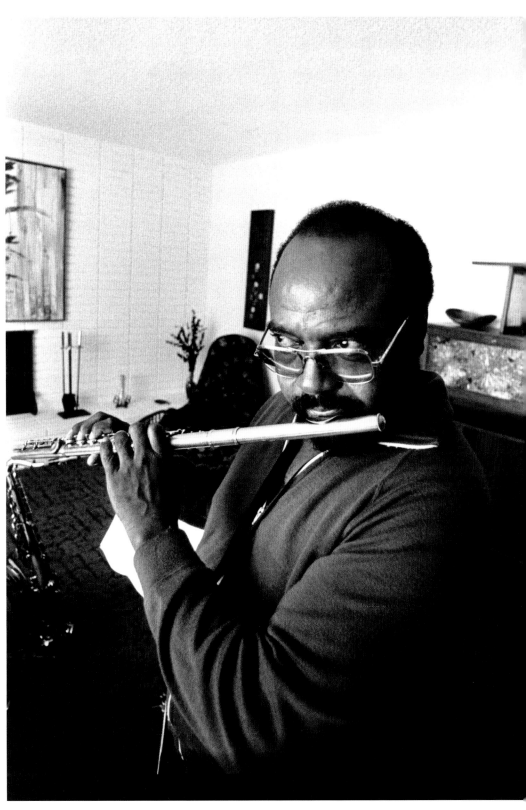

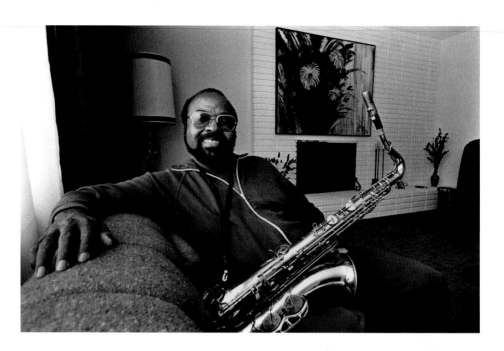

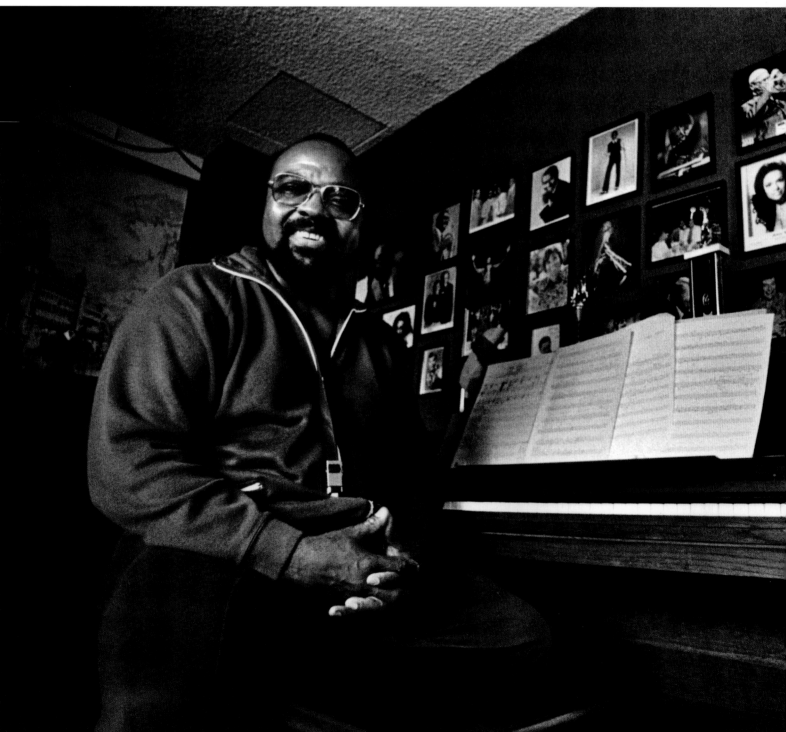

While taking photographs in his home, Moody explained that his current situation also allowed him the flexibility ". . . to work on new compositions and keep on practicing."

Before leaving, he showed me a postcard he had just received from Gillespie, who was in the midst of a three-week engagement at Ronnie Scott's in London. "You should be here," it concluded.

Moody was noticeably pensive. It was obvious that he longed again for that scene. Somehow, I knew it was just a matter of time before he would be reunited with his old boss, back on the road, back in his comfort zone, and back playing jazz steadily like he was meant to do.

Indeed, Moody not only returned to the jazz scene, but left a significant imprint in the music that lasted until his passing.

JAMES MOODY
alto, tenor saxophones, flute, composer
Born: March 26, 1925
Died: December 9, 2010

Somehow, I knew it was just a matter of time before he would be reunited with his old boss, back on the road, back in his comfort zone, and back playing jazz steadily like he was meant to do.

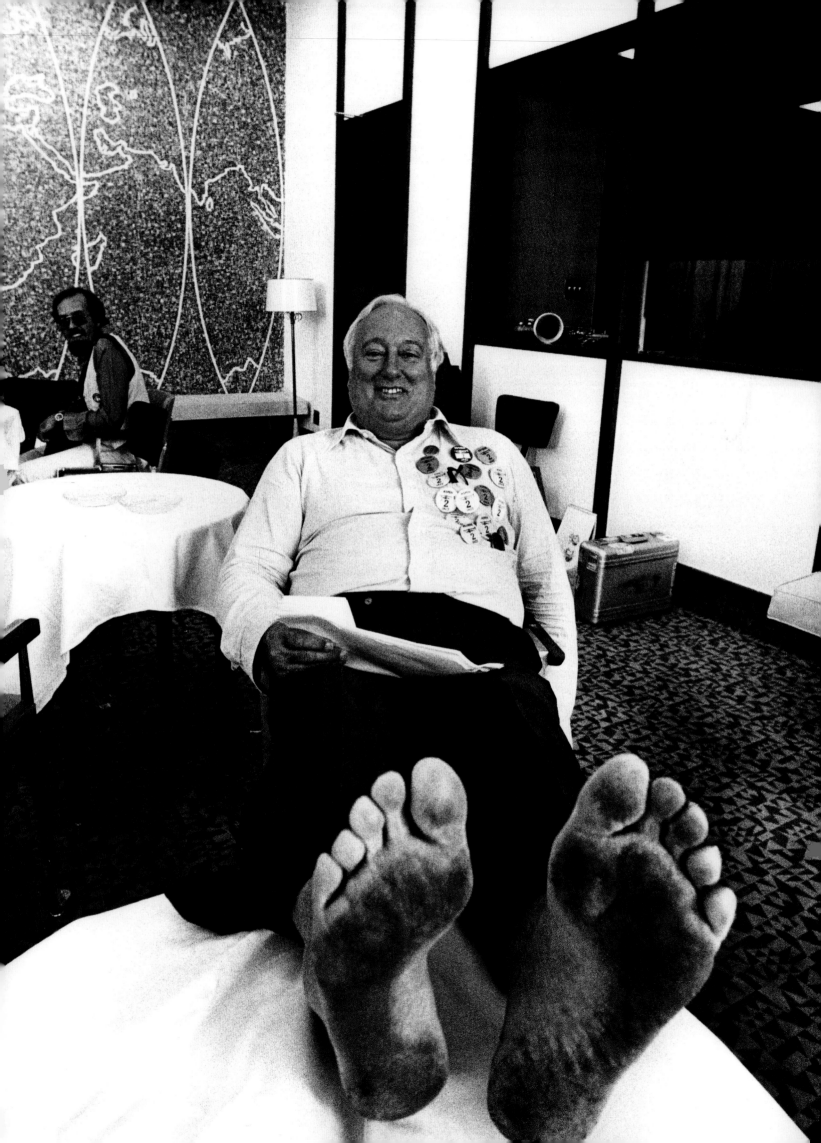

DICK
GIBSON

The Barefooted, Generous Impresario

**COLORADO SPRINGS,
COLORADO**

Jazz wasn't just his passion. Lots of fans have passion. For Dick Gibson, jazz was his obsession.

The difference in Gibson's case was that he had sufficient means to not only make his obsession fulfilling for himself, but lasting and meaningful for thousands of others—fans and performers alike.

A lifelong jazz musician wannabe, Gibson made his mark financially as a wizard on Wall Street. But after becoming thoroughly disenchanted with his business demands and hectic life as a commuter, he left his job as vice president of Lehman Corp. and moved to Denver. While there, the entrepreneur formed the Water Pik Company, and within five years had earned a small fortune when the firm was acquired by Teledyne Technologies.

Although truly in love with the mountain state, Gibson deeply missed the New York jazz scene that he left behind. So much so that in 1962, after a long meeting with his wife Maddie, he decided to become the unofficial jazz ambassador/producer for the State of Colorado.

Right away, he called top-name jazz musicians and got them to commit for the following Labor Day weekend. What began in 1963 at the Hotel

Each year the 500+ attendees who were lucky enough to score tickets for the weekend were treated to a wide variety of jazz performances.

Jerome, a luxurious boutique resort in Aspen, would continue every Labor Day weekend for the next three decades. Whether in Aspen, or at other five-star hotels in Vail, Denver, and Colorado Springs, an invitation to Dick Gibson's Colorado Jazz Party was the hottest ticket going.

Each year, Gibson invited upwards of sixty mainstream jazz artists to appear, paid them generous fees, and insisted they bring their spouses/partners for the weekend. All their expenses—airfare, food, lodging, goodie bags, and other incidentals—were on Gibson's tab. From the day of arrival until check-out, Gibson personally took charge of virtually everything, from providing each musician with red-carpet hospitality all the way to helping produce and direct the various weekend shows.

Gibson's earliest audiences consisted of jazz-loving friends and associates primarily from Colorado. But by the time I visited for the fifteenth anniversary edition in 1978, at the Broadmoor luxury resort in Colorado Springs, devotees on hand were now hailing from points around the globe, as far away as New Zealand. Each year the 500+ attendees who were lucky enough to score tickets for the weekend were treated to a wide variety of jazz performances, often including Gibson's

Opposite: Originator and host of the Colorado Jazz Parties, Dick Gibson puts his feet up to relax before going over the scheduled evening lineup (looking on in the background is pianist Roger Kellaway). The always-on-the-go promoter—who was most comfortable going shoeless both day and night—made sure that every last music and party detail was done to perfection, and that each artist was treated as royalty.

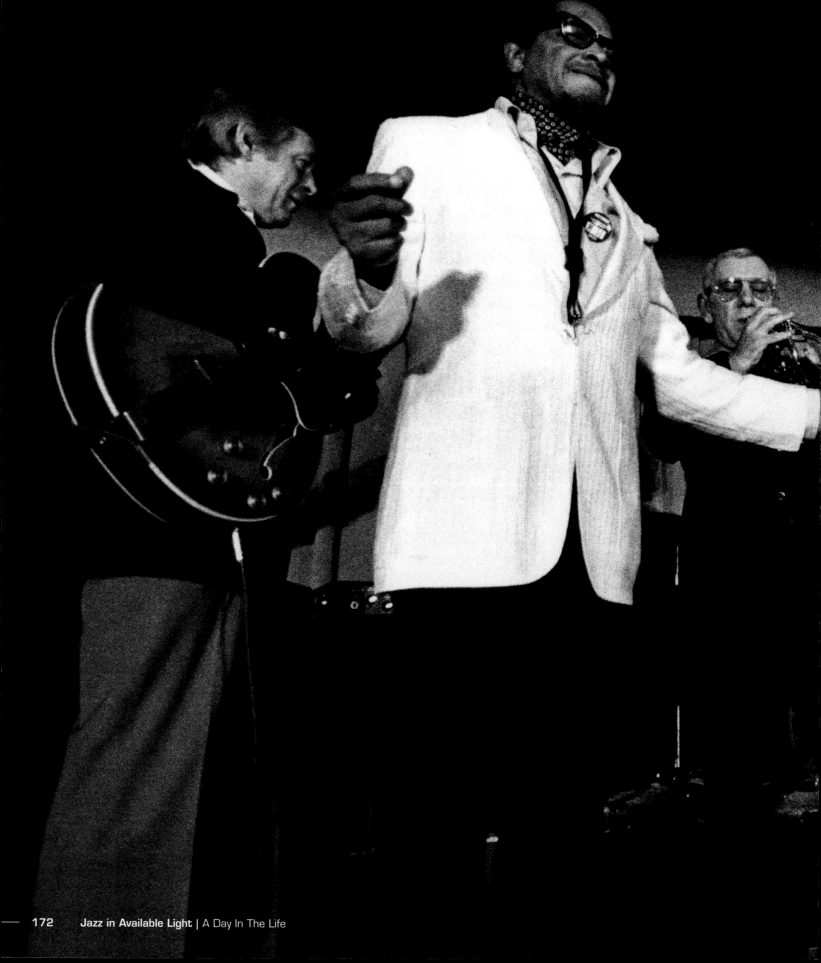

own sets featuring unusual and unexpected combinations of musicians.

Even after his jazz parties had concluded, Gibson's touch as a producer would occasionally have ripples far downstream. In 1972, his pairing of soprano saxophonists Bob Wilber and Kenny Davern, as described by William H. Smith in *The Wall Street Journal*, brought down the house with their rendition of Duke Ellington's "The Mooche." The two

were so taken by both the moment and the audience response that they formed the group "Soprano Summit." For the rest of the decade, Wilber and Davern would not only enjoy frequent club and festival dates throughout the world, but go on to record seven very successful Soprano Summit albums.

One of Gibson's regulars and a true fan favorite was bassist Milt Hinton, who was effusive whenever he talked about the gracious host of the Colorado

jazz parties and the impact he had on the very livelihoods of his fellow musicians. "If it wasn't for Dick Gibson," said Milt, "most of us would have been out of the business long ago."

One of the crowd favorites that brought both a warm feeling of nostalgia and solid swinging was the group consisting of (from left) guitarist Mundell Lowe, tenor saxophonist Illinois Jacquet, cornetist Ruby Braff, alto saxophonist Benny Carter, and trombonist Al Grey.

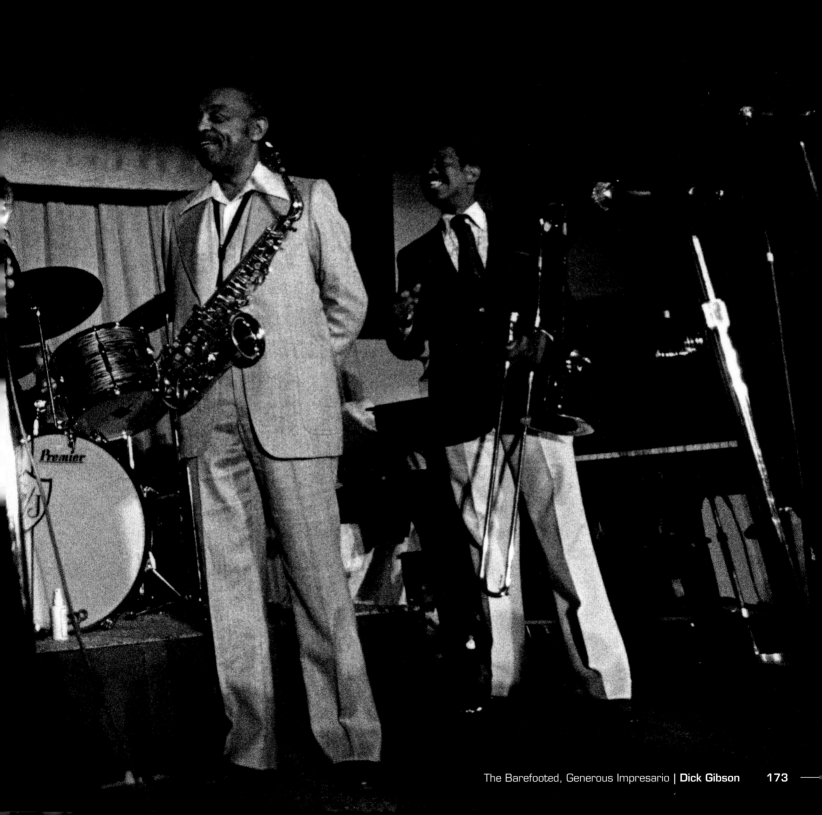

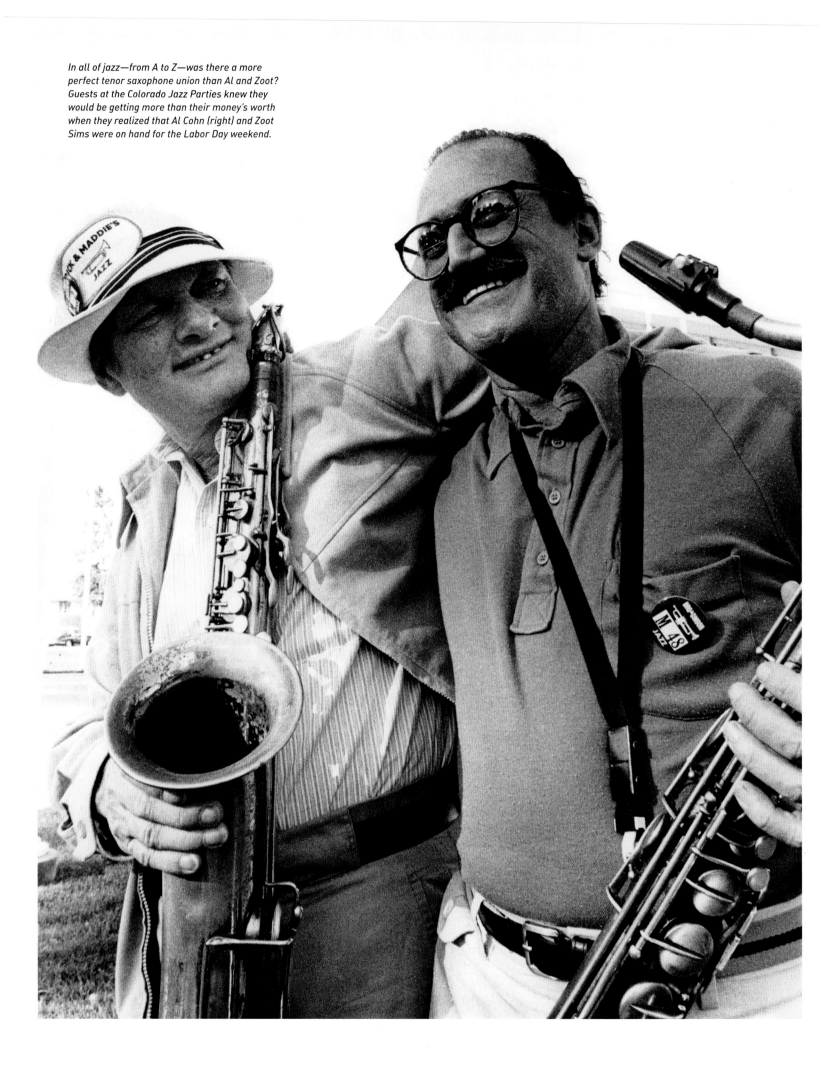

In all of jazz—from A to Z—was there a more perfect tenor saxophone union than Al and Zoot? Guests at the Colorado Jazz Parties knew they would be getting more than their money's worth when they realized that Al Cohn (right) and Zoot Sims were on hand for the Labor Day weekend.

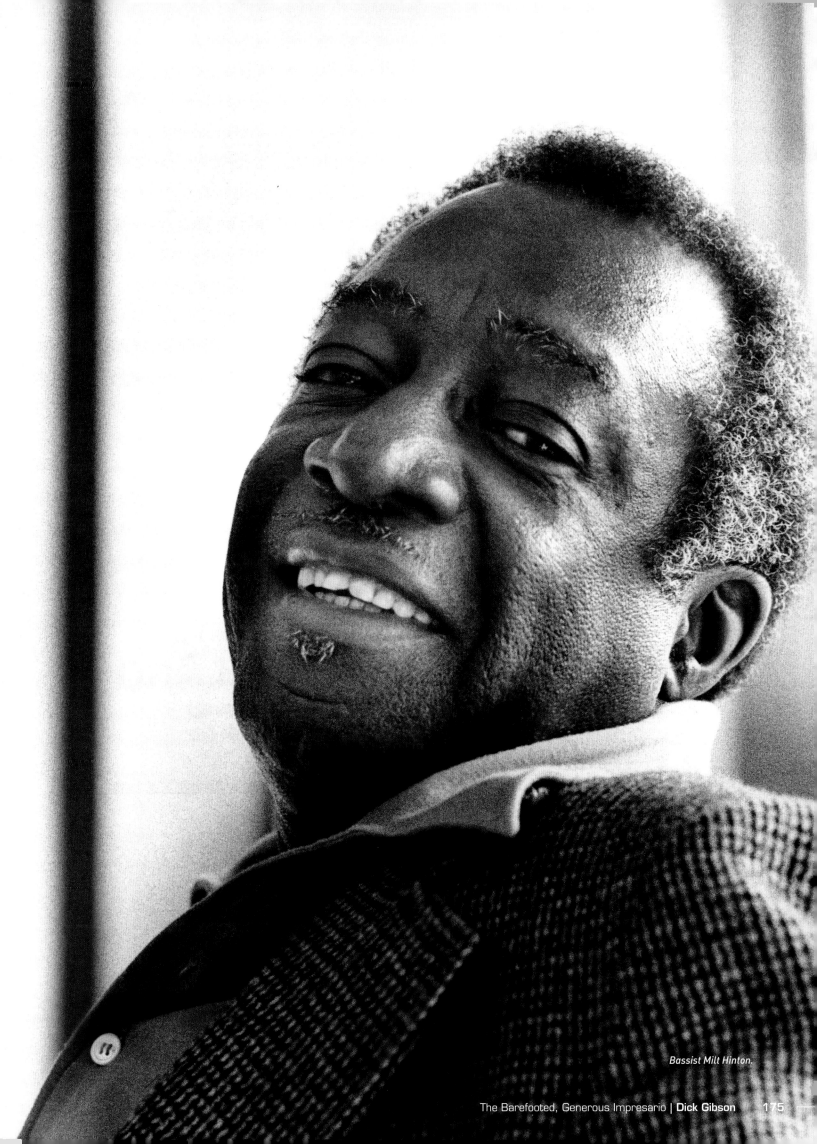

Bassist Milt Hinton.

JOE
HENDERSON

Jazz's Foremost Interpreter

To my mind, he was one of the more complex creative artists I ever encountered. Yet, for every example I could offer of his complexity, he could have just as easily proved its simplicity. Because to Joe Henderson's way of thinking, making the complex seem simple was, as much as anything, largely a matter of being prepared for whatever came his way.

Preparedness for Joe came early and often. Growing up in a family of fifteen children, Henderson heard and listened to everything around him. Among his siblings, their personal choices in music ranged from opera to Bo Diddley, from country/western to Charlie Parker. His first tenor saxophone influences were Ben

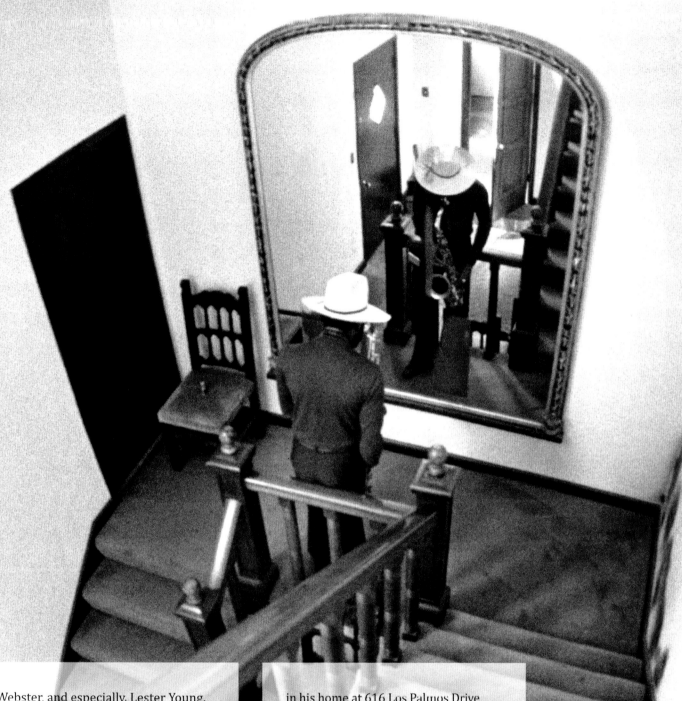

Webster, and especially, Lester Young. In school, if he wasn't deciphering how the sounds of a John Philip Sousa march all fit together, Joe was studying the works of such classical composers as Bartok, Stravinsky, and Schoenberg.

All of these wide-ranging musical influences were paramount in his evolvement of becoming one of jazz's most complete and well-rounded tenor saxophonists. Being fully at ease, playing in virtually any musical style with the most divergent of musical minds, was just as natural for Henderson as learning another language.

It was in May of 1981 that I met with Joe Henderson for a photo session in his home at 616 Los Palmos Drive near Mount Davidson in San Francisco. When not on tour, Joe was enjoying a period in his life where he was parlaying his many learned skills as a lifelong "jazz student" into that as an inspirational jazz teacher—giving private lessons at home, as well as conducting clinics at various universities.

If you were one of his fortunate students, forget charts. He taught improvisation. You learned everything by rote. Typically, he would play a few

Joe Henderson practices in front of a mirror on the landing of his stairs.

bars on the piano; your task was to commit it to memory and play it back on your horn. After another four bars, repeat until memorized. And so on.

For Joe, sharing knowledge in his own special way became a source of great pride; many of his students would go on to land gigs with well-known bands or become leaders of their own groups.

The word Henderson liked to use to describe what made him, his playing, and the way he led his life unique, was *interpreter*. Among other things, I was intrigued by what I had heard about Joe's multilingual capabilities (he was fluent in five languages, including being able to carry his own weight in Japanese). When I asked him about it, he said, "For me, it's simple. You play it back, you interpret what you're hearing, you form your words in response . . . suddenly, it all makes complete sense.

"It's like listening to new music that you haven't heard before," he continued. "You interpret how the sounds all fit together. What you play just becomes a natural extension of what you've already heard."

Near the end of our shoot, Joe glanced out his front window and ran over to his telescope where he witnessed a dangerously low-flying aircraft over the South Bay whose pilot had appeared to have flown off-course.

Recalling that event sometime later, I thought how the pilot—in that single instance—did what my host that afternoon had to do each and every day of his career: Improvise to survive.

"You interpret how the sounds all fit together. What you play just becomes a natural extension of what you've already heard."

JOSEPH A. (Joe) HENDERSON
tenor saxophone, composer, educator;
also flute, soprano saxophone
Born: April 24, 1937
Died: June 30, 2001

PHIL
WOODS

The Little Jazz Mecca

DELAWARE WATER GAP, PENNSYLVANIA

Campers, hikers, rafters, and rock climbers flock here by the thousands to enjoy this idyllic little hamlet on the Appalachian Trail in the Pocono Mountains region, part of the largest national recreational area in the eastern United States.

What they don't know is that Delaware Water Gap, this little gem of fewer than 1,000 residents—along with a scattering of other nearby burgs both in Pennsylvania and across the Delaware River in New Jersey—boasts more well-known and up-and-coming jazz musicians per capita than perhaps any area in the world.

So, other than the bucolic setting and relaxed, laid-back lifestyle, what's the draw? Simply, New York City—the world's recognized jazz mecca—is about an hour's drive away. Of "The Gap's" most acclaimed jazz denizens, alto saxophonist Phil Woods was proving

The famous little town and its most famous of all jazz stars, Phil Woods.

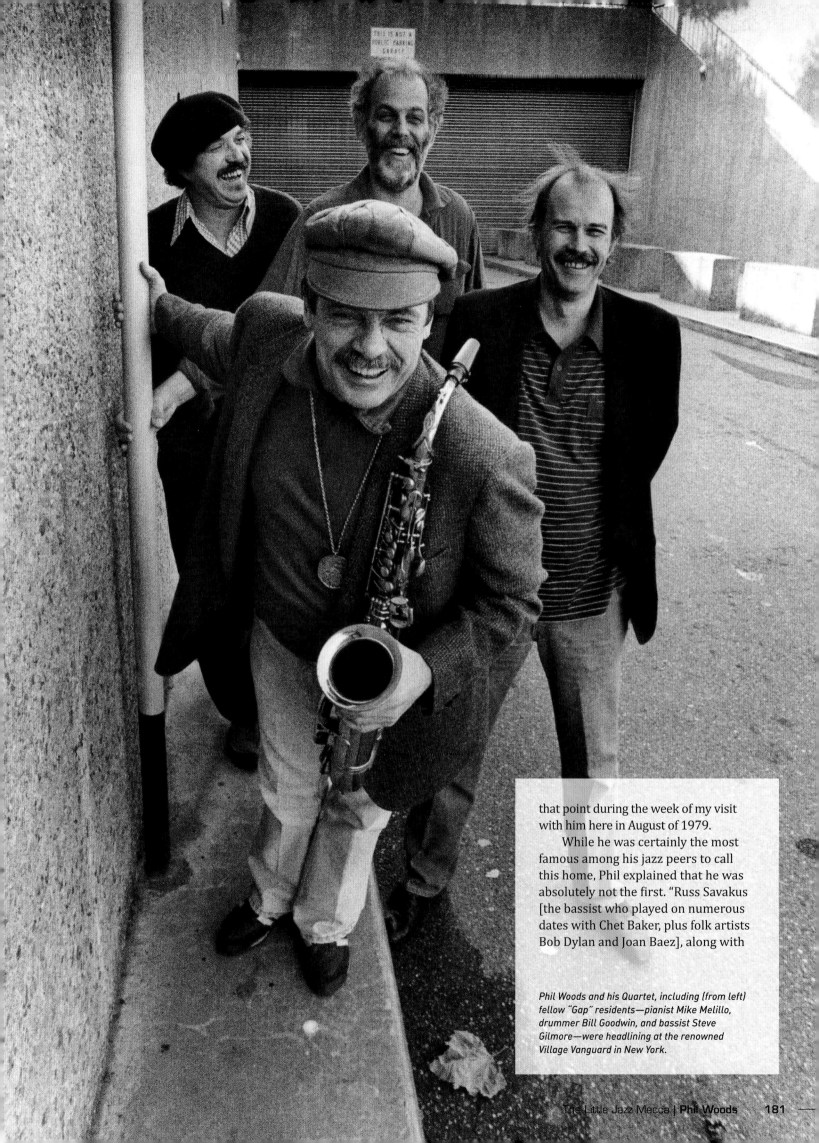

that point during the week of my visit with him here in August of 1979.

While he was certainly the most famous among his jazz peers to call this home, Phil explained that he was absolutely not the first. "Russ Savakus [the bassist who played on numerous dates with Chet Baker, plus folk artists Bob Dylan and Joan Baez], along with

Phil Woods and his Quartet, including (from left) fellow "Gap" residents—pianist Mike Melillo, drummer Bill Goodwin, and bassist Steve Gilmore—were headlining at the renowned Village Vanguard in New York.

Left: Woods catches up with long-time "Gap" notable, vocalist/pianist Bob Dorough, at the popular Sundance Leather and Hat Shop.

Below: Woods relaxes on the front porch of his Delaware Water Gap home.

Bob Dorough, were among the first to move here," he told me.

Just a few of the other local artists attaining notoriety included saxophonists Al Cohn, Dave Liebman, Jerry Dodgion, and George Young; trombonists Urbie Green and Steve Turre; pianist Hal Galper; and vocalist Dave Frishberg.

What may have helped bring many of the jazz world's future stars to this region was Phil's teaching success in the mid 1960s, when he served as jazz director of the Ramblerny Summer Arts Camp in New Hope, Pennsylvania, about forty-five minutes south of here. When not on tour, Woods continued giving private lessons in his spare time to understudies from Pittsburgh, New York City, even as far away as Boston. "I see my students an average of once every month or two," he said.

What I recognized early on during my visit with Phil Woods was that this was a most principled jazz man steeped in the belief of always giving back—to his peers, to aspiring young musicians, and to the community at large—not merely looking to make a name for himself. I was well aware of his devotion to, and fondness for, two personal heroes who helped champion his start and gave him the confidence to succeed—Benny Carter and Dizzy Gillespie.

It was his first teacher, Harvey LaRose, who introduced the great works of Carter in their early sessions, providing the young alto saxophonist with the solid jazz foundation he needed. What would

On the following pages:
Page 184: Phil and Benny Carter performing together at Dick Gibson's Colorado Jazz Party in 1978.

Page 185: Renewing old times, Woods and Dizzy Gillespie share a light moment during a break in their performances at the 1977 Russian River Jazz Festival in Guerneville, California.

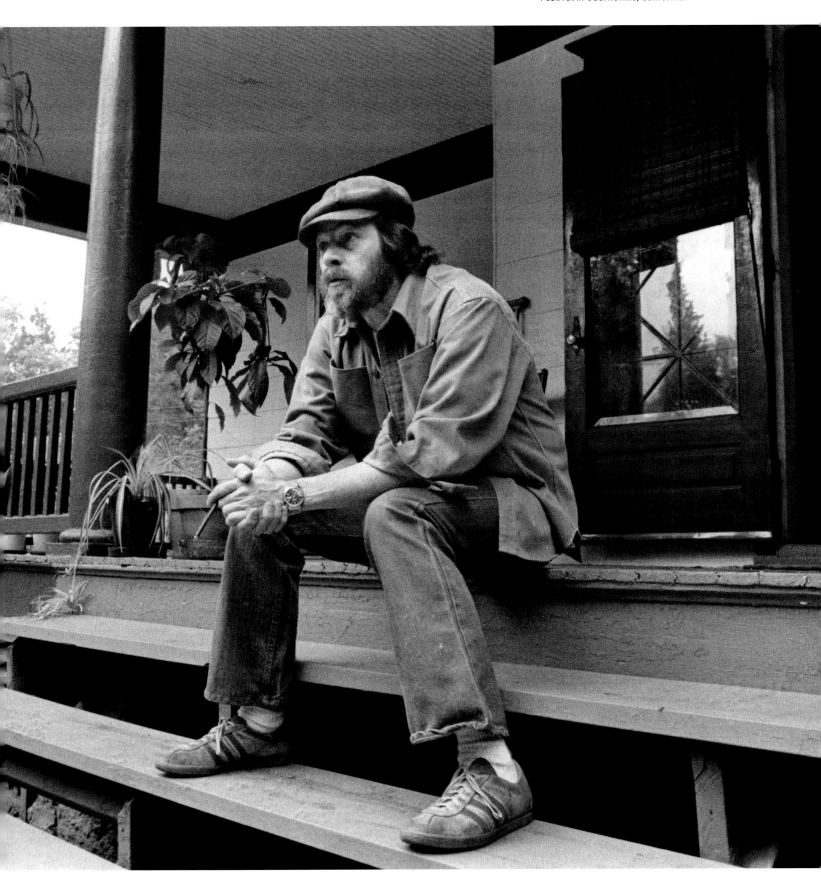

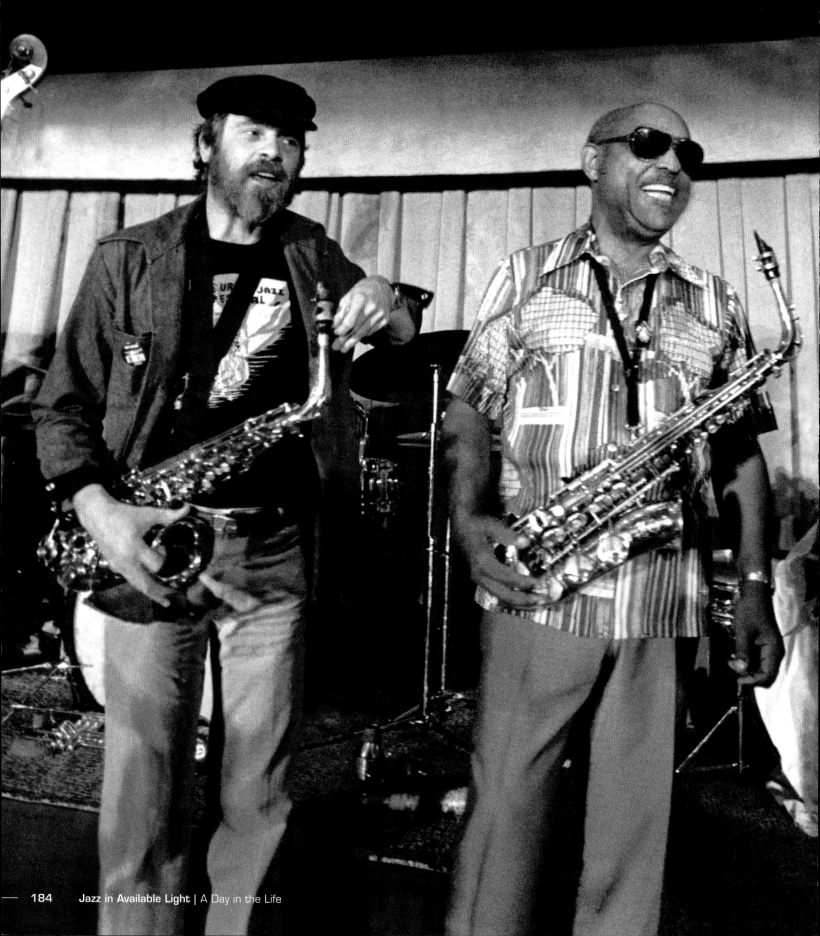

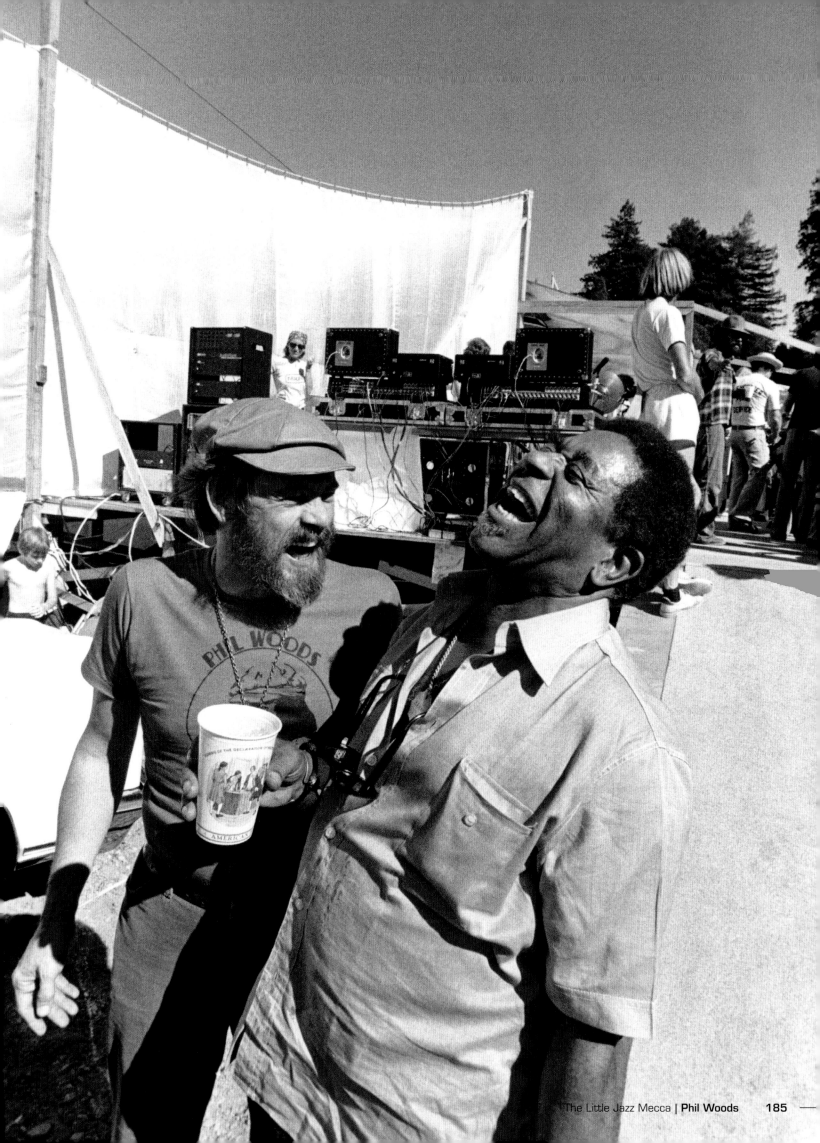

develop from those beginning lessons would only intensify. Not only would Benny become a dear friend and mentor of Phil's in the decades ahead, but the two would enjoy a lifelong bond, even recording together on numerous occasions.

The other jazz icon in his life may have been the most instrumental of all in providing Woods with the much-needed support and inspiration to persevere, even during times of self-doubt and insecurity. It was following a State Department tour of Latin America and the Middle East in 1956, where the listening public would get a sense of the depth of Phil's devotion to Gillespie.

During that tour, Dee Gee Records Producer Dave Usher recorded a three-volume set, *Dizzy in South America: Official State Department Tour, 1956*, featuring the trumpeter's band led by director/arranger Quincy Jones. Along with the music were personal interviews of the stars, including the following rite of passage story offered by Phil Woods:

"One night, at a club, I was down. I was saying, 'I'm not going anywhere. I'm a white guy in this music.' Hearing me whining and crying the blues, Art Blakey and Dizzy kidnapped me. They put me in a cab and took me to Dizzy's place in Long Island. Dizzy sat me down and said to me: 'Bird gave it to everybody. To all races. If you can hear it, you can play it.'"

The two would frequently cross paths throughout their musical careers.

At this time in his life, the thing that Phil Woods was most excited about was Delaware Water Gap's upcoming second annual Celebration Of The Arts (COTA) Festival, set for the weekend after Labor Day.

Phil described to me how he and a couple of his close friends had sat down for a discussion during the previous summer at Deer Head Inn, the unofficial "Home of Jazz in the Poconos" club since the end of World War II. There were a lot of good jam sessions going on that night, with all kinds of area musicians lining up to hit the bandstand. He turned to his fellow business partners—Rick Chamberlain, principal trombonist with the New York City Ballet Orchestra, and local tavern owner, Ed Joubert—and said, "We could have a helluva festival if we moved it outdoors."

Note: Little did they know that what began that year on a shoestring with several jazz groups playing on borrowed risers and a jerry-rigged bandstand before a couple of hundred people in the park, would become a celebratory, three-day event that has survived for nearly forty years. The September weekend COTA Festival continues to attract thousands of fans to see and hear at least twenty area bands, all drawn from musicians who live, or have lived, in the surrounding environs. The non-profit festival allows no outside corporate support, cultivates interest in the arts, and provides college music scholarships to worthy high school players. And to make certain that everything is kept on the up-and-up, Phil told me that the policy will always remain the same: "Everyone gets the same bread—$100—to play."

PHILIP WELLS (Phil) WOODS
alto saxophone, composer, educator; also clarinet, piano
Born: November 2, 1931
Died: September 29, 2015

Among fellow musicians, he was recognized unequivocally as "the King." For Phil Woods, who was so personally and professionally impacted by the preeminent composer/arranger, leader, and instrumentalist, Benny Carter (below) was, ". . . the consummate gentleman of the jazz world."

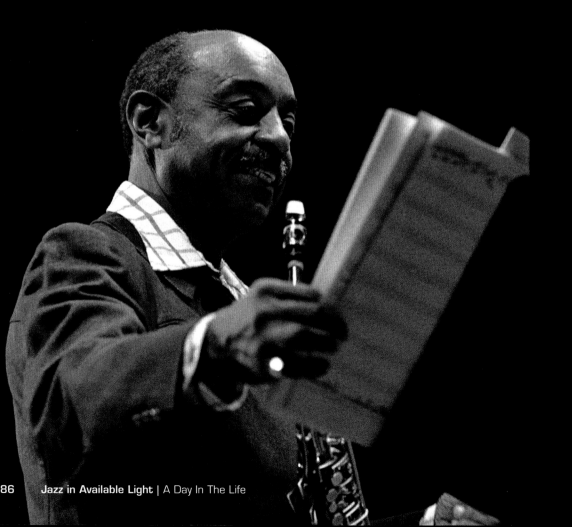

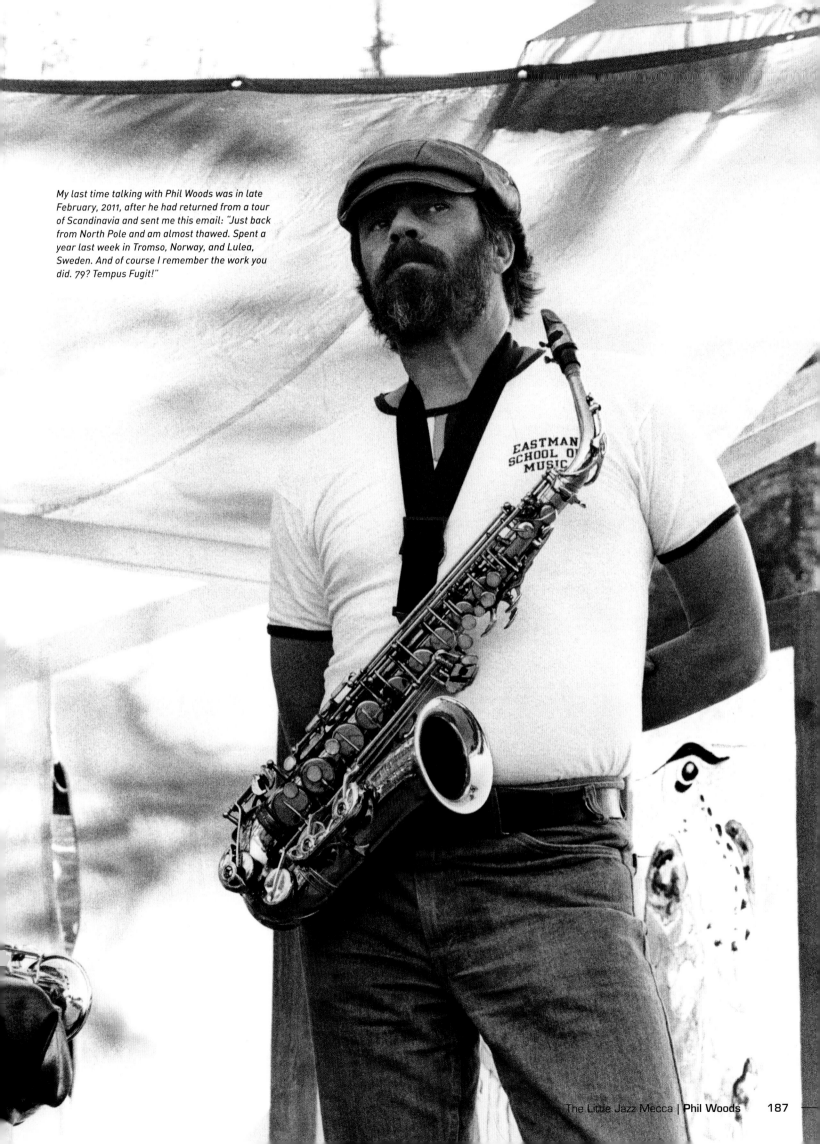

My last time talking with Phil Woods was in late February, 2011, after he had returned from a tour of Scandinavia and sent me this email: "Just back from North Pole and am almost thawed. Spent a year last week in Tromso, Norway, and Lulea, Sweden. And of course I remember the work you did. 79? Tempus Fugit!"

It was a whirlwind period in the guitarist's life . . . her short life.

When we met that summer afternoon in 1984, twenty-six-year-old headliner Emily Remler had just completed her second successful week-long gig in New York in as many years—this time at Lush Life.

Two years earlier, leading a trio at the Blue Note with bassist Eddie Gomez and drummer Bob Moses, she had already begun turning lots of heads. Not only was she winning over a youthful crowd of new listeners—as well as surprising plenty of long-standing players and jazz aficionados—she was also drawing high praise from some of the music's most revered guitar veterans.

For someone who had gone from not being able to read a note of music ten years earlier, to now drawing the attention of the jazz world's heavyweights, this was heady stuff.

I caught up with Emily during a soundcheck at the Concord Summer Festival as part of her west coast tour. Following their scheduled evening performance, the quartet would head the next day to Coast Recorders in San

Everything at that time appeared to be going her way.

Remler, in a rehearsal session with her quartet, including (from left) trumpeter John D'Earth, bassist Eddie Gomez, and drummer Bob Moses.

Francisco to produce her fourth Concord Jazz album.

Everything at that time appeared to be going her way. Later in the afternoon, I sat down with Emily at her hotel. She was bubbly, excited about all the recognition and exposure she was getting. On the heels of her previous recordings and the favorable reviews resulting from working with her current quartet, Emily was now in demand . . . just about everywhere.

Already, she had completed three separate tours of Europe, which had opened up a wide variety of playing opportunities. The guitarist was featured as guest artist at the Berlin Jazz Festival, and similarly, in many of the different countries' popular jazz radio broadcast programs. Along the way, she was feted with such notables as pianist Tommy Flanagan and guitarist Herb Ellis, in duo dates with pianist and then-husband Monty Alexander, and

with the John Clayton Orchestra in big band productions . . . even backing such singers as Nancy Wilson and the Brazilian Astrud Gilberto.

On one of her last stops at the Montreux Jazz Festival in Switzerland, she was thrilled to have learned that *Down Beat* magazine had announced the results of its International Critics Poll: for the second time, she was top guitarist in the "Talent Deserving of Wider Recognition" category.

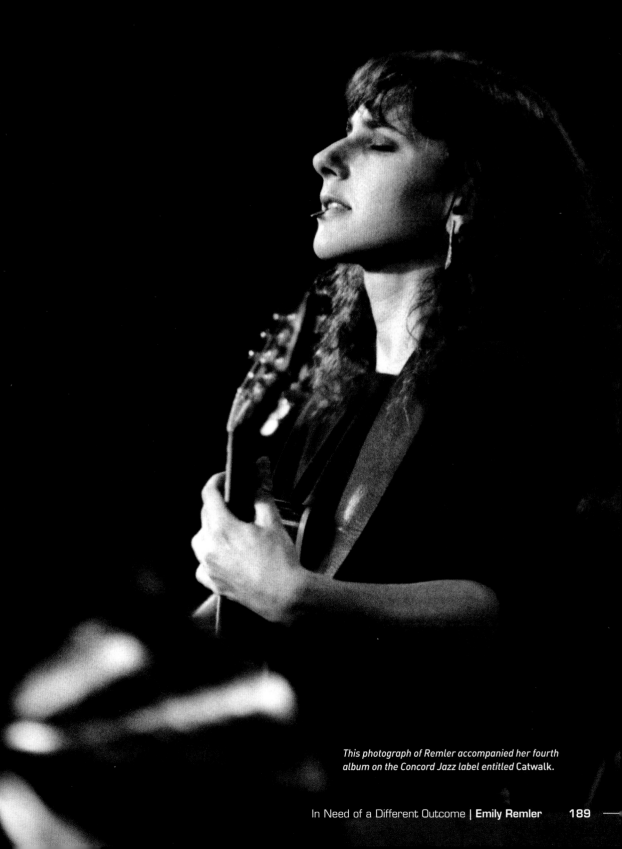

This photograph of Remler accompanied her fourth album on the Concord Jazz label entitled Catwalk.

In addition to sharing all of her most recent musical meanderings, Emily was enthusiastic about heading back into the studios and, for the first time, recording an album consisting entirely of her own compositions. It had been a project in the making for quite some time.

Writing and playing her own works was a significant milestone for Emily. "There's a lot of emotion in there," she told me about the songs she had written for the album. "They bring out a lot of my experiences. One of the tunes I'm calling 'Five Years,' because it took me five years to write."

Having already proven that she could fit in with the most seasoned artists playing any style of music, I asked Emily if she had one wish, who would she choose to have in her own band?

"It's already happened!" she burst excitedly. "I used to say, 'If I could play with Eddie Gomez, I could die right after that, happy.' And I've done that now. I really can't think of anyone I would rather play with."

In late 2016, more than three decades after that August afternoon, I reached out to Gomez for his recollections of Emily Remler from that time.

"She was committed," he told me. "She had that feeling. She loved Wes (Montgomery), and had that same swinging, melodic vibe—not [as] a clone—but she had that essence about her. There were fewer women around like her back then. She was a real stylist."

In the chapter entitled "Emily," from his book, *Waiting For Dizzy*, critic Gene Lees shared what made Remler especially proud was her sense of time and her comping abilities. Foremost in Emily's mind was to make sure that everyone else in the group sounded good.

I shared that point with Eddie, who remarked, "Absolutely. She didn't play a lot of notes, and was not ostentatious. She left a lot of room for the others in the band."

Gomez, who spent eleven years working with Bill Evans, one of jazz's most deeply-sensitive pianists who could reach listeners to their very core, likened the guitarist to some of the most tasty keyboard players. "She

came to the table with certain sensibilities . . . you immediately thought of pianists like Wynton (Kelly) and Red (Garland). It was all about her swing, that understatement. She was very musical."

After that weekend, I never got to see Emily Remler again.

In his final chapters, Lees wrote: "In May of 1990, I got a call from a friend who told me Emily had been found dead in her hotel room in Sydney, AustraliaThe sensitivity that makes it possible to produce good art makes life painful for those who possess it. Chemicals may not enhance the creativity, but they dull the pain, or seem to, for a little while. In the end they add to it."

I asked Eddie about his observations of Emily during the time they were together. "I had no sense there was anything wrong or that she was having any issues," he said. "When she came to the bandstand, she was happy, ready to play. As for her private life, I felt there was an emptiness . . . maybe [a lack of] love. Whatever happened, I sensed she channeled that into her music, tried to fill it with her playing."

When I shared with Gomez Emily's quote from so many years ago—about how he was the one musician who had fulfilled her wish professionally— Eddie was moved. It was something he hadn't heard before. "She was a special person, had an aura about her. There was something almost 'golden' about her. She made a great contribution and deserves her place in guitar history. She truly enriched our world."

EMILY REMLER
guitar, composer
Born: September 18, 1957
Died: May 4, 1990

"I used to say, 'If I could play with Eddie Gomez, I could die right after that, happy.'"

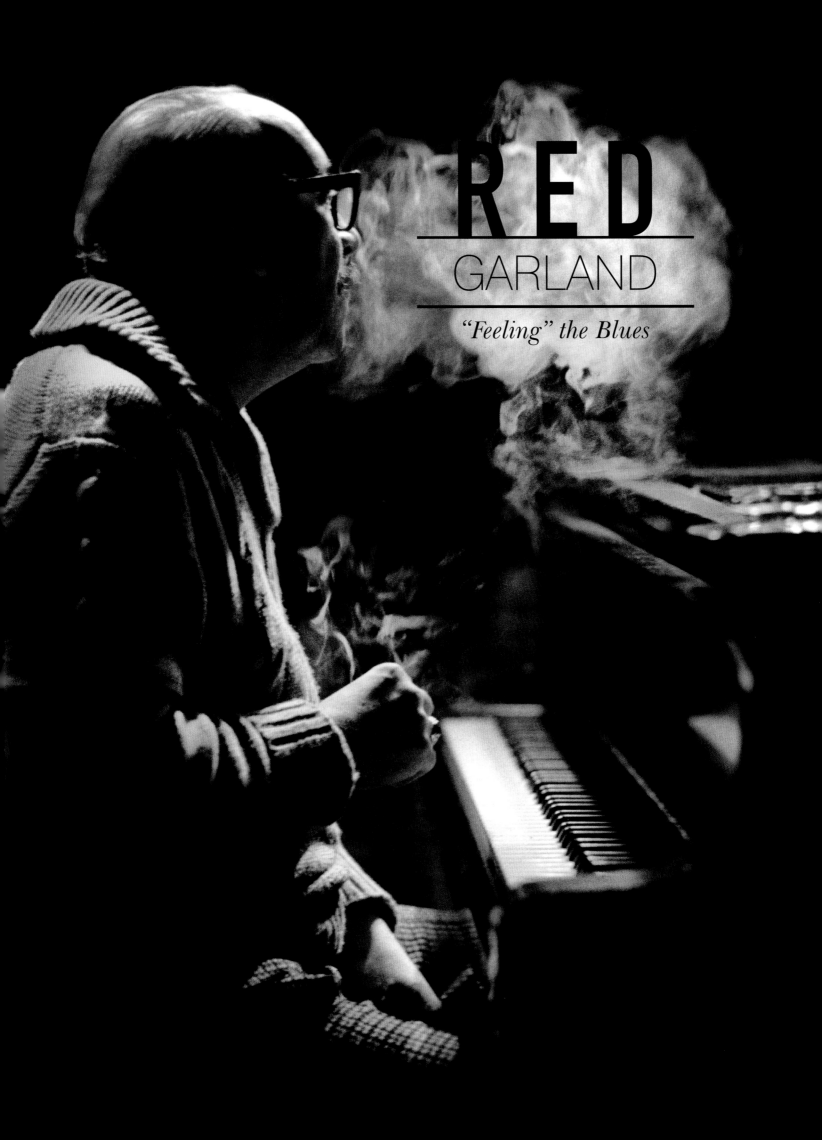

RED
GARLAND
"Feeling" the Blues

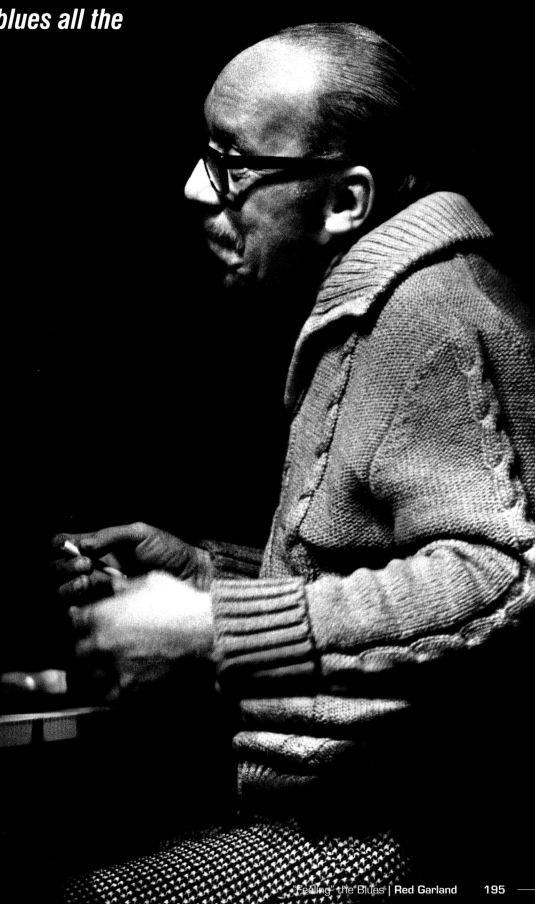

Here was the sublime piano master whose rich block chords made you "feel" the blues all the way to your core.

As a teenager who knew nothing about jazz, about all it took to become hopelessly addicted to this exciting new music and help set the stage for what would follow, was to hear Red Garland for the first time on the radio.

Bored while driving around late one night near my Midwestern home, I dialed across a spectrum of static, suddenly landing on the 50,000-watt clear channel AM radio station KSL in Salt Lake City. I was just in time to catch the theme song of emcee Wes Bowen's "All That Jazz" program. This most soulful pianist, backed by bassist Paul Chambers and drummer Art Taylor, was playing his composition, "Blue Red."

Pretty much from that time forward, I sought out everything I could find of Red Garland's music. For me, he was the embodiment of the blues.

When he began recording as the leader of his own trio in 1959, on the heels of his incredible run as pianist with Miles Davis's first great Quintet, the jazz public finally got to appreciate the solid, deep groove that was purely trademark Garland. Here was the sublime piano master whose rich block chords made you "feel" the blues all the way to your core.

My only personal exposure with Garland and his rich signature sound

Drummer Philly Joe Jones.

came toward the twilight of his career, some time after he had returned to assist his ailing mother in Dallas and lapsed into semi-retirement.

It was kind of a last hurrah for Red in 1977, when producer Orrin Keepnews signed him, along with bassist Leroy Vinnegar and drummer Philly Joe Jones, for a record date and engagement at Keystone Korner in San Francisco.

For Garland, it was an occasion to reflect on all the previous good times, in the company of stellar rhythm mates from his past. Later that week at his hotel, when I shared with him the early impact he had made on me as a newcomer to jazz, he appeared noticeably touched. It was an

enjoyable, easy-going time together, just the two of us. He was especially upbeat when he talked about what it was like to work once again with Philly Joe from their great days with Miles and Coltrane.

Following our photo session, as I was about to leave, I sensed a slight change in his demeanor, almost a feeling of resignation. Perhaps it was the realization of what would soon follow.

That time always comes . . . the time when you can no longer return to the well.

WILLIAM MCKINLEY (Red) GARLAND
piano, composer
Born: May 13, 1923
Died: April 23, 1984

WEATHER
REPORT

The Early "8:30" Tour

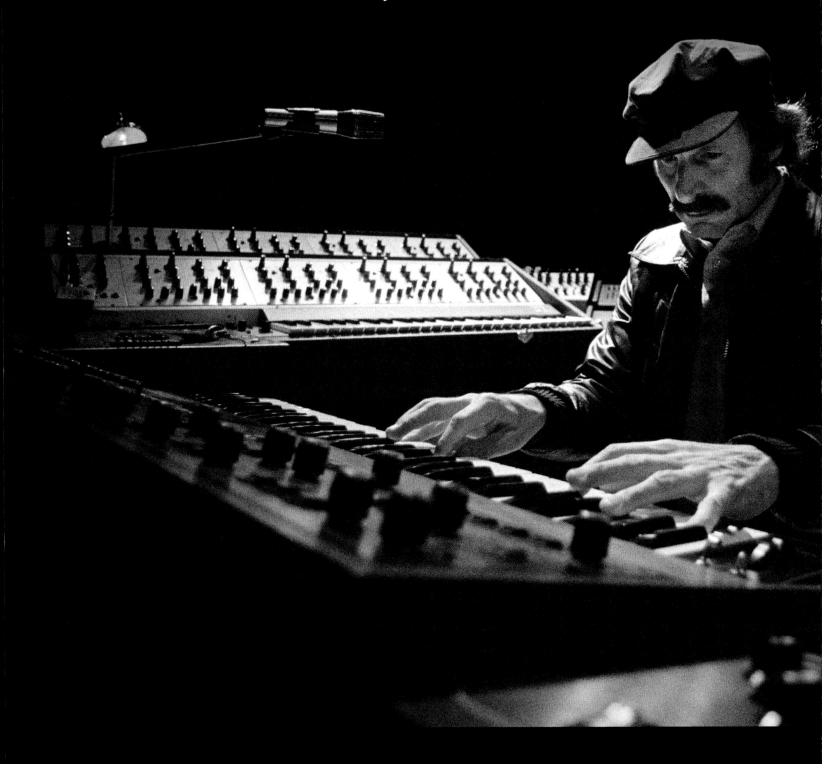

When they launched into Zawinul's huge hit, "Birdland," the place came unglued.

Keyboardist Joe Zawinul.

If you think back to some of the more memorable experiences that occurred in your life, you realize they were largely unplanned and unexpected . . . they just come out of the blue.

The words, "Weather Report 8:30," immediately remind me of one of those times.

It was late 1978, when Weather Report, recognized as the leading jazz fusion band, headed by keyboardist Joe Zawinul and saxophonist Wayne Shorter, announced the kickoff of their upcoming world tour. The new quartet, now featuring the electric bassist Jaco Pastorius and drummer Peter Erskine, would be performing across the globe in more than sixty cities.

One of the band's first live dates was in November at the Berkeley (CA) Community Theatre, a Grecian-style 3,500-seat hall located on—of all places—the Berkeley high school campus close to downtown. I immediately felt the good vibes and camaraderie among each of the players after seeing them during the afternoon soundcheck. I sensed something exceptional was in store.

From the opening fireworks that night, it was clear this was going to be a rollicking evening, one that most likely would never be witnessed here again. Spread out across the wide stage, the high-energy foursome sounded at least twice its size. When they launched into Zawinul's huge hit, "Birdland," the place came unglued.

Right away, I knew it was going to be impossible to capture any tight group shot of all four stars. Zawinul's keyboards arrangement was situated at the extreme left of the stage, while Erskine's drum kit was set far to the rear. Jaco, with his lively, inspiring jack-in-the-box forays across the floor, presented a whole different set of problems.

After the finale, I headed backstage, determined to get a photo

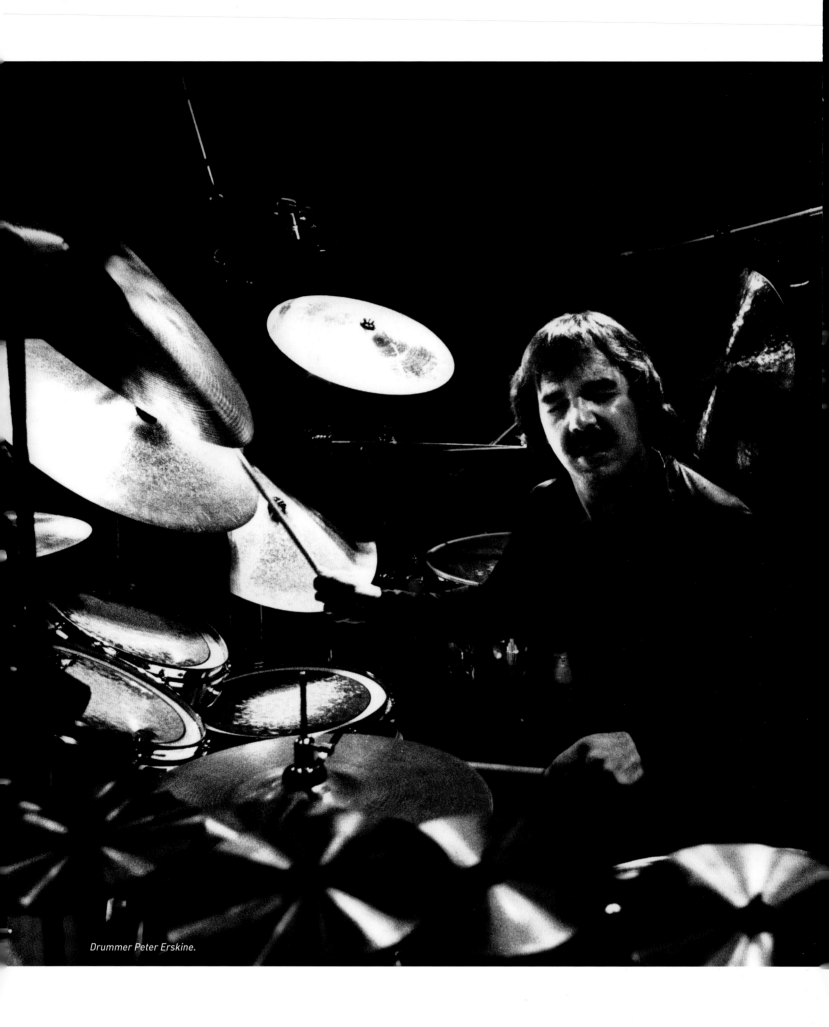

Drummer Peter Erskine.

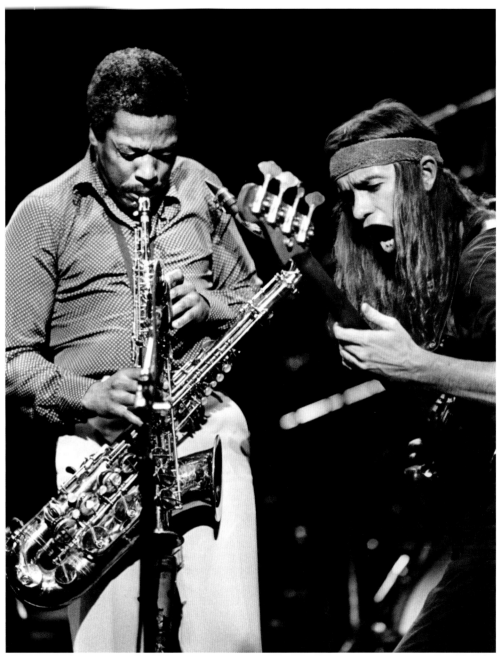

of the quartet together. The scene behind the curtains was bedlam. Weather Report's crew and managers were scrambling, urging everyone to pack up and get ready to leave. I managed to pull Peter Erskine aside and persuaded him to grab the others in one of the backstage dressing rooms for a quick shot.

Soon we had three of the members together, but Zawinul was otherwise preoccupied with fans and hangers-on. Finally, all four were on hand, but were being yelled at to hurry up so they could make their connections.

Thinking quickly, I grabbed a makeshift bench for them to sit on, but because the room was so small and confining, I knew it would be hard to pull off a shot. The only piece of glass I had that would fit them all on the bench was a very wide—but also very slow—20 mm wide angle lens (f-stop 3.5). A proper exposure meant using a shutter speed of 1/15 of a second. To complicate matters, Jaco barely had enough room at one end of the bench to even fit. Wayne, at the other end, could have moved a little to make more room, but he remained stationary.

Above: Soprano saxophonist Wayne Shorter joins with electric bassist Jaco Pastorius for a blistering interchange.

There was no more time. I squeezed off four shots, hoping that at least one of the images would be sharp and acceptable. And then Weather Report was gone.

After processing my film, I was honestly surprised to see the results. Belying what they exhibited onstage to their screaming fans, the artists on the bench appeared stoic. It was odd and unusual, but I felt the image carried a lot of impact.

Shortly thereafter, I reached out to Zawinul and his people and included a copy of that image. Columbia Records later selected that shot for the back cover photo of their blockbuster release, *Weather Report 8:30*. The following year, that album won a Grammy Award for "Best Jazz Fusion Performance."

No other group brought together the elements of jazz and rock as successfully, and for as long as Weather Report, which lasted sixteen years.

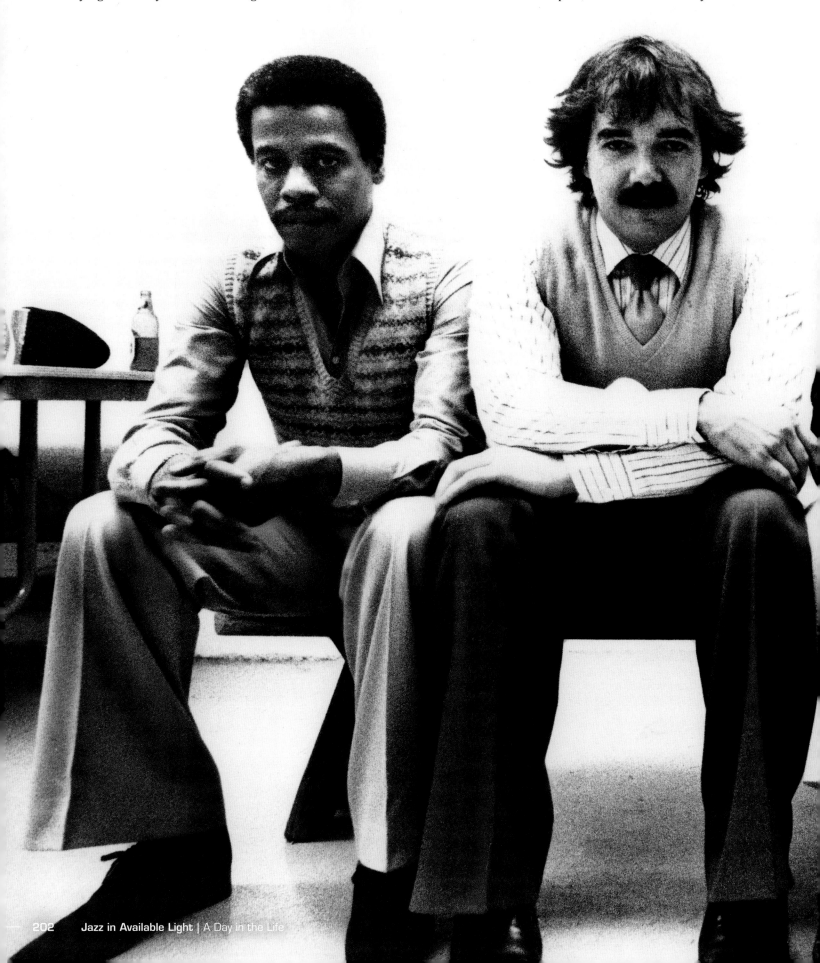

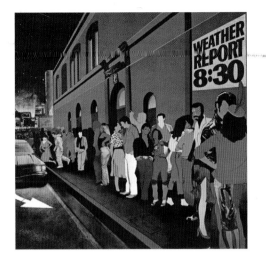

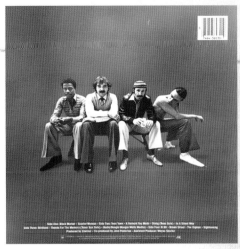

JOHNNY
GRIFFIN

Not in the Slightest

**MONTEREY,
CALIFORNIA**

Physically unimposing, the man stood 5´3″ and weighed barely 100 pounds.

If you didn't know that, and had never experienced this hard-driving, hard bop tenor saxophonist in person, you wouldn't have a clue why he was affectionately known as "Little Giant."

It was through listening to his recordings from the 1950s and 1960s, that I became an instant fan and permanent admirer of Johnny Griffin. As a key frontline standout for Art Blakey's Jazz Messengers, and later, the mercurial cog for the Thelonious Monk Quartet following the departure of John Coltrane, I was especially amazed by his consistently inventive solos spanning a multitude of choruses, all combined with such flawless, incredible speed.

I could never quite get enough of his 1958 live performance on Riverside Records at New York's Five Spot Cafe (*Misterioso*: *Thelonious Monk Quartet*), most particularly his scintillating, four-minute solo extravaganza on Monk's "Evidence."

With the advent of the free movement and its changing jazz styles—funk, jazz/rock, fusion—Griffin's playing opportunities began to dry up. The tenorman pulled up stakes and moved to Europe. Just like so many others before him, I thought I'd probably never get the opportunity to catch the expatriate live.

But then in 1979, after fifteen years abroad, I learned about the surprise homecoming. Johnny Griffin was not only returning to America, but would also appear in California. I immediately confirmed my plans and booked reservations.

Griffin's artistic triumph began at Carnegie Hall in New York and continued with a resounding west coast tour. Offering an exhilarating set at the Monterey Jazz Festival, he was overwhelmed by the crowd's reaction and outpouring of support.

The next day, while still greeting and glad-handing his many new-found fans, Johnny was packing up to leave the festival grounds. I caught up with him for a quick photo shoot. It was only some time later, while reviewing those images, that it hit me. I had captured what I had set out to do . . . present Johnny Griffin as the true giant he was.

Recalling that memorable weekend, I think to myself . . . Johnny Griffin was slight. And none of that mattered in the slightest.

JOHN ARNOLD III (Johnny, Little Giant) GRIFFIN
tenor saxophone, composer
Born: April 24, 1928
Died: July 25, 2008

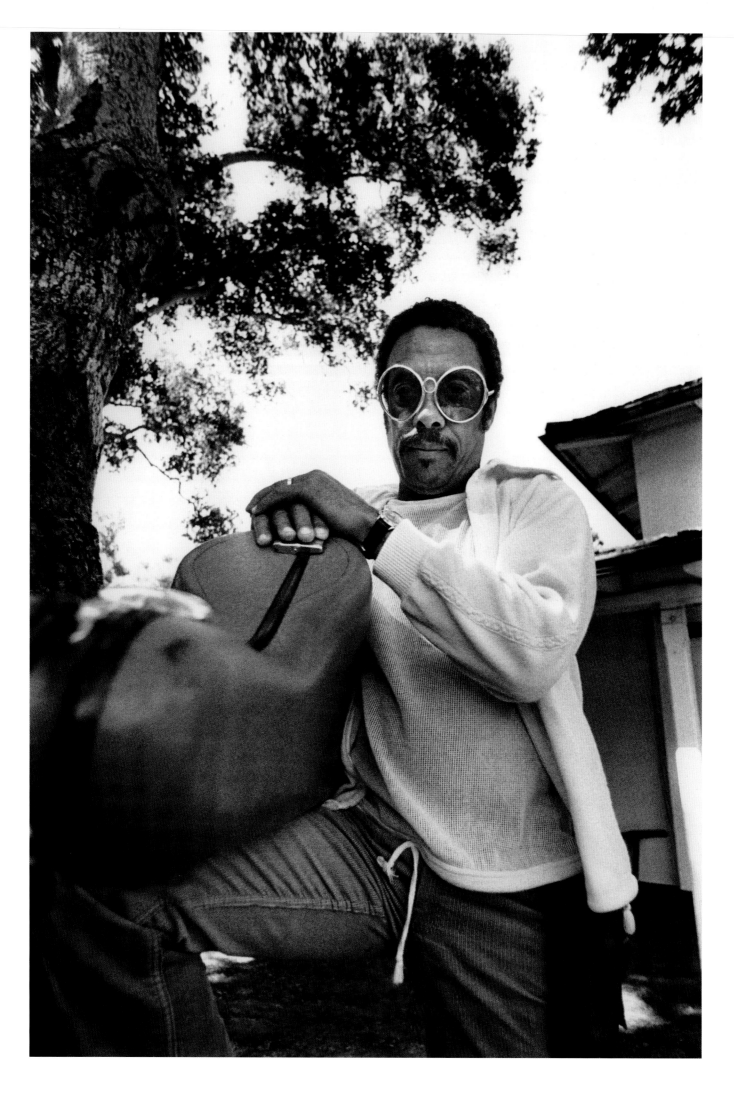

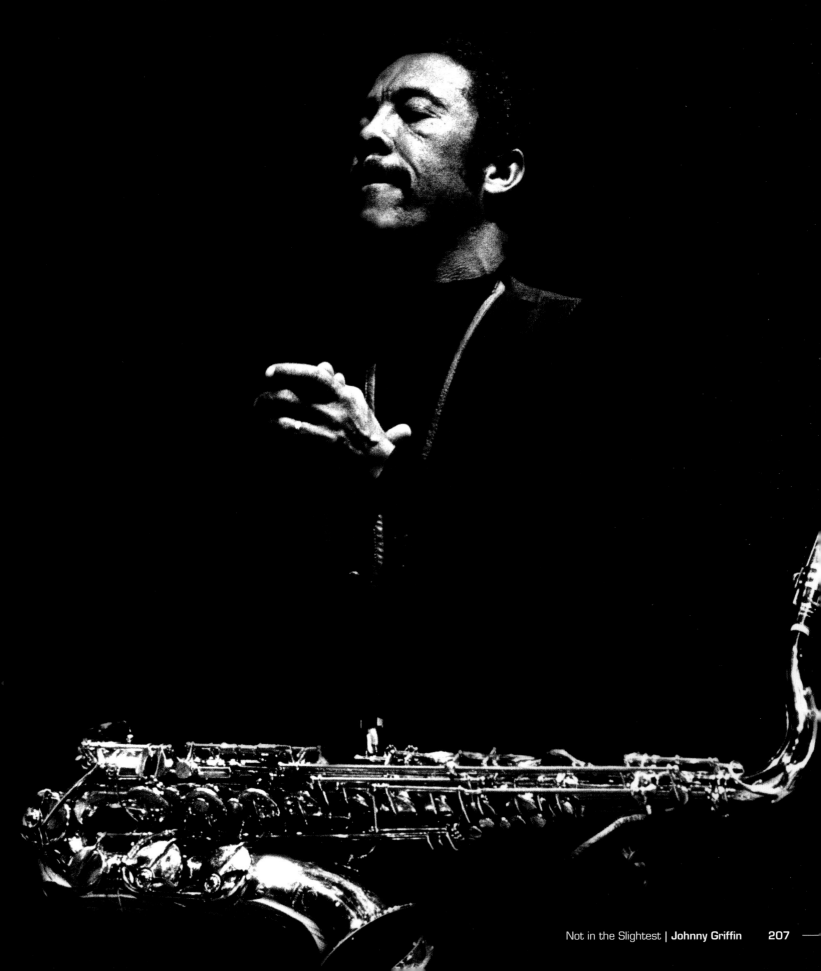

*He was overwhelmed by
the crowd's reaction and
outpouring of support.*

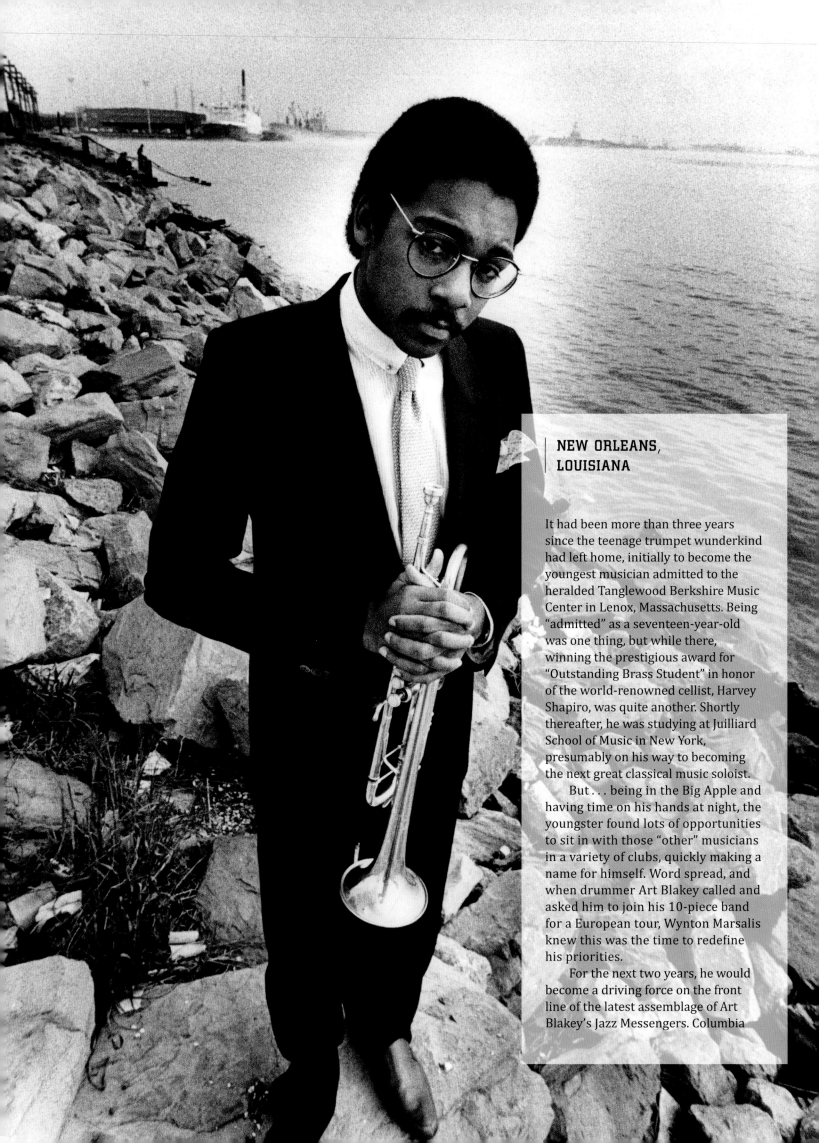

NEW ORLEANS, LOUISIANA

It had been more than three years since the teenage trumpet wunderkind had left home, initially to become the youngest musician admitted to the heralded Tanglewood Berkshire Music Center in Lenox, Massachusetts. Being "admitted" as a seventeen-year-old was one thing, but while there, winning the prestigious award for "Outstanding Brass Student" in honor of the world-renowned cellist, Harvey Shapiro, was quite another. Shortly thereafter, he was studying at Juilliard School of Music in New York, presumably on his way to becoming the next great classical music soloist.

But . . . being in the Big Apple and having time on his hands at night, the youngster found lots of opportunities to sit in with those "other" musicians in a variety of clubs, quickly making a name for himself. Word spread, and when drummer Art Blakey called and asked him to join his 10-piece band for a European tour, Wynton Marsalis knew this was the time to redefine his priorities.

For the next two years, he would become a driving force on the front line of the latest assemblage of Art Blakey's Jazz Messengers. Columbia

WYNTON
MARSALIS

A Triumphant Return Home

Records officials quickly took notice. While still working with Blakey, Wynton was teamed up with Miles Davis's former rhythm section mates— pianist Herbie Hancock, bassist Ron Carter, and drummer Tony Williams— for a couple of in-studio recordings in Japan during the summer of 1981.

One of those recordings—his debut album, simply titled *Wynton Marsalis*— also featured his brother, Branford, on tenor and soprano saxophones. The other date, *Quartet*, a two-record LP with Hancock as the leader, was originally released only in Japan.

Soon after the releases, the Wynton Marsalis "brand" was catching fire, records were selling briskly, and by the end of the year, some serious promotion was being coordinated from a variety of sources and locations.

When then-Mayor of New Orleans Ernest N. "Dutch" Morial proclaimed that February 16, 1982, would be "Wynton Marsalis Day," the promoters, the movers-and-shakers, swung into action. Wynton was finally coming home again, so all of his family, friends, and associates began to make plans. At the same time, CBS/Sony Records in Japan was now ready to re-release its *Quartet* recording in the United States and, with Tokyo's *Swing Journal*

magazine wanting to document the celebration and all of the activities, I received a call to cover the proceedings.

From the time he arrived at the airport to a swarm of media and well-wishers, and for the next two days as he fulfilled a myriad of personal and promotional obligations, it was obvious what I was witnessing: here was a man of complete confidence— polished, professional, and totally in charge, yet at the same time one who was humble, patient, appreciative, and giving. Stepping back and recognizing that Wynton Marsalis, all of twenty years old, was shouldering such heavy responsibilities, was almost more than I could wrap my head around.

As I would soon find out, what he exhibited throughout that weekend in February 1982, when he was named "Honorary Citizen of New Orleans" and given the keys to the city, was just a continuation of all that had become ingrained in Wynton Marsalis from the time he was a child.

After our initial introductions and before he would be deluged with a series of interviews and non-stop media events, Wynton got in the car and directed me to a variety of locations for our photo shoot around "The Big Easy," including the obligatory

tourist locations and a trip to Congo Square and Louis Armstrong Park. Later, we would head over to his home and meet the entire family.

Growing up, music was uppermost in the Marsalis clan. Wynton's father, pianist/educator Ellis Marsalis, Jr., was

Marsalis stands next to a street musician on the Riverwalk overlooking the French Quarter.

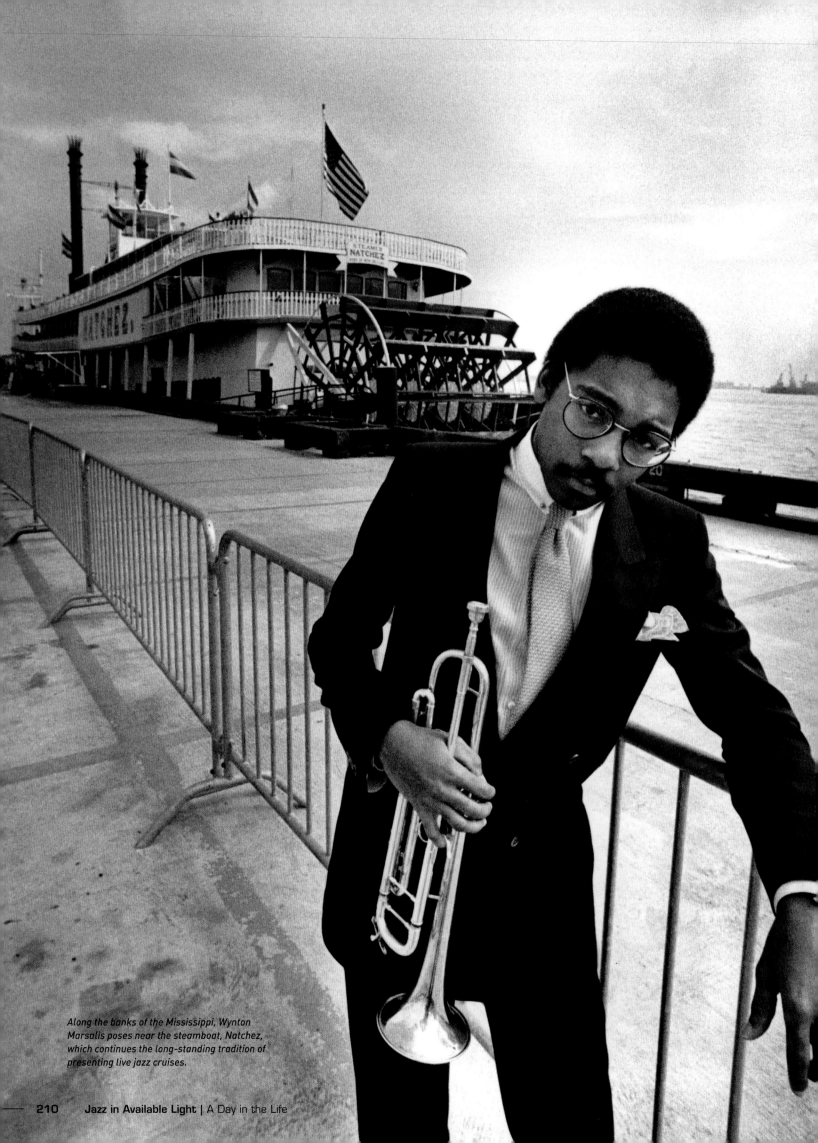

Along the banks of the Mississippi, Wynton Marsalis poses near the steamboat, Natchez, which continues the long-standing tradition of presenting live jazz cruises.

Wynton and his music-minded brothers . . . had the coolest teacher in town.

regarded by many as the premier modern jazz pianist of the New Orleans area. Eschewing traditional jazz and Dixieland, he preferred the bebop sounds of such icons as Charlie Parker and Dizzy Gillespie. In his earlier collaborations, he would play and record with the likes of Nat and Cannonball Adderley, drummer Ed Blackwell, and saxophonists Eddie Harris and David "Fathead" Newman.

Wynton and his music-minded brothers—four of the six siblings would all make jazz their successful and chosen profession—had the coolest teacher in town.

Wynton was also exposed to the early jazz sounds, those championed by such celebrities as banjoist/ guitarist Danny Barker. Crescent City-born Barker (1909), knew all the local legends as they were growing up—Louis Armstrong, Jelly Roll Morton, and King Oliver—and, among the highlights of his career, played in the popular orchestras of Benny Carter and Cab Calloway. He embodied the music style known as New Orleans Jazz and was able to instill in serious young players like Wynton just what they needed to know about the giants who came before them.

Wynton, who was given his first trumpet at age six by none other than the popular Dixieland trumpeter Al Hirt, would get his official start the

next year playing in Danny Barker's Fairview Baptist Church Band.

Note: Along with Wynton's father, Danny Barker had a tremendous influence on the young student and his growth as a musician; so much so that Wynton would later include Barker on his 1988 album, *Majesty of the Blues*, when the banjoist was just shy of eighty years old.

As the official honoree for his long-awaited return home, Wynton fulfilled an exhaustive schedule— conducting numerous live and in-studio interviews with all the major radio and television personalities,

The musical Marsalis brothers, including tenor saxophonist Branford (21), trombonist Delfeayo (16), and future drummer/leader, four-year-old Jason (with Wynton at the piano) in their New Orleans home.

giving inspirational talks before selected schools and classes, signing albums at local record stores, and answering a multitude of questions from up-and-coming musicians, as well as fans of all ages throughout the neighborhood. Wherever he went, Wynton had an endearing entourage, all hanging on his every word.

Near the end of the day, we were finally able to squeeze in some time for relaxation. Back home with the Marsalis family, I was about to luckily experience firsthand what Wynton had

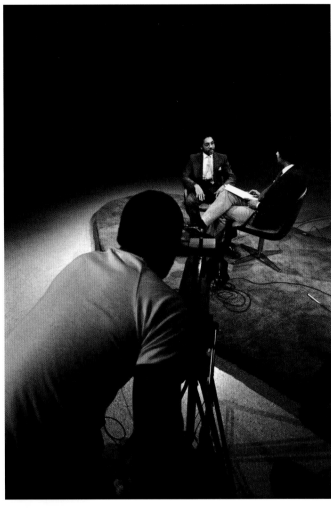

alluded to earlier when we had talked about the many draws of New Orleans, including "home cooking and gumbo."

Showing me into the kitchen, Wynton's mother Dolores was finishing adding the freshest ingredients—shrimps, crabs, oysters, chicken wings, and a variety of sausages—to the largest pot of gumbo I'd seen. I was honored to be a part of the delicious, joyous occasion.

On the final evening of his return, a large contingent of close friends, local leaders, and area musicians took over a restaurant for a most festive "Welcome Home Wynton" tribute.

Top left: Wynton, along with brother Branford, conducts a motivational talk to a typist/stenographic class in New Orleans while the cameras are rolling.

Top right: Wynton takes part in a live television interview, one of many scheduled during his "Welcome Home" New Orleans promotional tour.

Left: During his promotional tour at a local record store, Wynton takes time to answer questions from local fans and well-wishers.

The entire Marsalis Family takes time out for a
group photo, including: (standing, from left)
brothers Wynton, Delfeayo, Branford, and Ellis III;
and (seated) mother Dolores, brothers Jason and
Mboya, and father Ellis Marsalis, Jr.

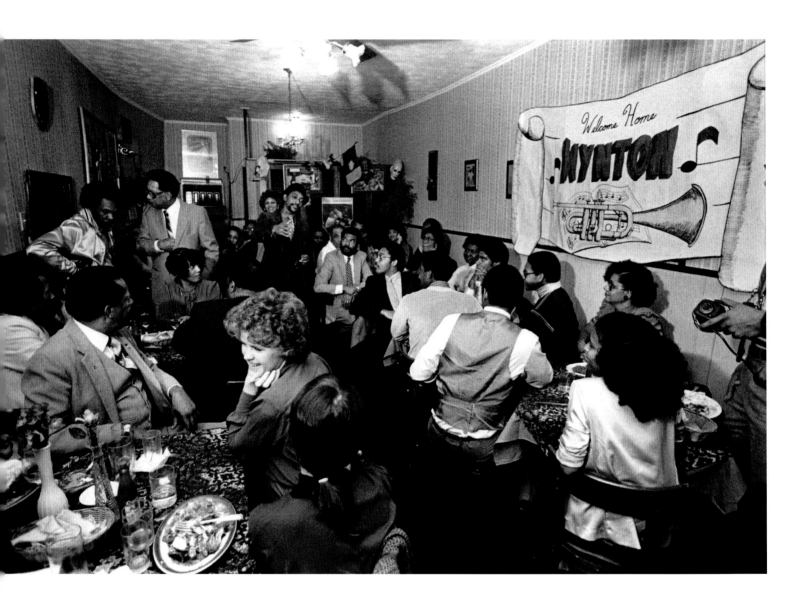

With the night drawing to a close, everyone in that setting knew one thing for certain—Wynton Marsalis had arrived. Nothing was going to stop this young man with a horn. I like to think what that period foretold was made clear five years later when the trumpeter penned his composition "Soon All Will Know" for his album, *Wynton Marsalis Standard Time, Vol. 1.*

Note: In his book, *Moving to Higher Ground: How Jazz Can Change Your Life*, Marsalis devoted several pages to Louis Armstrong, someone he never met. He wrote: "Louis Armstrong is a celebration of the freedom to be yourself. He always knew and loved himself. He embraced the things he was most proud of, like his artistry, as well as the things he knew needed work."

WYNTON LEARSON MARSALIS
trumpet, leader, composer, educator
Born: October 18, 1961

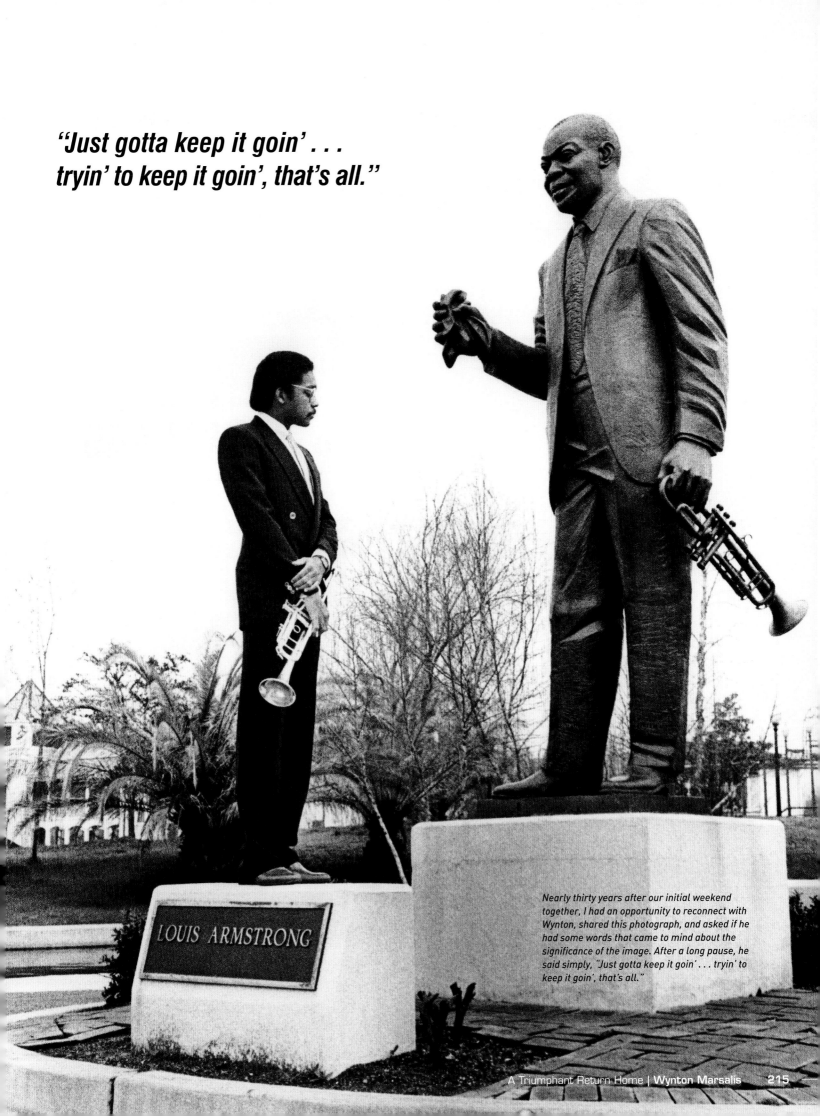

*"Just gotta keep it goin' . . .
tryin' to keep it goin', that's all."*

LOUIS ARMSTRONG

*Nearly thirty years after our initial weekend
together, I had an opportunity to reconnect with
Wynton, shared this photograph, and asked if he
had some words that came to mind about the
significance of the image. After a long pause, he
said simply, "Just gotta keep it goin' . . . tryin' to
keep it goin', that's all."*

IN THE
SPOTLIGHT

THELONIOUS MONK

BILL EVANS

SARAH VAUGHAN

JO JONES

BETTY CARTER

ELVIN JONES

TOOTS THIELEMANS & QUINCY JONES

THELONIOUS
M O N K

"Let's Cool One"

Like all great innovators, Thelonious
Monk had his detractors—most
notably those who criticized his
flat-fingered, hard-edged, percussive
attack of the piano, his jagged solo
lines, his ever-present dissonant
chords, and his unpredictable accents
that were dropped in the most
unexpected places of a tune.

He was a true nonconformist. He
didn't do the intricate runs. While
others sought attention with showy
sixteenth notes, Monk used space
and silence, but still utilized the
entire keyboard.

Unlike many listeners, I embraced
his peculiarities early on. By replaying
Monk's albums over and over, I found
myself paying closer attention to what
I was hearing. Despite his playing
irregularities and unorthodox
melodies, his works were always
anchored with a solid blues feel. After
seeing him live for the first time in

1968, and feeling that infectious *swing* of his quartet, everything started to fit.

I also became particularly enamored with his writing. Some of his compositions were so simple, but in the most remarkable way. Perhaps it was through spending more and more time discovering all I could about Monk, combined with my many years of musical study, that got me to thinking more deeply about what was actually being played on his recordings.

Listening to "Blue Monk," one of the artist's greatest pieces that today is performed by virtually all jazz players, I kept hearing the basics of "Santa Claus Is Coming To Town." Just change a couple of notes at the beginning, I thought, and you've got the germ for Monk's tune. And when I heard "Teo" from the 1964 Columbia album, *Monk* (not to be confused with Miles Davis's identically-named, but very different piece, recognizing producer Teo Macero), I immediately thought of the dreamy, time-honored standard, "Yesterdays." Nothing dreamy about Monk's take, and thank goodness for that. I continue to love that solid swinger.

Monk's sidemen also cherished their association with the creative genius, clearly recognizing what it meant to be in the moment with such greatness. Charlie Rouse, who served as the leader's other frontline soloist for more than a decade, knew The Monk Playbook every which way; backward, forward, inside-out, sideways . . . even, if you will, "Criss-Cross." Just as with his leader, Rouse never lost sight of the song's theme, and—more completely than anyone else—easily navigated in, around, and through the pianist's irregular, angular lines.

Everywhere he went—be it in live performances or in the recording studios—Thelonious Monk took special pride in featuring his uniquely identifiable compositions: from his unmistakable jazz standards, such as "'Round Midnight," "Straight, No Chaser," "Ruby My Dear," and "Evidence," to such whimsically-named

Tenor saxophonist Charlie Rouse catches Monk's attention during a quick break between tunes.

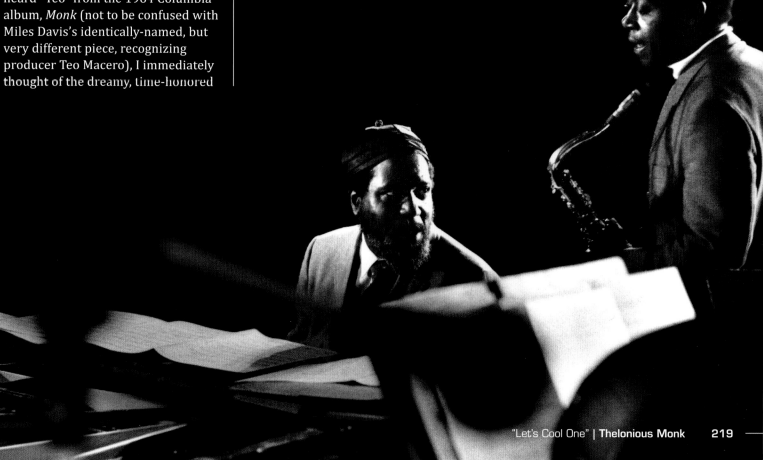

pieces as "Trinkle Tinkle," "Little Rootie-Tootie," and "Green Chimneys." If you were fortunate to be in attendance, you always knew you were in for a genuine treat.

Having listened in advance to a sizable number of Monk's many dozens of compositions, part of the fun of catching him live was to anticipate which tunes he would perform and then seeing how fast I could name them. If I happened to hear one of his songs I didn't know, I had to find out what it was, and then go out to buy a new album.

One of the great spontaneous flukes for me as a jazz photographer occurred while covering Thelonious Monk and his Quartet at the 1969 Monterey Jazz Festival. From one of the backstage porthole openings—twelve-inch circular cut-outs used to observe, but not distract, the performers—I had a telephoto lens focused directly on the pianist. In one fleeting moment between tunes, he raised up one of his title compositions, allowing for a most treasured shot. While it may appear otherwise, there was nothing concocted, nothing staged. For me, that one image captured what was so precious about the man . . . Monk and His Music.

THELONIOUS SPHERE MONK
piano, composer
Born: October 10, 1917
Died: February 17, 1982

In one fleeting moment between tunes, he raised up one of his title compositions, allowing for a most treasured shot.

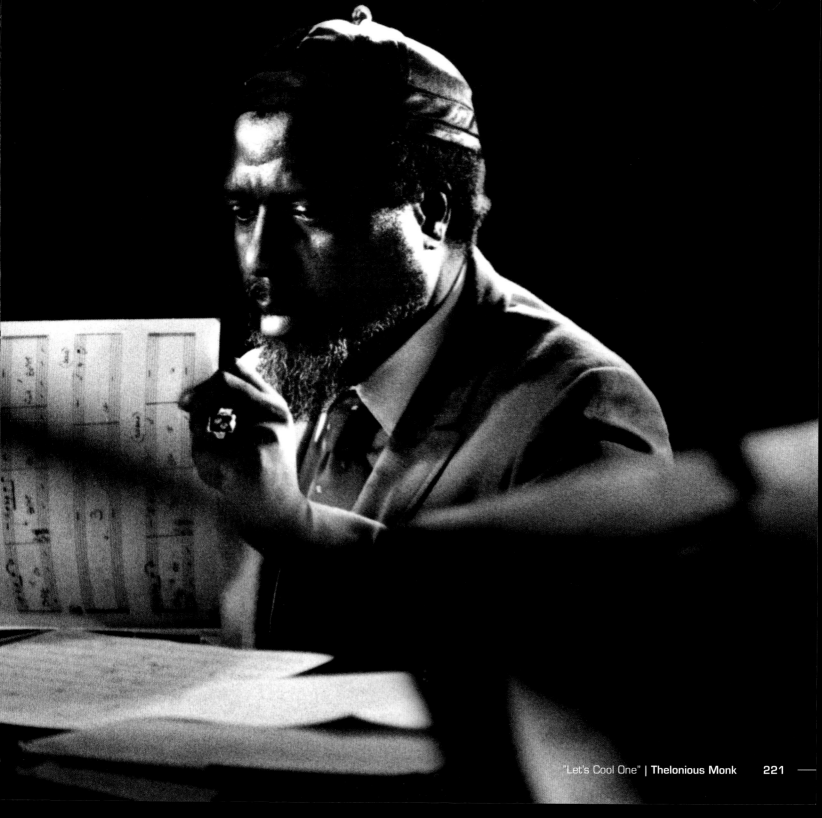

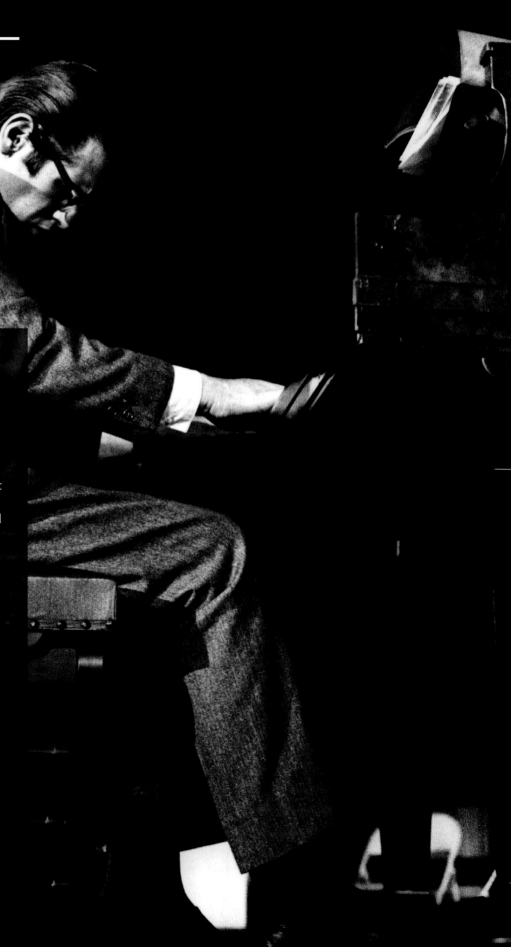

BILL
EVANS

Intimate Environs

BERKELEY, CALIFORNIA

Opportunities such as this just don't materialize very often. For a candid photograph to encapsulate both the music and the moment so palpably isn't something you can really aim to do.

From the very first time I heard Bill Evans on record, I became a devotee. His style of playing and the way he delivered his lines were so engrossing. And each time I saw and photographed him live, my feelings for him were only elevated that much more.

What struck me was not just his serious stage demeanor, but the uncommon image he projected while performing. Particularly on the most tender of ballads, he would become completely immersed in the moment, almost to the point of becoming "one" with the piano.

The most memorable Bill Evans performance I ever witnessed occurred in April of 1969. The pianist was headlining at Bear's Lair, a most confining—yet intimate—basement room on the University of California-Berkeley campus. While seemingly a

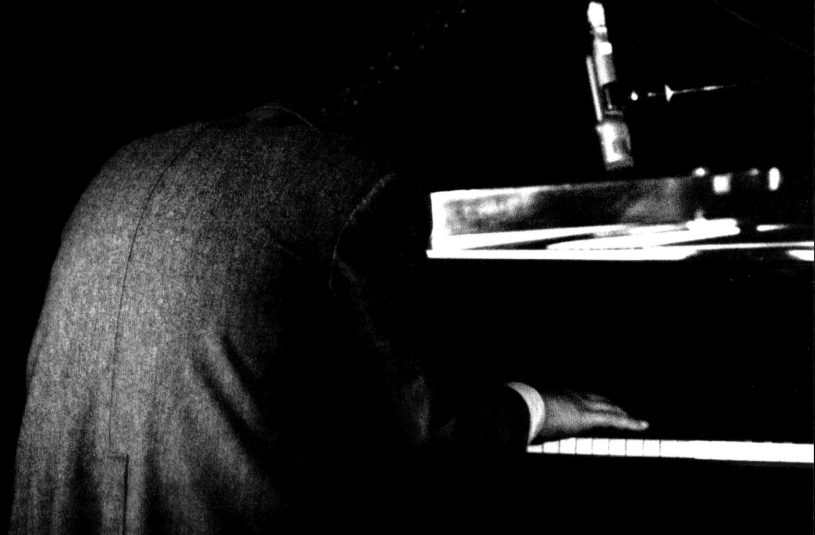

strange setting, it was absolutely ideal for appreciating Evans at his expressive best.

Along with the rest of the small audience, I was seated in the darkness facing the stage. The mood, the pure delicacy of the music, everything about the setting, was perfect. On one especially poignant piece, Evans became totally absorbed as he crafted his elegant solo one chorus after another. Slowly and progressively, he hunched over, lower and lower, ostensibly getting nearer to the notes

he was creating. I squeezed off several images of him as his head settled ever closer to the keyboard.

Seeing him in that position, I sensed something unusual happening that had to be captured.

Quietly retreating to the rear of the room—away from the gathering who were now completely locked in on his performance—I used a telephoto lens to frame Evans as his head literally disappeared from view.

Listening to the pianist's deeply moving presentation and seeing him

in that fully absorbed state, practically gave me the shivers. Looking back, the total experience was easily one of the more fulfilling events of my life in music. To this day, I can think of no other artist who was able to reach me on such a personal level as did Bill Evans on this particular night.

WILLIAM JOHN (Bill) EVANS
piano, composer
Born: August 16, 1929
Died: September 15, 1980

SARAH
VAUGHAN

A Night to Remember

"The Divine One" knew she had nailed it. On that September night in 1971, the vocalist simply had the festival-goers in the palms of her hands. It was an absolute lovefest.

Sarah Vaughan possessed what other singers could only envision in their dreams. She had the most impressive, extraordinary vocal range covering all three types of voices—soprano, mezzo-soprano, and contralto—along with such an alluringly rich tone and vibrato. And because she was an accomplished pianist and improviser blessed with horn-like phrasing abilities, all of the top musicians who backed her during performances regarded her as an instant equal.

Or, as Miles Davis wrote in his autobiography, "Sarah sounding like Bird and Diz and them two playing everything! I mean they would look at Sarah like she was just another horn. You know what I mean?"

She was the complete package.

I marveled as Sarah brought down the Monterey house with her final number, "Tenderly," and immediately headed backstage. I wanted to see the buzz and excitement she had most certainly caused among all of her close friends and well-wishers waiting in the wings, and perhaps even catch a meaningful shot.

But as I made my way around in the background, I noticed Sarah sitting alone. She was waiting near the curtains for an encore appearance, just off-stage behind the props. When I walked by, I told her, "You just knocked them out. Everybody's still standing."

She pulled me over, placed my hand over her heart and asked, "Is it still beating?"

She was so happy.

Over her career, there was a reason why Sarah Vaughan appeared at the Monterey Jazz Festival a total of nine times. She was absolutely adored by her fellow musicians, her countless fans, and all the staff. On this glorious night, she owned them all, big time.

SARAH LOIS VAUGHAN
singer, piano
Born: March 27, 1924
Died: April 3, 1990

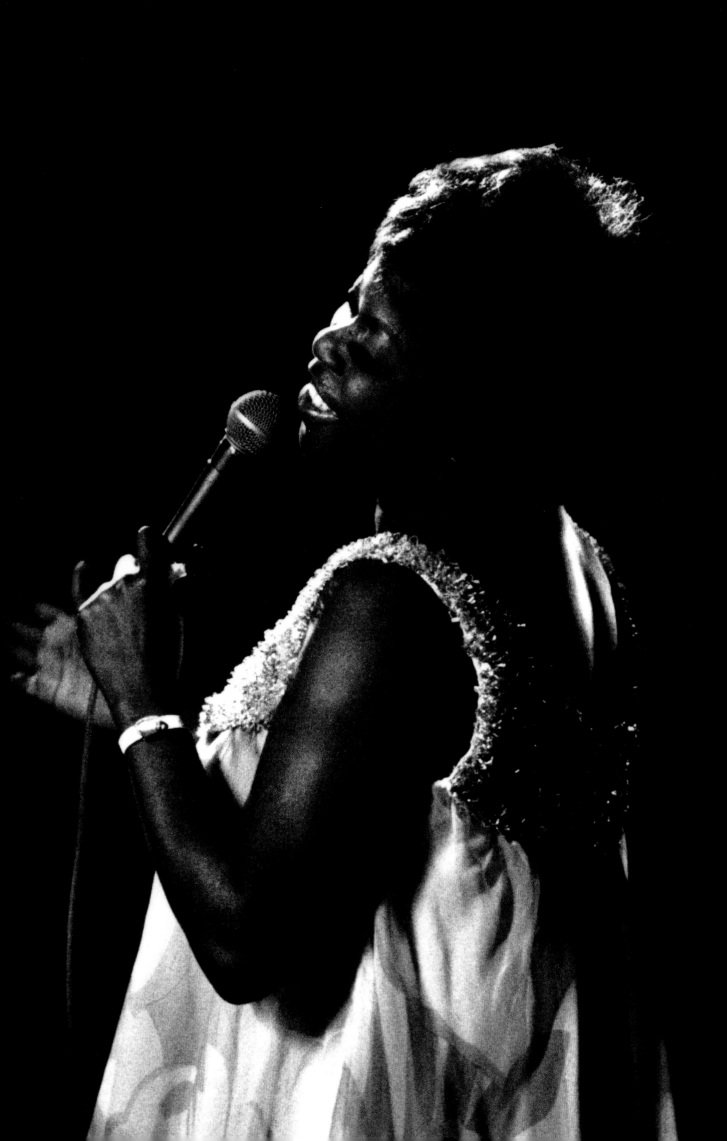

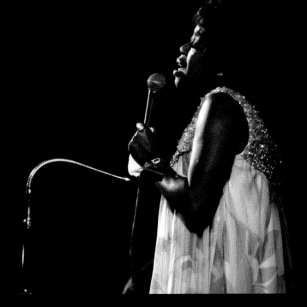

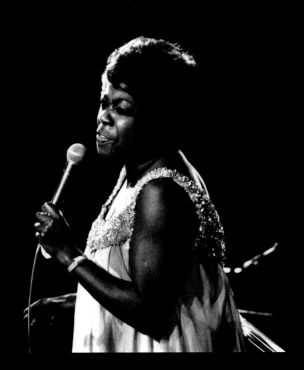

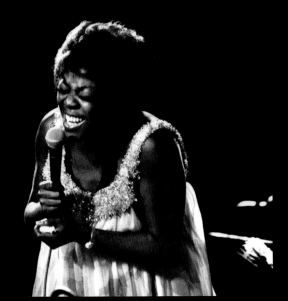

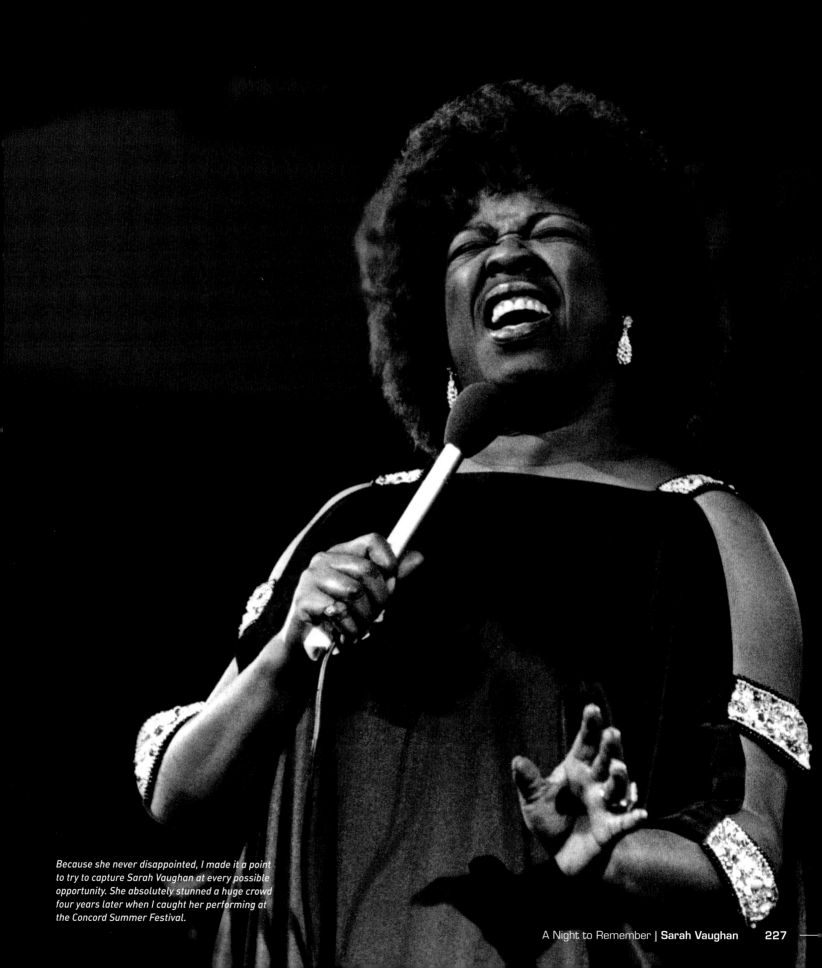

[She] possessed what other singers could only envision in their dreams.

Because she never disappointed, I made it a point to try to capture Sarah Vaughan at every possible opportunity. She absolutely stunned a huge crowd four years later when I caught her performing at the Concord Summer Festival.

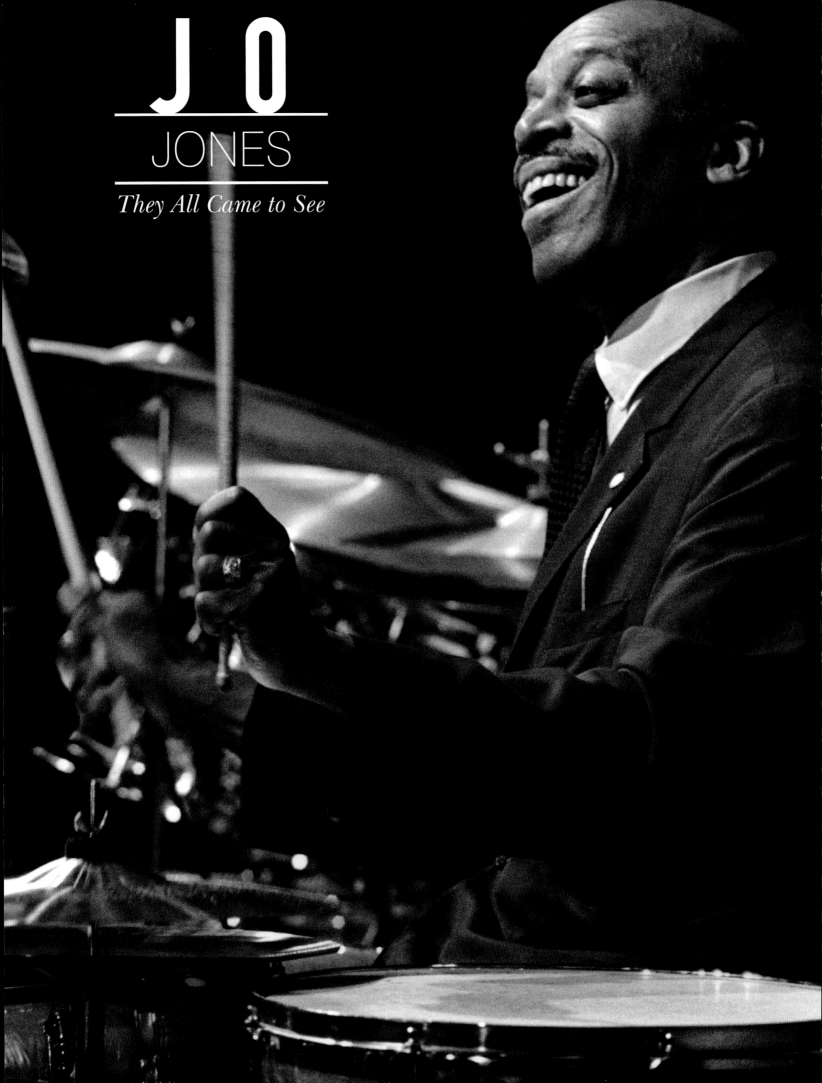

J O
JONES
They All Came to See

He built an indelible name for himself during the 1930s and 1940s, as part of Count Basie's "All-American Rhythm Section." Unlike his fellow percussionists who relied heavily on the bass drum, Jo Jones pioneered the use of the ride cymbal and hi-hat cymbals for a lighter, more irresistible, beat.

Long after leaving Basie's orchestra, he still had a strong legion of admirers.

Papa Jo was like a human magnet. Wherever he appeared, the crowds formed: not just the audience throngs, but insiders, working crew, fellow musicians, and most of all, other drummers. All of his peers—from such big band leaders as Buddy Rich and Louie Bellson, to bop drummers Roy Haynes, Art Blakey, Philly Joe Jones, and Elvin Jones—were members of the unofficial Jo Jones Fan Club.

The much-revered drum master Max Roach was one of those who was so taken with the artificer's performances that he would occasionally—as a tribute to Jones—execute an entire drum solo using the hi-hat. No greater form of flattery than that.

In a cover story for the June/July 1990 issue of *Drums & Drumming* magazine by Robin Tolleson (reprinted in the book *Playing From The Heart*), Roach described an event in Central Park celebrating the career of an ailing Gene Krupa during the 1973 Newport in New York Festival.

"It was a very moving event," said Max. "But the guy who closed the show was Papa Jo [Jones] . . . ended the whole concert when he did this hi-hat piece. It was the first time I heard it done. He just came onstage with a hi-hat, a pair of sticks, and a stool, and it was beautiful. It just gave us all an idea that you can get the most out of the least. That was the perfect lesson."

The always innovating drummer, gentleman Max Roach, was also one of the jazz world's true fashion plates and could have easily belonged in the pages of GQ magazine.

I got to witness this same magnetism the first time I saw Jones performing in a quartet with pianist/organist Milt Buckner, guitarist Slim Gaillard, and bassist Slam Stewart at the 1970 Monterey Jazz Festival.

Moving around behind the curtains when his name was announced, I couldn't help but notice how practically everyone with a backstage pass stopped what they were doing. Fellow music professionals, festival staffers, and hangers-on all headed toward any side stage opening they could find to get a glimpse of the technician as he worked his special magic.

He was exactly as advertised. You honestly couldn't take your eyes off of him.

JONATHAN DAVID SAMUEL (Jo, Papa Jo) JONES
drums
Born: October 7, 1911
Died: September 3, 1985

Opposite: Jo Jones acknowledges all the whooping and hollering from his stageside fans.

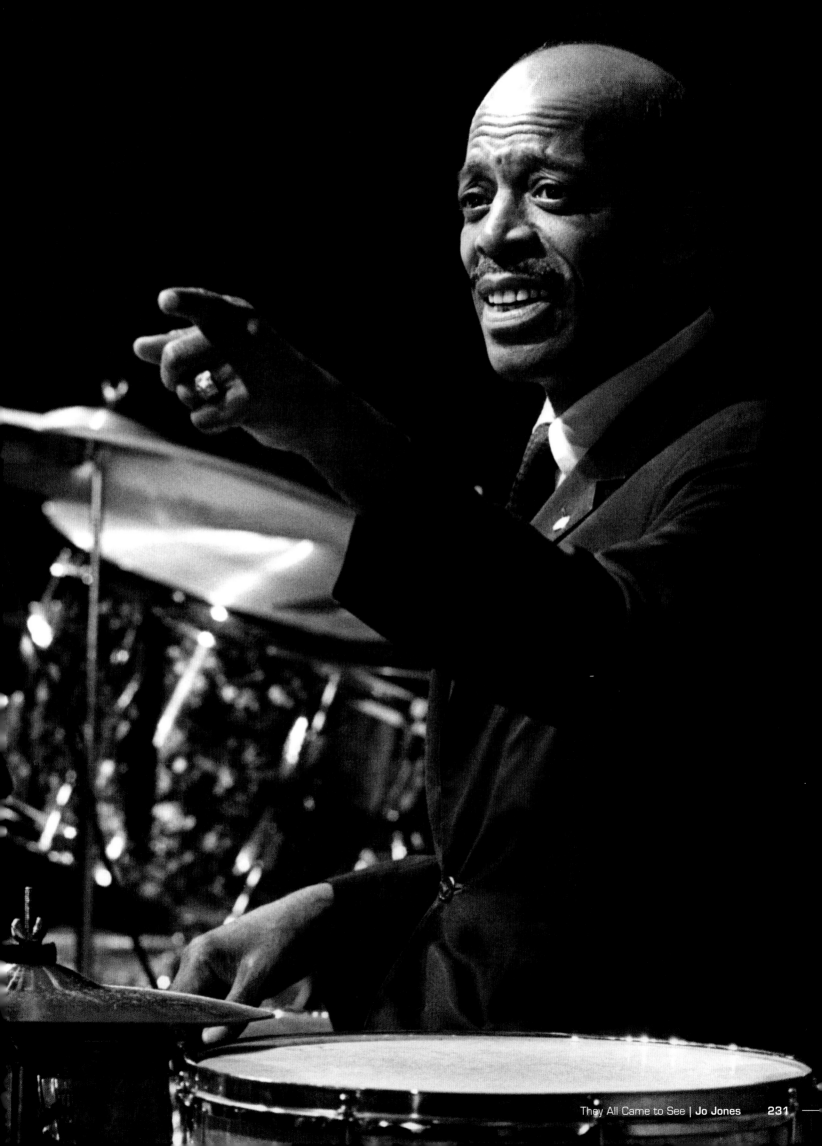

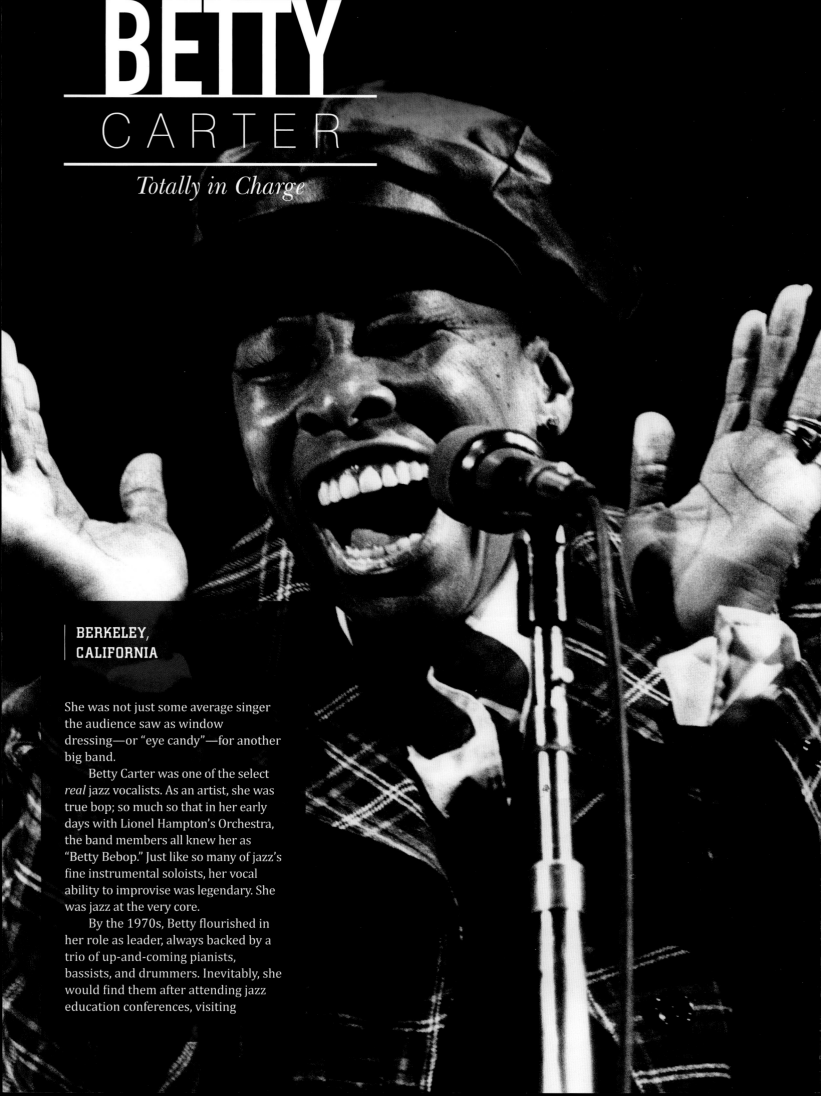

BETTY
CARTER
Totally in Charge

**BERKELEY,
CALIFORNIA**

She was not just some average singer the audience saw as window dressing—or "eye candy"—for another big band.

Betty Carter was one of the select *real* jazz vocalists. As an artist, she was true bop; so much so that in her early days with Lionel Hampton's Orchestra, the band members all knew her as "Betty Bebop." Just like so many of jazz's fine instrumental soloists, her vocal ability to improvise was legendary. She was jazz at the very core.

By the 1970s, Betty flourished in her role as leader, always backed by a trio of up-and-coming pianists, bassists, and drummers. Inevitably, she would find them after attending jazz education conferences, visiting

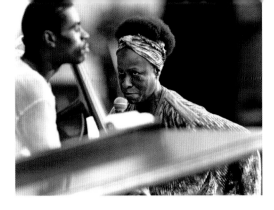

institutions such as the Berklee College of Music, and catching new talent in clubs. She was always searching, listening for the solos, the rhythm, the creativity that each exhibited.

They became her young lions, each personally judged, then groomed, rehearsed, and finally showcased to her devoted fans. If you were fortunate enough to be welcomed as a member of Betty Carter's Proving Ground, you were not onstage props whose job was to simply keep time.

Working for Betty Carter was like going twelve rounds, but with her in your corner. She was pushing, prodding, always looking to get the most out of you. Night in and night out, you were there to express your own musical identity to the best of your ability.

Knowing this, I was on the lookout for just the right moment to catch this delicate interaction as it unfolded. It was in 1979 during an afternoon performance at the Berkeley Jazz Festival's Greek Theatre that I recognized the possibility. Hidden from the audience after squeezing into a completely cramped spot amongst the onstage equipment and speakers, I soon had my opportunity.

Betty Carter was feeling the moment on a dazzling, up-tempo tune.

After completing her early choruses and then beaming from the roar of the crowd, she was now focused on her soloist, Curtis Lundy. Standing directly in front of him, Betty implored, induced, and inspired her young bassist to reach the highest level of performance.

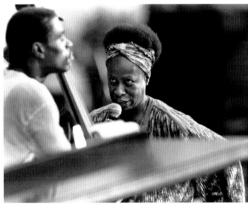
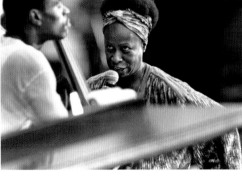

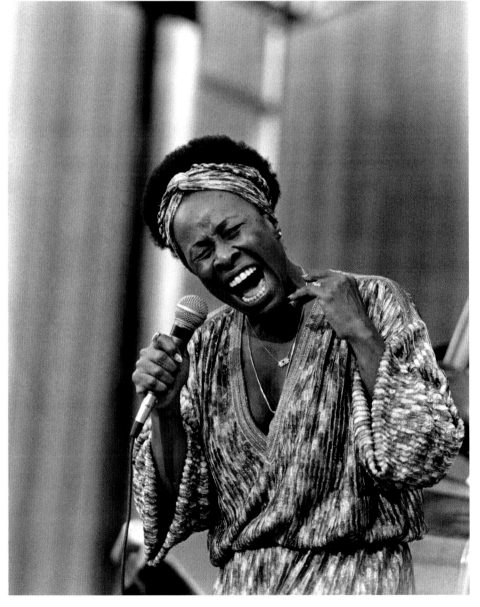

The interaction between teacher and student was powerful, and for me that day, even more moving than the music itself.

BETTY CARTER (Lillie Mae Jones)
singer
Born: May 16, 1930
Died: September 26, 1998

ELVIN
JONES

Penetratingly Precise

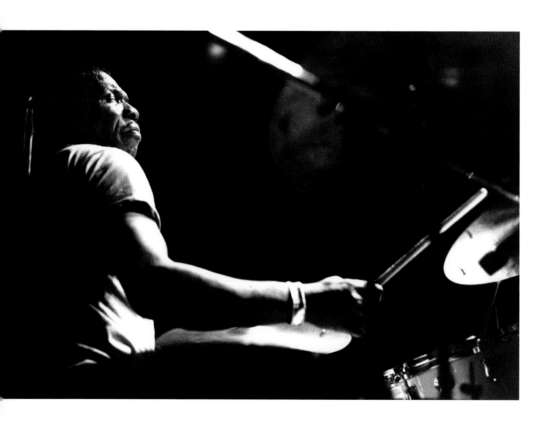

The most well-oiled, high performance jazz engine on the planet.

He had that presence, that overall bravura about him. Up close, one could not miss the chiseled look of Elvin Jones—his distinctive, pronounced facial lines and cheekbones, those penetrating eyes so focused and intense. You just knew this man was serious business.

Photographing the high-energy drummer was always a challenge, especially when he was performing in the darkest of jazz clubs.

That was the quandary. On the one hand, I preferred the close confines and overall ambience of a club's atmosphere—the mood and the intimacy of being right next to the action was unmatched. For me, that's where Elvin was at his finest.

But his flashing action, coupled with the club's low lighting, definitely posed limitations for an available-light photographer in search of crisp results. Witnessing Elvin Jones in such an intimate setting was a blurring, mesmerizing experience—whether one was taking photographs or just plain watching. In those situations, I decided that about the best I could do was to selectively capture him in an expressive moment during any brief lull, if I could find one.

The rest of the time when Elvin was just *burning*, I became a student. I

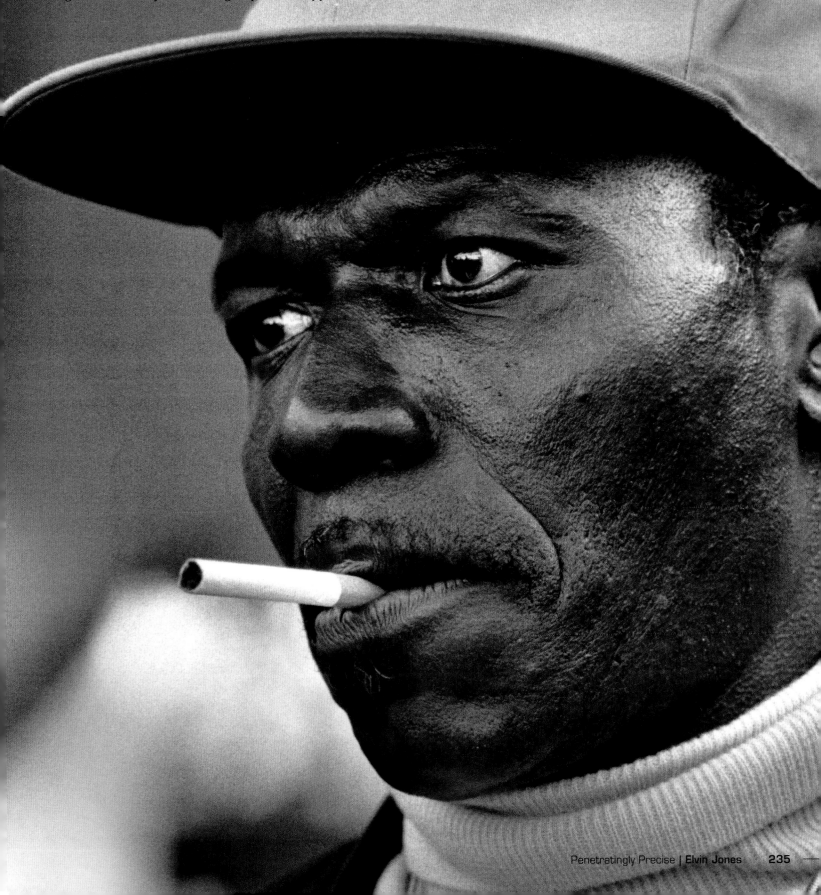

sat there in those close quarters transfixed by his unique artistry, never quite understanding how—using the entire drum set, from ride cymbal all the way down to the bass drum—he could simultaneously weave together such a variety of contrasting rhythms in different meters and still make it so supremely swinging and coherent.

Beginning in the 1970s, there was a good reason why he and his groups became known as the "Elvin Jones Jazz Machine," even recording under that name during part of his career. His was the most well-oiled, high performance jazz engine on the planet. There was never another drummer quite like him, one who so perfected the exhibition of polyrhythms, or cross-rhythms, while at the same time remaining complementary and supportive of his bandmates.

To really appreciate—and to begin to understand—the uncanny work of Elvin Jones, I'd venture to use the cliché, "You had to be there." But, even after studying the craftsman up close on numerous occasions, as well as trying to capture a meaningful shot of what I was seeing, I always left the scene floored, practically in disbelief at what I had just experienced.

ELVIN RAY JONES
drums, leader
Born: September 9, 1927
Died: May 18, 2004

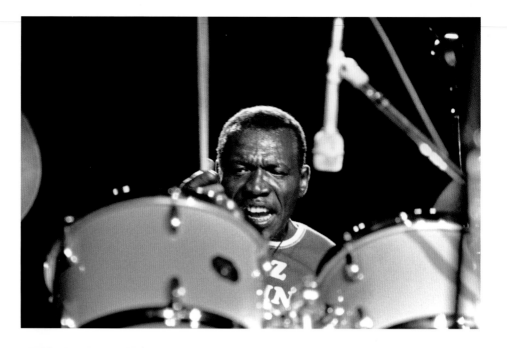

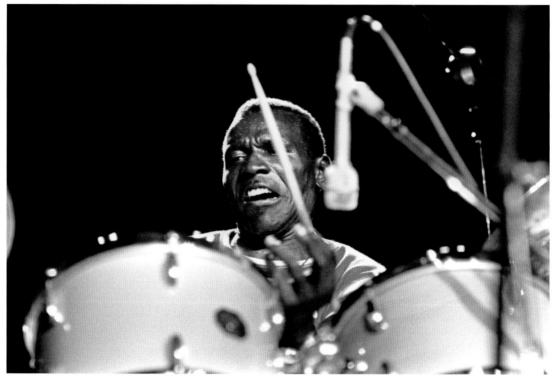

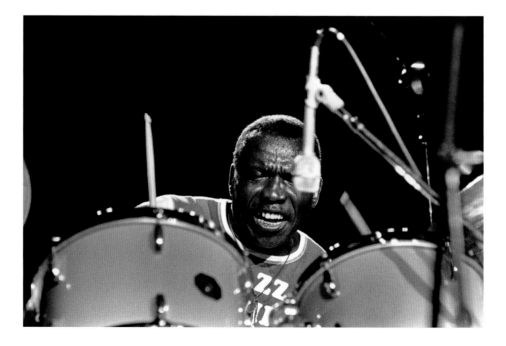

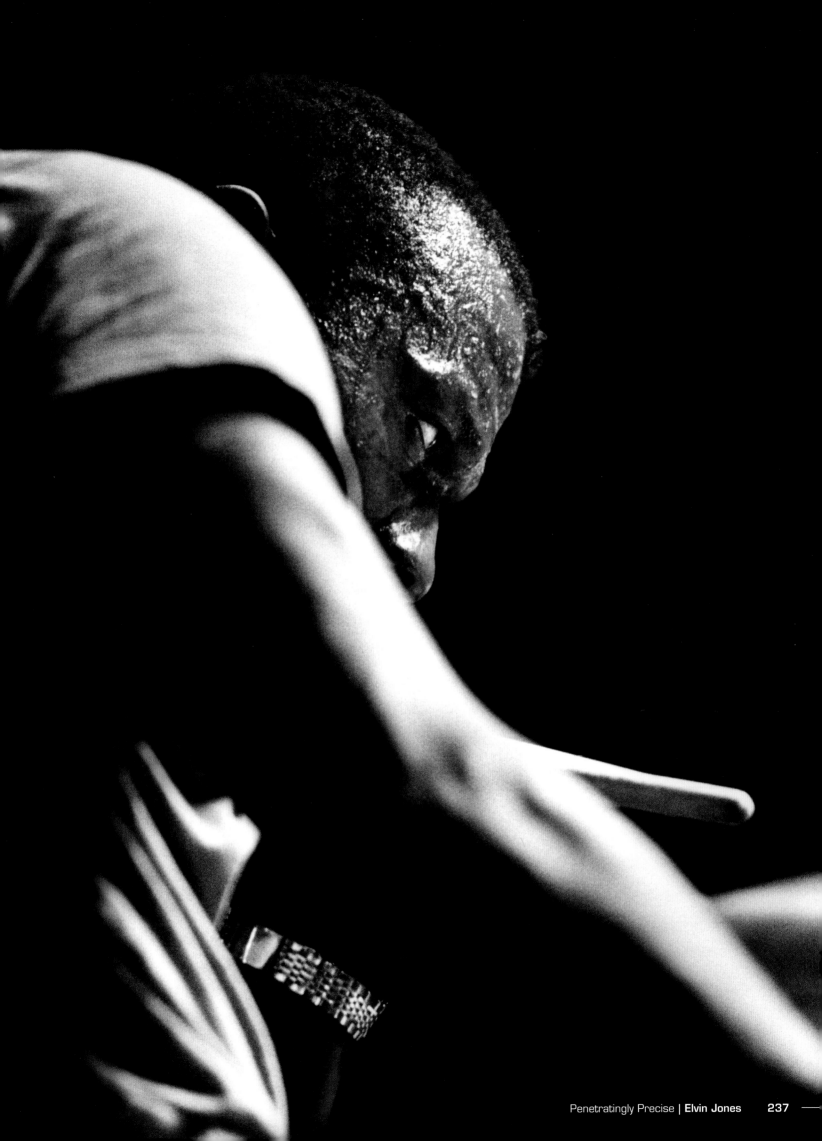

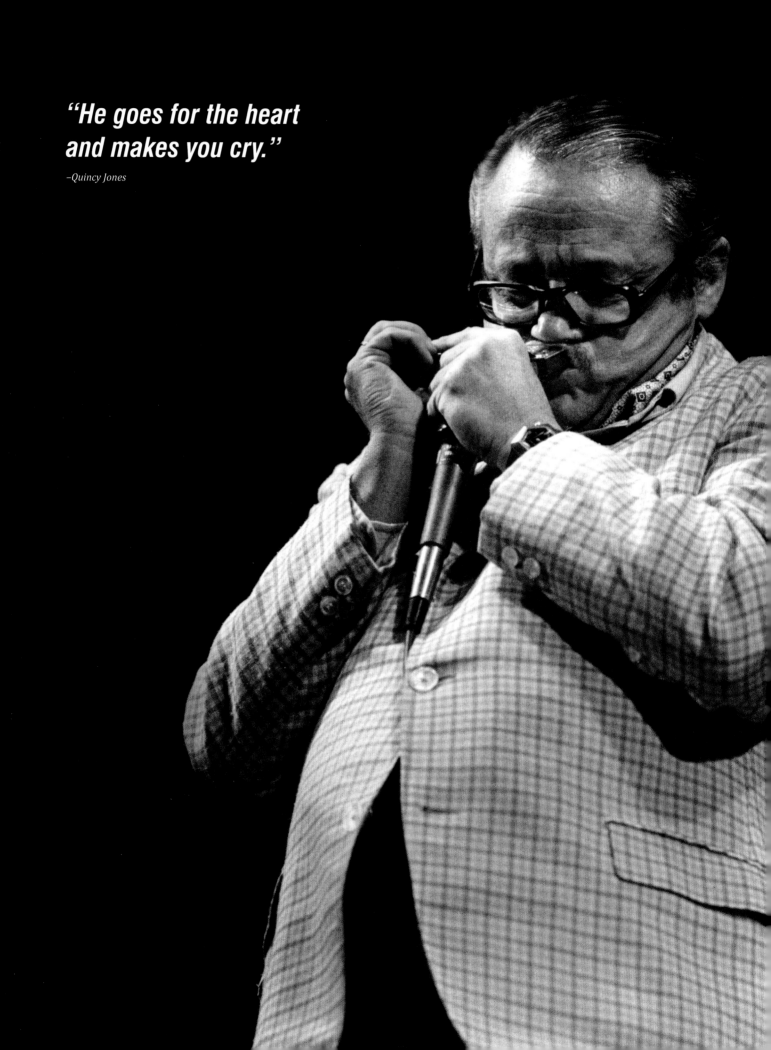

"He goes for the heart and makes you cry."

–Quincy Jones

TOOTS
THIELEMANS

& QUINCY
J O N E S

In Search of That Gripping Sound

**MONTEREY,
CALIFORNIA**

Most everyone growing up has owned or tinkered with the simple and primitive little musical device that fits in the palm of one's hand. Critic Leonard Feather had it exactly right when he described the harmonica as an "... odd instrument ... [with] tonal limitations."

Except in the hands of Jean "Toots" Thielemans. The *Baron* is the only jazz artist ever to come to prominence as a harmonica soloist, something that will likely never be repeated.

Many jazz purists recognized Thielemans' special gift in the 1950s, after he first joined clarinetist Benny Goodman's sextet as a guitarist, and later teamed with pianist George Shearing.

But it was after working as a harmonica soloist on numerous albums and motion picture projects in New York with the celebrated producer/arranger Quincy Jones that his star really began to shine. The creative bond that quickly developed between them would not be broken.

By the time the general public heard Toots Thielemans' achingly mournful solo on the unforgettable score for the movie *Midnight Cowboy*, the Belgian native essentially had become a household name.

Whenever Quincy got the opportunity to leave the studios and take his show live, he would bring together a top-flight crew of favorite musicians he wanted to complement his scores. And for his headliners, he would add such stars as vocalist

Thielemans and Jones were having the most fun of all.

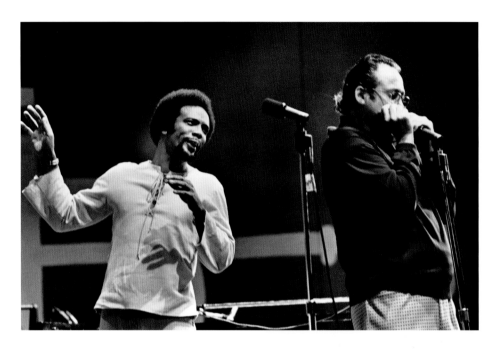

Roberta Flack and—more often than not—Toots Thielemans. The results were overwhelmingly popular.

Despite working with something so minimal, there was nothing primitive about the sounds that Thielemans coaxed out of his harmonicas. His creativity and expressive flow of ideas matched that of jazz's top horn soloists—whether he was blazing through a bop-inspired jazz standard, or tearing at every fiber of your being on a tune so poignant and touching that it was guaranteed to bring tears to your eyes.

"I can say without hesitation," said Jones, "that Toots is one of the greatest musicians of our time.... He goes for the heart and makes you cry."

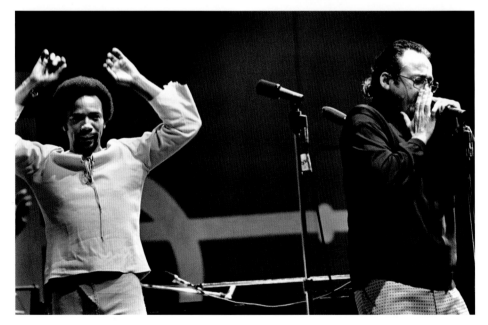

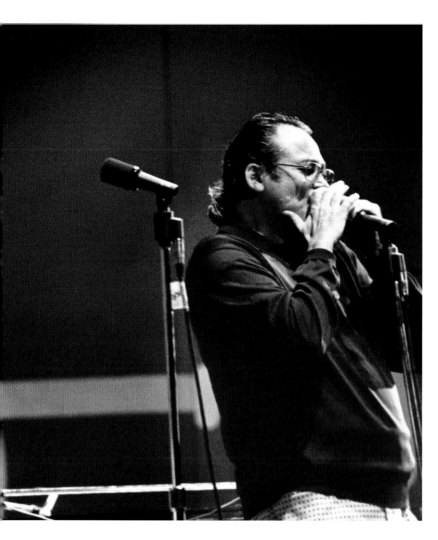

Note: The title "Baron" was given by King Albert II of Belgium, who raised Thielemans to the rank of nobility in 2001.

JEAN-BAPTISTE FREDERIC ISIDOR, BARON (Toots) THIELEMANS
harmonica, guitar, composer, whistler
Born: April 29, 1922
Died: August 22, 2016

One of those fabulously entertaining dates between the two occurred at the 1972 Monterey Jazz Festival.

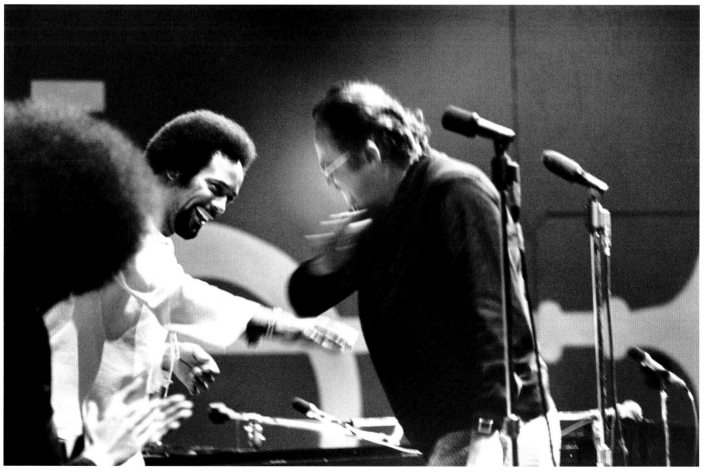

UNEXPECTED
TREATS

DIZZY GILLESPIE & JON FADDIS

COUNT BASIE & OSCAR PETERSON

JOE VENUTI

STEPHANE GRAPPELLI

JEAN-LUC PONTY

ZBIGNIEW SEIFERT

LEROY JENKINS

JOHN MCLAUGHLIN & CARLOS SANTANA

CLARK TERRY & FRIENDS

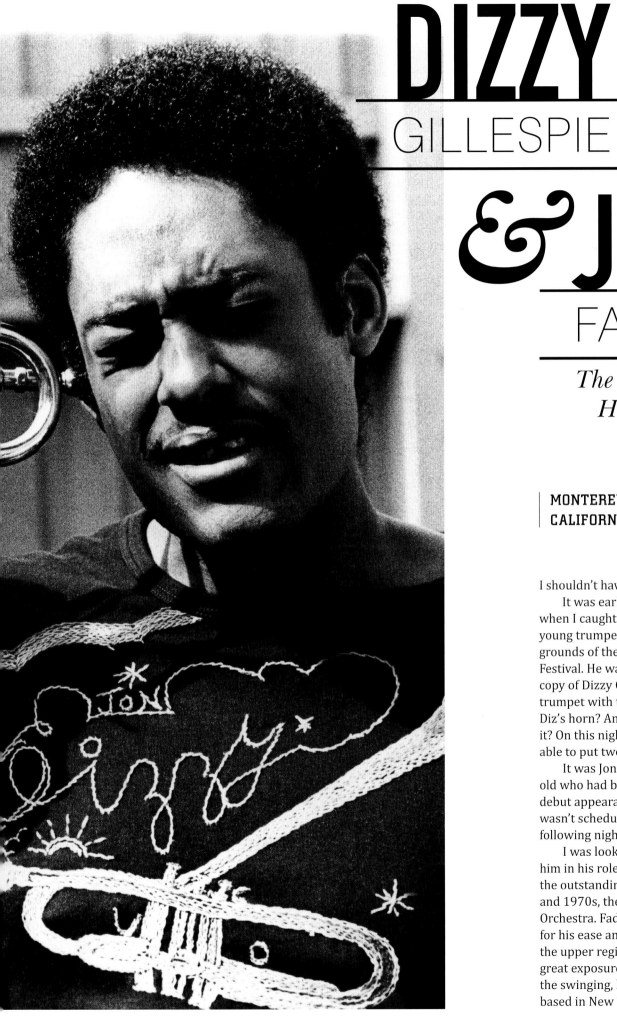

DIZZY
GILLESPIE

& JON
FADDIS

The Master and His Protégé

| MONTEREY,
| CALIFORNIA

I shouldn't have been surprised.

It was early that Saturday night when I caught a quick glimpse of the young trumpeter on the festival grounds of the 1973 Monterey Jazz Festival. He was carrying a carbon copy of Dizzy Gillespie's signature trumpet with the upturned bell. Was it Diz's horn? And if so, why did he have it? On this night, I should have been able to put two and two together.

It was Jon Faddis, the twenty-year-old who had been booked to make his debut appearance at Monterey, but he wasn't scheduled to appear until the following night's grand finale.

I was looking forward to seeing him in his role as lead trumpeter with the outstanding big band of the 1960s and 1970s, the Thad Jones/Mel Lewis Orchestra. Faddis, already recognized for his ease and stamina in negotiating the upper register, had been enjoying great exposure since recently joining the swinging, high-energy ensemble based in New York.

While covering Gillespie's Quintet later that evening, my earlier questions were answered. I discovered what the festival promoters had in store all along. Near the end of the set, as Birks was about to kick off a new number, in strode the unannounced Jon Faddis carrying a duplicate of Gillespie's trumpet. The master feigned surprise, but within seconds the tandem trumpeters locked horns and—with blistering runs seemingly high into the heavens—began to tear things up, much to the delight of the crowd.

The chemistry and solid blowing between the two that night proved so popular that when their paths crossed while on tour at major venues around the world, concert promoters frequently added Dizzy Gillespie and his "Musical Son" as a bonus package.

For Faddis, the opportunity of performing with his boyhood idol that night at Monterey was the beginning of a dream come true. When he was introduced to Gillespie's music as a fifteen-year-old—and a short time later met the man himself—it was the foundation for what would become a lifelong musical friendship. This was the giant he would emulate.

JON FADDIS
trumpet, flügelhorn, piccolo trumpet, composer, educator; also piano
Born: July 24, 1953

Above: Happy co-leaders Mel Lewis (left) and Thad Jones loosen up in this informal portrait.

Opposite: The biting, upturned trumpet sounds from Dizzy Gillespie and Jon Faddis cut through the night sky to the delight of Monterey's fans, as guitarist Al Gafa (left) and bassist Earl May provide the solid background support.

Promoters frequently added Dizzy Gillespie and his "Musical Son" as a bonus package.

COUNT
B A S I E

&OSCAR
PETERSON

Proof That Opposites Attract

As pianists—separately, in performance—the two could hardly have been further apart.

At one end of the spectrum was big band leader Count Basie, the jazz world's premier minimalist and master of understatement. At the extreme opposite was Oscar Peterson, the technical exhibitionist with speed and power to burn.

Among the early mental notes I made as a photographer—particularly at jazz festivals where numerous personalities were on the same evening's agenda—was to look for opportunities to catch images of artists together who were polar opposites in terms of their music, styles, and actual play. For example, I had often thought how great it would be to photograph the pianists Cecil Taylor and Dave Brubeck in the same frame, especially since no one would ever expect to see them performing jointly on the same stage.

It was during that August night of the 1971 Concord Summer Festival when I thought I might be able to catch a similar moment. Among the featured guests were the Oscar Peterson Trio, plus the evening's closer, Count Basie's Orchestra. Prior to the beginning of the show and periodically between acts, I ventured backstage, looking for such an opening. Oscar, along with guitarist Herb Ellis and bassist Ray Brown, were in especially

good moods as they met with friends and well-wishers. The same was true with many of Basie's stalwarts—Sweets Edison, Al Grey, and Lockjaw Davis—but the leader remained on his bus.

Instead, both the crowd and I—at the end of Basie's set—got to enjoy a surprise musical spoof involving the two leaders that is probably best described photographically.

In his wisdom, Norman Granz—founder and impresario of the hugely popular Jazz At The Philharmonic (JATP) tours beginning in the late 1940s—had long considered the value of featuring the dissimilar pianists on the same date, having first recorded Peterson with the Count Basie Orchestra in the 1950s, on a piece entitled "Blues for the Count and Oscar."

Three years after I caught their appearance together in Concord, Granz produced his first Pablo Records album actually featuring the two pianists, entitled *Satch and Josh*. Eventually, he released five popular albums of the unlikely pair.

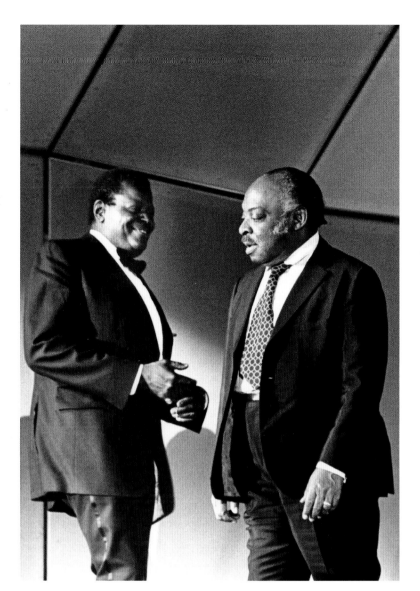

WILLIAM JAMES (Count) BASIE
leader, piano, organ, composer
Born: August 21, 1904
Died: April 26, 1984

OSCAR EMMANUEL PETERSON (OP)
piano, composer; also organ
Born: August 15, 1925
Died: December 23, 2007

Opposite: Oscar Peterson makes an unannounced visit onstage while Count Basie and band are performing.

Left: Peterson takes over the piano chair as a seemingly perturbed Basie walks off.

Bottom left: Basie feigns annoyance with having "lost control" of his band.

Bottom right: Basie, recognizing the fans' excitement to all the proceedings, shares a happy handshake before directing the rousing finale.

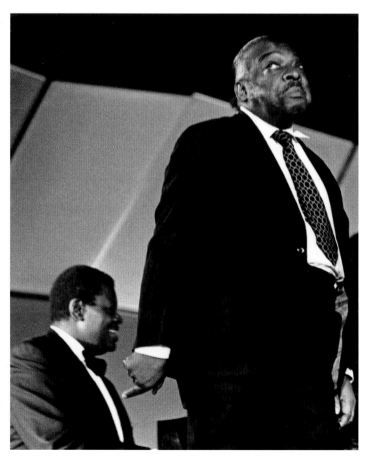

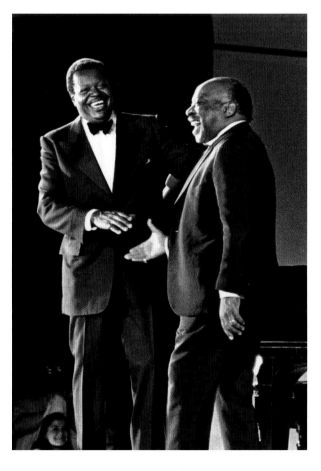

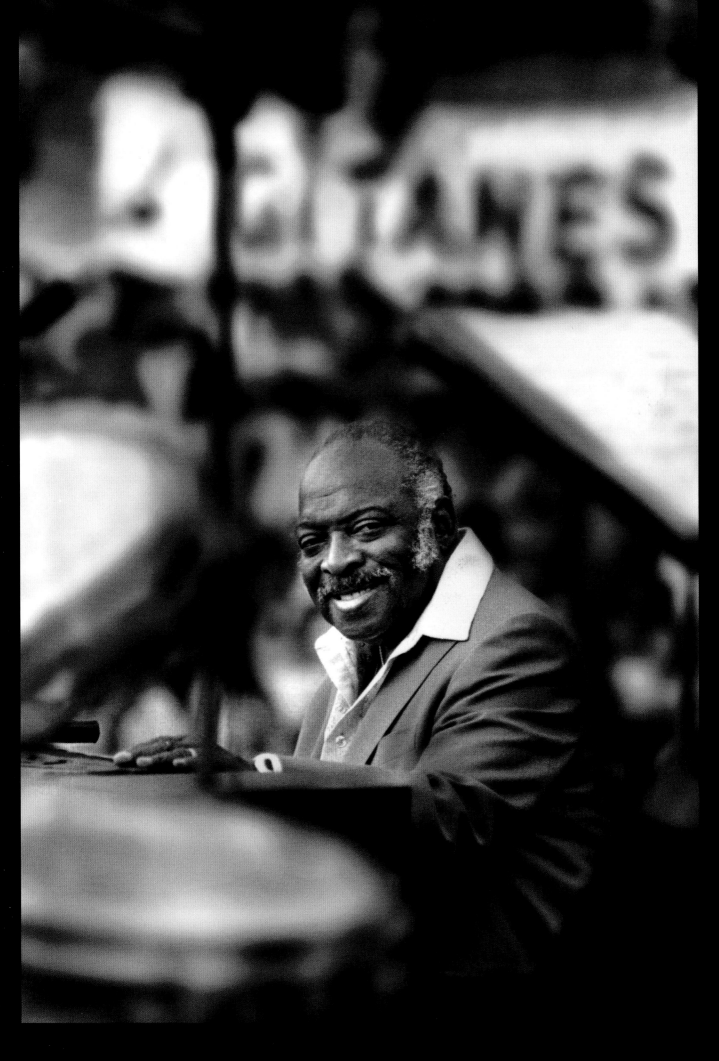

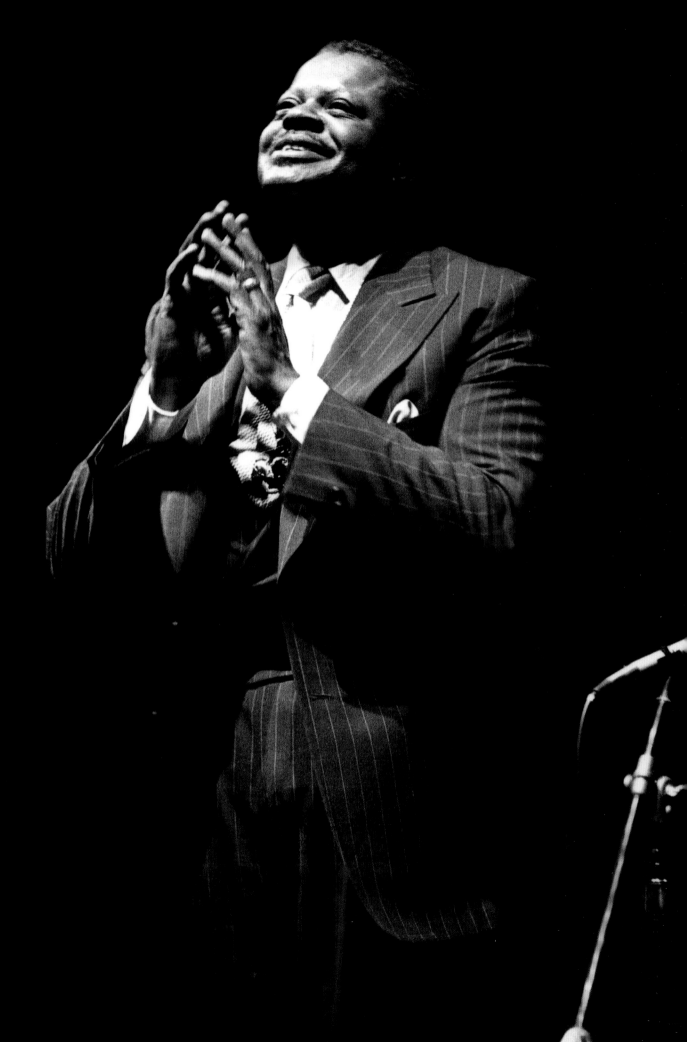

JOE
VENUTI

STEPHANE
GRAPPELLI

JEAN-LUC
P O N T Y

ZBIGNIEW
S E I F E R T

LEROY
JENKINS

The Burgeoning Violin Wave

From a historical standpoint, there was certainly nothing unusual instrumentally about linking violins and jazz music. Dating back to the early 1900s, popular ragtime and early New Orleans bands were just as likely to have included violinists as they did trumpeters and saxophonists.

But with some exceptions—notably: Stuff Smith, the heavy-vibrato, hard-swinging stylist who became the first to use an amplified violin; trumpeter/violinist Ray Nance, best known for his 20+ years with Duke Ellington's Orchestra; and the top strings player across Europe, Denmark's Svend Asmussen—it was rare to see a jazz violinist make it to center stage on a regular basis in the decades to follow.

Violinist Ray Nance shown capturing everyone's attention, especially his rhythmic support team, pianist John Lewis, and bassist Ray Brown.

Opposite: Europe's most popular jazz violinist, Svend Asmussen, in performance.

By the 1960s, the violin had become all but inconsequential as a jazz instrument. Yet by decade's end, and from that point thereafter, everything changed.

Around the same time in the late 1960s, two rejuvenated old-timers re-emerged on the scene, along with a youthful French trailblazer who soon electrified the violin. The listening public took notice of the refreshing sounds. Before long, the floodgates opened, bringing a virtual wave of new and extraordinary modern violinists. Nothing about jazz fiddlers would ever be quite the same again.

Because the "Violin Wave" has had such a sustaining effect—still progressing after more than half a century—it seems only appropriate to highlight just a few of the succeeding dominant violinists from the 1970s and 1980s, whose jazz pedigree was without question, and whose legacies have ensured that this important movement continues.

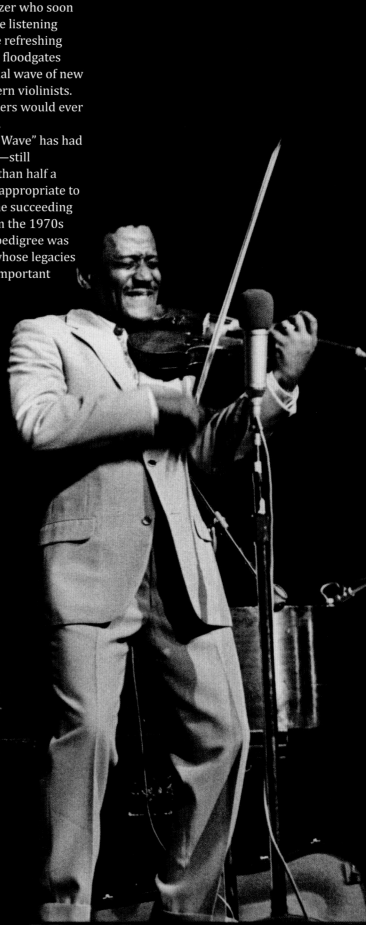

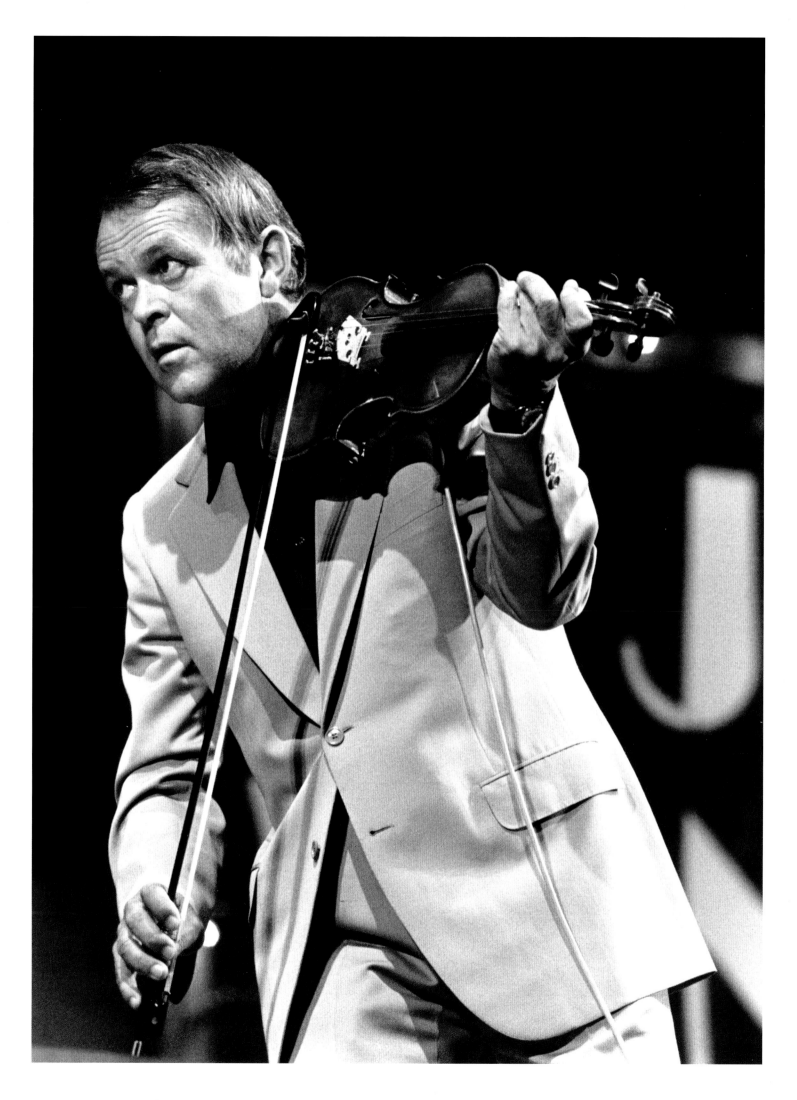

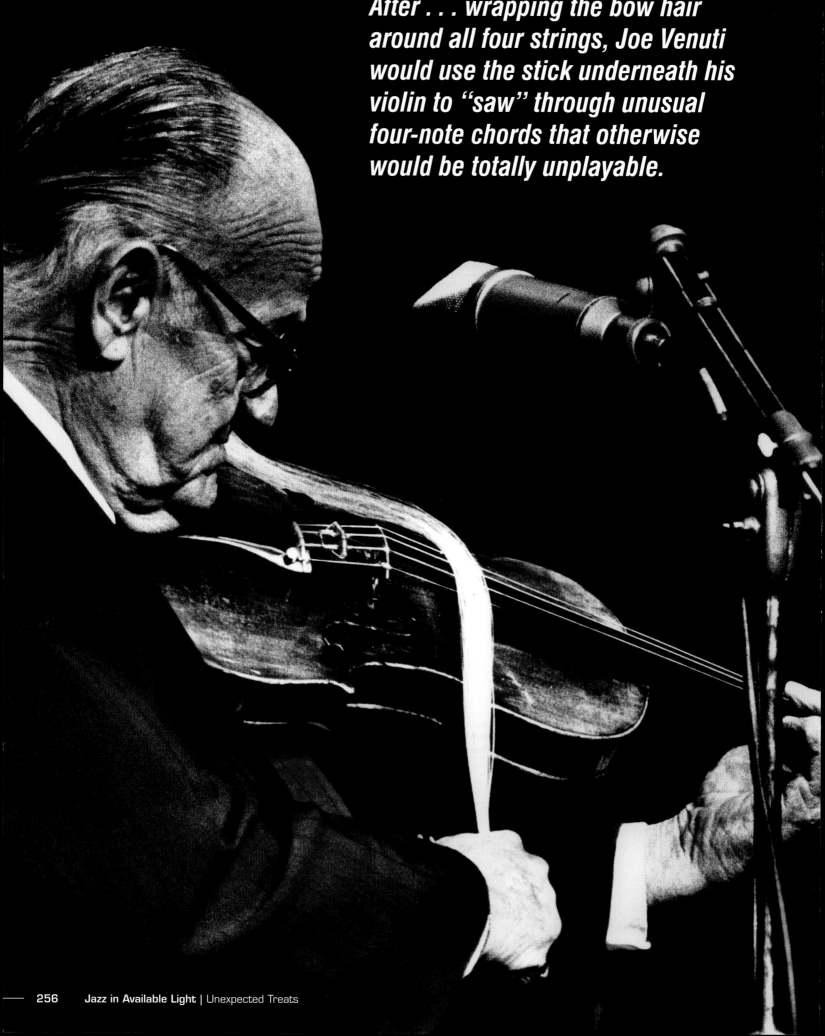

After . . . wrapping the bow hair around all four strings, Joe Venuti would use the stick underneath his violin to "saw" through unusual four-note chords that otherwise would be totally unplayable.

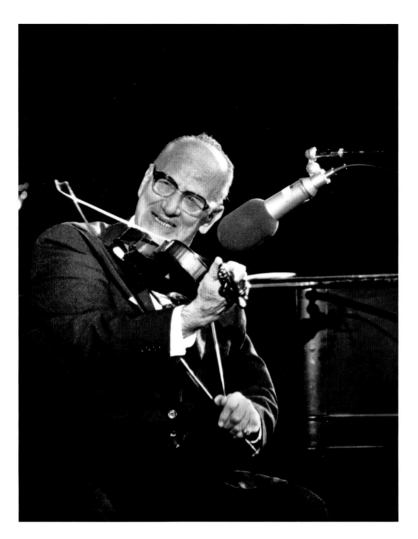

his remaining years in full discovery mode, wowing audiences and fellow musicians alike with his energizing, show-stopping presentations.

Joe Venuti was one of the true musicians/entertainers who recognized the value of engaging his close friends and fans alike. When it came time for a Venuti solo, all anyone needed to see was the gaze of his fellow bandmates—almost on cue, trained on the portly performer. They knew the real excitement was about to begin.

GIUSEPPE (Joe) VENUTI
violin, composer
Born: September 16, 1903
Died: August 14, 1978

After removing the pin from the frog of the bow and then wrapping the bow hair around all four strings, Joe Venuti would use the stick underneath his violin to "saw" through unusual four-note chords that otherwise would be totally unplayable. Even as early as the 1920s, performing with the Jean Goldkette Band, Venuti would surprise fans with his capriciously entertaining solos.

JOE VENUTI
CONCORD, CALIFORNIA

Acknowledged as the first artist to make the violin an accepted jazz instrument, Joe Venuti began winning over a whole new generation of followers just about the time he was ready to hang it all up.

Whenever I learned that Venuti would be appearing in my vicinity—even if it was hours away—I knew the trip would pay off. Whether watching him interact with fellow sidemen during rehearsals, or just catching him as he naturally lit up every crowd, he was always a kick.

The whimsical storyteller, who loved being the center of attention both on and off stage, took advantage of a couple of late career record dates and some favorable regional appearances—including serving as an occasional guest at Dick Gibson's annual Colorado Jazz Parties—to exuberantly launch his way onto the international festival circuit. Somehow, he became an immediate and lasting hit. Venuti spent

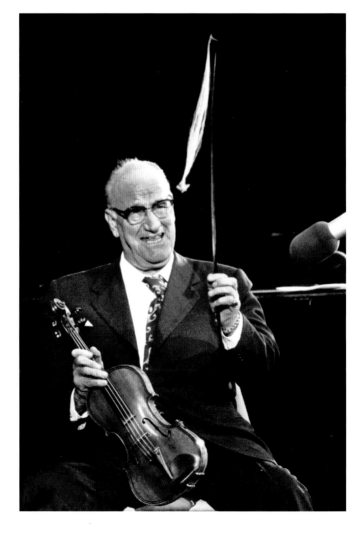

STEPHANE GRAPPELLI
SAN FRANCISCO, CALIFORNIA

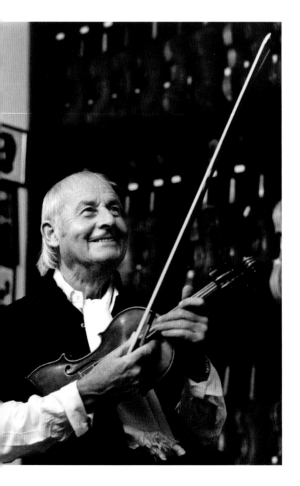

The striking senior best known from 1934 to 1939, as a key member of the famous Quintet du Hot Club de France with guitarist Django Reinhardt, Stephane Grappelli also took advantage of the resurgent interest in jazz violinists.

My opportunity to spend some time with the distinguished Frenchman materialized when I learned of his trip here in October of 1978. After tracking him down and suggesting we do a photo session together, he offered to meet while he was visiting at a violin maker's shop in the middle of Union Square.

For better than a decade, Grappelli had been reaping the benefits of all this renewed attention on jazz violinists. Now, at age seventy, he was still a major player in the violin movement, having just completed his eleventh recording in as many years—

often with musicians half his age. On the big stage, he not only played the most elegant, lyrical lines on tender ballads, but could also swing like mad on uptempo standards.

Witty, charming, and always refined in appearance, Grappelli was the absolute jazz aristocrat who made anyone in his midst feel blessed by his presence. My day with Stephane, in this seemingly out-of-place—but most appropriate—establishment, was truly invigorating. For any and all who happened to drop by the shop that afternoon, their attention was centered not on the racks of rare violins, but on this most refined and rarefied visitor.

STEPHANE GRAPPELLI (Grappelly)
violin, piano, composer
Born: January 26, 1908
Died: December 1, 1997

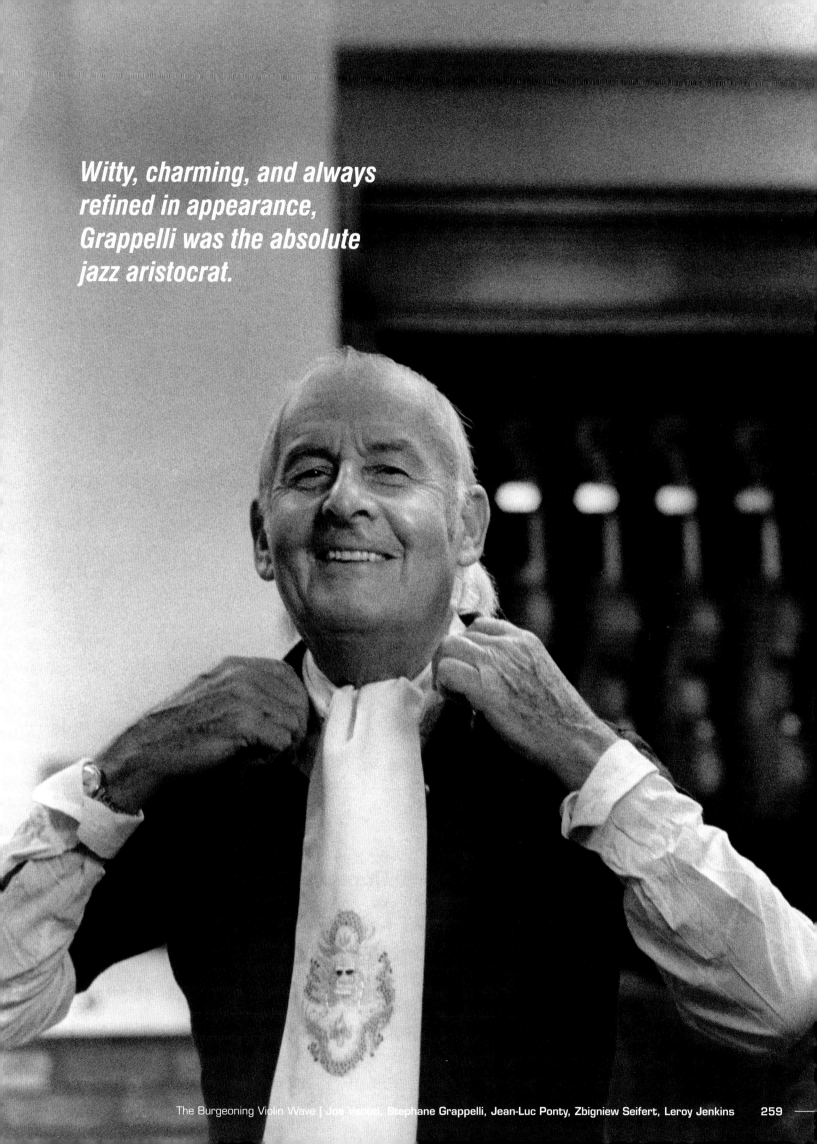

Witty, charming, and always refined in appearance, Grappelli was the absolute jazz aristocrat.

JEAN-LUC PONTY
MONTEREY AND BERKELEY, CALIFORNIA

While the two violin elders Venuti and Grappelli were once again reclaiming the spotlight, America got its first glimpse of the young man who would come to personify everything new and exciting about the jazz violin.

In his role as musical director for the Monterey Jazz Festival, pianist John Lewis of Modern Jazz Quartet fame staged a "jazz violin conclave" for the 1967 edition, recognizing stalwarts Nance and Asmussen, but also introducing Jean-Luc Ponty as the lone representative of the new guard. The demure, almost shy twenty-four-year-old's first US performance drew a thunderous welcome and rave reviews, followed quickly by a recording contract.

Despite studying classical violin in his youth, Ponty initially distinguished himself by employing bebop phrasings that many critics branded just as exciting as those played by major horn soloists. From there, Jean-Luc completed a successful fusion crossover into the worlds of rock and electronic music, reaching vast, previously elusive audiences.

By the 1980s, Ponty's transformation was well under way, both in his music and his appearance. Gone was the conservative, modest player with the boyish good looks content sharing the limelight with his fellow musicians. Now, sporting a full beard, the most fashionable attire, and an entourage befitting that of an international rock star, he was center stage wherever he went.

As I covered the violinist over a number of years, it was fun to watch how the performer, almost chameleon-like, changed both his image and style of playing, and with it the makeup of his passionate crowds. Everything about his presentations was now *electric*.

JEAN-LUC PONTY
acoustic and electric violins, violectra, composer; also keyboards
Born: September 29, 1942

> ## *It was fun to watch how the performer, almost chameleon-like, changed both his image and style of playing.*

Preparing for Jean-Luc Ponty's appearance was a full-on production.

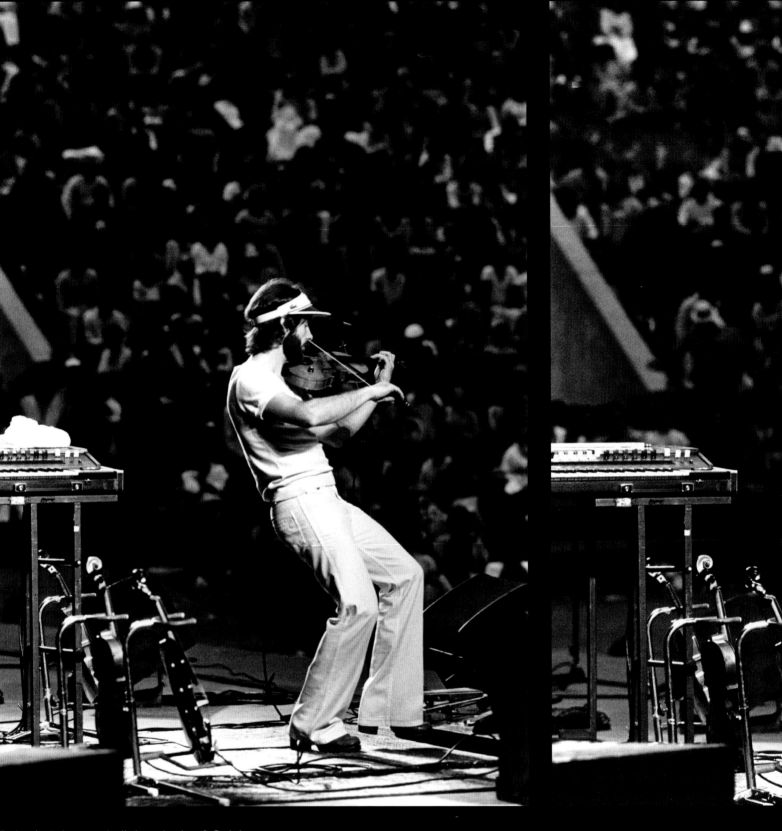

*Performing before an enthralled crowd at the 1981 Berkeley
Jazz Festival, Jean-Luc Ponty utilized an assortment of acoustic
and electric violins, plus a violectra (actually, a baritone violin
with the strings tuned one octave lower than a normal violin).*

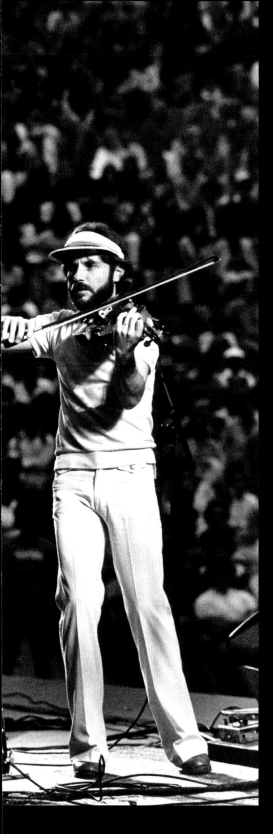
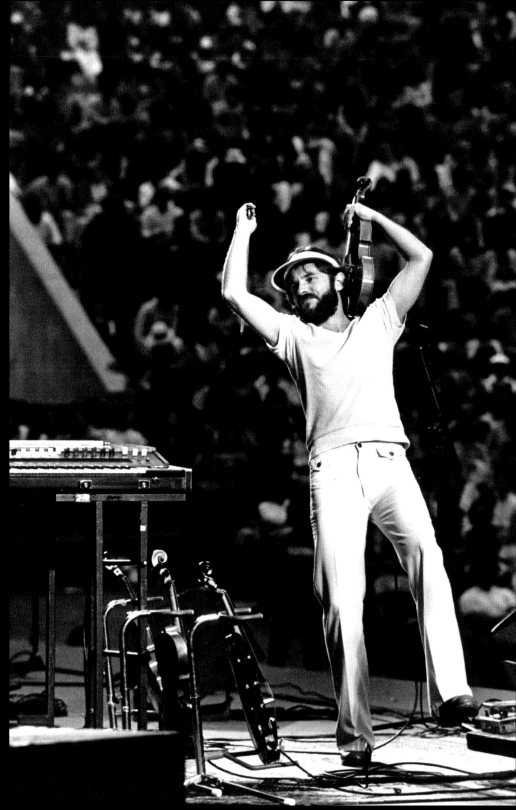

ZBIGNIEW SEIFERT
MONTEREY, CALIFORNIA

Among the many inspirational violinists who followed Ponty to critical acclaim was Zbigniew Seifert, formally trained at the Chopin School of Music in Krakow, Poland.

Like Ponty before him, Seifert's classical aesthetics played a strong role in his early development. But he was also an accomplished saxophonist, and as a disciple of John Coltrane and his music, employed the tenor saxophonist's phrasing and articulation throughout his many works. The response to his creations was quick and lasting, not only gaining him notoriety throughout the jazz world, but influencing a host of new violinists who would follow.

In Joachim Berendt's *The Jazz Book: From Ragtime to the 21st Century*, Seifert described himself this way: "What I play on the violin, I imagine being produced by the saxophone. I . . . try to play as [Coltrane] would if his instrument were the violin."

Although having tried that day, I never had the opportunity to meet the young Pole following his remarkable performance at the 1976 Monterey Jazz Festival, my only time witnessing him. My intent was to spend some time with this brilliant young innovator, certainly destined for greatness.

And then he was gone.

ZBIGNIEW (Zbiggy) SEIFERT
violin, composer; also alto saxophone
Born: June 6, 1946
Died: February 15, 1979

Opposite: Violinist Zbigniew Seifert, recognized as a national treasure in his native Poland, was stricken with cancer and died at age thirty-two.

> ## "I . . . try to play as [Coltrane] would if his instrument were the violin."

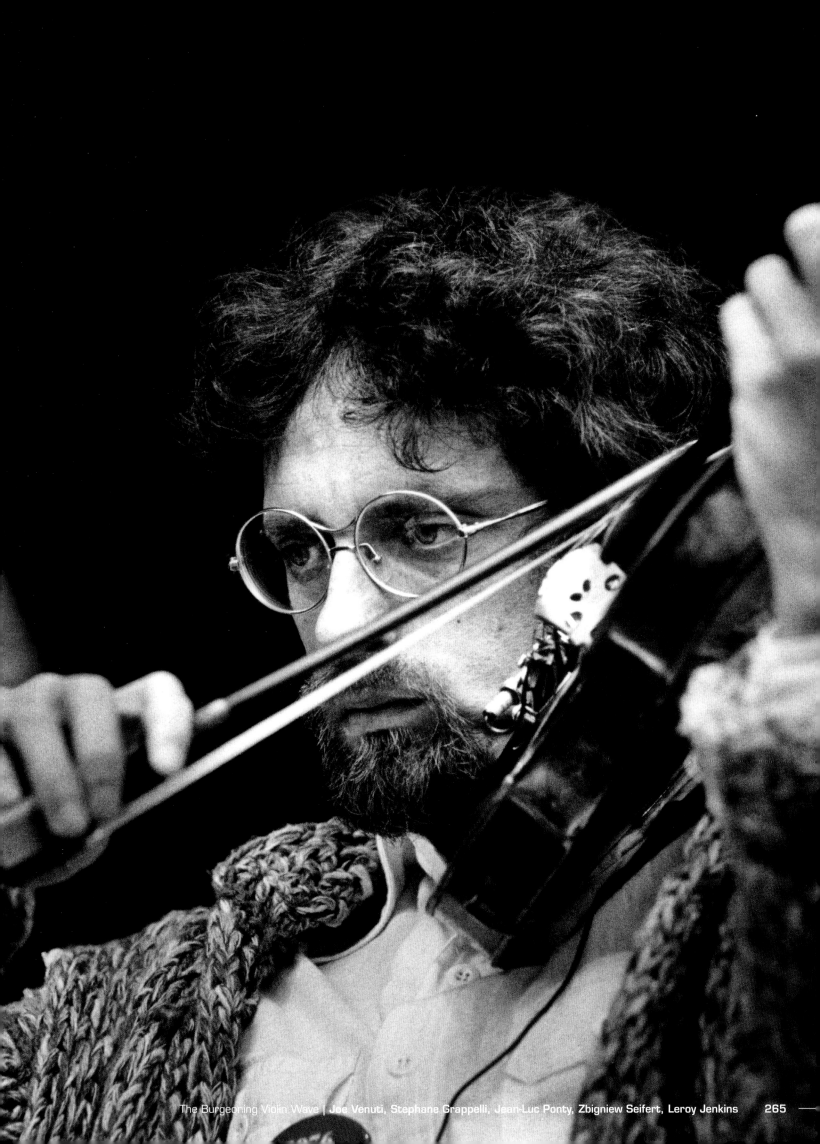

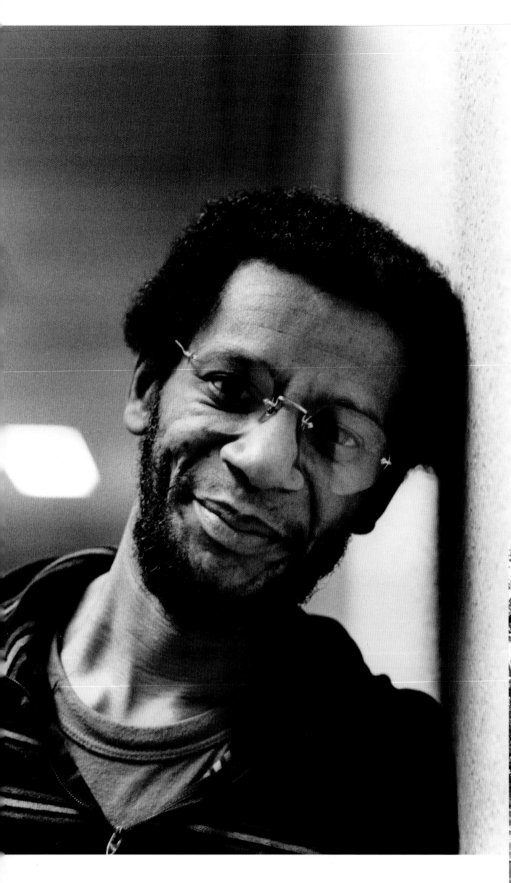

LEROY JENKINS
NEW YORK CITY, NEW YORK

Beginning in 1965, violinist Leroy Jenkins became one of the major players closely associated with Muhal Richard Abrams, the famed pianist, composer, and founder of the Chicago-based Association for the Advancement of Creative Music (AACM) directly responsible for advancing jazz's free movement.

From the beginning, the affinity that he—along with the dozens of others directly tied to the AACM—shared with Abrams would dramatically affect the progression of jazz music from that point forward.

By the 1970s, Jenkins epitomized the free-jazz period among violinists, often using percussive techniques with his instrument. His work with Abrams, along with other such avant-garde representatives as pianist Cecil Taylor and saxophonists Ornette Coleman,

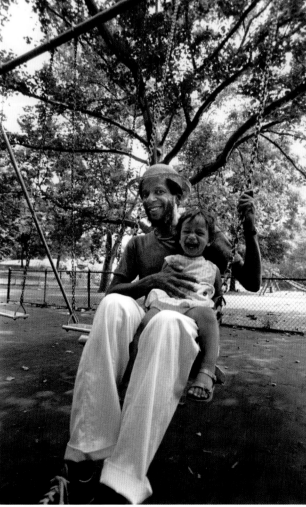

Right: Leroy Jenkins enjoys some bonding time with his daughter Chantille in New York's Central Park, in July 1979.

Opposite: An informal portrait of Muhal Richard Abrams, founder of the Association for the Advancement of Creative Music (AACM), taken in San Francisco.

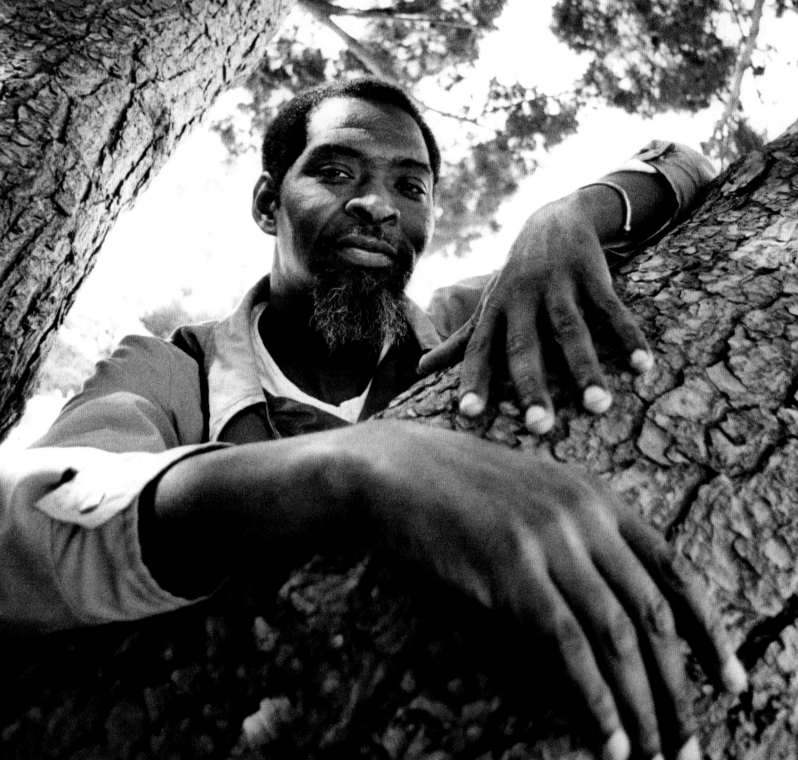

Anthony Braxton, Albert Ayler, and Archie Shepp, drew worldwide acclaim from enthusiasts hungering for change. As one of the boldest explorers of the instrument, Jenkins recognized that the absence of specific borders allowed him the freedom to maximize his creativity and expand the range of improvisatory violin.

On several occasions—and on both coasts—I met with Jenkins, a warm and inviting, self-assured artist who welcomed me into his inner circle, expressing—through both words and playing—his passion for life, his family, and his total commitment to the direction he was taking modern music. At one point, I remember him telling me something along the lines of the following: There's no guarantee that what we create will be lasting, but if we believe strongly in what we're doing, we're obligated to get it out there.

LEROY JENKINS
violin, viola, composer, educator
Born: March 11, 1932
Died: February 24, 2007

JOHN
MCLAUGHLIN

& CARLOS
SANTANA

The Coltrane Connection

It was a most unlikely collaboration. One guitarist was from England, the other from Mexico. John McLaughlin grew up with Bach, Beethoven, and Brahms. Carlos Santana was immersed in the Latin sounds. Despite their geographical distances and disparate musical influences, both were passionate devotees of the same legendary jazz icon.

The two met in the early 1970s, when McLaughlin was touring with his Mahavishnu Orchestra, the jazz fusion band's name given to him by his religious teacher, Sri Chinmoy. For several years, each would embrace the Eastern spiritual values espoused by the Indian guru.

But the most lasting and endearing musical bond tying the two together was a "devotional awareness" to the recognized leading tenor/soprano saxophone voice of the 1950s and 1960s, John Coltrane. It was his historic album *A Love Supreme*, that brought out the guitarists' shared artistic affinity for the jazz giant. As a way to pay their personal respects, they recorded *Love Devotion Surrender* on Columbia in 1973, which included their own renditions of Coltrane's memorable compositions, "A Love Supreme" and "Naima."

After going their separate ways, years after their special tribute to Coltrane, McLaughlin and Santana would occasionally cross paths. It was an unusual set of circumstances on May 25, 1980, near the end of the Berkeley Jazz Festival's final afternoon concert, that not only brought the two guitarists together, but turned a potential day of disappointment into dizzying delight.

Earlier, one of the backstage staffers told me that because of some programming changes, the festival had a couple of surprises in store. He suggested that I ". . . might want to stick around until the end."

Among those originally scheduled that day was John McLaughlin, who had completed an earlier duo guitar set with the Frenchman Christian Escoude. The much-anticipated Art Ensemble of Chicago (AEC)—with their choreographed costumes and wide assortment of horns and other instruments—had also been booked but didn't perform.

To fill the programming void, pianist Herbie Hancock and an all-star rhythm section were introduced to take the festival to a rousing finale. Midway through Hancock's set, as McLaughlin reappeared onstage,

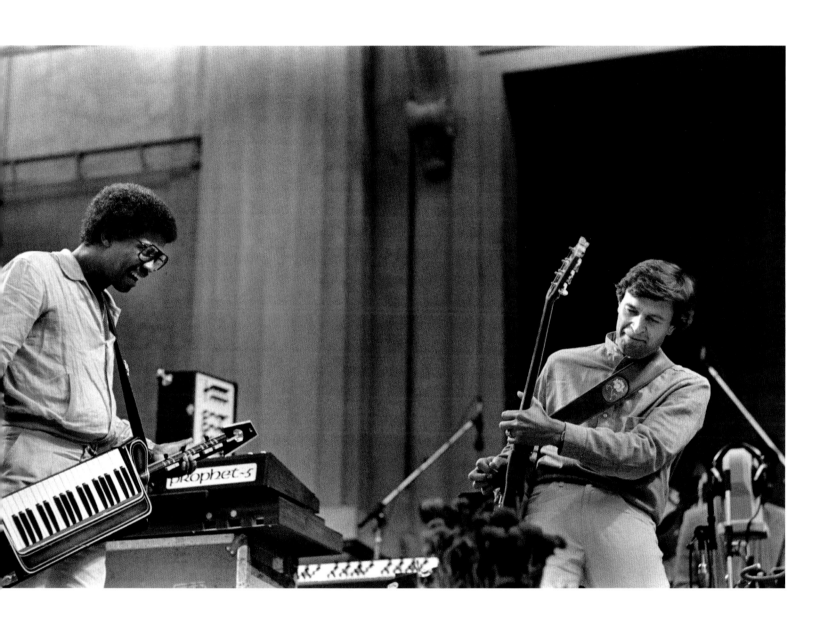

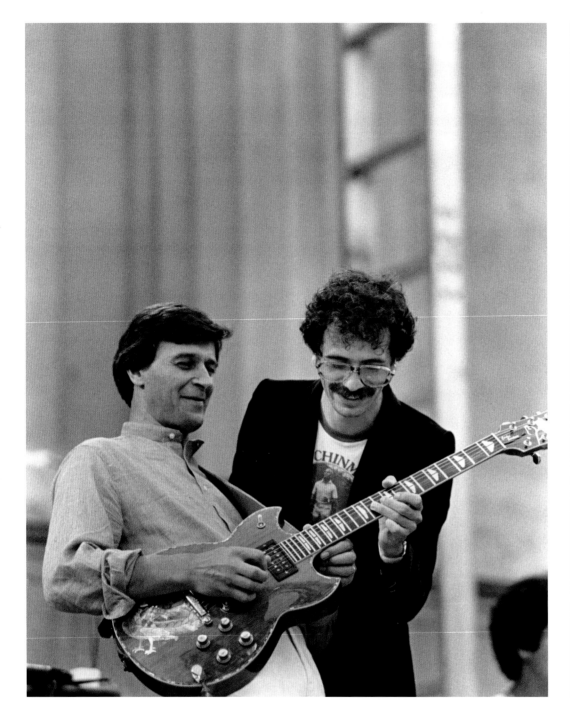

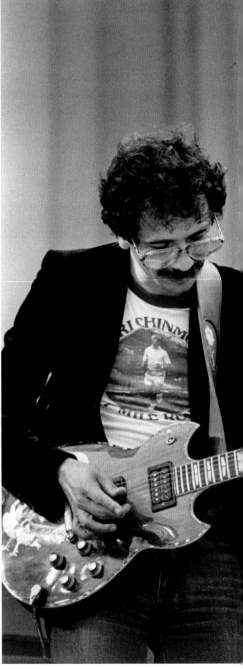

Herbie left his keyboards set-up, grabbed a strapped-on keytar, and launched into a heated exchange with the guitarist.

As the twosome brought the Greek Theatre to its feet, an unannounced, unexpected Carlos Santana walked out—without his ax—and proceeded to share the playing of McLaughlin's guitar. Each took turns controlling the instrument while the other performed fingering duties. Nobody was expecting this, and the response was immediately electric—the crowd rose as one, cheering wildly. It was a rousing finale to a rollicking afternoon.

JOHN MCLAUGHLIN
guitar, composer
Born: January 4, 1942

CARLOS SANTANA
guitar, composer
Born: July 20, 1947

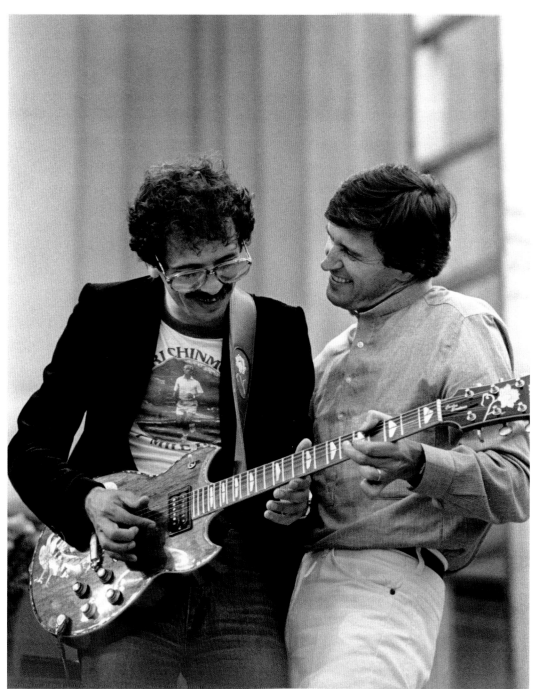

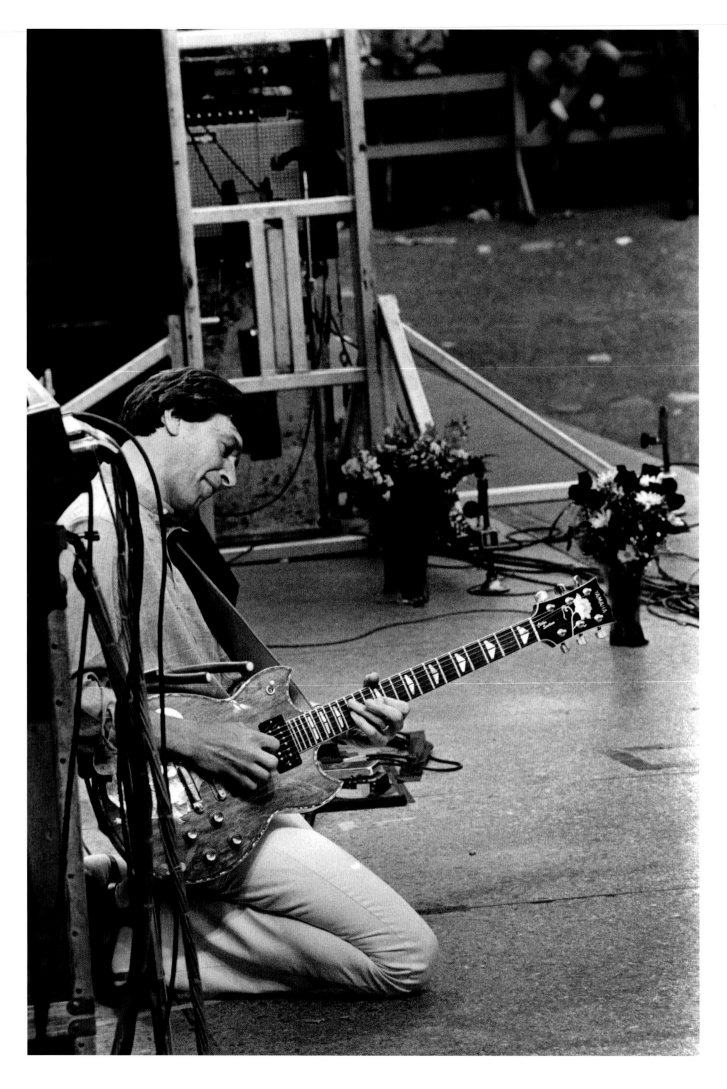

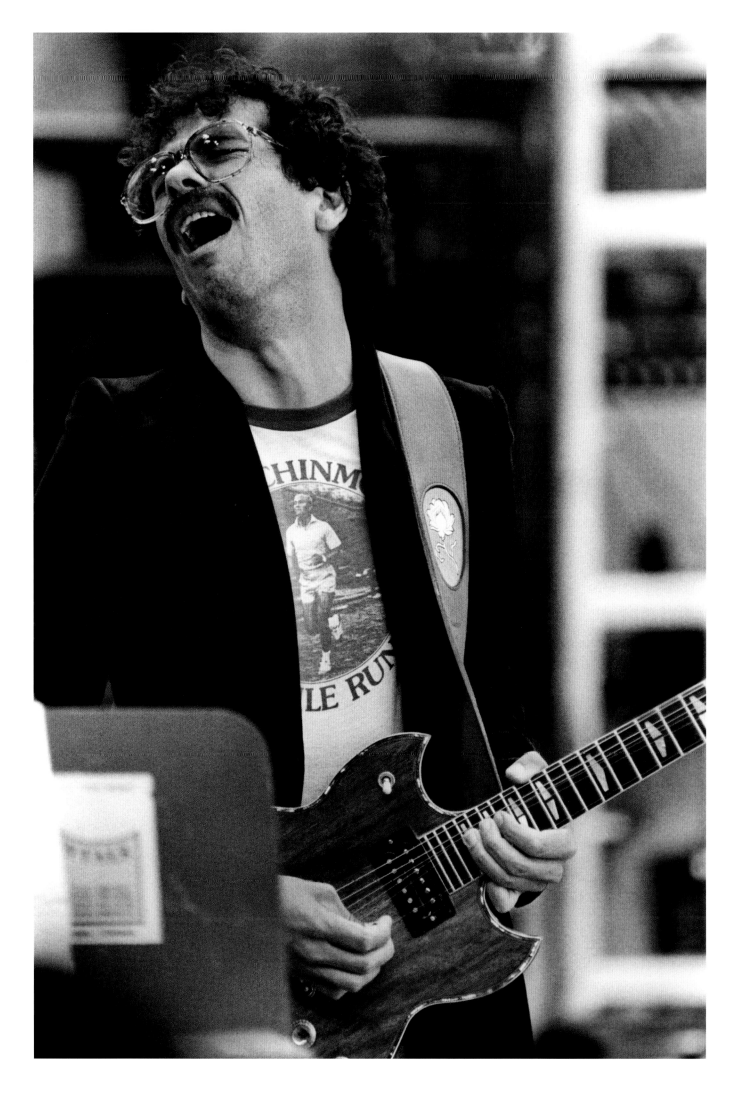

CLARK
TERRY
&
FRIENDS

The Mumbles . . . It's Contagious

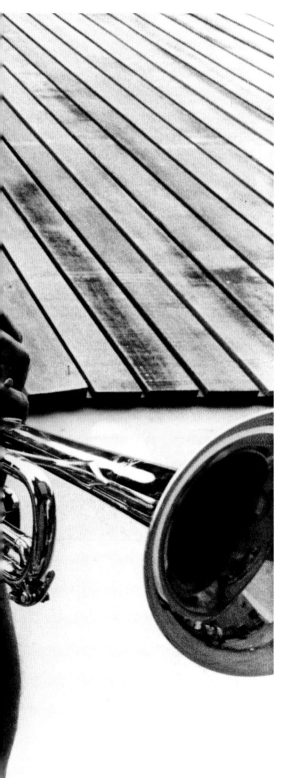

Officially, the simple little spoof originated during a recording session for the 1964 Polygram release *Oscar Peterson Trio Plus One.* It was just a couple of inane, two-minute blues pieces— "Mumbles" and "Incoherent Blues"— coined by the "One" on the date, trumpeter/flügelhornist Clark Terry. The idea was to simply change the pace and add a little humor to the proceedings.

In his memoir, *Clark: The Autobiography of Clark Terry,* the artist described how he convinced Oscar to add his "wordless blues" numbers to the recording date. "I gave him the tempo and he started playing . . . some real funky blues.

"I joined in with my mumbling. When I looked at Oscar, he was cracking *up.* Practically on the floor."

The presentations were always hilarious, drop-dead funny.

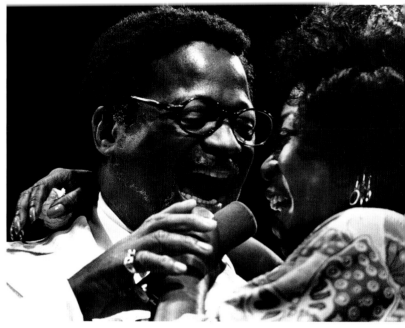

To my mind, Clark Terry was one of the most exceptional, professional, and complete artists I ever met, whose instantly identifiable solos were often gemlike. He took his musicianship very seriously. But Clark was also a fabulous entertainer. He liked to dress up and have a lot of fun with everyone around him.

Little did he know then, but with the release of his recording with Peterson, "Mumbles" and "Clark Terry" would become just about as synonymous as "be" and "bop." Pretty much everywhere he performed after that, Terry would inevitably offer, or be coaxed into, his slurring, unintelligible version of scat singing. And always to the total delight of his audiences.

Asked to describe his signature brand of vocalizing, Terry characterized it as that of a drunk murmuring at a local bar. But when he made those sounds—along with that low-down blues beat and his special inflections—the presentations were always hilarious, drop-dead funny.

Clark Terry's "Mumbles" routines were not only a kick, they even became infectious. At jazz festivals and other special events, a variety of unannounced friends would inevitably join him onstage, add their own versions to the mix, and proceed to just tear the place up.

CLARK TERRY
trumpet, flügelhorn, composer, singer, leader, educator
Born: December 14, 1920
Died: February 21, 2015

Clark Terry shares the Mumbles "contagion" with (top left) singer/songwriter Jon Hendricks, (top right) vocalist Sarah Vaughan, and (left) trumpeter Dizzy Gillespie.

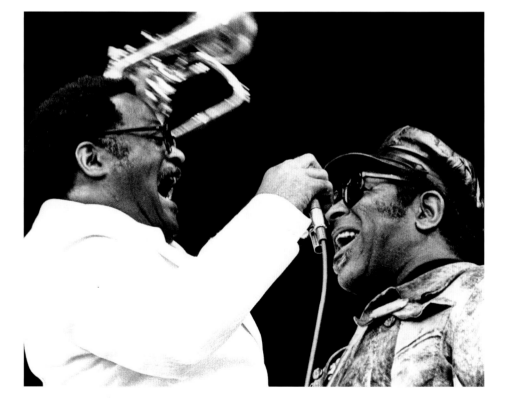

SPECIAL ENCOUNTERS

SHELLY MANNE

CECIL TAYLOR & MIKHAIL BARYSHNIKOV

LOUIE BELLSON & TONY WILLIAMS

DUKE ELLINGTON & DIZZY GILLESPIE

ART BLAKEY & WAYNE SHORTER

BUDDY RICH

SHELLY
MANNE

Honoring a True Elite

The last time I photographed him was late on a Sunday, the final day of the 1984 Monterey Jazz Festival. He was relaxing on the grounds behind the main stage, appearing just as mellow, easygoing, and fit as always. I approached him and said, "Shelly, we should do some informal candids . . . you're looking better than ever."

Because we had crossed paths so many times over the previous fifteen years, it only seemed natural that my meetings with the drummer who symbolized West Coast Jazz would continue for many more years to come. Three days later, after returning home to Los Angeles, Shelly Manne died of a massive heart attack.

Most everywhere the drummer appeared, it was *his* name that usually received top billing: "Shelly Manne and His Men." And true to form, whenever I caught him in performance, whether guiding a huge studio orchestra or providing the delicate touch to a smooth quartet, he struck me as the consummate leader.

He was internationally celebrated as one of the prime movers of the established cool style of modern music that sharply contrasted with the driving bebop, and later, hard bop styles preferred back east. And because he stood apart from so many of his peers stylistically, some gave him a bad rap. Certain critics insinuated that Shelly Manne couldn't be considered a serious jazz musician if many of his music business credits included dominating the Hollywood motion picture and TV film scores.

I believe he was so much more. To my mind, Shelly Manne was the epitome of the melodic drummer, and perhaps as comfortable as any of jazz's recognized greats in virtually all musical settings. He was subtle, not showy. No matter the group, you could not miss his versatility—he could bring whatever beat, whatever exceptional sound necessary, to make the performance eventful.

I remember that August night when the original "LA Four" members

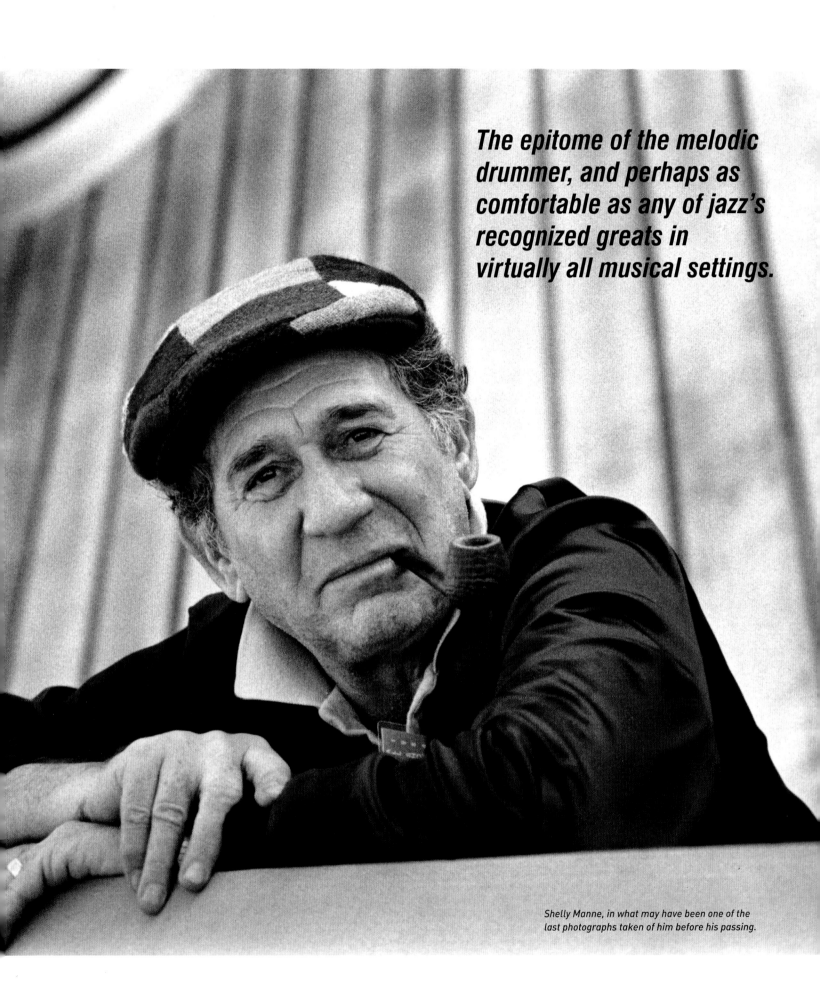

The epitome of the melodic drummer, and perhaps as comfortable as any of jazz's recognized greats in virtually all musical settings.

Shelly Manne, in what may have been one of the last photographs taken of him before his passing.

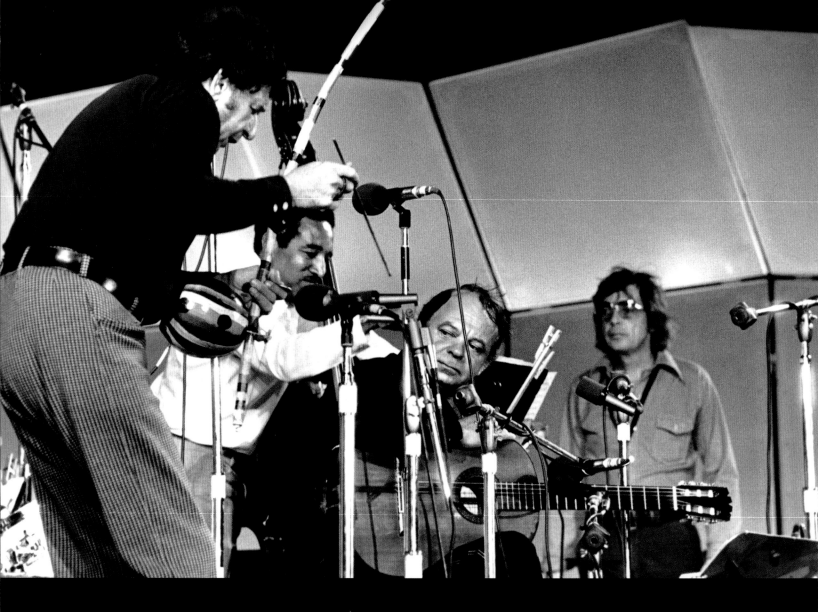

(guitarist Laurindo Almeida, saxophonist/flutist Bud Shank, bassist Ray Brown, and Shelly Manne) appeared at the 1974 Concord Summer Festival. Their live recording date, *LA Four Scores!*, was that group's debut offering, featuring some bossa nova and classical-oriented compositions by Almeida.

On one of those numbers, "Berimbau Carioca," Shelly retrieved a *berimbau* from his drum kit, a strange-looking, Brazilian-made wooden single-string bow attached to a gourd. Despite his tongue-in-cheek comment to the audience about the berimbau's many uses—"You can hunt with it, or you can smoke it . . ."—Shelly's deft pecking and tapping on the string perfectly embellished the sprightly interchange between Shank on flute and Almeida. Appreciating the warm summer breezes that evening, it was almost as if we were being transported to the sandy shores of Bahia.

For those who continue to trivialize the drummer or try to lessen his impact in the jazz world, I find myself in the opposite camp. Had he remained in New York, the home of his birth, who's to say that Shelly Manne wouldn't have been ranked right up there with the recognized East Coast elites, led by such drummers as Max Roach, Roy Haynes, Art Blakey, Philly Joe Jones, and Elvin Jones?

SHELDON (Shelly) MANNE
drums, leader, composer
Born: June 11, 1920
Died: September 26, 1984

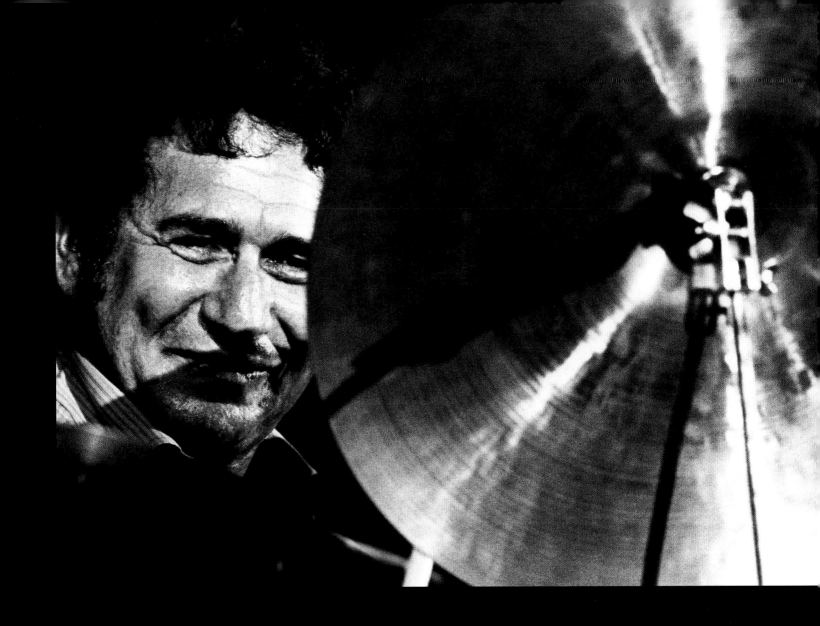
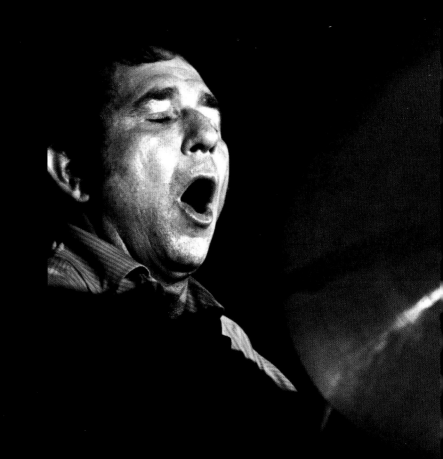

CECIL
TAYLOR

&

MIKHAIL
BARYSHNIKOV

Looking for a Little Respect

HOLLYWOOD BOWL, LOS ANGELES, CALIFORNIA

Although universally recognized as the forerunner of avant-garde jazz piano, plus one of the primary innovators of twentieth century music, he didn't exactly receive top billing.

In fact, the blazoning marquee at the entrance to this spacious outdoor facility in August of 1979, failed to even have his name listed as one of the keynote performers. Of the 18,000 patrons who had eagerly paid top dollar just to be in attendance, I'd bet ninety-five percent of them did not even know the name of the unannounced artist unless they thoroughly read the program.

Nevertheless, it was an artistic triumph for the man. And perhaps even more important, the performance represented a significant milestone for the jazz world at large.

To this throng representing the so-called "upper crust," pianist and composer Cecil Taylor was virtually an unknown quantity. They had come to see the world's premier ballet dancer, Mikhail Baryshnikov, and the cast of the New York City Ballet Company.

The unheralded Taylor had been commissioned by the NYC Ballet Company to write a fourteen-minute composition as one choreographed segment for the opening portion of a five-part program the troupe performed that summer—here at the Hollywood Bowl, as well as in Chicago and Philadelphia.

Cecil's score, entitled "Tetra Stomp," subtitled "Eatin' Rain in Space," featured him as solo pianist with Baryshnikov and partner Heather Watts doing the interpretive ballet moves.

Entering extreme stage left to a pair of grand pianos—one facing the other and seemingly fit together as two

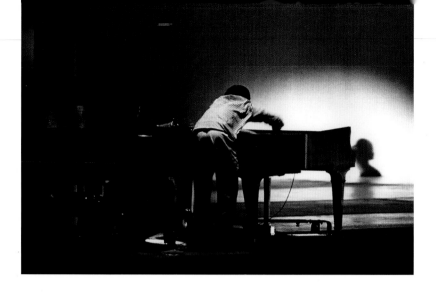

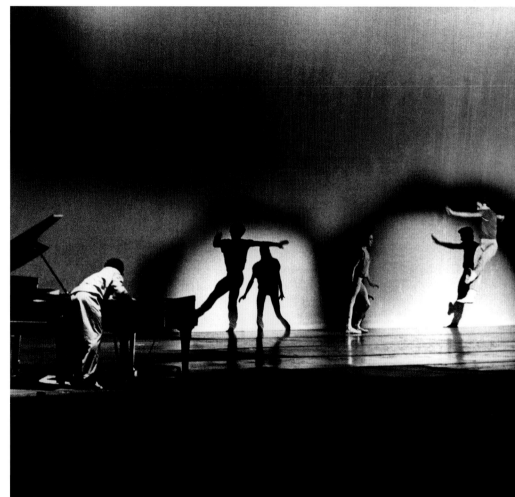

pieces of a puzzle—Taylor began with a rhythmic pattern of hand-drumming on the raised cover of one piano as the dancers approached center stage.

Picking up the tempo, Taylor moved into a light staccato beat as the two began their routine. Cecil abruptly changed positions and, reaching into the other piano whose top had been removed, began plucking and strumming the strings. From where I stood, expressly relegated quite some distance away from the stage as dictated by the event's producers, there appeared to be some unease among those in the audience. Were they really expecting the dancers to be formally accompanied by an out-of-sight, full pit orchestra for Cecil's portion of the program?

Before long, the slow, even, and deliberate harp-like strumming had reached a crescendo with Cecil performing intermittent two-fisted thumps and rolls. The dancers, meanwhile, paced and pranced, leaped and cavorted, while ranging the breadth of the stage.

Taylor again changed positions, retreating this time to the keyboard for the remaining major portion of the piece.

Compared to a Cecil Taylor solo engagement within the intimate confines of a jazz club or theatre where one of his pieces could last more than an hour and reach numerous bombastic climaxes, this composition was relatively subdued. That's not to say there wasn't intensity in his performance. But because he was aware of the imposed time limitations, as well as knew the nature of the program and the audience, Cecil purposely offered a more restrained presentation for this outing.

Afterwards, with my mind racing, I envisioned the scenario of Cecil Taylor performing in this same setting, only this time totally unrestrained, really stretching out. As the camera pans to the crowd, the high society elitists in attendance are sitting there in outright shock.

The fact that such a collaboration came about, even if it did take until Taylor was fifty years old, was a profound achievement. For Cecil, who had been an ardent fan and admirer of ballet for some three decades, the opportunity to showcase his very special artistry in such a setting was a happy occasion, but, as he told me, ". . . [it was something] I always wanted to do earlier in my life."

Top: Taylor reaches into the piano to pluck the strings.

Note: Far too often, many of our creative trailblazers really only begin to receive notoriety long after they're gone. Fortunately, that is not the case with Cecil Taylor. For ten days in April of 2016, the Whitney Museum of American Art devoted its entire fifth floor in honor of the eighty-seven-year-old jazz treasure, whom they described as "one of America's most innovative and uncompromising living musicians." In celebration of his life, the five-part exhibition documented the pianist's multifaceted career through archival videos, audio, notational scores, photographs, poetry, and other ephemera, as well as featured him in live performances at the museum. I found out about the event, in part, because The Whitney asked to use a few of the photographs from that night in 1979. Perhaps the focus nearly four decades ago was on the ballet dancers, but this time, the attention was—deservedly—on Cecil.

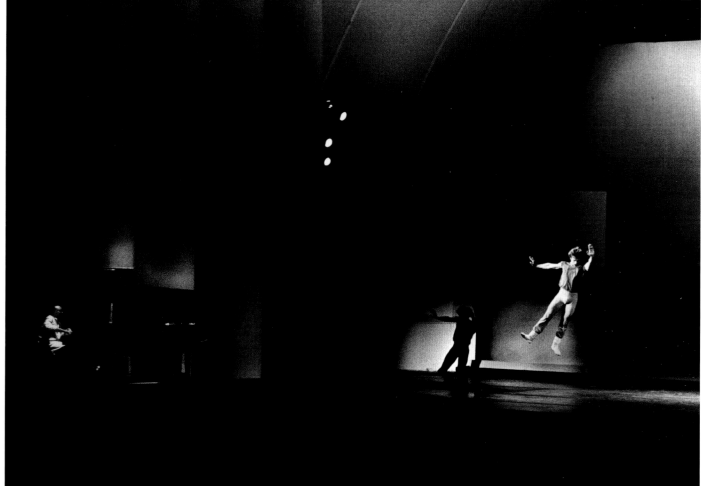

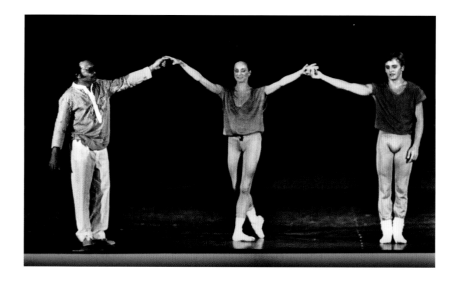

LOUIE
BELLSON

& TONY
WILLIAMS

Mutual Admiration

BERKELEY,
CALIFORNIA

From a distance, it appeared to be a chance encounter: there, just off-stage at the 1978 Berkeley Jazz Festival, stood the wise sage and the young buck sharing a warm embrace.

Of course, both were drummers, so it wasn't exactly a revelation. After all, battery mates of every stripe have lots in common. But for any casual observer looking on, Louie Bellson and Tony Williams—born practically a generation apart—were seemingly about as mismatched as two percussionists could be.

It was only natural that their influences, tastes, and actual performance artistry would be dissimilar. Bellson made his bones solidly backing some of the most popular big bands of the swing era, particularly the Duke Ellington Orchestra, which adhered to the written scores. Williams, who represented the changing free/fusion period of jazz music styles, was the powerhouse teenage upstart hand-picked by Miles Davis for his second great quintet from the mid-1960s.

Seemingly about as mismatched as two percussionists could be.

The longer I stood there watching, I realized there was nothing accidental about this meeting. The two continued to carry on a purposeful dialogue, thoughtfully engaging one another. Here were a couple of really close friends getting together once again to talk shop and share meaningful times.

Instead of concentrating on their differences, I began to think of the many attributes that made these artists such close musical soulmates: the pair, uniquely blessed with astonishing technique, shared the commonality of perfect time; both were astute listeners who always complemented their respective band members; and perhaps most importantly, the duo took special pride in being complete musicians, highly regarded for their considerable skills as serious composers and arrangers. Their respective leaders paid them the highest compliment by frequently playing, and recording, their works.

It was some time later, after reading his book, *Louie Bellson Honors*

Top: Drummer Tony Williams unleashes a torrent of sound.

Bottom: Louie Bellson, leading his own big band, with guitarist Joe Pass looking on.

12 Super Drummers: Their Time Was the Greatest, that I discovered just how strong of a bond existed between these two craftsmen. Bellson, who had helped revitalize the Ellington band in 1951, by prominently being featured center stage as the first percussionist to use two bass drums in his setup, talked about one of his initial encounters with the youngster.

Because Tony recognized that many other drummers—both in jazz, as well as in rock bands—were suddenly following in Bellson's footsteps, he remarked, "I'm getting two bass drums."

Louie, who considered Williams a natural player and a true original, told Tony, "Don't do it. You don't need it."

The elder time-keeper, who was a keen observer of new talent arriving on the scene, assured Tony that his playing style was unique and didn't require any equipment tampering. He was quick to rave about Williams being one of his personal favorites of all time. "Tony Williams gave us all a new approach to the drum set—a stylist who can swing hard and solo with great imagination."

LOUIE PAUL BELLSON (Luigi Paulino Alfredo Francesco Antonio Balassoni)
drums, composer, leader, educator
Born: July 6, 1924
Died: February 14, 2009

TILLMON ANTHONY (Tony) WILLIAMS
drums, composer
Born: December 12, 1945
Died: February 23, 1997

DUKE
ELLINGTON

& DIZZY
GILLESPIE

Perfectly Compatible

Set changes during a jazz festival can be interminable, but they provide a welcome respite for fans needing a bathroom break, refreshments, or a chance to simply walk around and stretch out. But, it's just not always a good idea to do that.

Many fans thought the ideal time to get out of their seats was prior to the opening night's finale of the 1970 Monterey Jazz Festival featuring the Duke Ellington Orchestra. The Modern Jazz Quartet had just finished, and everyone knew it would take some time to rearrange the stage for a full orchestra.

Within a minute or two, I noticed that a grand piano and microphone had been placed outside of the closed curtain to the right of the stage. I went down front. Soon Duke Ellington appeared alone and began a playful banter with the audience. I figured that, as the *entr'acte* artist, he would simply do some noodling at the piano to help pacify those still in their seats while stagehands completed the necessary changes.

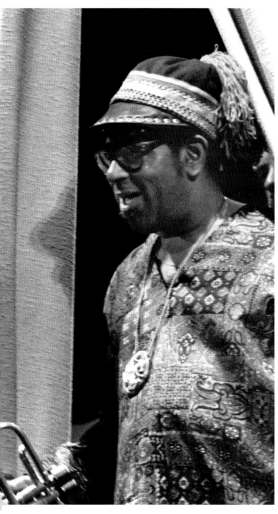

Diz and Duke should have been given a complete forty-five minute set.

But all at once, peeking through a slit in the curtain, stood an impish Dizzy Gillespie with his up-turned trumpet making a surprise entrance. Suddenly, things got serious.

Over the next several minutes, the spirited interplay that followed turned out to be one of the highlights of the evening. As the trumpet/piano duo were really cooking, I briefly closed my eyes and envisioned being in the confines of a major jazz club listening to the best of two bop-inspired giants from the past.

When they finished, I looked back to see the expressions of those who had remained in their seats, obviously excited with what they had just heard. Two of jazz's finest had delivered a most unexpected musical treat, and everyone I witnessed couldn't have been happier. On that special night, I'm sure all of us who hung around believed that Diz and Duke should have been given a complete forty-five-minute set.

It was some time later, after reading his autobiography, *Music Is My Mistress*, that completely confirmed to me the total genius of Duke Ellington. Had he not devoted his life to composing for, and leading, his nonpareil orchestras, he could have easily made his mark just stretching out and showcasing his more personally expressive side as a pianist. He would have been the master in any musical style, including bebop.

Ellington wrote, "I always liked the bop, and I am proud to say that the fabulous, flamboyant John Birks Gillespie worked in our band once, for four weeks. Diz played with us at the Capitol Theatre [in New York] in

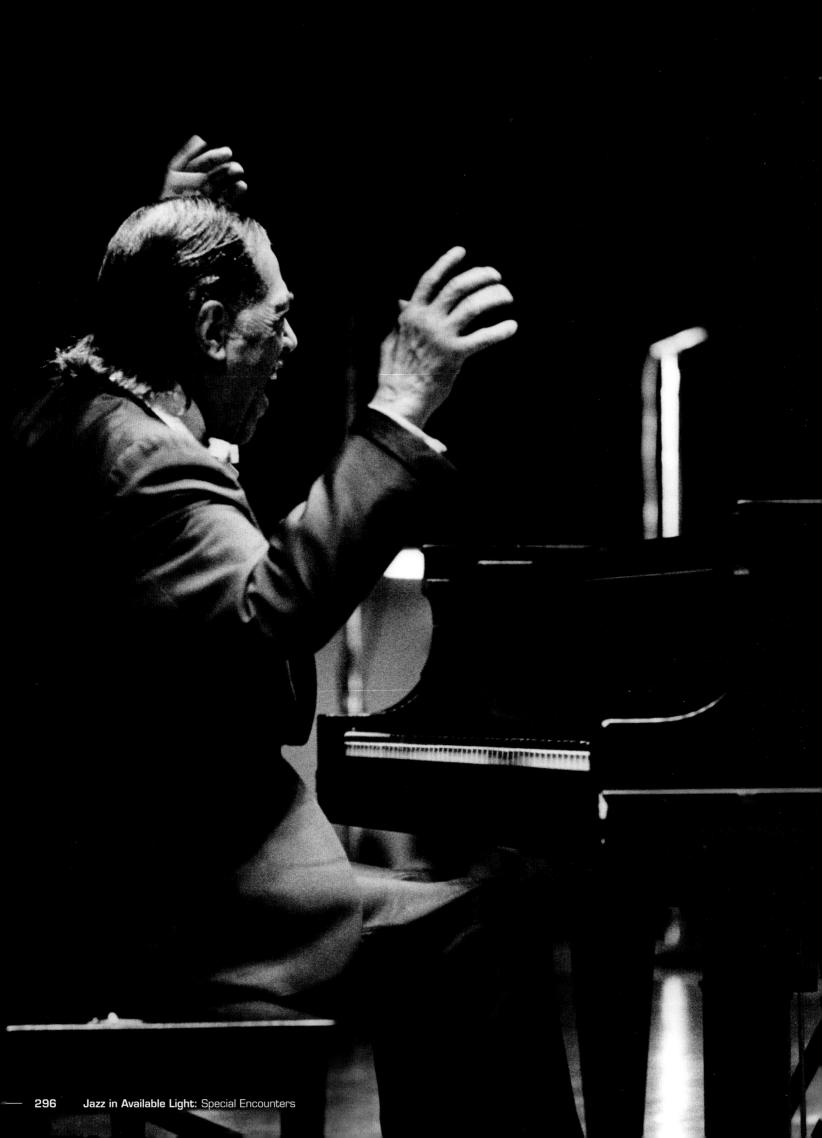

1944, when we had the gorgeous Lena Horne on the bill. Of course, I had known him for quite awhile before that, because I was an avid visitor on Fifty-second Street. I don't think I missed going there a night after we finished work"

Gillespie recalled the same four weeks he spent with Ellington in his memoirs, *To Be, Or Not . . . To Bop*: "Duke had his band set up and used it as an instrument to get certain musical effects, especially tonal colors What he did for the instruments in the band—the sounds that came out of his band—were unprecedented in the history of jazz, and you will never hear sounds like that again. . . . When the king is dead, long live the king, he'll be there. You don't have to worry about him, he'll be there."

EDWARD KENNEDY (Duke) ELLINGTON
composer, leader, piano
Born: April 29, 1899
Died: May 24, 1974

JOHN BIRKS (Dizzy) GILLESPIE
trumpet, composer, arranger, singer, leader; also piano
Born: October 21, 1917
Died: January 6, 1993

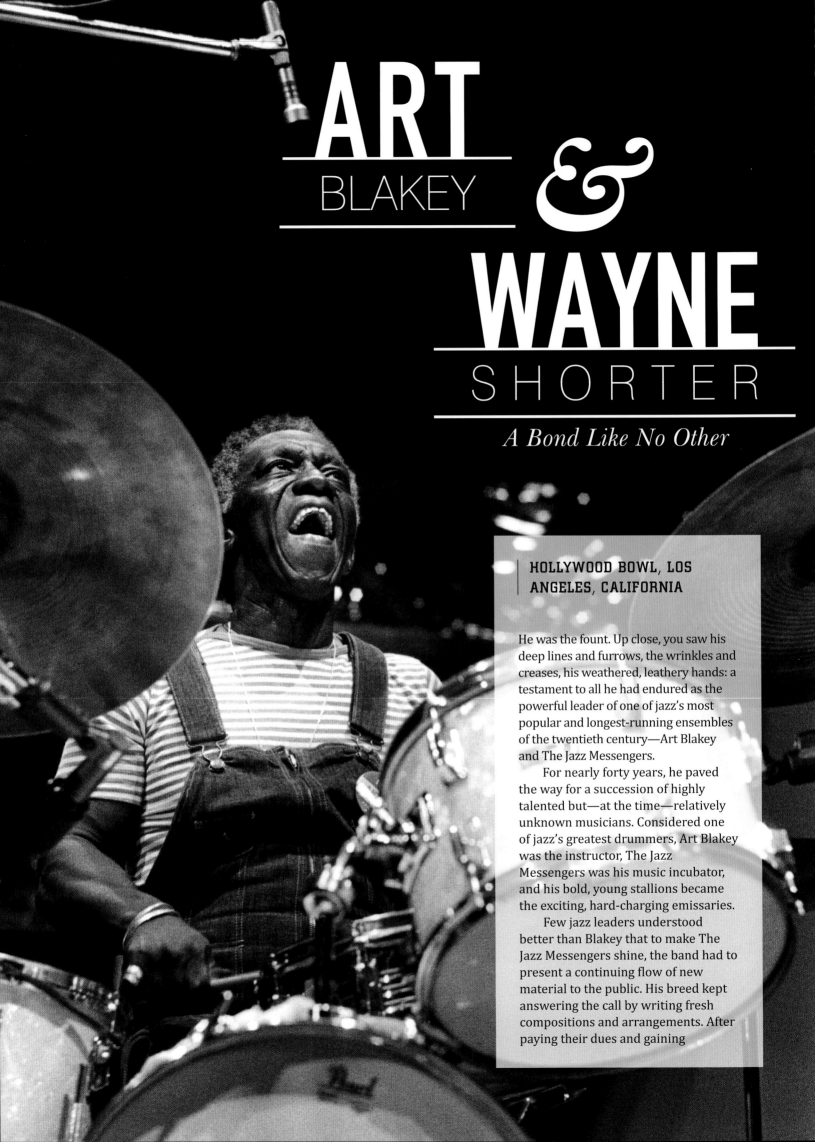

ART
BLAKEY

&

WAYNE
SHORTER

A Bond Like No Other

HOLLYWOOD BOWL, LOS ANGELES, CALIFORNIA

He was the fount. Up close, you saw his deep lines and furrows, the wrinkles and creases, his weathered, leathery hands: a testament to all he had endured as the powerful leader of one of jazz's most popular and longest-running ensembles of the twentieth century—Art Blakey and The Jazz Messengers.

For nearly forty years, he paved the way for a succession of highly talented but—at the time—relatively unknown musicians. Considered one of jazz's greatest drummers, Art Blakey was the instructor, The Jazz Messengers was his music incubator, and his bold, young stallions became the exciting, hard-charging emissaries.

Few jazz leaders understood better than Blakey that to make The Jazz Messengers shine, the band had to present a continuing flow of new material to the public. His breed kept answering the call by writing fresh compositions and arrangements. After paying their dues and gaining

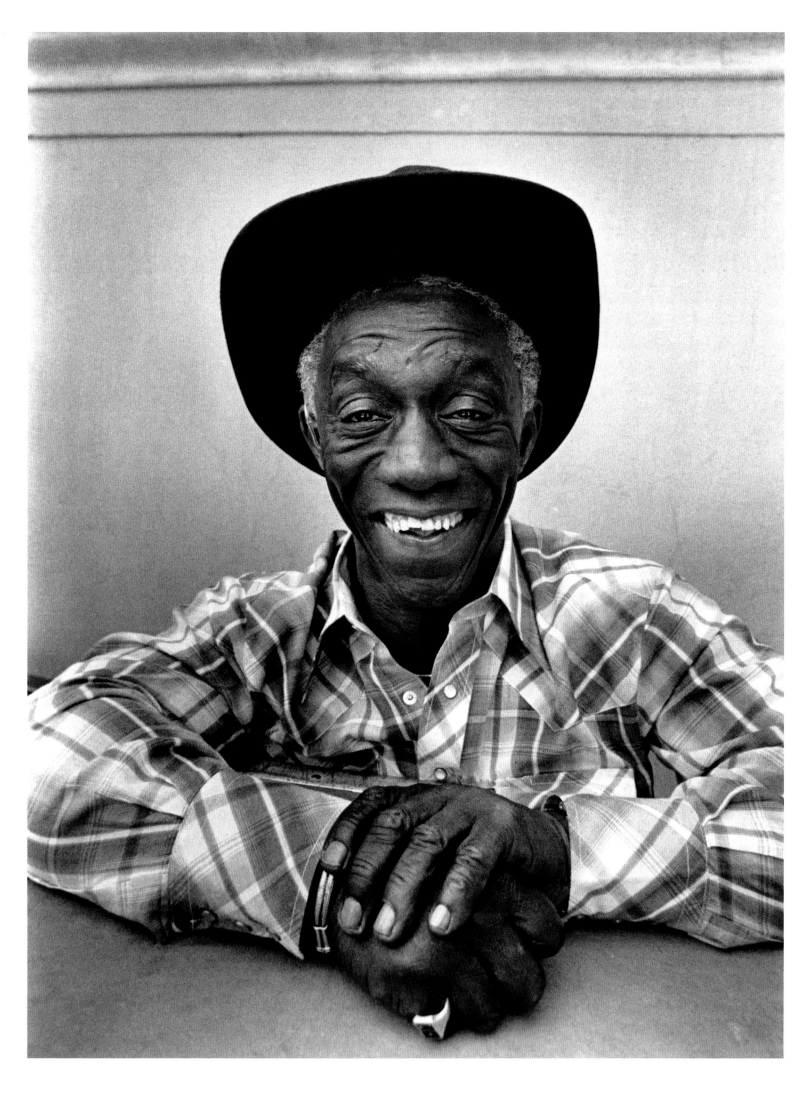

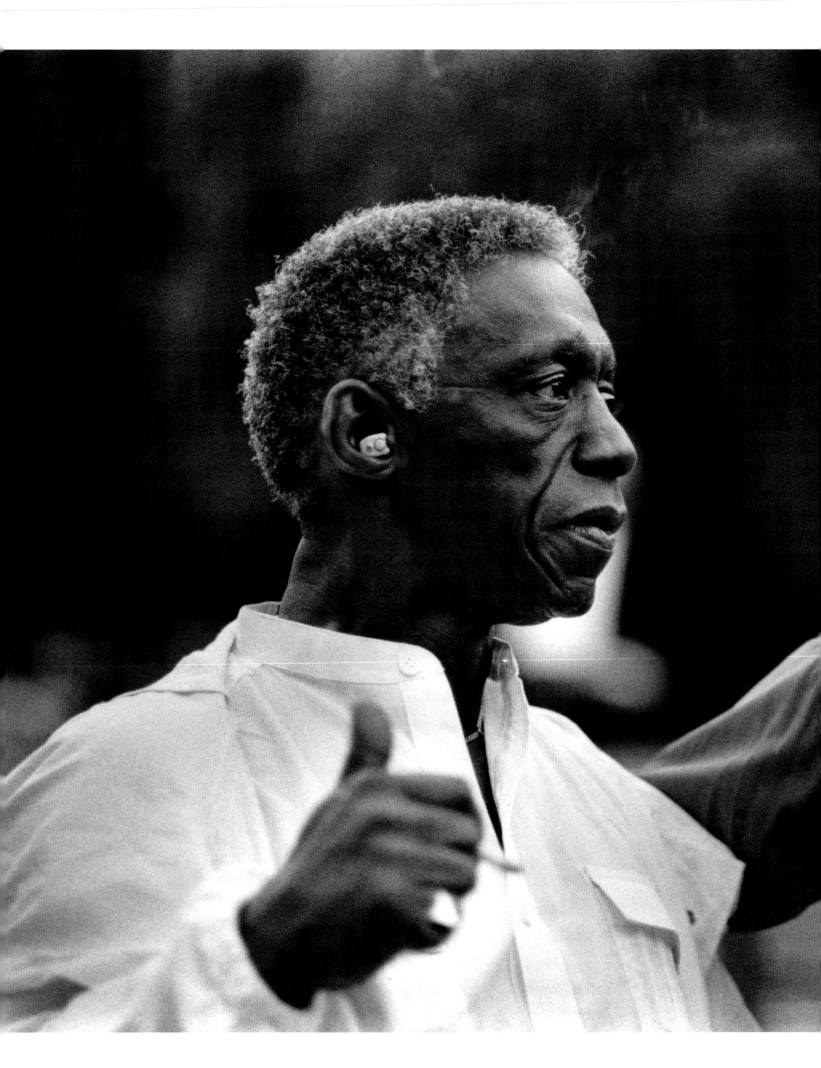

I could see the obvious bond.

notoriety, these same messengers would inevitably become successful leaders/headliners of their own bands, delivering their own musical missives.

Saxophonist Wayne Shorter, today one of jazz's greatest living composers and improvisers, got his first big break when he joined Blakey in 1959. To this day, his compositions from that period are considered among the group's most masterful ever recorded.

It's safe to say that every Jazz Messenger from the 1950s-on held the deepest respect for their first real boss, and would easily have written reams of praise on his behalf for helping them forge their own careers. Yet, one intimate photograph may suffice as the ultimate testimonial.

It was while covering the 1979 Playboy Jazz Festival at the Hollywood Bowl, some two decades removed from the time of their initial bond, that I spotted them. There, off in the distance, stood the two jazz giants conversing in a quiet setting well beyond the backstage area. I knew what was happening, the significance of it all. I could see the obvious bond.

As I made my way closer, I grabbed a telephoto lens and captured what was palpable: a clearly reverential Wayne Shorter, the former student, in awe of his master/tutor, Art Blakey.

ARTHUR (Art, Bu) BLAKEY (Abdullah Ibn Buhaina)
drums, leader, educator
Born: October 11, 1919
Died: October 16, 1990

WAYNE SHORTER
tenor, soprano saxophones; composer
Born: August 25, 1933

BUDDY
R I C H
The Showman, Personified

At the time, I didn't know he was the man who played the "Lone Ranger" theme on popular radio broadcasts that I listened to every week. What I do remember was his visit to Sioux Falls, South Dakota, and his featured performance with our Washington Senior High School Band.

According to my band instructor, "America's Premier Cornet Soloist" Leonard B. Smith was the one I should try to emulate as I continued to improve as a young fledgling on the same instrument. I remember how technically perfect he sounded that night playing "Carnival of Venice" to a packed auditorium. Some time afterwards, the school also invited the flamboyant trumpeter Rafael Mendez as guest soloist. When he played "The Flight of the Bumble Bee" I was amazed.

Notwithstanding the excellence that each of these brassmen exhibited, it was a live big band performance several months later that really got my juices flowing.

In the mid-1950s, my parents took me to the Corn Palace in Mitchell, an hour's drive away, to see the Harry James Orchestra. As expected, the band swung hard and the trumpet virtuoso drew standing ovations for his spectacular solos.

But it was the human dynamo surrounded by all the percussion equipment who practically stole the show that day. That was the first time I heard the name Buddy Rich.

I got to know the flamboyant drummer after he had formed his own big band. By 1969, Rich had become a regular fixture on the festival circuit, and I began crossing paths with him frequently. For many, he was the main draw for any big night of entertainment. He easily qualified as one of jazz's greatest technicians, yet didn't overshadow his young corps of disciplined, swinging players. He was also his own best promoter, becoming the unpredictable, semi-regular foil on such popular programs as *The Tonight Show with Johnny Carson*.

Some found the man to be caustic and condescending. But I always saw

Buddy's mannerisms as his way of simply staying loose. His *schtick*, just as you saw him on TV, was to purposefully fluster and play games with his questioners, constantly keeping them off-guard. He was without doubt a most serious musician, but he certainly didn't take himself seriously.

Maybe it was only because I was carrying cameras every time he saw me, but I always found Buddy to be open and engaging, pleasing to be around. In one of our earlier meetings, I shared my story about seeing him for the first time as a high-schooler. He appeared to have gotten a kick out of

If any other drummer could have matched Buddy Rich's pyrotechnical fireworks display that night, their teeth would be aching, too.

that. Whatever discussions we had were playful, mostly amounting to small talk. Over the years, he seemed to welcome my occasional intrusions of his space and was always responsive to a particular photo request.

Catching Buddy Rich in performance was always a major event. I was reminded of just how prescient the jazz writer and critic Whitney Balliett was when he described one of Buddy's concerts for his book *Collected Works: A Journal of Jazz, 1954–2000*. He wrote, "[Rich] . . . punctuated breaks and shaded melodic passages and underlined crescendos with such pinpointed verve that the musicians were nearly lifted out of their seats, and then he took a breathtaking solo. It had dynamics, unbelievable speed, and a whirling inventiveness. It was a mad, magnificent performance."

Similarly, while covering the drummer and his band during the 1972 Monterey Jazz Festival, I cap-tured an instant that might serve as an exclamation mark to what the critic had offered in his book. Near the conclusion of his set, after completing a wickedly-sustained, white-hot drum solo, Buddy Rich reacted to his pulsing nerves by grabbing his chops as the crowd roared in unison.

BERNARD (Buddy) RICH
drums, leader, singer
Born: September 30, 1917
Died: April 2, 1987

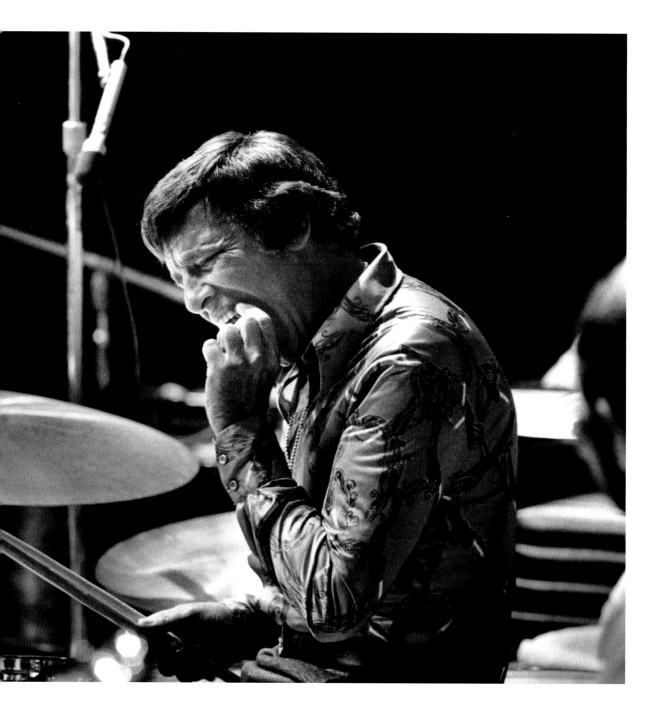

EPILOGUE

A Parting Tribute

PHINEAS NEWBORN, JR.

LOS ANGELES,
CALIFORNIA

The life of a jazz musician is a constant struggle. Years of preparation, an abundance of creativity, and the ability to innovate, improvise, and deliver stunning performances night in and night out are still no guarantees that he or she will actually "make it." And even if success does follow, it can be so short-lived.

Pianist Phineas Newborn, Jr. *was* one of those artists who seemingly had it all, success included.

By the time he was twenty-five years old, with his uncanny velocity, a fountain of ideas, and the technical brilliance to put it all together, some critics were hailing him as one of the greatest jazz piano virtuosos of the twentieth century—on par with the likes of Art Tatum, the Frenchman Bernard Peiffer, and the Canadian Oscar Peterson.

In his autobiography, *A Jazz Odyssey,* Peterson expressed deep admiration for his close friend, Phineas. He wrote, "His lithe, flowing ideas were based on complementary left-hand harmonic phrases that sometimes served not only to augment but even supplant the right-hand phrases. His keyboard fleetness was marvelous and must have seemed awesome to many other pianists. The thing about his playing that seemed to undo a lot of pianists was his ability to play double-handed phrases with ease."

My introduction to Newborn came in the early 1960s, when I acquired his trio album on Contemporary, *A World of Piano.* I loved his playing on the album so much that within just a few years, I had completely worn out the record.

The first time I caught up with him was in November of 1975, at the Shrine Auditorium in Los Angeles. He, along with numerous other jazz all-stars, were on hand to perform at an event billed as

the "1st Annual World Jazz Association Concert." During breaks interspersed throughout the afternoon's rehearsals and soundcheck, Phineas was having a good time, enjoying the camaraderie of his fellow artists.

At the time, I will admit that I knew only remotely about Newborn's bouts with mental illness. I was vaguely aware he had been admitted to Camarillo State Hospital in California in the 1960s, but it wasn't anything

A slightly more reserved Phineas Newborn, Jr. joins in the fun backstage with organist Jimmy Smith.

that stuck in my mind. Nor did I know that the year before his Shrine Auditorium engagement, he had sustained several broken fingers following a mugging in Memphis, Tennessee. Despite these problems, he performed two numbers that evening, displaying—at least to me—no signs of lost art or technique.

About seven years later, in the early 1980s, we reconnected once again, this time at the Keystone Korner jazz club in San Francisco. He looked and performed extremely well,

his stay.

It was only after his death in 1989, at age fifty-seven that the jazz world would begin to learn of the disturbing and ignominious treatment of Phineas Newborn, Jr. Once he had made his last trip home to Memphis and was no longer "famous," it was almost as if the man had never existed. Virtually nothing had been reported about Phineas or his condition. At a time when he needed them most, even the jazz community had let him down. For someone of his

been instrumental in helping put Memphis on the music map—he had become a literal unknown.

As a final insult, because no one would even pay for his funeral, the pianist was buried unceremoniously in a pauper's grave in Memphis National Cemetery.

PHINEAS NEWBORN, JR.
piano, composer
Born: December 14, 1931
Died: May 26, 1989

The same year, news of that unsettling event led to the founding of the Jazz Foundation of America (JFA), followed by its incorporation a year later. Its stated purpose was to assist jazz artists who have fallen on hard times, or are in need of medical benefits and other basics for survival.

Critic and author Nat Hentoff devoted a section of his book, *American Music Is*, toward urging support for the foundation—appropriately entitled "Musicians Taking Care of Their Own." Hentoff frequently championed the many good deeds of the JFA in various forms of media, and also served on their Board of Directors.

From its inception, the JFA has maintained its mission statement, reading "The Jazz Foundation of America is committed to providing jazz and blues musicians with financial, medical, housing, and legal assistance as well as performance opportunities, with a special focus on the elderly and veterans who have paid their dues and find themselves in crisis due to illness, age, and/or circumstance. JFA achieves its mission through compassionate and personalized social work care that restores dignity and hope to their clients. JFA is saving jazz and blues 'one musician at a time.'"

An honorable mission indeed.

A couple of those "saved" musicians included trumpeter Freddie Hubbard and baritone saxophonist Cecil Payne. Hubbard, who suffered congestive heart failure shortly after his wife lost her job and the couple's medical coverage, spent all of their savings on medical bills. The Jazz Foundation stepped in, paying the Hubbards' mortgage for several months and saving their home.

Payne had gone into seclusion when his eyesight was failing because of severe glaucoma. Since he was such a strong and independent man, Cecil never reached out, but friends learned of his deteriorating condition and put him in touch with JFA. "I was going blind and couldn't see to shop or cook," said Payne. "I was living on two cans of

SlimFast and a package of M&M's a day for over a year-and-a-half. The Jazz Foundation saved my life."

A portion of all proceeds—both from the sales of this book as well as future purchases of jazz archival prints by Veryl Oakland—is earmarked for the Jazz Foundation of America.

To gain further information or provide additional support, please contact:

Jazz Foundation of America
322 West 48th Street, 6th Floor
New York, NY 10036
Telephone: (212) 245-3999
email: info@jazzfoundation.org

Cecil Payne buried deep within the saxophone section from his earlier days with bandleader Woody Herman.

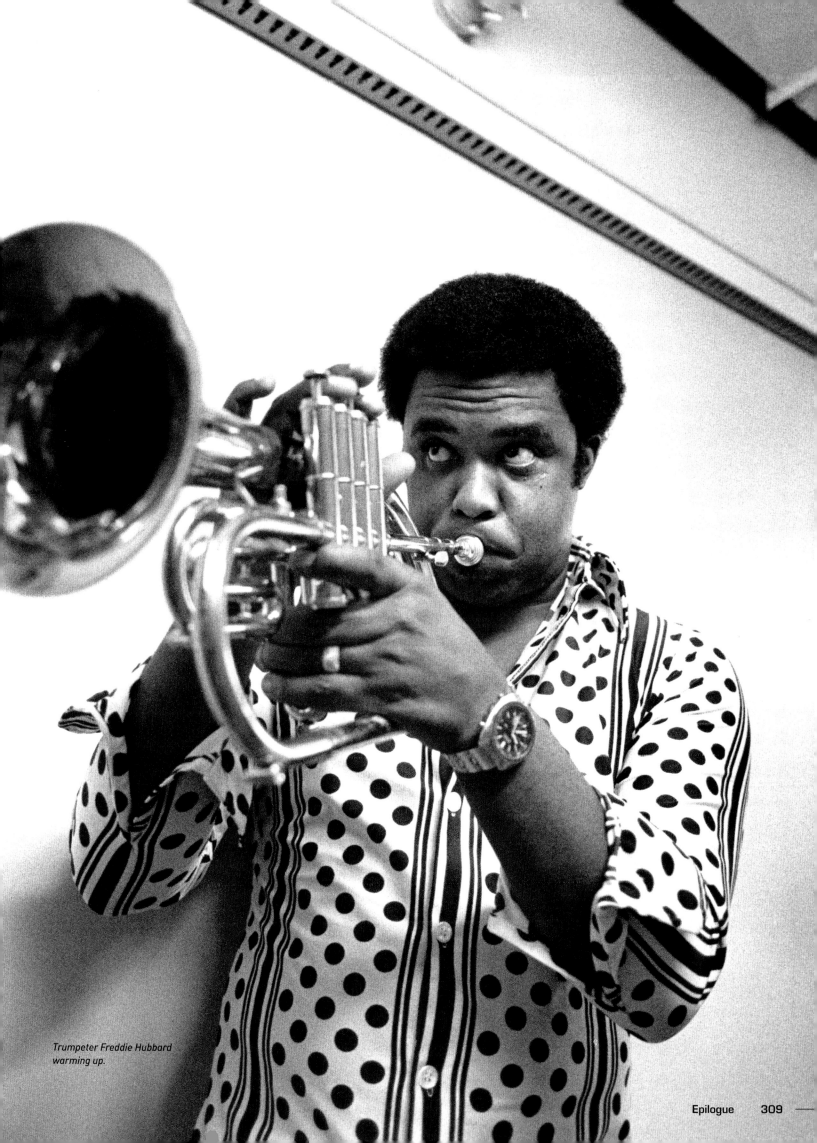

Trumpeter Freddie Hubbard *warming up.*

AFTERWORD

Inside-out Piano Man

DON PULLEN

In the big picture, those who have an enduring, lifelong passion for jazz make up a tiny universe. We are a special breed. I'm convinced that all of us, if asked—with or without any prior musical background or training—could cite specific examples about how we first got hooked on this magnificent music, as well as name the artist(s) who made it all happen.

Wherever I went in my business travels—whether on assignment close to home or abroad—and had the opportunity to sit down with friends or acquaintances for any length of time, the subject just naturally turned to jazz. Inevitably, each of us would soon get around to talking about our "first experience."

I encountered one of those people in 1985, while covering "Jazz City," the Sixth Annual International Jazz Festival held in Edmonton, Alberta, Canada.

The circumstance surrounding our meeting was somewhat unusual. After photographing a concert in one of the festival's more intimate theatres, this man approached me and asked, "How are you able to take your photographs in the dark like that?"

We introduced ourselves. His name was Don Currie, and in his position as executive director of the Alberta Chamber of Resources, worked as a lobbyist on behalf of Canadian natural resources companies. It was clear from the start that he was a big jazz fan. I had

mentioned during our conversation that I was planning on being around for most of the week covering the festival, so before we finished our chat, he invited me to lunch at his home the following afternoon.

After having lunch with he and his wife, Ollie, the next day, he took me down to his music room for some serious listening. I quickly learned just how genuinely attached Don was to one particular jazz artist, pianist/composer Don Pullen. He told me he had first become exposed to the man's playing after hearing a portion of his inaugural Sackville Records release in 1975—*Don Pullen Solo Piano Album*—produced in Toronto's Thunder Sound Studios.

Currie also shared what was an impassioned, front-row-seat experience he and his teenage daughter Sara had in the early 1980s, when Don Pullen performed in Edmonton. Following the concert, despite having spent every ounce of emotion and energy, Pullen still took time out to greet the two with kindness and a sincere handshake. It would wind up being one of Don Currie's two most fulfilling lifetime jazz encounters.

I explained that I, too, was a great admirer of Pullen's music, having first appreciated his innovative ideas while working with bassist Charles Mingus in the mid 1970s. And we talked about my personal experiences working

with, and photographing, the pianist in the late 1970s, after he had headed in a different direction.

Don Currie and I met again that same week when he hosted me on a

Close friends and fellow Charles Mingus alumni Don Pullen (right) and trumpeter Ted Curson take time out to reminisce during the Playboy Jazz Festival afternoon soundcheck proceedings at the Hollywood Bowl in Los Angeles.

visit to the Yardbird Suite, an intimate jazz club that had opened just the year before and was featuring both local and internationally-known artists on its stage. There I met several members of the Edmonton Jazz Society and talked with the executive director of Jazz City, Mark Vasey.

After that, we stayed in touch off-and-on, passing along jazz tidbits of interest, and occasionally sending each other CDs. Among the first albums he sent me was Don Pullen's superb Blue Note disc, *Random Thoughts*, with bassist James Genus and drummer Lewis Nash, one that remains as a personal favorite in my jazz library today. The two of us reconnected once more when I returned to cover the Jazz City Festival in 1987.

In one of his letters to me, Currie wrote about the day he was driving home from work and pulling up to a stop light, only to be confronted by an acquaintance whose stereo system was blaring rock music from the open windows of the car next to him. Don rolled down his window, threw a copy of *Random Thoughts* into the driver's lap, and called out, "Why don't you try this? Best music you'll ever listen to."

A few days later, the acquaintance called Don and thanked him for the dramatic, fantastic introduction to the virtuosic Don Pullen.

Sometime in 1991, Currie called me up, clearly animated, and launched into a story about something that happened the previous week. He said he had been listening all evening to Don Pullen and, around midnight, just picked up the phone and called the information operator. He asked for a Don Pullen listing in New Jersey. Fortunately, the operator was kind and inquisitive, asked a few more questions, and finally came up with Pullen's phone number. The hour in New Jersey would have been around 3:00 a.m.; Currie figured that would be just about the right time for a New York jazz musician to be returning home from a Friday night gig.

Much to my friend's surprise, Don Pullen picked up, and for the next twenty minutes, the two talked about the importance of jazz in their lives, their respective families, and related personal interests.

He told Pullen how strong of an impact the composition he wrote in honor of his daughter, "Tracey's Blues," had made on him. It was one of Currie's most favorite songs. And then Don explained to the pianist that every time he would sit down to listen to "Ode to Life," it would strike a chord so deep within him—all the way to his very fiber—that he would inevitably be brought to tears.

"Yes," Pullen said simply. "That is what I intended when I wrote it."

Two years after Pullen's passing at age fifty-three from lymphoma, Don Currie published the first of his pamphlets on poetry, *Lateral Sidetracks*, of which the centerpiece verse, "Evidence of Things Unseen," honored the great jazz pianist and composer. The words in his verse—including the title—contained the names of thirteen Don Pullen compositions and concluded with the following dedication:

On the Death of Don Pullen
Inside-out Piano Man
East Orange, New Jersey
April 22, 1995
May he Rest in Peace

DON GABRIEL PULLEN
piano, composer
Born: December 25, 1941
Died: April 22, 1995

* * * * *

There are countless first jazz experiences out there—available through so many sources, markets, and media—just awaiting the future Don Curries of the world. It's a discovery process. Many, like both Don and me, will merely stumble on their own—not necessarily knowing what they are looking for—and somehow find the artists and music that capture their inner sensibilities. Others will need some guidance, some direction, maybe even a push from those of us who are already "enlightened."

Really, what we need to do for our youth of today and for the descendants who follow, is to *expose* them—in one manner or another—to this munificent bounty: the art form we call jazz. We who have already been won over and are true believers can do our part by sharing with friends, associates, and acquaintances the many sounds of artists who get our blood flowing, and encourage them to become just as passionate when they discover their own favorites.

America's music education leaders also need to plant those seeds and provide the necessary opportunities for learning about this unique musical treasure. As Quincy Jones wrote: "Such knowledge is a gift; it is one we must preserve and pass along to younger generations so that they may know the multitude of others who are pillars upon which we and our music stand."

Veryl Oakland
November 2016

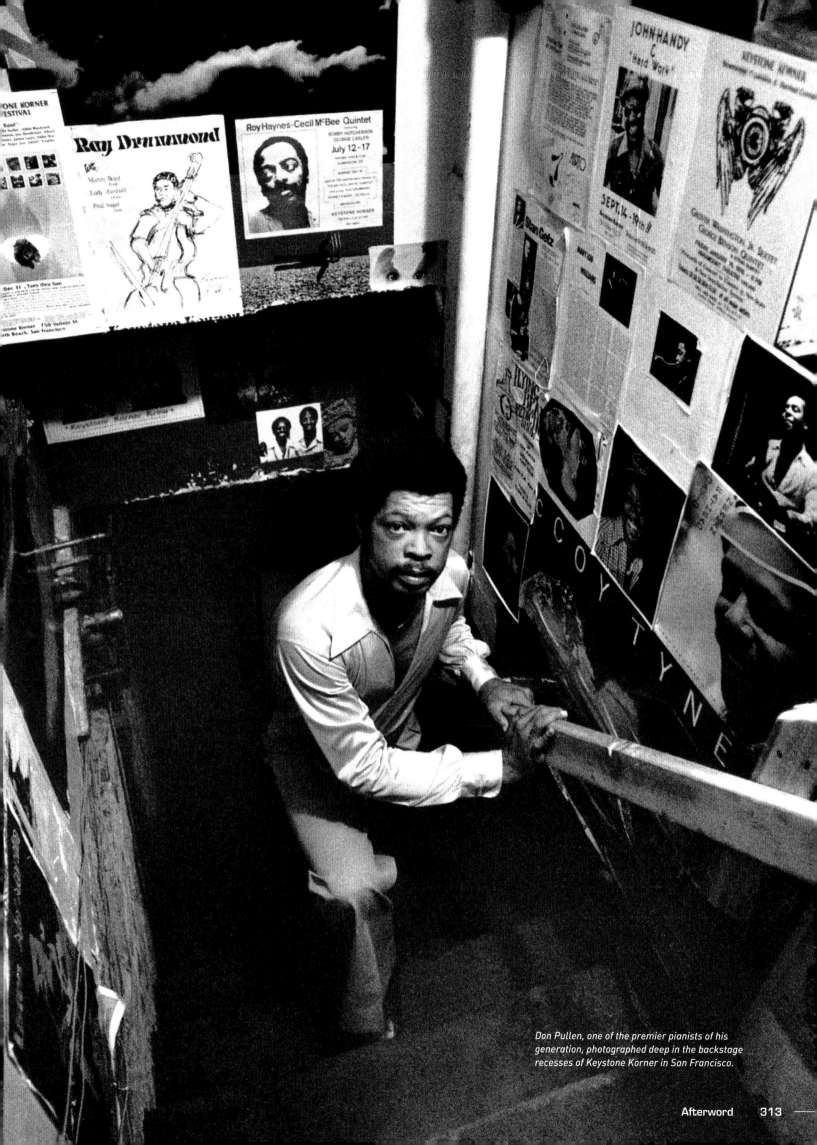

Don Pullen, one of the premier pianists of his generation, photographed deep in the backstage recesses of Keystone Korner in San Francisco.

ACKNOWLEDGMENTS

First and foremost, I want to use this opportunity to honor the men and women of jazz—past and present—especially the many hundreds of those with whom I interacted and photographed throughout the decades of the 1960s, 1970s, and 1980s. I am forever indebted to you and your craftsmanship—especially your individualism and unique creativity—for commanding my personal attention, lifelong interest, and continuing enthusiasm for this fabulous art form.

I am indeed fortunate to have worked in a field made up primarily of fellow professionals who have like-minded goals of further promoting this modern music blessing that we all enjoy. At the top of this list is Darlene Chan, president of FestivalWest Inc., whose entire lifetime career has been devoted to championing the cause of jazz and its spectrum of preeminent artists. In her current role, Darlene's clients include the Playboy Jazz Festival (having worked on its behalf for thirty-eight years), the L.A. Philharmonic, the New Orleans Jazz & Heritage Festival, the Detroit Symphony, the New Jersey Performing Arts Center, as well as many others. From road manager, to talent buyer, to producer of numerous nationwide tours and television specials, Darlene Chan has done it all.

Growing up with parents who were jazzers, Darlene is one of those rare people who recognized her

destiny long before she was even old enough to drive a car. "When I couldn't get into jazz clubs," she wrote me, "I naively decided I would just bring jazz to UC Berkeley; thus, the beginning of my Festival career."

Indeed, that is where I was introduced to this remarkable individual, who would prove to be an undeniable fixture in my own career path. It was in April of 1967, while still a student at the University of California, Berkeley, that she produced her first jazz festival—a two-day, first-class extravaganza featuring the likes of the Miles Davis Quintet, the Bill Evans Trio, Horace Silver's Quintet, the Modern Jazz Quartet, and John Handy's Quintet.

From that initial happenstance, our paths crisscrossed from time to time, and I quickly learned what it meant to have a true jazz friend. Early on in my career, while still struggling to make a name for myself, Darlene recommended me to the powers that be at Brown & Williamson Tobacco Company. I wound up serving for two years as their west coast photographer for the popular KOOL Jazz Festivals.

For more than half a century, Darlene Chan has served as a jazz industry leader—an insider revered and respected by the movers and shakers, entertainment officials at all levels, and musicians of every stripe. I am privileged to have been included in her sphere of influence.

I would also like to pay my respects to some key jazz people

throughout the industry who early on provided me with the necessary exposure, as well as directly facilitated, and otherwise assisted, in my efforts to help recognize and publicize these great artists. They include:

Leonard Feather: The author/critic/composer was instrumental in helping me gain international recognition when he published more than one hundred of my photographs for his book, *The Encyclopedia of Jazz in the Seventies*.

Joachim-Ernst Berendt: The prolific German author/critic/jazz producer was a close friend and collaborator of mine during the 1970s and 1980s, when he was producing his popular jazz calendars, magazine articles, albums, and his acclaimed book, *Photo-Story Des Jazz*.

Kiyoshi Koyama: As editor-in-chief of Japan's influential *Swing Journal* magazine, Koyama was instrumental in expanding my outreach throughout the Far East and beyond as a photojournalist contributor. The "Boxman," as he is affectionately known because of his production of two important Grammy-nominated boxed set jazz recordings, was an early supporter who encouraged me to develop more personalized, human interest photo-stories of jazz artists for the benefit of his readers.

Philippe Carles: The chief editor of *Jazz* magazine in Paris also afforded me the space to present more

expanded coverage of notable musicians for the appreciation of European jazz followers.

My sincere thanks also go out to the following:

Authors: Ted Gioia for sharing the actual book proposal for his work, *Delta Blues*, which served as a helpful guide for developing my own project; Dan Morgenstern, Director Emeritus of the Rutgers Institute of Jazz Studies, for encouraging me to actually write

my book before trying to search out and land established photo galleries to show my works; Tad Hershorn, archivist for the Institute of Jazz Studies, for sharing his thoughts on book publishing; Dr. Wolfram Knauer, director of Europe's foremost jazz archives/research center, Jazzinstitut, in Darmstadt, Germany, for his ongoing support, direction, and guidance through the publishing minefield; Dr. Herb Wong, for his friendship and

frequent collaboration on multiple joint efforts involving jazz writing and photography; Len Lyons, for his publishing guidance and being such a close collaborator over the years on multiple jazz undertakings; Stuart

At the conclusion of the final night's performance featuring the Gerald Wilson Big Band, UC-Berkeley Festival organizer Darlene Chan presents a floral bouquet to guest vocalist Willie Mae "Big Mama" Thornton.

Isacoff, for his thoughts and expertise regarding publishing; and Scott Yanow, for his direct involvement in editing my book.

Publishers, Editors, Producers, Writers, Promoters: Frank Alkyer, publisher of *Down Beat* magazine, for his early support, suggestions, and assists in making my book project successful; Nobuo Hayashi, Yasuki Nakayama, and Takafumi Ohkuma, the succession of *Swing Journal* magazine editors, for their close cooperation in working with me during their tenure; Todd Barkan, producer and former owner of Keystone Korner jazz club in San Francisco, for his close friendship and lifelong support of all things jazz; Gary Vercelli, jazz director of Capital Public Radio in Sacramento, for his promotion/production skills and direct support of my ongoing jazz efforts; Kristian St. Clair, producer of Century 67 Films in Seattle, for his direct assists and promotion of my book; Donald Derheim, CEO of the SFJAZZ Center in San Francisco, for his coordination and assistance of my jazz outreach; Jim Crockett, publisher of *Guitar Player* magazine; Bob Doerschuk, author/editor and former collaborator; and Michael Bloom, writer and fellow collaborator.

Music Professionals: Adam Fell, vice president of Quincy Jones Productions, Inc. for his direct link to producer Quincy Jones for the writing of my book's Foreword; and Alyssa Smith, project manager.

Literary Agents: Michael Larsen of Larsen-Pomada Literary Agency in San Francisco, for his early guidance in navigating the world of book publishing; and Peter Rubie, CEO of FinePrint Literary Management in New York, for his initial review of my work and direct involvement in developing a more preferred, hard-hitting, book proposal.

Business Associates: Jeff Cox of Cox Black-and-White Photo Lab in Sacramento, for his attention to detail and consistency in delivering custom photo finishing to my personal specifications, and to Katherine Weedman-Cox; Martin Salazar, photographic conservator in San Francisco, for his early assessment and expertise in assisting/correcting damaged negatives; Brittney Cook of Sacramento for her retouching and correcting of negatives; Kathy Ueyama of Sacramento for her diligence in translating jazz writings written in Japanese; Tom Head, owner of Abreu Gallery in Grass Valley, California, for his consistent high-quality photo framing and mounting; Mark Feirer, book author and brother-in-law, for his early and ongoing assistance in understanding the publishing business; Irwin Chusid, administrator of the Sun Ra Estate, for his authorization to use Sun Ra's poetry for my book; and to Danny Ray Thompson, Sun Ra road manager, for his direct assistance in coordinating my work.

Jazz Friends: Jimmy Lyons, founder of the Monterey Jazz Festival, and to Ernest Beyl, public relations director, Dr. Henry Hutchins and Cleve Williams, festival directors, Tim Jackson, artistic director, and Tim Orr, media manager; Carl Jefferson, president of the Concord Summer Festival; Paul deBarros, writer for *Down Beat* and the *Seattle Times;* fellow photographers Mark Mander and Bruce Talamon; former college alum George Butorac of Reno, Nevada, for his never-ending encouragement and direct support; Donna Burke of Sacramento, for her ongoing association and continuing friendship; Shane Streifel, mutual friend of our close Canadian jazz fan Don Currie; and daughter Sara (Currie) Pretzlaff.

Most particularly, I want to acknowledge my immediate family, starting with my wife and frequent business traveler, Lynn, who has sacrificed our shared home office for a very long time, as well as foregone more than one vacation, while I have been working to complete this book. I also give thanks and share deep love for my daughters: my eldest, Tory, an early and often cheerleader of my many jazz efforts—including sitting on my lap as a child while I developed film in the darkroom; and my youngest, Alexis.

Without Alexis and her drive, determination, critiques, and prodding, this book would likely have still been in search of a publisher. As early as 2009, when I first mentioned that I could no longer just sit on all the valuable material I had accumulated, she began pushing me to give it new life. It was Alexis who researched and discovered the original archivist for salvaging my damaged negatives, which then gave me the spark to move forward. Once I realized the viability of my work, she not only helped get the project under way, but has remained steadfast throughout this process.

I very much appreciate the personal attention and multiple creative skills that both she and her partner Steve Thompson—co-owners of a design and brand development company—have provided in helping me extend my overall reach to music-lovers everywhere; thus, ensuring that these formidable jazz greats continue to receive the ongoing recognition they so well deserve. We have much more in store beyond this publication, so be sure to stay tuned. . . .

Getting to this point has been a journey—at times involving challenges, uncertainties, and even my share of setbacks.

With the loftiest of intentions, I all but assumed that once my book proposal was made available, publishers would welcome me with open arms. Instead, my outreach became a time-consuming, sometimes frustrating—but unquestionably valuable—learning experience.

My sincere thanks go out to the team at Schiffer Publishing—especially my senior editor (and fellow jazz lover) Bob Biondi—who early on recognized the potential of this most worthwhile project, and have continued to exhibit their encouragement and strong support.

BIBLIOGRAPHY

Alkyer, Frank, and Ed Enright. *Down Beat—The Great Jazz Interviews: A 75th Anniversary Anthology.* Milwaukee: Hal Leonard Corp., 2009.

Alkyer, Frank, Ed Enright, and Jason Koransky. *The Miles Davis Reader.* New York: Hal Leonard Books, 2007.

Balliett, Whitney. *American Singers: Twenty-Seven Portraits in Song.* New York: Oxford University Press, 1988.

Balliett, Whitney. *Collected Works: Journal of Jazz, 1954–2000.* New York: St. Martin's Press, 2000.

Balliett, Whitney. *Goodbyes and Other Messages: A Journal of Jazz 1981–1990.* New York: Oxford University Press, 1991.

Balliett, Whitney. *New York Notes: A Journal of Jazz, 1972–1975.* Boston: Houghton Mifflin, 1976.

Balliett, Whitney. *The Sound of Surprise.* New York: Da Capo Press, 1978.

Basie, Count, and Albert Murray. *Good Morning Blues: The Autobiography of Count Basie.* New York: Random House, 1986.

Bellson, Louie. *Louie Bellson Honors 12 Super Drummers—Their Time Was the Greatest.* Van Nuys: Warner Brothers Publications, 1997.

Berendt, Joachim-Ernst. *Jazz: A Photo History.* New York: Schirmer Books, 1979.

Berendt, Joachim-Ernst. *Jazz '80 (Calendar).* Kempen, Germany: teNeues, 1980.

Berendt, Joachim-Ernst, and Gunther Huesmann. *The Jazz Book: From Ragtime to the 21st Century.* Chicago: Lawrence Hill, 2009.

Bley, Paul, with David Lee. *Stopping Time: Paul Bley and the Transformation of Jazz.* Montreal, Quebec, Canada: Vehicle Press, 1999.

Brown, Anthony, recorded by Ken Kimery. *Interview with Louie Bellson.* Archives Center, National Museum of American History. Washington, D.C., October 20–21, 2005.

Burton, Gary. *Learning to Listen: The Jazz Journey of Gary Burton.* Boston: Berklee Press, 2013.

Bushell, Garvin. *Jazz From the Beginning.* Cambridge, MA: Da Capo Press, 1998.

Cohen, Harvey G. *Duke Ellington's America.* Chicago: The University of Chicago Press, Ltd., 2010.

Crouch, Stanley. *Considering Genius: Writings on Jazz.* New York: Basic Books, 2006.

Currie, D.V. *Lateral Sidetracks.* Westword Communications Inc. Calgary, Alberta, Canada, 1997.

Dance, Stanley. *The World of Duke Ellington.* New York: Charles Scribner's Sons, 1970.

Davis, Francis. *Like Young: Jazz and Pop, Youth, and Middle Age.* Cambridge, MA: DaCapo Press, 2001.

Davis, Francis. *Outcats: Jazz Composers, Instrumentalists, and Singers.* New York: Oxford University Press, 1990.

Davis, Miles, and Quincy Troupe. *Miles: The Autobiography.* New York: Simon & Schuster, 1989.

DeVeaux, Scott. *The Birth of Bebop: A Social and Musical History.* Berkeley, CA: University of California Press, 1997.

Doerschuk, Robert L. *88: The Giants of Jazz Piano.* San Francisco: Backbeat Books, 2001.

Doerschuk, Robert L. (editor). *Playing from the Heart: Great Musicians Talk About Their Craft.* San Francisco: Backbeat Books, 2002.

Down Beat (magazine). Chicago: Maher Publications,1962 to present.

Down Beat: 60 Years of Jazz, edited by Frank Alkyer. Milwaukee: Hal Leonard Corporation, 1995.

Ellington, Edward Kennedy. *Music Is My Mistress.* New York: Doubleday & Co., 1973.

Feather, Leonard. *The Encyclopedia of Jazz in the Sixties.* New York: Horizon Press, 1966.

Feather, Leonard. *The Jazz Years: Earwitness to an Era.* New York: DaCapo Press, 1987.

Feather, Leonard. *The New Edition of The Encyclopedia of Jazz.* New York: Horizon Press, 1960.

Feather, Leonard. *The Pleasures of Jazz.* New York: Horizon Press, 1976.

Feather, Leonard, and Ira Gitler. *The Encyclopedia of Jazz in the Seventies.* New York: Horizon Press, 1976.

Gavin, James. *Deep in a Dream: The Long Night of Chet Baker.* New York: Alfred A. Knopf, 2002.

Giddins, Gary. *Visions of Jazz: The First Century.* New York: Oxford University Press, 1998.

Giddins, Gary. *Weather Bird: Jazz At the Dawn of Its Second Century.* New York: Oxford University Press, 2004.

Gillespie, Dizzy, and Al Frazer. *To Be or Not . . . to Bop.* Garden City, NY: Doubleday, 1979.

Gioia, Ted. *The History of Jazz,* vol. 2. New York: Oxford University Press, 2011.

Gluck, Bob. *You'll Know When You Get There: Herbie Hancock and The Mwandishi Band.* Chicago: The University of Chicago Press, 2012.

Gridley, Mark C. *Concise Guide to Jazz.* New Jersey: Pearson Education/ Prentice Hall, 2010.

Gridley, Mark C. *Jazz Styles.* New Jersey: Pearson Education/ Prentice Hall, 2009.

Haskins, James, and Kathleen Benson. *Lena: A Personal and Professional Biography of Lena Horne.* New York: Stein and Day, 1984.

Hasse, John Edward, and Tad Lathrop. *Jazz: The First Century.* New York: HarperCollins, Inc., 2000.

Hawes, Hampton, and Don Asher. *Raise Up Off Me: A Portrait of Hampton Hawes.* New York: DaCapo Press, Inc., 1974.

Hentoff, Nat. *American Music Is.* Cambridge, MA: Da Capo Press, 2004.

Hentoff, Nat. *Jazz Is.* New York: Limelight Editions, 1984.

Hentoff, Nat and Nat Shapiro, editors. *Hear Me Talkin' To Ya.* New York: Holt, Rinehart and Winston, Dover Publications, 1955.

Hershorn, Tad. *Norman Granz: The Man Who Used Jazz for Justice.* Berkeley, CA: University of California Press, 2011.

Hodeir, Andre.*Toward Jazz.* New York: Grove Press, 1962.

Isacoff, Stuart. *A Natural History of the Piano.* New York: Alfred A. Knopf, 2011.

Jazz (magazine). Paris, France: Fillipacchi Publications, 1969-1990.

Kart, Larry. *Jazz In Search of Itself.* New Haven, CT: Yale University Press, 2004.

Kernfeld, Barry (editor).*The New Grove Dictionary of Jazz, Volumes 1 and 2.* London: Macmillan Press, 1988.

Knauer, Wolfram (editor). *Gender and Identity in Jazz.* Darmstadt, Germany: Wissenschaftsstadt Darmstadt, 2016.

Kolb, Rosalinda. *Leave 'Em Hungry: A Love Story and Cautionary Tale.* Minneapolis, MN: Publish Green (Hillcrest Media Group), 2014.

Lees, Gene. *Waiting for Dizzy.* New York: Oxford University Press, 1991.

Lewis, George E. *A Power Stronger Than Itself—The AACM and American Experimental Music.* Chicago: The University of Chicago Press, 2008.

Lyons, Jimmy, with Ira Kamin. *Dizzy, Duke, The Count and Me.* San Francisco: Hearst Corp., 1978.

Lyons, Len. *The 101 Best Jazz Albums: A History of Jazz on Records.* New York: William Morrow & Co., 1980.

Lyons, Len. *The Great Jazz Pianists: Speaking of Their Lives and Music.* New York: William Morrow & Co., 1983.

Lyons, Len, and Don Perlo. *Jazz Portraits: The Lives and Music of the Jazz Masters.* New York: William Morrow & Co., 1989.

Maggin, Donald L. *Stan Getz: A Life in Jazz.* New York: William Morrow and Company, Inc., 1996.

Mandel, Howard. *Future Jazz.* New York: Oxford University Press, 1999.

Marsalis, Wynton, with Geoffrey C. Ward. *Moving to Higher Ground: How Jazz Can Change Your Life.* New York: Random House, 2008.

Martino, Pat, with Bill Milkowski. *Here and Now! The Autobiography of Pat Martino.* Milwaukee: Backbeat Books, 2011.

Mercer, Michelle. *Footprints: The Life and Work of Wayne Shorter.* New York: Penguin Group, Inc., 2004.

Mingus, Charles, edited by Nel King. *Beneath the Underdog.* New York: Penguin, 1980.

Minor, William. *Monterey Jazz Festival: Forty Legendary Years.* Santa Monica, CA: Angel City Press, Inc., 1997.

Morgenstern, Dan, edited by Sheldon Meyer. *Living With Jazz: A Reader.* New York: Pantheon Books, 2004.

Pepper, Art and Laurie. *Straight Life: The Story of Art Pepper.* New York: Schirmer Books, 1979.

Peterson, Oscar. *A Jazz Odyssey: The Life of Oscar Peterson.* London: Continuum, 2002.

Porter, Lewis. *John Coltrane: His Life and Music.* The University of Michigan Press, 2001.

Porter, Lewis. *Lester Young.* Boston: G. K. Hall and Company, 1985.

Reisner, Robert George. *Bird: The Legend of Charlie Parker.* New York: Citadel Press, 1962.

Sales, Grover. *Jazz: America's Classical Music.* New York: Prentice Hall Press/Simon & Schuster, Inc., 1988.

Schuller, Gunther. *Musings: The Musical Worlds of Gunther Schuller.* New York: Oxford University Press, Inc., 1986.

Silver, Horace, edited by Phil Pastras. *Let's Get to the Nitty Gritty.* Berkeley, CA: University of California Press, 2006.

Simon, George T. *The Big Bands.* New York: Macmillan Co., 1967.

Smith, William H. "His Jazz Parties Brought Down the House." *Wall Street Journal* (March 20, 2007).

Swing Journal (magazine). Tokyo, Japan: Swing Journal Co., Ltd., 1969–1990.

Szwed, John F. *Jazz 101: A Complete Guide to Learning and Loving Jazz.* New York: Hyperion, 2000.

Szwed, John F. *Jazz 101: Space Is the Place: The Lives and Times of Sun Ra.* New York: DaCapo Press, 1998.

Terry, Clark, and Gwen Terry. *Clark: The Autobiography of Clark Terry.* Berkeley, CA: University of California Press, 2011.

Wulff, Ingo. *Chet Baker in Europe, 1975–1988.* Kiel, Germany: Nieswand Verlag, 1993.

INDEX

Copyright © 2018 by Veryl Oakland

Library of Congress Control Number: 2017953839

All rights reserved. No part of this work may be
reproduced or used in any form or by any means—
graphic, electronic, or mechanical, including
photocopying or information storage and retrieval
systems—without written permission from the publisher.

The scanning, uploading, and distribution of this book
or any part thereof via the Internet or any other means
without the permission of the publisher is illegal and
punishable by law. Please purchase only authorized
editions and do not participate in or encourage the
electronic piracy of copyrighted materials.

"Schiffer," "Schiffer Publishing, Ltd.," and the pen and
inkwell logo are registered trademarks of Schiffer
Publishing, Ltd.

Design concepts by Alexis Oakland and Steve Thompson
Interior layout by Molly Shields
Cover layout by John Cheek

Front cover & title page: Miles Davis at Greek Theatre,
University of California, Berkeley, 1970
Pages 4–5: Sonny Rollins, Greek Theatre, University of
California, Berkeley, 1979
Opposite: Benny Golson, Monterey (CA) Jazz Festival, 1975
Following spread: Count Basie (left) and Eddie "Lockjaw"
Davis at Concord (CA) Summer Festival, 1971

Type set in Swis721 BT/Cambria

ISBN: 978-0-7643-5483-0
Printed in China

Published by Schiffer Publishing, Ltd.
4880 Lower Valley Road
Atglen, PA 19310
Phone: (610) 593-1777; Fax: (610) 593-2002
E-mail: Info@schifferbooks.com
Web: www.schifferbooks.com

For our complete selection of fine books on this and
related subjects, please visit our website at
www.schifferbooks.com. You may also write
for a free catalog.

Schiffer Publishing's titles are available at special
discounts for bulk purchases for sales promotions or
premiums. Special editions, including personalized
covers, corporate imprints, and excerpts, can be
created in large quantities for special needs. For more
information, contact the publisher.

We are always looking for people to write books on new
and related subjects. If you have an idea for a book, please
contact us at proposals@schifferbooks.com.

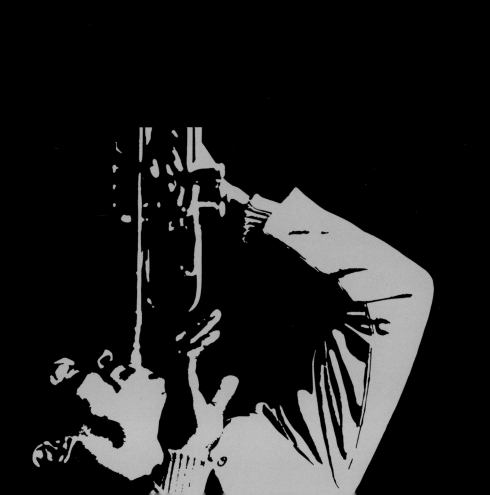